W9-BTM-389

DOING

The Remarkable
Parent-Child Workshop
of The Metropolitan Museum
of Art

Workshop photographs by Seth Joel

ART TOGETHER

MURIEL SILBERSTEIN-STORFER

WITH

MABLEN JONES

SIMON AND SCHUSTER • NEW YORK

To my parents,
Mara and Sam Rosoff

To my teachers,
Dr. Victor D'Amico, Jane Cooper Bland,
Dr. Muriel Gardiner Buttinger, and Dr. G. Henry Katz

To my children and grandchildren,
Wendy, Jeffrey, and Charles, Tali and Dov

To my husband, Herb, whose loving help
brings everything all together

Copyright © 1982 by Muriel Silberstein-Storfer, The Metropolitan
 Museum of Art, Mablen Jones

Published by Simon and Schuster
A Division of Gulf & Western Corporation
Simon & Schuster Building
Rockefeller Center
1230 Avenue of the Americas
New York, New York 10020
SIMON AND SCHUSTER and colophon are trademarks of Simon & Schuster
Designed by Eve Metz
Workshop photographs copyright © 1981 by Seth Joel
Manufactured in the United States of America

10 9 8 7 6 5 4 3 2 1

Library of Congress Cataloging in Publication Data
Silberstein-Storfer, Muriel, date.
 Doing art together.

 Bibliography: p.
 1. Art—Study and teaching (Elementary)—United States. 2. Art—Study
and teaching—United States. 3. Artists' studios—United States—
Handbooks, manuals, etc. I. Jones, Mablen. II. Title. III. Title: Parent-Child
Workshop of the Metropolitan Museum.
N362.S5 707 81-9418
ISBN 0-671-24109-5

ACKNOWLEDGMENTS

So much in life is a matter of connectedness, that interdependent web of people and ideas that spin into a creative act. I have been most fortunate in having the support and assistance of many wonderful individuals, so many in fact that it would be impossible to name them all within the space allowed. Each of the parents, teachers, and children with whom I have had the privilege of doing art together has contributed in some way to the pages that follow. While preparing the various chapters, I truly enjoyed reviewing and thinking about the many experiences that have emerged in anecdotal form as examples to clarify ideas.

Early on, Dr. Richard Silberstein's strong and brilliant leadership in the field of child development, community education, and mental health provided insights and opportunities for understanding the work in which he was involved. Through sharing experiences, I discovered how closely it all related to the principles of learning and communicating through the arts.

I wish to express particular thanks to those who were most instrumental in helping me bring the parent-child workshop concept to The Metropolitan Museum of Art. Initially, it was Thomas Hoving, then the Director of the Museum, who invited me to become involved with its programs and proposed my election to the Board of Trustees. The Board, with Douglas Dillon as its Chairman, Roswell L. Gilpatric and J. Richardson Dilworth as Vice Chairmen, the current President William B. Macomber and Director Philippe de Montebello, have always been supportive of my active role in the area of educational services. In 1972, it was Harry Parker III, Vice Director for Education, and Louise Condit, Museum Educator in charge of the Junior Museum, who made a dream come true by inviting me to teach the studio workshops for members and their young children.

The book itself is an outgrowth of numerous relationships and many minds. In 1973 Bradford D. Kelleher, now Vice President and Publisher at the Museum, became enthusiastic about my idea and provided the impetus for its development. Faye Lee, his most helpful assistant, recommended Seth Joel to do the photography. His enormous patience, sense of humor, and skill in handling cameras and people were much appreciated, and the delightful results are evident throughout the book.

The Metropolitan Museum of Art is filled with extraordinary people who were most supportive and encouraging in a variety of ways. Ashton Hawkins, Penelope K. Bardel, Richard R. Morsches, Arthur Rosenblatt, Cecilia Mescall, and Margaret P. Nolan and her staff in the photograph and slide library—Mary F. Doherty, Deanna Cross, and Franklin Riehlman—were unstinting in their help. Lowery S. Sims and Ida Balboul gave valuable advice; Elizabeth Usher and Stella Blum were also very kind. Artist-teachers who were generous in discussing ideas included Hilde Sigal, Sharon Adler, Susan Holtzel, Randy Williams, Arlette Buchman, and, in particular, Suzanne Geller. I feel a special debt of gratitude to Arthur Brady and his successors as assistants in the studio workshops, Ellen Rosenthal, Jane Cohn, Charlene Marsh, Lisa Roggli, Annette Mohr, Electra Friedman, and numerous interns and volunteers for their loyal support and help.

Others who were generous with their time were Madeleine Chalette Lejwa, Stephanie Stern, Ada Owens, Lee Rampulla, Madeleine Ribaudo, Carol Borzumato, Anne Einhorn, Toni Weaver, and many of the staff of the Staten Island Mental Health Society programs and schools. Mrs. Mary Burke allowed me the unique experience of viewing her collection of Japanese art, and discussions with her curator, Andrew Pekarik, were most informative and helpful.

I am especially indebted to those who assisted with professional editorial skills and moral encouragement over the last six years. Nan Talese, Senior Editor, and her successor, Roslyn Siegel, were knowledgeable and supportive. My collaborator, Mablen Jones, deserves special mention, not only for her writing ability, but also for her skill in organizing and clarifying ideas, which were enriched by her own knowledge as a practicing artist. Dianne Janis, Joan Harvey, Virginia Wolff, and Kathy Simmons were most helpful in the mechanics of putting the manuscript together.

Elizabeth Flinn, who is in charge of the Junior Museum and High School programs, has been supportive throughout, taking time to read the manuscript and make suggestions, as did Joan Cavanaugh and Carol Moon Cardon.

I also appreciated the kind help of Roberta M. Paine, Mary E. McNamara, Meredith Johnson, Sally Harris Ritter, Felicia Blum, Paul J. Patane, Elizabeth Lorin, Andrée Markoe, Suzanne Gautier, Margaret Lunney, and Eugene Fitzpatrick.

Education services under the direction of Merribell Maddux Parsons continue to offer an atmosphere of serious purpose and exciting projects for the future. Altogether, I am deeply grateful for the climate of stimulating ideas and concern for learning in which this book has been nurtured.

Contents

Preface

THE IDEA THAT ART AND LIFE ARE INSEPARABLY INTERTWINED like vines growing in and out of the branches of a tree became clearer to me at Fieldston High School where I was privileged to have Victor D'Amico as my art teacher. Although I had always been involved with art, his classes were different from any I had experienced before because he brought the studio activities into our everyday lives. He helped us feel close to art by showing us how we could use our studio skills and aesthetic awareness to become better observers in every area of life.

The development of working relationships and common interests became as important as the projects themselves. We learned to accept ourselves and others and to appreciate and respect the differences between our aesthetic choices and those of people of other times and places. We experienced what it meant to stay after school working individually yet side by side at a table, or collaborating as a group sharing long hours together. Victor guided, supported, and respected our efforts as we found excitement in the discovery and exchange of ideas.

At Carnegie Institute of Technology School of Fine Arts, I studied costume and scene design, and after was employed in theater and interior display. Later it was quite natural for me to bring my aesthetic orientation to community work and activities with my young family. When my first child was three, we both enrolled in a parent-child workshop at the Museum of Modern Art where Victor D'Amico was Director of Education and Jane Bland was our first instructor. While Victor had inspired appreciation of art and exploration with materials, Jane's class was an added joy because I shared the experience with my daughter, Wendy. I was so taken with the idea that I went back to the museum with my other two children and enjoyed working under the guidance of Jean D'Autilia, Elizabeth Spiro, and Susan Weitzman. We also delighted in searching through the galleries together and eating lunch in the Sculpture Garden.

At the same time I worked with community mental health programs that offered education to parents and teachers in workshops on child development and prevention of mental illness. There were parallels between the programs at The Museum of Modern Art and those of the Mental Health Society. Both recognized that lectures to parents on furthering their children's development weren't nearly as

effective as workshops with parent participation. As I remembered my high school experiences, once again I observed that often people working together in a group stimulate each other to greater awareness more rapidly than if each works alone. The group interaction is similar to a family, where members are responsible not only for their own efforts and behavior but also for supporting a group.

Now I found that even after taking my three children to the parent-child sessions, I still needed additional guidance to set up studio activities for them at home. I had been enjoying the class projects so much that I didn't pay attention to the teaching methods that made the sessions so successful. When I used studio materials for my children at home, I often wasn't organized enough. Although I had the best intentions, I was not sure of the most effective approach and consequently decided to return to the Museum of Modern Art to take Jane Bland's highly regarded teacher training course.

She invited me to assist her. Eventually, I taught two workshops on my own. Jane Bland's creative teaching process made everything she said seem so reasonable and logical. She offered the "nuts and bolts" know-how for guiding sessions with art materials. We learned how to substitute different materials and improvise facilities, how to create excitement right where you are, even if you have limited resources, and how to stimulate and motivate the inner person, while giving him the courage to try. It was a philosophy of life and a way of living that went beyond the studio. She encouraged us to steer away from the stereotypes and clichés, urging us to try things in different ways ourselves before offering them to anyone else.

Having gone through many art experiences with my own children, I began to hear Victor's ideas with fresh ears. He believed that because parents are their children's first teachers, they too need to learn how to promote creative growth. Most important, I was reminded that art was not an isolated facet of daily living. I realized that what Victor and Jane were doing was essential to human development in many respects, and fundamental to all learning.

As the Mental Health Society continued to develop, I became an art consultant for their day care programs for preschool children, becoming particularly involved with the Head Start program doing work with parents and teachers. We invited Jane Bland and Victor D'Amico to lecture and Jane conducted workshops to help train parents as teacher aides and volunteers in the community.

Working with Head Start, I learned from parents (many of whom were on welfare) the validity of Jane's philosophy and Victor's statement that "art is a human necessity." One woman in particular, a young mother with five children and a very troubled husband, was depressed about her home situation. She told me that she felt trans-

ported far from her troubles and good about herself while working with art materials. She continued attending the workshops and started working part-time in the Head Start school kitchen. Whenever I, or anyone else, talked about art and education she was always in the front row. Next, she became a teacher's aide and enrolled in a teacher training program. Today, she is a successful teacher who brings art experiences to children at every opportunity.

Personal experience as well as research has convinced me that the ability of an aesthetic approach to change one's life is universal and not restricted to any economic, cultural, or educational level.

Just before the Institute of Art at the Museum of Modern Art closed, I met the director of the International Playgroups, Inc., an organization for the children and families of United Nations personnel, who invited me to initiate parent-and-child workshops for her school. I taught similar classes for the Staten Island Community College on their campus as well as in a low income housing project, and one semester, even in someone's unfurnished living room. No matter what the environment or the background of the students, the classes thrived.

In 1972, I was asked to organize parent-child workshops at The Metropolitan Museum of Art. How gratifying it has been to see this concept flourish in a museum setting once again. It is an ideal place because students have continuous access to collections of art objects. Here they are cared for, displayed, and protected in a manner that reflects the greatest respect for human creativity. Students can, in time, become aware of historical traditions and feel they are a part of a cultural heritage. However, the method will work anywhere for you if you are well organized, have basic tools, a minimum of materials, and a positive attitude. It is essential to have realistic expectations, to support and respect everyone's efforts and accept them at their own level of development. Keep in mind that what someone knows and is capable of doing has little to do with his or her age. Never "talk down" to anyone—child, parent, or teacher. Start with the basics, whatever the age of the group, because you do not have to be a child to be experiencing art for the first time. It is important for you to know what to expect and to present possibilities to help everyone in the workshop go further. Personal preferences sometimes may make it difficult for you to work in a group format. However, your ability to respect the group's aims is extremely important for a harmonious atmosphere in the studio.

The significant thing about these workshop experiences is that they are successful with people of all ages and backgrounds. They give everyone a way to start, a process for continuing, and an opportunity to discover their own abilities as well as to increase awareness of their

visual surroundings. Visits to museums and galleries often become an integral part of life once one has this exposure. Even experienced artists have told me that they have benefited by learning to apply some of the workshop principles to their own routines. A painter I know found that her twenty-two-year-old student apprentice, who had studied for two years in a professional art school, constantly knocked over the glue as he worked, so she set up the tools and materials as I do in my workshop for the three-year-olds, using a shortened brush in a glue jar filled only one-third full. It solved his problem. Often, even advanced art students are not given any pointers in elementary studio procedures because instructors sometimes assume that good work habits are common knowledge to everyone.

Many adults and their children find this studio involvement so absorbing that they return to the workshop programs four and five times. The program not only serves as an enjoyable, creative experience in itself, but also as an important foundation for setting up a home workspace and for cultivating new perspectives in other aspects of their lives.

A major difference between the museum and home workshop experiences is a change of roles. The adults in the museum group are students and I am the leader. At home they have to become acutely sensitive to the demands of being role models themselves.

One initial problem facing people who are learning how to guide others in the mastery of any skill is their lack of awareness of the absolute necessity for their own intellectual and emotional preparation for the responsibilities of being a leader. This role involves both spoken and unspoken standards that they must set: putting specific limits on behavior, establishing values about doing things well, and inspiring courage to enable others to go from the known to the unknown.

Besides the responsibilities delegated to the leader, everyone (including the leader) needs to learn how to work independently in his or her own space. How to share experiences with others (including your own children) without dominating them can be an important lesson in the art of doing things together.

The following chapters give you specific instructions for adapting these museum workshops to your own home or group situations and also describe how to incorporate your studio discoveries into your living routines.

MURIEL SILBERSTEIN-STORFER

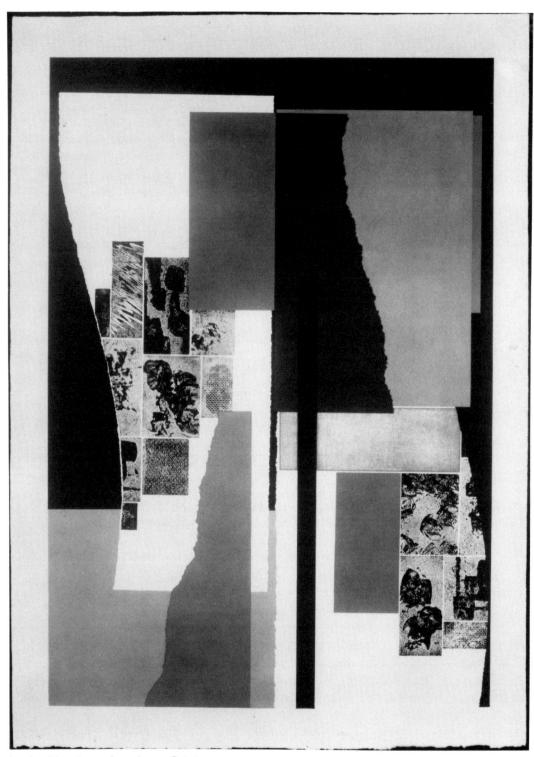

Louise Nevelson, American. *Celebra-
tion Series, #520-88-4,* 1979. Torn-
paper collage and aquatint etching.
44" × 31½".

ONE

The Art Experience

After all it is a great adventure—a great explora-
tion with the infinite beckoning on.
 AUGUSTUS VINCENT TACK, American painter
 (Letter from the artist quoted in *The Natural*
 Paradise, edited by Kynaston McShine)

BELONGING TO A TRADITION

WE ALL BELONG TO A TRADITION of people who have made things
with their hands. However, today, anesthetized by modern
conveniences and machine-made products, Americans rarely prac-
tice folk arts or crafts by necessity. Woodworking, cooking, quilting,
gardening, and writing (in the absence of telephones) provided mar-
velous tactile and emotional enrichment and were activities passed
down from parent to child and from master to apprentice. Often
these activities were performed in social gatherings, further reinforc-
ing the emotional satisfaction of working with the hands.

Now it seems that many adults have had very little tactile experi-
ence since leaving grade school. Consequently, they often enter into
a materials workshop with either tremendous enthusiasm or deep
concern. Once in a workshop I noticed a young mother, a highly
educated and successful scientist, giggling as she worked. I asked her
why. She replied, "I'm just feeling so happy! I never thought I could
do anything like this."

If you cook, not only do you taste unfamiliar dishes with great
interest detecting the individual herbs and spices, but you also can
feel an identification with the other cook who made the meal. If you
sew, you appraise new clothing designs with a more precise eye. If
you do woodworking, you notice the details and care in finish and
joinery in furniture. Deep knowledge often comes by learning things
through the hands as well as the mind. Art history courses may
provide a certain amount of information about appreciating art, but,
when you participate in the studio process you learn with your hands
to actually feel a part of the human process that brought forth a work

of art. Moreover, participating in a communal creative experience brings a sense of belonging. This is one reason why doing these projects with others can be more enjoyable than doing them alone.

Within any group, even within a family group, shared studio activities can provide us with a kind of lifeline of communication. Even when we could not agree on some things, my sons were always alert, wherever they were, for interesting collage materials such as fossils, seashells, and pieces of rock that we could share together with pleasure. Similarly, a young acquaintance from a small town in middle Florida found that after living for over ten years in New York City he had very few topics of conversation in common with his parents. However, he and his father could go out to the garage and do cabinet work in harmony. Woodworking, the hobby his father taught him, was something they could still enjoy without arguing.

DEFINING YOUR EXPECTATIONS OF SUCCESS

When you teach someone how to row a boat, you don't necessarily expect him or her to become a ship's captain; when a child learns numbers, you don't anticipate he or she will be a bank president, although both of these things may happen. Neither can you expect students to become professional artists if you teach them to draw. But if you share a body of positive experience with a child you can expect to develop an aesthetic dimension in both your lives, no matter what else you decide to do. However, if your idea of studio success is based on comparing your end products with someone else's, you both will lose. If you are writing a diary you don't compare it with anyone else's, because you lead different lives. Like a diary, your collection of workshop projects is a record of your own experiments and explorations.

Popular opinion has sometimes held that artistic talent is born. Yet not all visual sensitivity is innate. It is created by a mixture of exposure and encouragement. Using your talents or abilities effectively involves an open approach to new ideas, and having the self-confidence to execute them. The following projects do not teach facile techniques for pleasing and impressing others with pretty projects, but rather stress learning to trust your own way of seeing the world around you, so you can be receptive to all kinds of experiences.

Children, like Alice in Wonderland, are stimulus-bound. They eat the cookie when it says "Eat me!" They are defenseless against the sophisticated visual commercials that say "Want me!" If you can point out to them when those dazzling ads appear on television: "Look how big they made that candy bar! Do real ones really look

Student-teachers' workshop.

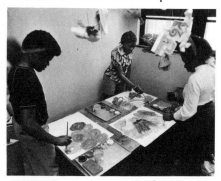

like that? See all those shiny parts and colored patterns on that box?" If you can go on to point out the visual qualities that make the image so appealing, the changes of scale and proportion, and how images of beauty and energy often have nothing to do with the intrinsic qualities of the products, then you are teaching the many uses of visual language. You may both come to recognize that visual language is not merely an element of art but is also a means of daily communication. When you have a context in which to deal with images, you and your children can think about them and make judgments instead of responding automatically.

Many kinds of abilities can be developed through the projects described in this book: a talent for making choices, a talent for patience, a talent for sensory awareness and visual discrimination, a talent for finding solutions, and a talent for recording fantasies and dreams in a visual way.

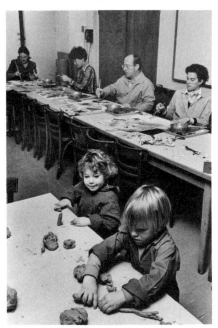

Parent-child workshop.

You can't judge yourself or your inexperienced child against others of the same age who may be experienced with art materials, no matter how bright. Your four-year-old might not be able to do something as easily and fluently as a younger child who has already been encouraged to develop fine motor coordination. If you try to push him by telling him exactly what to do in order to produce a pretty product, he will probably become dependent on your direction all the time. Presenting advanced practices or theory to anyone (with the hope he or she will develop faster) is useless because concepts won't be understood. If you correct your children's studio work to make it look pleasing to other adults, you deprive them of the confidence to make their own aesthetic choices. Everyone, young and old, must work through every stage of development himself. There is no skipping any step along the way.

Your children will continue to develop at their own rate of progress and their work will change naturally. In their preschool days your home workshops may be a central focus of their week, while, of course, many different activities will compete for their time and attention later. Yet the built-in awareness and skills you have helped to implant will later resurface, and their enjoyment of their visual world will continue.

MAKING CONNECTIONS: BRINGING TOGETHER YOUR LIFE EXPERIENCES THROUGH STUDIO WORK

Sometimes it is through your children that you discover new experiences and also return to enjoyable ones that you may have left behind. My daughter, Wendy, brought me back to my painting. My

son Jeffrey brought me back to visiting offbeat places to search for unusual materials to use in my work, and my son Charles to exploring in the woods and the beaches. You probably enjoyed using paint and clay and cutting up paper some time in your grade school career, but because you never learned how to generate visual ideas of your own it was something you left behind.

This is a book for beginners of all ages and for those who would like to pick up where they left off somewhere in the past. Adults sometimes have difficulty starting something new because they are reluctant to place themselves in the uncomfortable role of the beginner, particularly with things they think they should know. My mother told me in her later years that she would have loved to have known more about art and to have worked with studio materials herself, but she felt self-conscious about trying at her age. Like so many others she did not know how or where to begin.

When you start to relate studio skills to other things you've learned in your life and put these into a new focus, you may find that you're not as much of a beginner as you thought. Certainly you have more basic experiences than your children. There's nothing in these workshop projects that you can't relate to some skill or sensitivity you've developed in your daily life. For example:

• You've probably learned how to organize the spaces in your home and know at least some elementary manual skills of home maintenance, clothing repair, and cooking.

• You probably color-coordinate your clothing and furnishings.

• You may make a variety of doodles while at the telephone.

• You may write letters in longhand and have fine small-muscle coordination.

• You may decorate packages and cakes and make holiday ornaments.

• You may have a fine sense of appreciation of nature and enjoy looking at landscapes and natural objects.

• You may see films and theatrical performances that display a variety of visual arrangements, expressing moods and ideas.

• If you sew and are acutely fashion-conscious, you may be aware of how the cut of fabric lines, patterns, and colors affect a design visually.

• If you are a sports fan, you may be sensitive to changes in the visual rhythms and movements that influence the outcome of a game, and a keen observer of the choreography of people's gestures.

• If you are in the sciences, you may organize visual information and may have developed powers of observation beyond those of the general population.

•If you are interested in music, you may have considered or examined changes of rhythm, color of sound, phrasing, and intervals in melodies, and repetition and contrasts of themes.

So you see, although you may not know how to mix colors or cut and paste, you come to these projects with your own unique package of experiences and skills which you can incorporate into the use of art materials to express your own thoughts, feelings, and impressions.

Many parents come to the classes to do something for their children without knowing that I have high expectations for their own success. They are astonished to find out that they can invent paintings, collages, and sculptures with guidance and complete projects that allow for each individual's stage of development. If you've had no experience, you can develop your own skills further than you might expect. Because you can accomplish something every time, you will have the courage to go on to the next step. There are no miracles here. It's just that almost every potential problem or obstacle has been as realistically considered as possible so that you can have the best possible chance for success.

While rediscovering old pleasures, you may well discover new ones because these workshops provide an excuse to do things you never would attempt at home alone, or even in an adult education class. But seeing youngsters making juicy color mixtures and squeezing clay into odd shapes will give you the courage to do it yourself. Excitement is contagious.

In using studio materials we develop and give play to all our natural senses. Sometimes, in the very beginning, young children try to see, hear, taste, touch, and smell everything. They may even try to taste the clay, paint, and glue, or smell and feel the materials in their first classes. They often have the urge to smear and scribble. Adults, who are just larger-size beginners when it comes to art, may go through some of the same processes as the children. A father who once came to the tissue-paper collage workshop, poured out the glue and started smearing it with his hands. I asked him to please use the brush, and told him that I would explain later. After class, I explained that if the children poured out the glue they couldn't control their materials, and would get glue everywhere. He looked at me sadly and nodded as he said, "But I never get to do anything like that anywhere else."

If before experiencing these projects I tell you that there is a way to rediscover the wonder of the visual world, you probably will not believe it. You may not think that you can learn a language that communicates all around the world and transcends time and place, that captures fleeting sensations and constructs new ways of think-

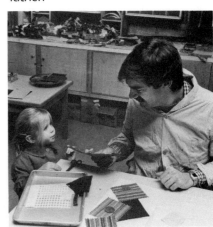

Child showing her collage to her father.

ing. Yet I have seen many people who have taken these workshops discover these possibilities themselves.

If the painter wishes to see enchanting beauties, he has the power to produce them. If he wishes to see monstrosities, whether terrifying, or ludicrous and laughable, or pitiful, he has the power and authority to create them. If he wishes to produce towns or deserts, if in the hot season he wants cool and shady places, or in the cold season, warm places, he can make them. If he wants valleys, if from high mountain tops he wants to survey vast stretches of country, if beyond he wants to see the horizon on the sea, he has the power to create all this; and likewise, if from deep valleys he wants to see high mountains or from high mountains deep valleys and beaches. Indeed, whatever exists in the universe, whether in essence, in act, or in imagination, the painter has first in his mind and then in his hands. His hands are of such excellence that they can present to our view simultaneously whatever well-proportioned harmonies real things exhibit piecemeal.

Leonardo da Vinci, Italian Renaissance painter*

Although none of my own children elected to become painters or sculptors, they have all incorporated their early studio experiences into their daily existence. Jeff, a graduate student in business administration, has told me that he gained the courage to try things his own way, to experiment on the piano and in the kitchen. As a teenager, he made kinetic sculptures from electrical parts and still works in a creative way with his hands and tools. Wendy, a nurse, has returned as a parent to the workshops herself, and finds drawing a calming influence when waiting out a difficult situation. Charles, a pre-med student, has told me that learning to observe and to communicate visually has been invaluable. When he visited India he frequently encountered people with whom he shared no spoken language, where almost every visual aspect of the world was different from his own. He was suddenly confronted with an urgent need to use his eyes to communicate and observe.

He started to sketch and wished that it came more easily to him. If he could sketch well, he thought, it would not only help him to communicate, but it would be an invaluable way of recording thoughts and images that couldn't be duplicated by a camera, simply because they only existed in his mind. Seeing visual work in this new way made him think about my classes. "It seems to me you are enabling children to transcribe their very personal feelings and thoughts onto paper," he wrote to me. "When they're finished they can feel that this creation is theirs, all theirs, only theirs. I can't think of what experience would be more important for a child. Their expression can be their own property apart from cultures, verbal language, parental and peer pressures."

* Excerpt from his notebooks.

As you discover alternative ways of seeing through art, you will find you can share sensory experiences with people of all ages by encouraging interest in the sensory world. For example, when I led a workshop for older men and women, I found them very self-conscious about doing what they considered "kindergarten" activities. When I showed them photos of eighty-year-old Matisse cutting out collages in his wheelchair and work by other established artists, they were able to drop their inhibitions and become intensely involved with their own projects.

On another day, four-year-old Vicky came into class clutching a small, red, dime-store balloon under her arm. She was very proud and protective of it and worried that something might happen to it while she was working. So she gave it to her mother to hold for safekeeping. Later, Vicky became so fascinated with her cutouts that she stayed and worked at the collage table for over a half hour. All the other children went on to the clay table and she was still cutting and pasting even after the others had finished and were busy washing their hands. I told her that class was over and she would have to leave. Her collage was intricate and I pointed out all the many shapes and color events that were occurring on the paper. She was so overjoyed with her experience that she ran over to her mother, got the balloon, and came back and gave it to me. Her mother nodded approval. I had the feeling that Vicky was giving me a present because the pleasure she had created for herself by her accomplishment was greater than that of owning the balloon.

When you can guide other people gently, supportively, and firmly without undermining their self-confidence or intruding upon their territory unknowingly, you can open up wonderful new worlds.

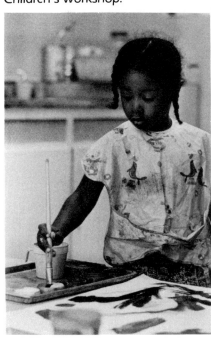
Children's workshop.

Y'know the real world, this so-called real world,
It's just something you put up with, like everybody else.
I'm in my element when I am a little bit out of this world.
Then I'm in the real world—I'm on the beam.
Because when I'm falling, I'm doing all right;
When I'm slipping, I say, hey, this is interesting!
It's not when I'm standing upright that bothers me:
I'm not doing so good; I'm stiff.
As a matter of fact, I'm really slipping most of the time, into that glimpse.
I'm like a slipping glimpser.

Willem de Kooning, American painter*

In parts of many cultures, aesthetic perception and practice are not separate from but totally a part of daily life where traditions give the opportunity to look at things in a contemplative way. For exam-

* Excerpt from a film script "Sketchbook I, Three Americans."

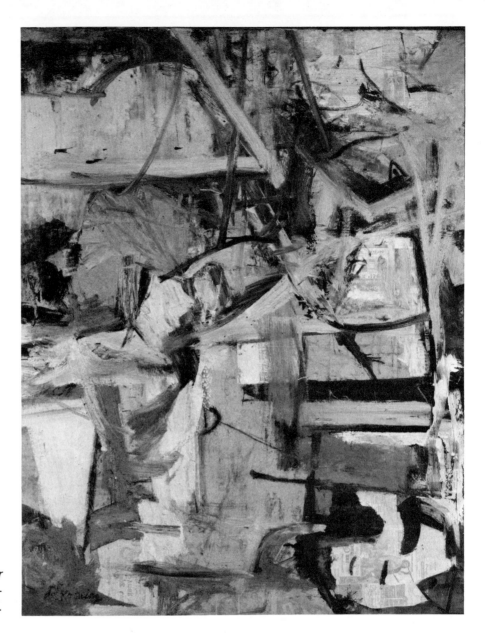

Willem de Kooning, American. *Easter Monday*, 1955–56. Oil and newspaper transfer on canvas. 96" × 74".

ple, in the past the Japanese directed respectful attention to the quality and form of executing simple tasks such as wrapping a half-dozen eggs to carry home for dinner or placing a single flower in an appropriate container. Presenting a meal attractively on a plate, viewing the cherry blossoms in the spring, and negotiating the delicate choreography of everyday social encounters, were viewed by a part of the society as necessities of life. This reverence for the aesthetic personality creates awareness of surrounding nature so that everyone can take an active part in improving his or her environment.

Mai-Mai Sze in *That Way of Chinese Painting* notes that the earliest Chinese Taoist philosophers regarded painting with a similar attitude as they did prophecy, divination, and alchemy. In Taoism each of these practices had a similar precision of method and approach. The range of paint colors represented the five elements and preparation of their pigments was thought to have come out of alchemical brewing, for both came out of a distillation or refining process to extract colored minerals. And something magical did indeed happen when the brush transmitted spirit to silk or paper—things changed. Superior artists were revered for their ability to see beyond surface appearances and instill in their painting the ineffable spirit of things.

This reverence for the aesthetic quality of living is still relevant for us today. It functions to balance the personality and to create an awareness of our surroundings so that we can take an active part in improving our environment. Even today we elevate those who display insight in their works, yet every one of us has this capability. However, most do not know how to bring it forth.

Taoist painting in China was seen as part of the *tao*, or ever-moving rhythm and way of life. The projects presented in this book have a similar underlying aim: to celebrate the processes of change, to learn to accept and be aware of the present moment. I believe that accepting life is accepting change. These projects focus on changing forms. When you have the courage to wipe out or change things, you have the possibility of personal growth.

The aim of our workshops is similar to the practice of the Japanese *sumi-e* brush-ink painters: that is to express free movement of the spirit with effortless self-control. This effortless realization is the fulfillment of life, since once we learn to do anything well, it will seem easy. The activation of the senses in the studio process can be a first step away from imprisonment within the solitary confinement of the self. From this all else follows.

TWO

The Home Workspace

W HEREVER YOU ARE WORKING, it's important to feel comfortable and "at home" in your space so that you can be free to use your tools and materials. I think of a workable arrangement of space as a basic requirement no matter how small or large, whether indoors or outdoors, in an office, kitchen, basement, museum-studio, or school.

FEAR OF PAINT

When I first suggested setting up an area where children could come to paint and make collages at an outdoor Family Holiday fair, an experienced elementary school teacher challenged me saying, "How could you possibly do that with hundreds of children participating all day? It will be a disastrous mess." She had not had the experience of successfully organizing a workspace and system for using it with children. This lack of knowledge and fear of loss of control is the same reason parents often don't allow children to help in their kitchens—let alone paint there.

I don't think of working with art materials as "messy," although it is very possible that it can be so. When you sit down to a beautifully set meal table, it is impossible to eat without creating some disorder. Forks and knives are rearranged, plates and glasses will need washing, and crumbs may fall on the floor. Likewise, as you paint, cut, paste, or use clay, things will get redistributed. But they need not get out of hand if you plan and set up the workspace carefully.

Your planning should take into account the fact that little hands with undeveloped coordination may often spill, drop, or knock things over. You can minimize your frustration at this by organizing your setup so you can give them the opportunity to do things for themselves without making life difficult for you. But you must let them try things, or they will never learn to be independent. For example, you can protect your floor with newspapers or a washable covering, keep paint and water containers inside a tray with sides to contain any spills, fill bowls no more than one-third full, and make sure chairs or

stools are at the right height for their bodies and work surfaces. When smocks fit properly, there are no long sleeves trailing through the paint or paste. If you give beginners proper supervision, set up the workspace in the manner discussed in this chapter, and dress them appropriately, you needn't be afraid of paint.

Much of your own apprehension and handling of the studio situation depends on your idea of what you think is "dirty." Dirty implies a foul or filthy substance, something vile or worthless. Paint has none of these qualities. When you wash your hands after greasing a pie pan, your hands are not dirty, they are greasy. When you wash a brush that has been used for a deep color, the water is not dirty although it is darkened by paint. If you equate paint with dirt, you are apt to be compulsive about studio organization and spilled drops of paint.

WHEN TO SET UP A HOME WORKSPACE

If you set up a well-stocked workspace and then try to entice your youngster into it, he or she may not be interested at all. Your well-meaning surprise may be doomed to disappointment. Older children may already have been coerced into various types of lessons they haven't enjoyed and now may feel "Here comes another one!" However, by showing them pictures in this book and taking them (not forcing them) to local museums and art exhibits, they may *want* to do their own studio projects.

Your young child is not ready to settle into an organized workspace for painting if, when you set up the tray, you find that he obviously feels the need to touch, rub, and smear the paint. If this is so, he probably needs to have more tactile experience before you offer paint and brush. There are many other things to do. Aside from allowing free play with sand and other natural materials outdoors, Play-Doh and clay indoors, one parent told me that she added a little water to a mild soap powder making it into a thick mixture (good to squish and smear), colored it with vegetable dye, and let her child use it on the empty tub surface for a while before filling the tub with water for a bath. The same mixture can be used for drawing or smearing on a large metal tray, Formica or other washable countertop, or even on heavy paper. Also, young ones seem to love to help Mommy by using absorbent sponges to wipe up and squeeze out.

To avoid confusion about the use of paint, I prefer these activities to finger painting. If your children are still smearing when you give them poster paints and brushes, they will have no regard for their real purpose, and it will be wasteful and costly. Moreover, it will be

more difficult to teach them the proper use of all tools and reflects irreverence for the problem-solving aspect of art. However, like any activity, if finger painting is presented and supervised by an experienced person who understands child development and chooses to use it as a tactile and emotional experience, it may serve a useful purpose.

When you are ready for it, you can set up a workshop space where the entire family can come to work with materials, and help maintain the area. This family support can give the youngest members a sense of belonging and greater self-confidence when doing their own work.

If you have fired up your children's enthusiasm but won't have a space available that you can both use regularly for some time (because you are about to move, perhaps, or go on vacation), postpone setting up your work area until you can expect to use it for at least several weeks together. You can keep up the children's interest during field trips to the local supermarket where you point out the shapes, patterns, and colors, by encouraging sculptural projects at the beach or park with stones and found objects, by teaching free-form cookie sculpture and decoration in the kitchen, and other activities I will suggest throughout the book.

DESIGNING FOR SUCCESS

A popular cliché is that impassioned artists create under any circumstances, scribble on tablecloths or phone books—in short, that nothing can stand in the way of obsessive artistry. This is not, however, generally true. Most artists turn their backs on disorder and work in the clearest areas they can find with the fewest distractions. Experienced professional artists have learned to use their time, energy, space, and supplies to work in the most productive ways and it is interesting to study them. We can learn by their examples.

Jon Carsman

Perhaps the more sensitive the artist the more carefully he or she must cultivate surroundings that nourish his or her creative growth. American painter Jon Carsman has organized his living-working space both for minimum distraction and housekeeping and for maximum inspiration and painting. His plants not only serve as subject matter in many of his pictures, but their radiating energy has also become part of Jon's painting style. It is in this well-lit place speaking of precise, orderly living, that both plants and art are successfully nurtured.

Jon's disciplined productivity has brought him unusual professional success for so young an artist. His watercolors and oil paintings are constantly shown by galleries and museums across the country.

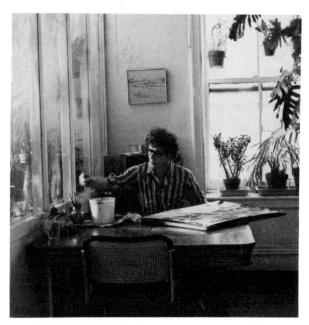

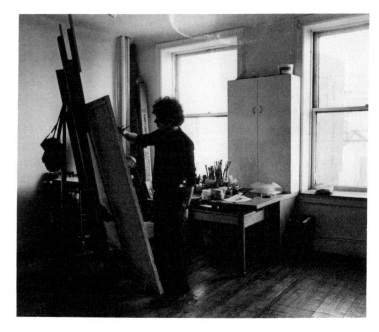

Jon Carsman's studio.
A. Jon painting with watercolor.

B. Jon oil painting.

Love and Order

Hiroko and Michel Swornik's home is a total integration of living and working spaces.

Hiroko, a graduate of Tokyo University who specializes in cloisonné jewelry-making, is nationally acclaimed and exhibited. Michel, a cabinetmaker and contractor, came here from France about ten years ago.

Hiroko's workspace is simple and efficient: a counter, shelves, and a separate forging table. No doors cover the shelves (high enough to be out of reach of their young son, Ivan) so that any item can be withdrawn or replaced quickly and easily.

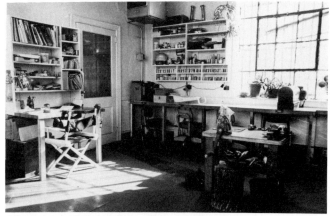

Hiroko and Michel Swornik's studio.
A. View of Hiroko's workspace from the living area.

B. View of kitchen from the workspace.

We Americans are often prodigal and extravagant in our demands for lots of space because we isolate ourselves by physical and spatial barriers instead of the psychological concentration and mental separation common to peoples of more crowded countries.

Michel constructed their apartment here in what was once a small office space walled off into tiny cubicles. His open space design, adapted for both art work and leisure, is only made truly comfortable by their carefully disciplined working and living style.

The most important thing in setting up is to make certain that your space functions well for your purposes. I've seen studio spaces that were beautiful to look at but didn't serve the needs of the workshops. My organization and routine studio procedures are meant to minimize accidents and confusion, not just to look neat or pretty. A well-set-up space leads to extraordinary freedom and confidence and the realization that there is nothing incompatible between control and aesthetic release. One makes the other possible.

CHOOSING A ROOM

When you stop to think of it, your home or apartment has workspaces that can serve as models for many studio areas: a kitchen, sewing corner, or tool closet kept in an orderly fashion are good examples. I find that equating the studio process with a special place where specific activities are done helps focus attention and establish a serious attitude. Young children must also learn to respect your space and your right to coexist there. In the beginning, it is necessary to work in the same room with the youngsters (or in an adjacent space where you can see them), although when they become more experienced you may both decide to separate your work areas.

The design of a studio space is similar in its requirement for functioning to that of a kitchen or cafeteria. In both, you need places for preparing and setting out materials and consuming them, areas for waste disposal, traffic control, cleanup, and storage of leftovers. When they are set up for the greatest efficiency and comfort, and there are specific places established for every tool, material, or activity (be it painting or eating), accidents are prevented.

Every house has its own possibilities for developing a studio space, but, naturally, proximity to your activities, comfort, and good light are necessities. Everything beyond that can be improvised. Some people have successfully set up home studios in basements, walk-in closets, kitchens or breakfast rooms, on bridge tables in the child's room, on low coffee tables and covered dining room tables. In the summer, you can cover a picnic table in the backyard or on a porch,

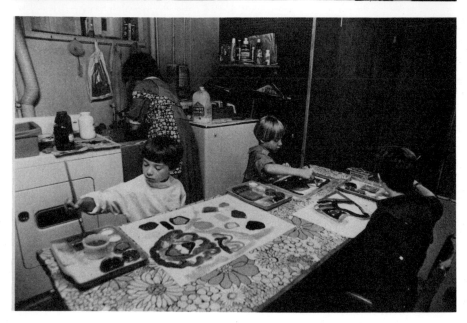

Mohr's closet. The Mohr family organized a space for their children in a large closet near the kitchen in their city apartment. A table outside the closet was always available for working. The three-year-old loved the cozy feeling of sitting on the lower shelf to draw or work with clay.

Ribaudo's basement. This multipurpose room serves for laundry, games, carpentry, and household and art-material storage, as well as for a functional workspace.

smoothing its rough surface with layers of newspapers and then with a sheet of plastic.

You might also consider your home traffic patterns. If your chosen area is heavily traveled, there will be more distractions. Remember to keep the workspace out of the path of swinging doors to avoid accidents.

While a large sink is convenient, it is not necessary, since you can keep a large plastic dishpan of water nearby to clean tools and hands

at the appropriate time. (It is better not to put it out ahead of time. Although water play is a wonderful experience and young children love it, washing hands every time you get paint, paste, or clay on them is unnecessary and might lead children into a different kind of activity.)

Even though you need to be within sight of very young beginners at all times, everyone, no matter what age, needs some privacy. If you're both working at the same table, put enough space between you so that you don't become overly directive of the children's work, and they don't have the desire to work on yours. One experienced kindergarten teacher, who was an amateur painter, worked with studio materials with children for over fifteen years. But when she was in a teachers' workshop attempting to draw, she found she couldn't work because other students started to look over her shoulder at her sketch pad as they passed by. She had never realized before that she had been doing this to children for years.

Rooms with windows have the added luxury of enabling you to observe the ever-changing conditions of nature and to get ideas from them. They also give the opportunity to point out the colors, shapes, and patterns of buildings, the silhouettes of branches against the sky, and the changing shapes of clouds.

I can sit right here in the dining room of 29 Spring Street, looking at the enormous school building across the street. Hundreds of windows with the sunset reflected on them like molten gold . . . then the moon will come over and give it another light, then the windows at night will be totally black, and one window with one tiny light will appear . . . for me. These are the keys to my existence.

Louise Nevelson, age eighty-two, American sculptor*

I looked out my window. . . . All the lights.
four-year-old boy, in parent-child workshop

I looked out my window and saw things I never thought about before. I never stopped to realize all the shapes of the city skyline, how different they look early in the morning before I send my children off to school and in the nighttime after I put them to bed.
twenty-nine-year-old mother, in Head Start parents' workshop

On the other hand, rooms where there are no windows can work equally well. For years I have taught in studios where the walls only contained bulletin boards, storage counters, and sink space. For visual motivation, I tacked up reproductions of works of art, photo-

* Conversation with Diana MacKown in *Dawns & Dusks*, New York: Scribners, 1976. See illustrations, pages 12 and 199.

graphs, and collage materials, and made an arrangement of variously shaped objects on the table. Sometimes I brought tree branches, leaves, and flowers to help the children build an awareness of shape, line, and color.

HOW TO SET UP THE WORKSPACE

In order to build in smooth studio routines when planning the area, try to determine what responsibilities you wish to allot to your child (also keeping in mind his muscular control capabilities and experience). Some tasks may be impossible, given the heights of your furniture. Containers that are too big for him to handle may create difficulties and accidents leading to feelings of failure for everyone.

Keep your area simple and uncluttered to limit visual distractions and the number of choices you both have to make. Seeing a lot of different materials while working is like visiting a candy store and wanting to taste everything in sight.

"All the lights!" Four-and-a-half-year-old's nighttime painting on black paper. (See Plate 1.)

STORAGE

Because storage is important, try to make the storage area as close to your immediate work table as possible. You can use closet or kitchen shelves, a small cupboard, bookshelves, a chest of drawers, or any drawers (there are marvelous pressed-cardboard cabinets available that are inexpensive) set aside just for art materials in your space. Although drawers are less convenient than shelves because you often have to unbury items you don't see, shelves must be out of younger children's reach, lest they spill large paint or glue bottles upon themselves before they know how to handle them correctly. (A one-pound jar of paint dropped on a small foot can be very painful.) Drawers can be fitted with dividers to organize paper in one section, scissors and brushes in another (cake tins will work here). Using one large box or trunk to dump everything into, without dividers, creates chaos and wastes time and energy when you have to search through everything to get one item. Using regular cardboard shoe boxes or plastic boxes with labels or pasted samples of materials on the outside eliminates having to open all of them to find something.

It is desirable, with young children, to keep supplies out of sight, for if they are visible at all times, they may provide strong temptation for very young beginners to use them at the wrong time in the wrong place. As children get more experienced and you can trust their judgment and skill in handling materials, you can make everything more accessible so they can work independently.

After work is finished, store it carefully. Showing that you value

the work by handling it with respect is important. If you need to store paintings before they are completely dry and don't have a place to leave them lying flat, gently lay a piece of wax paper over the wet surface. I have stacked more than a dozen partially wet paintings this way without smearing them. The wax paper doesn't stick to the surface and you can save it to reuse. When you pick up a wet painting, hold it horizontally so that the paint won't run. Completed dry paintings can be stored between two larger pieces of cardboard hinged with tape to make a portfolio that is easy to keep on a closet shelf, in a drawer, or behind a piece of furniture. This method will ensure that you don't crack thickly layered paint surfaces.

THE WORK TABLE

When water-base paint is used, it is preferable to work on a flat surface. It is difficult to control liquid paint (unless it is very thick) on a tilted or upright surface because it will drip and run. For this reason, most art educators feel that easels can be a handicap for children.

Because very young children have a limited attention span, I like to have them sit at a table to work. When they are comfortably seated on a chair or stool at the right height, it is likely that they will continue to work for a longer time. If they are standing or working on the floor, they may be tempted to walk away if there are any distractions. And if they walk about with a brush loaded with paint, it might drip. However, if your children work well standing up, certainly allow them to do so.

If you have no suitable table to work on and decide to use the floor, I would suggest you mark off a workspace with masking tape and lay out supplies as I do on a table. This taping off of an area is particularly important if you are working with more than one child. Everyone should have a clearly defined space in which to work and for which he will be individually responsible.

Sharing supplies can also be a problem. When children share large cans of paint with many brushes in every can (and no place to wash the brushes), if someone grabs for a brush quickly, there is a good chance the can and brushes will fall over. In this situation it is also difficult to mix and control the colors. So the first thing to do if you are setting up a work area is to give everyone his own space and tools to work with. If it is necessary to share, be certain that everyone understands the guidelines governing the use of materials to avoid problems in personal relationships.

The work surface should be smooth so that it will be easy to clean and the materials (paper or clay) won't pick up unwanted textures (as will happen, for example, if you try to do crayon rubbings on a

bumpy table). If you don't have a smooth table, you can pad a rough surface with a few layers of newspaper or wrapping paper and then cover that with a sheet of heavy plastic or oil cloth. If you use paper to cover the table, it's a good idea to tape down the ends so it doesn't buckle or get in the way. A washable waterproof covering is a necessity for any surface that may be harmed by water. A Formica or metal tabletop or a piece of quarter-inch Plexiglas, laid over the existing tabletop, is ideal. Whatever you use to cover the work surface, try to find a neutral, solid color because prints and bright shades are distracting. I always prefer to have children work directly on a washable table surface if possible.

If you don't have such a table or one that is the right height for each individual's chair, you can hinge a shelf board covered with Masonite or Formica (plywood or other soft woods will have a raised grain). It should be about 20 by 30 inches, or large enough to allow a person to move his arms around and to accommodate both the paint tray and paper.

No matter what you decide to use as furniture, please make sure you eliminate anything wobbly, rocking, or unsteady, and adjust the seat to the proper height for the work surface.

HOW TO CHOOSE TOOLS AND MATERIALS

If you've never had the experience of shopping for art supplies, you could end up spending a fortune on beautifully packaged, seductive-looking tools and materials. Even if you buy the most expensive of everything, you may still find yourself frustrated when you attempt to use the materials, if they are inappropriate for your particular project (for example, if you buy sable watercolor brushes for use with poster paint).

I always provide quality tools and materials, not necessarily the most expensive, but standard professional ones that work well and last a long time when used with care and respect. (Specific tools are discussed and listed within each project.) I have found that this is the best way to get good results from my workshops. If you must economize, buy just the basic tools and materials, but of a quality good enough to really give you both a chance to get interested in the mediums. Emphasize that each tool is very special and make a container to store it in by covering a can with Con-Tact paper or painting it. Later on you can add to equipment on birthdays and holidays.

I will always remember a particular meeting with Dorothy Maynor, the opera star who founded the Harlem School of the Arts. Mrs. Maynor asked my advice about organizing their studio program for

parents and children. When I expressed my ideas about the needed equipment, she fully agreed and reminisced about her father who told her when she was growing up in the South that they were too poor to buy anything but the very best quality merchandise—because otherwise, things wouldn't last. When you visit the school it reflects this attitude in every aspect of its physical and philosophical existence.

Toward the end of one semester when new brushes were late in arriving, I began to notice that the children's paintings didn't have the wide range of expression and great variety of individual marks as when the brushes were newer. When the new ones arrived the difference in their paintings was remarkable. Because the worn-down bristles of the old brushes didn't hold enough paint, the children had had to work twice as hard and long to control them and fill the space. Consequently, the new paintings were alive with a greater variety of brush strokes and larger masses of color. Everyone present in the studio recognized the importance of having tools that are good quality. (Remember that scissors must cut properly and the paste and clay must be of the right consistency for the same reason.)

Although I always use good quality materials so no one wastes his time and energy on pieces that will collapse or dissolve, this doesn't mean that they have to be new. For example, I have used found materials in my own collage paintings for years. I remember my grandmother saying "Waste not, want not" as she patched her sheets with neat tiny squares that made the old fabrics very special with the patterns of white on white. Malevich, a very avant-garde Russian artist, amazed the art world with his paintings of "white on white." I was startled by the similarity, and wondered if he too had a grandmother who patched her sheets so exquisitely. Using familiar materials in an artistic context opens our eyes to the aesthetic qualities of the world around us.

I choose art materials not only because of their sturdiness (painting paper can't be so thin or absorbent that it wrinkles or bleeds) but also for their appearance. The newspaper classified ad section has an all-over regular pattern to paint over while the comics will only be distracting, although they could be used for collage. Heavy wrapping paper and large paper bags can also be trimmed for painting. Paper shopping bags might be decorated with painting as well. Light tan or white papers give a more neutral ground upon which to make aesthetic decisions. Some synthetic sheets, although beautiful, won't hold paint or glue, and liquids will bead on them instead of sticking. With all the plastics you merely have to try using them yourself before giving any of them to beginners.

All art materials for young beginners, paint, glue, and clay, must

be nontoxic. It is not uncommon for young children to taste and smell the materials (especially if they are working close to mealtime). I saw one child, while trying to make up his mind about what to do next, unconsciously stick a wet paint brush into his mouth the same way some people chew on the opposite end of a pencil when thinking what to write. No one got upset when this happened, because we knew the paint was nontoxic.

COMPARING ALTERNATIVE COLORING MEDIUMS

"Why is my child so relaxed when I pick him up here after class, while he gets so tired when he works at home?" a mother once asked me. I inquired what materials he was using at home. I wasn't surprised when she said, "Crayons," because I have found that when very young beginners hold crayons tightly and press them down constantly with a lot of pressure, their undeveloped muscles rapidly become fatigued. While some children use them more for linear drawing, if they want to make rich marks and mix colors, the effort may cause their arms to tense up. Tight finger work with tiny constricted strokes will be the result. New art materials are constantly put on the market and the consistency of crayons has been improved. The water-soluble ones are quite expensive. However, there are many kinds of oil-base crayons available that are very soft and have excellent colors. I do not offer oil crayons to young children because they will stain almost any fabric although most older beginners can use them with care. If children have wax crayons and want to use them, peel off the paper or break them in half so that they can use the sides of the stick to color in larger areas. They can also make a variety of textured effects with crayons, as well as using the ends for drawing lines.

For a young child who loves to mix colors, a medium like paint, that flows easily and responds to a light touch, is the most gratifying. However, water-soluble felt-tip markers may be used for drawing and coloring and are available in several widths. Make sure they are water soluble because the nonsoluble ones are extremely difficult to remove from fabric or walls.

Colored chalk and pastels are also soft and have good color, but they rub off and you must buy a spray fixative to bind the powder on the finished work. In general, I prefer poster colors, which are both water soluble and easy to use.

MATERIALS FOR COLLAGE

In beginning collage sessions, I use only simple construction paper so that beginners can concentrate on cutting, gluing, and placement. After a few initial experiments, I begin to add a new material at each

session. When you are working at home, part of the excitement and learning happens when you gather different and unusual materials and begin to transform them in your collages. It is preferable for everyone to collect some of their own materials so that decisions and choices will be personal ones. However in the beginning if they don't have enough of their own, you should make available a general supply of papers, cloth, yarn, and other pasteable materials.

BASIC STUDIO SUPPLIES

Your own list of basic supplies will be determined by what kind of projects you choose—according to what you think you are capable of guiding and the extent of your home facilities. If you feel you lack the patience to deal with liquid paint at first, you can turn to the collage chapters and assemble those particular supplies. However, if you experiment with the paint by yourself, you may not find it as formidable as you imagined it might be.

I always try out all tools and materials myself before giving them to my students to use. You should do this also.

The following list will give you a general idea of what is needed for each medium. However, please read the chapters on each specific medium to find the precise types of brushes and other tools and materials recommended.

MATERIALS

PAINTING:

white drawing paper, 18 by 24 inches

poster paint: red, yellow, blue, black, and white

masking tape (to secure paper to the table for young beginners)

bristle-type brushes (used for oil painting—see page 82)

cellulose sponges (these are more absorbent than the plastic or rubberized ones with tiny even holes)

water bowls, about 5 inches in diameter

very small, shallow dishes for paint, 2 to 2½ inches in diameter (such as furniture caster cups, jar tops, or the smallest baby food jars)

trays to set paint containers in (such as cookie pans about 9 by 12 inches by ½ inch deep)
Optional:
syrup dispensers with slide closures on top, for dispensing paint

COLLAGE:

small cardboard or plastic boxes for materials (such as used shoe boxes or polystyrene food containers)

pasteable materials (including papers, natural and synthetic fabrics, and small, flat objects)

scissors: 4 to 6 inches long with blunted tips for very young children; 7 inches long with pointed tips for older children and adults, and for larger work

paste (in jars with brush applicators)

trays for choosing materials from (aluminum foil pie or cake pans, tops of boxes with sides no more than one inch in height, cardboard takeout trays from restaurants. You can also use the tray you used to hold paint materials.)

Materials gathered for touching and feeling before doing texture collage.

CLAY:

clay (water-base, air drying)

assorted tongue depressors and applicator sticks from drugstores

plastic, leakproof bucket with airtight cover

tools for removing clay from work base: wire, bent hanger, or spatula

linoleum or ceramic tile, 12 inches square (to make work bases for sculpture. You can also use a 12-inch piece of oil cloth or vinyl for the same purpose.)

MISCELLANEOUS:

smocks for everyone (old shirt or work apron—if you use an apron, wear a short-sleeved shirt so your sleeves won't get paint on them.)

bucket or dish pan (if you have no easily accessible sink in the room)

newspapers (to pad a rough surface)

sheet of heavy plastic or solid-color oil cloth (to protect nonwashable work surfaces and rugs)

cleanup rags or sponges

WHERE TO BUY TOOLS AND MATERIALS

I usually suggest that beginners go to a professional art supply store for their supplies. Although some toy and craft stores offer quality art supplies, many do not. An art supply store generally handles art materials not only for professional artists and art students but also for amateurs; it supplies many kinds of books, tools, and materials for

beginners as well. No matter where you buy materials, try to avoid attractively packaged paint sets that contain small quantities of too many colors and cheap, soft brushes. (Also see discussion of kits on pages 215 to 217.) Most art materials can be found in art supply stores, and the rest of the items you'll need are available in hardware stores, variety stores, stationery stores, or supermarkets.

CLOTHING

Even though poster paint, white glue, and clay wash out of clothing, everyone with whom I work wears a smock or other coverup over their comfortable clothing. Not only does it protect your garments, it provides a material to wipe your hands on during work. Wearing a smock or special work shirt also establishes the proper attitude for class, setting the studio activity apart from all others in daily life. Plastic is best used under an absorbent material on which you can wipe your hands. If you use a plastic coverup, have an extra sponge or rag nearby.

If you cut down an old shirt, make the sleeves and body length short enough and close-fitting so that they don't drag in the wet paint. Elastic at the wrists can help. A piece of plastic sewn inside the front can also be useful for protecting a vigorous young painter.

USE OF TOOLS

That time, I must have been eight or nine, I was going down the stairs mooshing up some sand to try splattering it on a piece of wood to make a drawing, and I remember distinctly thinking, I can do anything in the world, if I only have the tools to do it with.

Lee Bontecou, American sculptor*

While there is never any question of right or wrong, good or bad, within the work itself, I do stress that there is a right way to use tools and materials and that everyone must learn respect for their tools and how to care for them. Although I never lecture, I stop improper behavior at once. I explain that banging a brush to make marks on the paper is harmful to the brush because it loosens the metal band holding the bristles. If you want to make the brush walk around the paper, do it without making noise, like a cat or lion in a jungle. For banging, you can use a stick on a drum or spoons on a pan. Likewise, a scissors is used with one hand so you can hold the paper with the other hand; it is not to be dipped into the paste or used on the clay.

* Interview with Eleanor Munro in *Originals: American Women Artists*, New York: Simon and Schuster, 1979.

I try never to talk about improper uses, but emphasize the proper usage of the tool. All these principles, applied as general rules with few exceptions, help to show how everyone can get the best results from their supplies.

For example, when four-year-old Jimmy returned to class after several months of absence, he remembered that he had made cakes and cookie shapes out of some kind of material the last time he was in the workshop. Although eager to do it again, he had forgotten which tools and materials he had used to make them. He sat at the collage table becoming troubled and annoyed as he attempted to squeeze and roll the paper. I suggested that "Because you're making a cutting and pasting picture, it will be easier if you keep the paper flat to make a collage." "But I want to make cakes." "You can do that with clay when you finish this and put away your scissors and paste. The clay is for patting and rolling, not the paper."

Once he remembered that he had made cakes with clay, he proceeded to uncrumple his paper, cut shapes, and paste them down. His mistake became a learning experience with no feeling of guilt, stupidity, or inadequacy. Now that he became aware of the limitations of each material and which tools to use, he progressed from session to session, increasing his skills in each separate medium. If I had made him feel that he was messy, bad, or incompetent, he would not have been so eager to return to the activity another time.

Beginners eventually discover why you have suggested certain procedures, although at the start they may develop a habit without really understanding the reason for it. Spare your child confusion in the early stages by gently but firmly insisting on these principles.

I do not allow finger painting because the lesson is learning how to use the brush. While finger painting may be an exploratory tactile experience, it is not really a means of controlled expression for a young beginner when it becomes a smearing activity. Children of two-and-a-half or three, struggling to control their impulses and body movements, feel better when adults can support them in mastering activities that develop coordination and skills, so that they can feel accepted by older people and be part of the bigger world outside. Children rarely put their fingers in the paint after their initial experiences, simply because they are too involved in the pleasure of painting with the brush. Using tools, like using a fork and spoon instead of fingers to eat with, is doing what a big person does and gives a child a feeling of power.

For a long time I never knew what to say when a child turned the brush around and used the handle to scratch in the paint. I would try to redirect him or her to use the bristles by turning the brush around without saying anything. Sometimes that would work. The

Lee Bontecou, American. *Untitled,* 1961. Relief construction of welded steel, wire, canvas. 6'8¼" × 7'5" × 34¾".

danger of allowing young children to scrape with brush handles is that both ends of the tool become loaded with paint. While they are handling one end they don't realize or remember that the other end may be dripping all over the other side of their paper, on the table, their clothes, and the floor. A more experienced painter will be aware of this problem and can handle the tool with control.

However, one day four-year-old Sam took his brush handle and began scratching into his paper with great energy. All of a sudden it came to me that there was a name for what he was doing. "Oh, you want to do sgraffito!" I announced with great enthusiasm. He looked at me with amazement and stopped. "Sgraffito is drawing in paint with a stick. Would you like a stick to try it?" "Yes," he said, and put the brush down. Of course, every other child wanted to try a stick as well. They soon tired of the limited range of marks the applicator stick could make and went back to their brushes.

The way you eliminate improper use is important. You can generally avoid punishment by redirection. If a child uses his brush to poke or annoy another child, you can say, "It looks like you're finished painting for today." If the child says, "No," you can reply, "Okay, if you're going to use your brush to paint with, that's fine."

But remember, if you are working in a group and you let one person do something, you have to be prepared with similar alternative tools for everyone. Behavior is contagious for people of all sizes.

Many objects can be used as tools, but found objects are only useful when beginners become more experienced. I tell parents at the orientation for my workshops at the museum to avoid the temptation of using their tools in any way the children will imitate without being able to control—such as using their sponges for painting or the brush handle to scratch paint, or picking up caster cups to pour paint on the paper. It's a good idea to have young children use each piece of equipment for its original purpose and not to confuse them.

Once when a young child seemed distressed because he got paint on his hands, I used the sponge from his tray to wipe them. Before I knew it, the child sitting next to him picked up her sponge, dipped it in the water bowl, and started wringing it out over her paper making a big puddle. From that day on I have never picked a sponge from the painting trays to wipe up anything. I keep a special one for that purpose nearby.

Similarly, I don't offer unusual tools for any medium nor substitute any as alternatives unless there is a pressing reason. You will only distract young people by giving out tools such as sponges, potato brushes, nail- or toothbrushes you've discovered for painting. Later on, you may paint with found objects as a separate activity. For the same reason, it's a good idea to use the same pair of scissors for

cutting all the time, and avoid using knives or other kitchen implements to make interesting marks in clay. If children see you using household utensils as tools, they may try experimenting themselves.

PRESENTING THE MATERIALS

Your preparation of the materials not only determines their visual appeal but also helps establish a respectful attitude toward studio work and encourages visual thinking.

For collage sessions, if you put out boxes or bags overflowing with mixed-up materials that are oversized or wrinkled, you take for granted the complexity of skills you have accumulated throughout a lifetime, your abilities to organize and evaluate, as well as your patience and manual dexterity. That's why I always prepare found materials by taking apart and trimming them so that they lose their previous associations and meanings. For instance, old clothing can be cut into squares, artificial flowers separated into petals and leaves, and old toys divided into small parts. These can then be reordered into new personal forms. We don't really see what we take for granted every day. Once you've taken things apart and they are singled out and arranged in an organized way for studio use, their visual and tactile qualities become more evident. I use neutral-colored trays, boxes, or pans for materials. If the containers aren't attractive, I line them with foil or light, neutral-colored, or black paper so the special qualities of the prepared supplies will stand out more easily. When these materials are prepared and presented in this way, beginners are less likely to cut up and use something you don't want them to use. Once, an adult in my class cut up one of my treasured demonstration photographs for a collage. Since that experience, I never assume that anyone—adult or child—will know which materials are for studio projects unless I say, "This is for cutting and this is only to look at." Try to be specific at home.

Careful preparation of materials is also essential when painting and working with clay. If you are using paper bags or the backs of heavy wrapping paper or newspaper to paint on, the paper should be trimmed and cut into regular rectangles or squares. Children will know that the shape of the paper provides the boundaries of the painting. They will also focus on the regular form as a field for composition. Although you can vary the paper sizes later, it's easiest to gain control of the tools when you don't have to cope with changes in scale at first, and the paper is large enough to move the brush freely without going off the paper. Also take into consideration the size of the children's hands and body when dividing up materials.

Edward J. Steichen, American. *The Flatiron Building*, 1909. Photograph. This rainy scene is a good example of reflections on wet surfaces, overlapping shapes, and ''see-through'' shapes (in the branches).

You can always give children more if they need or request it, but it's hard to take away materials if you have given too much.

When you offer clay to young beginners, take care to see that it is of workable consistency and manageable size for their small hands to squeeze, pat, and take apart. They might only work on the surface of a piece that is too large. Clay that looks "gloppy" because it is too wet is something young ones might not want to touch because they think they will get dirty, and hard clay is very difficult for them to manipulate.

SETTING UP A PICTURE FILE

A collection of museum postcards or small reproductions of art and photographs of many subjects can be invaluable for inspiring ideas for projects. Buying postcards is a smaller initial investment than purchasing art books for their illustrations. They are versatile because you can pin or tape them up while working, display them on a bulletin board, or paste them into homemade or purchased books with blank pages. Magazines and brochures are also good sources of colors and shapes for collages. You might ask friends, neighbors, and your local library for old picture periodicals they are throwing out such as natural history and fashion magazines, photographic calendars, and seed catalogues with examples of a variety of colors, shapes, and patterns. Also save photo-postcards and brochures from vacation trips to assemble a picture file that will build awareness of the great visual differences and similarities there are among people, animals, and places in the world.

The "Source Books for Studio Work" listed in the Recommended Additional Reading list on page 283 contain many reproductions. The other categories of volumes in the list are more for historic and other background information and have very few pictures.

INVITING FRIENDS TO YOUR WORKSHOP

If you've never had any experience guiding newcomers, it is a good idea to start your workshops with your own child alone at first because organizing a group activity is easier once your own youngster already enjoys working with studio materials. You can't assume any level of skills of the other children or predict their behavior.

However, once you are comfortable with the procedures and materials, you might want to invite neighborhood children in to work with your own. I always prepare the parents without their children at the orientation for my program so they will have a realistic expectation of the way we work and *why*. It would be a good idea for you to

do the same with your visitors and their parents so that there are no misunderstandings.

It's possible that visitors may need time beforehand to socialize and that you will need to plan for that period before leading up to a studio experience. If their first experience is a positive one, you may not have that problem a second or third time. If you also plan socializing times during field trips, the children will probably do less of it during the studio sessions. Once they become involved, they can socialize at the same time they are working and talking about the projects.

It also helps to know the children who are coming. Sometimes very energetic youngsters can channel their energies into the activities but sometimes they cannot. If you sense that there is going to be an abuse of the materials, you must say "It seems as if you really don't want to make collages or paint today." If they say that they do want to, then reply: "Well, then, let's see what you can do with them."

I never use the materials as a reward or take them away as punishment because I feel that this kind of experience is important, not merely a luxury. To take away your child's potential ability to enjoy working independently and skillfully would only be defeating your purpose in helping him to grow.

If you organize with other parents, it will take several meetings for you to decide among yourselves how you are going to run the classes. You can't start disagreeing among yourselves in front of the children. Who is going to be leader for the day or the activity? To what extent should the leader be allowed to discipline the children? One person might be skilled at ordering and organizing materials, another might be good at presenting ideas to children, and another might especially like to take them on field trips. When one parent takes the leadership in any activity, all the rest of you should look to that person. Most parents are so used to having to be there and jump up all the time to tend to their offspring that it's an automatic reflex. All will have to agree to some basic guidelines and stick to them no matter what, so that everyone will know what's expected of them. It would also be a good idea for all the children to understand that there are different rules in different houses.

Be certain to label all of your visitors' and your own work in very light pencil in the corner of the painting or collage so that it can be erased and written on the back when dry. Sometimes, adults put children's names on paintings with black markers in such large print that it dominates the work. As soon as children can write, I encourage them to put their own names on their work. If some care is taken to introduce them into the studio process, the experience can be enriching for all concerned.

John Thomson, British. *Physic Street, Canton*, 1873. This photograph is a good illustration of patterns, shapes, and lines.

THREE

Guiding Beginners

SETTING UP A TIME

ALTHOUGH THE ROUTINE of going to a regular workshop sets up expectations for something anyone can look forward to, when you are working at home it's better not to box yourself in with a rigid schedule. The important thing is to keep a regular, consistent routine when you do use studio materials. Try to set your own priorities first, in order to have a positive experience. You can't cope with a workshop if you have a sick, crying baby or other interruptions. Try not to feel guilty. Children have to learn to recognize human limitations. If you are really sick, don't martyr yourself, but if you are only a little uncomfortable, you may feel better once you get involved. You might think of substituting a less complicated project like working with clay or a simple collage instead of painting. If you explain what you are going to do instead of what you can't do, the children will usually be quite satisfied.

STARTING OFF

I motivate and explain processes to all beginners before they go to the work table. For the youngest beginners, the materials themselves are the primary motivation, and a demonstration of their use is enough to start them off and keep them involved for many sessions. As they begin to be more visually aware, outside stimuli become important. If there is no input, there may be very little output. Going to the store or any place away from home, can, with your help, become an aesthetic adventure. The key is to emphasize the visual aspects of things you see along the way by calling attention to their colors and shapes.

A parent once told me how the influence of the workshops had served to relieve tension in an exasperating situation. She and her husband were feeling miserable as they sat in an overheated car stalled in traffic. Four-year-old Elizabeth, sensing their distress, blurted out, "Don't be sad, look over there and see how the blue is

talking to the red in the picture on the side of the big truck and you'll feel much better!"

Most of the time if you set people down to paint without any preliminary discussion, and say, "You can paint anything you want," they freeze and don't know how to start or what to paint. I show photographs and reproductions before we go into the painting area and encourage students to contribute their own visual impressions to the discussion. If we look at a reproduction of a landscape, I might talk about what kind of a day it was in the picture (Does that look sunny? Rainy? Do you think it's a sunset? Is it because of the colors? Have you seen sunsets with those colors? And so on).

Discussion of visual elements and feelings is a way to spark ideas and get everyone started. As they work with the materials, their original intents may change and the subjects of the paintings may take off in different directions. This is because studio work is involved with the exploration of feelings and abilities that they didn't know they had, or that were submerged because of the necessity to focus on the practical rather than the aesthetic aspects of daily situations.

SEEKING AND COLLECTING FOUND OBJECTS

Collecting objects while on field trips can create an intellectual and sensuous adventure as well as an opportunity for obtaining free supplies. You perceive more different qualities of things when you have a reason for using what you see. Collecting is a way of going from general observations to fine discriminations of particular qualities of objects that catch your attention. As you walk on a hill you may be attracted by the shape of a rock and, when you pick it up, discover the fine patterns of color formed by different layers. You may see several other similar stones and then begin to examine them more closely to see if you want to take a few home for a collage construction. By contrast, if you are hiking with no particular focus of attention except to travel from one place to another, you may never discover some of the remarkable treasures that lie on your path.

Collecting can bring people together in a social way. Often when I am collecting things, people around me stop to find out what I'm looking for and begin to do the same thing. Even if they have no interest in making collages themselves, they become intrigued and participate in the creative process by offering me objects they've discovered.

Of course, it is a pleasure to discover all kinds of unusual objects when preparing for these projects. Very richly textured and opulent materials can be seductive for a beginner because they look attractive without your having to do anything to them. Things which form complete images in themselves such as toy figures or baby shoes,

may catch your attention because of their associational qualities rather than their purely visual and tactile ones. The emphasis in these projects is on taking the ordinary and transforming it into the extraordinary. I know of one artist who used the lint collected from a clothes dryer for collages. What I really want to nurture when looking for materials is the ability to imagine what they might *become* as well as immersing myself in their sensory qualities and emotional associations. Seeing ordinary things anew is different from merely seeking new objects or novelty. The former is a transformation of your own powers of perception while the latter is not.

I have found that seeing old materials transformed by nature, such as weathered wood or rounded pebbles has led me to the view that nothing need be lost if you can envision it in a context of your own making. For example, I was walking on the beach at the end of Montauk Point, Long Island, picking up rocks when I noticed something reflecting sunlight between them. When I uncovered it, I found a very large metal can that rocks had torn and molded into their own shapes. The rusted patina of the metal contrasted with the shiny parts that had been covered and protected by the sand. There was a quality that made me think about what is changed and what is preserved by nature and also made me notice how shadows and light appear to change the substance of things. I immediately knew that I wanted to use this material for a collage and started to look around to find other pieces of metal that would work with it to represent the feelings and ideas that were evoked by the first one. After I had collected others during several different field trips, I attached them to a board backed with a wood frame and painted sections of the composition.

THE MUSEUM EXPERIENCE

You can discover works of art in a similar way. The closer you come to them the more you may see and feel about the pieces. If you want to encourage more studio involvement, sharing additional visual discoveries outside the studio will stimulate this more effectively than emphasizing art theories and techniques. Going to a museum to look at the work of people who devoted their lives to translating their perceptions of the world into lines, colors, shapes, and forms in a variety of mediums can also be a very important beginning.

ROSALYN DREXLER: When did you first have the art impulse?
ELAINE DE KOONING: When I was five years old, my mother took me to the Metropolitan. I remember being overwhelmed by the hush—the glamour of the place. Also I used to be mesmerized by the stained-glass windows in church—but it never occurred to me that anyone *made* them. I thought

they were just *there*, like trees, chairs, houses, and the reproductions on the wall at home. I was always drawing, but I didn't make the connection.

Elaine de Kooning, American painter*

Elaine de Kooning's experience was not unique. For most beginning museum-goers, the visit may be visually joyful and even overwhelming, but difficult in making the connection between what they are seeing and their personal lives. If children work in an isolated studio situation, it is hard to relate what they have done with art materials to what they see hanging on walls of museums.

Studio projects can become outlets for making connections between your own ideas and feelings and those of others whose work you see, especially as you develop the ability to choose your own themes and ways of working.

Each of the projects in this book highlights a different aspect of works you might see in a museum. Museums can provide many examples of the ways in which people of different times and places have utilized all kinds of materials, making it easier to develop a visual vocabulary and an awareness of color, shape, and line.

When you visit a museum with children, remember that their attention span is shorter than yours and they may tire easily. Just as you will prepare tools and materials before your young child comes into the studio space, you need to familiarize yourself with the layout of your local museum before you visit it together. You can spoil an experience if you have to drag them around from room to room looking for a particular work. It's also a good idea to find out where the bathrooms, water fountains, and nearest exits are. As you walk through halls and passageways, point out shapes, sizes of objects, colors, light and dark spaces, and any interesting architectural detail.

* Excerpt from an interview with Rosalyn Drexler in Thomas Hess and Elizabeth Baker, editors, *Art and Sexual Politics*, New York: Macmillan, 1971.

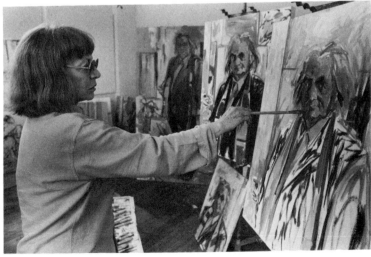

Elaine de Kooning with works in progress.

Looking at only a few things at any time will be much more enjoyable and less confusing than trying to encompass the history of art all at once. When you are in a particular room or exhibit, you might let the children lead you to what interests them. If you force beginners to stand while you examine a work for a long time, they are likely to get restless and unhappy. Ask them questions instead of lecturing, so that you stimulate them to discover different kinds of shapes, colors, and brush strokes as well as what is happening in the painting that can relate to their own experience. Have them think about time of day and people. Are they young or old, near or far away? What are they wearing and why? Are they happy? Sad? Resting? Tired? Is it summer or winter? How can you tell? Obviously, when you once get the idea, the questions are infinite, but you have to be sensitive to the needs of your companions, young or old—some people love to look and think while others have a need to be motivated with talk.

HOW TO USE REPRODUCTIONS

Although reproductions of art works can be enjoyable and useful, they are like travel guide maps and books; they can't substitute for having the experience of visiting a place yourself. I'll never forget the first time I came face to face with Van Gogh's *Cypresses* after seeing a reproduction of it in a book. I had expected to like it, but had no idea that I would have such a feeling of inner excitement when I came close to it and could see the quality of paint and vigorous brush strokes. The energy jumped off the canvas at me. Because I was familiar with the painting from reproductions, I had a set of expectations that gave me a frame of reference in which to receive it. My familiarity with the reproduction in the Van Gogh book I treasured, made the anticipation of going to visit the museum to see the original painting like waiting for a holiday. Sometimes seeing the actual work is all I expected it would be, sometimes not. Unfortunately, reproductions are not always true to the color and scale of the original work. That is why the sizes of works are mentioned in the captions.

It's important to see real sculpture and paintings as well as reproductions of them. If you tell children that the reproductions are paintings (instead of photographs of paintings), they may be confused or disappointed when they see the real thing. When you look at many paintings the varied textures of the paint and brush strokes show a surface that suggests that it was indeed made by human hands. By contrast, the smooth-textured, glossy reproductions give the feeling that they are produced by machines and not people. In addition, many of the reproductions in this book are of oil paintings even though you will be working with water-base poster colors.

Therefore, you will get different effects in your own works from those you see in reproductions.

Reproductions are for getting ideas and learning different ways of seeing, not for examples of "great art" to be copied. With older children and adults, I always try to present a broad range of visual ideas, displaying reproductions of similar subjects from many periods in history. By showing a wide variety of interpretations and styles I hope to encourage each person to paint in her/his own way and not copy the work of a friend.

Reproductions can also build an awareness of the pleasure of having pictures in your home or office. Children often enjoy picking out a postcard reproduction or two each time from the museum store, although they might not want to tell you why they choose it. However, if they put up a collection of their favorites in their room or paste them in their scrapbook, they may feel a personal identification with the act of making a painting or sculpture when they come to the studio.

Vincent Van Gogh, Dutch. *Cypresses,* 1889. Oil on canvas. 36¾" × 29½".

When my daughter, Wendy, and I took my four-year-old grandson, Dov, and his five-year-old friend to the Arms and Armor exhibit in the medieval galleries at the Museum, Wendy asked, "Who do these knights remind you of?" The children instantly thought of the people from other planets they had seen on television, with the Black Knight in particular. How exciting it was that these armored suits came in all sizes, even for children not too much bigger than they were. They were able to connect these five-hundred-year-old pieces to their own experiences. After we finished looking, I asked, "Would you like to have a picture of a knight in armor?" They were delighted with the idea, so we visited the museum shop and got one for each of them. Some children in my workshops have made castles and knights in clay after visiting these galleries.

Although I always put up reproductions and photographs that relate to the adults' projects before class, young children rarely pay much attention to them. They are too involved with doing their own work. I do refer to them occasionally, and point out shapes, colors, and different ways of using the brush. After youngsters become more experienced and show interest in knowing more about art, you might begin to inform yourself about individual artists and the backgrounds of some objects in order to be able to answer their questions. But just as I caution you to have patience with their manual skills, you need to deal carefully with their conceptual skills. Let them initiate questions about particular artists or styles. There are beautiful, informative books on this subject that make wonderful gifts for special occasions and are available in libraries. Also see the Recommended Additional Reading list at the back of this book.

The purpose of looking at art is not to set up criteria for measuring yourselves against, but to become familiar with and to enjoy the language of art. You don't need to make aesthetic judgments, but allow yourself the freedom to feel and respond to the visual qualities of objects. Try to select reproductions that have the greatest variety of approaches. If you only show one kind of work, your children may think that you want them to imitate that style instead of developing their own tastes. Try to keep a balance between abstract and representational subjects. If you display a lot of old masters who work in a highly representational style, your child may feel frustrated, for he or she can never hope to achieve such virtuoso effects in his or her own painting. You might include works of folk artists, primitive artists, and modern artists who paint or sculpt in a simple, direct style.

When one three-year-old began to paint a lot of little dots on her paper during a workshop, I immediately thought of Seurat and pulled out a reproduction of his work (see illustration, page 105). I told her, "You know, Christina, there were painters who mixed the colors in their paintings by making lots and lots of little dots." She didn't say anything and continued painting. When her mother came in I showed her Christina's papers and she said that they recently visited the museum and had seen works by Impressionist and Pointillist painters. At the end of the semester, we were reviewing the painting folders to put up an exhibition. Christina paged through the early dotted papers, lowered her eyes looking terribly guilty, and said to me, "I copied these." I said, "You didn't copy them." I got out the Seurat reproduction again and showed it to her. "Is this the picture you think you copied? They don't look at all alike. You didn't copy. You got an idea. That is how we learn new things sometimes. You saw something that you wanted to try, and you did it. You used the idea in your own way and made a very special painting that is different from the one you saw." She was relieved and excited that she had really done something that was her own.

HOW TO GUIDE YOUNG BEGINNERS

Just as when you are making bread there are certain ingredients and processes needed to make it rise, so with these workshops. After you know the basic recipe for the success of these sessions, you can vary it to your own requirements to make it work even better.

When you are guiding beginners, it will be helpful to hold to some basic attitudes and procedures because if you are ambivalent about them it will be confusing to the children. *First, wait to start any studio work until you feel you really want to do it.* Don't feel guilty if you don't want to get involved with materials right away. If you are

timid, it will be hard to communicate enthusiasm to anyone else. You might begin by visiting art galleries and museums and talking about what you see.

Second, although working with one's hands is pleasurable and absorbing, it can also be a serious study for both of you. The idea that children will profit from the uncontrolled use of paint and clay to release their feelings is a misconception and will undoubtedly cause problems in your studio if you allow it to happen. Once you learn these studio skills in an appropriate way, then you may acquire the ability to use them spontaneously.

Freedom doesn't mean freedom from anything,
it means freedom towards something.

<div align="right">Arthur Dove, American painter*</div>

I see the studio processes as re-creation (the act of creating anew) as well as recreation (that which is refreshing and enjoyable). After you work at acquiring a skill, you can use it playfully by moving materials and ideas about freely, and welcoming changes as they happen. When a child is sent out to play, it may mean "Go amuse yourself" or "Stay out of my way." Yet play in its best sense can be more than just physical movement. It can provide an intellectual activity that has a role in the inventive process as well. Moving shapes and colors freely around in your projects, by putting them into play with each other, helps you get new ideas. Focused play becomes a vital part of the studio encounter when it intensely engages the tasks at hand. Pseudocreativity, like nondirected play, is a kind of amusement without strong engagement that may become boring. There is no sports coach who would send a person onto the field to play a game before he understood the rules, had limbered up, and had the proper equipment and uniform.

When anyone learns to ride a bicycle, usually after much effort on the part of both the guiding person and beginner, he or she rides at first for the sheer joy of making the bike move and pleasure in controlling it. When the bicycle finally becomes a vehicle for exploration, transportation, and adventure, it is an instrument of new experience. Similarly, when anyone starts to work with art materials, he or she experiences this same exhilaration of moving the medium and controlling the brush and colors. After gaining control, studio work becomes involved with movement or communication of ideas. Art work becomes more interesting if approached in this way, because it becomes a conceptual bicycle on which to move, a tool to deal with personal experience and fantasy.

* From Kynaston McShine, editor, *The Natural Paradise: Painting in America 1800–1950*, New York: The Museum of Modern Art, 1976. See illustrations, pages 127 and 207.

"I come to the museum class to work and I go to my other school to play," three-year-old Jenny delightedly told her father when he came to pick her up. She had done a painting, two collages, worked with clay, and helped to clean the clay table.

CLASS ROUTINES: WORKING WITH PAINT, COLLAGE, AND CLAY

In my hour-long classes for parents and young children the routine is always the same: painting, collage-making, clay work, and then cleanup. Young children seem to love routine because they like knowing what's coming next. They will ask to hear the same story or play the same games time after time. They don't like surprises because they feel most secure when their expectations are fulfilled. I read a story about colors and shapes to each class every meeting throughout the semester. If I happen to skip it because the children seem so involved with other things, someone will always be disappointed and say, "You didn't read *Little Blue and Little Yellow*." (See "Books That May Be Shared with Young People" in the Recommended Additional Reading list at the back of this book.)

Children find it supportive if you can be consistent in setting your guidelines. If you give in to breaking routines at first, they will be discontented and not understand how to behave the next time. If you consistently follow a procedure from the very start, they will learn to work independently and later won't need close supervision.

In an hour workshop at the museum the children use all three mediums—paint, clay, and paper collage. As they gain experience, however, their attention span will increase and they may choose to work with only two mediums. The parents work with one medium each time. In the beginning, at home, you may not want to take out all three, but it is a good idea always to have a second one available. If you push children to stay with one activity after they decide they're finished, you may only turn them against further involvement. However, don't offer a medium to them if you are not ready to handle it yourself.

Before you start working, it would be a good idea to eliminate any possible distractions. I suggest that you take care of hunger, thirst, and trips to the bathroom so that once everyone comes into the workspace the focus can be their projects.

I usually begin the session in an area away from the work tables. In the parent-and-child workshop, I talk to the children at their eye level, demonstrating at a very low table the process of using their tools and materials, at the same time trying to make clear the aim and goal of the adult's project. Then I seat the children at the table directly in front of their own materials.

Beginning three- or four-year-olds may paint as little as five or ten

minutes or longer than a half hour. There's no predicting how long they will continue, because it depends so much on the circumstances in the room. The energy and attention span of each individual may influence his neighbors or someone across the table.

Whatever you set up, be prepared to try to extend the activity as long as you can. Speed is not useful here. If you whiz through each medium you will not increase their attention span and little will be accomplished in depth. The children will only get restless. If the pace is slower and more relaxed, they will become more involved and not overstimulated.

When both you and your children agree that whatever you are doing is finished (in reality, the children's decision), they get down off their stools and put away their tools.

In my classes, once they have made the decision that they are finished painting, and their water bowls are emptied, they may not go back to painting during that sesssion. One mother in my class was very upset the first week when her daughter wanted to go back and paint after she had emptied her water bowl. I told her that she could paint again, next time. The child was able to accept the rule after her initial disappointment, but her mother was very distressed. She didn't realize that if every child were allowed to go back and forth there would be chaos. At home, indecision over when to clean up with a child who is starting and stopping might cause you to lose patience and spoil the session.

WHY BEGINNERS NEED YOUR GUIDANCE AND SUPPORT

Inexperienced people need to learn processes, as well as to have support and motivation for their work. If there are no guidelines, how does one know what to do? When you are the model and guide, you set the standards and demonstrate how to keep and use the workspace and tools.

From my experience, I have found that the more consistent you can be, the happier everyone will feel, because most people want the sense of knowing boundaries within which to move. One mother, a research biologist, was amazed at my insistence on these routines at the very beginning of classes. It seemed comparable to her own laboratory techniques. She was also overjoyed to see how uninhibited her son became with the studio work, and that he didn't dissipate his energy in inappropriate behavior.

I always keep the same basic order of activities in the workshops because young children especially need the security of a routine without having to make too many choices at once. Even adults can devote their entire energies to aesthetic decisions when their methods of work become automatic. Of course you can allow more flexibility once everyone learns and understands the reasons for the

procedures. As a more experienced person you must make choices for a less experienced beginner. Asking "Would you like to put your scissors and paste away?" implies that there is a choice. Saying "You need to put your scissors and paste away before we take out the clay" implies a necessity (as you gently guide them physically if necessary). Cajoling and bribing in order to get them to do their part may cause them to feel that they are only doing it to please you instead of finding out that they are working for themselves.

All beginners need encouragement, because it is difficult to motivate themselves continuously. Although they may start off with passion, they may get frustrated and appear to be bored when they don't know what to do next. They don't know how to get new ideas when they see no additional possibilities from the materials themselves or their surroundings. The youngest ones also have more trouble with extended efforts when left to their own devices, because they have little control over their impulses and may get sidetracked easily. Unless you guide him carefully, Johnnie may take the paste and pour it out instead of using the brush applicator, because it won't come out fast enough. He may discover that once it starts to flow it's wonderfully gooey, shiny stuff to slide his fingers in. So he may continue to pour the paste just for the pleasure of those sensations. Aside from the waste involved, and the fact that too much paste takes a long time to dry and squeezes out from under the shapes on the paper, all the materials will now stick to his fingers instead of onto the collage. He may now end up like the tar baby, caught up and miserable, with the insurmountable obstacles of having to cut with sticky, encrusted scissors and being unable to place anything on the paper where he wants it.

SETTING AN EXAMPLE YOURSELF

If you're not doing studio work yourself, try to be busy with something of your own nearby, such as reading, repairing something, cooking, sewing, or the like so that your child won't demand unnecessary direction and assurance from you all the time, but will learn to take initiative in making decisions with his projects. Your quiet work telegraphs confidence and is a demonstration that working seriously can be enjoyable.

If you are engaged in your own project and the children continually keep interrupting you to look at their work, you can calmly reply, "I'm busy with my work now, so why don't we look at your painting together after we both have finished." By the same token, if you are delighted with your own work, try to have equal respect and refrain from interrupting the children with your comments—leaving the sharing until later.

If you are not satisfied with your work, remember that what you may regard as a mistake, something you don't like, can always be changed or done in a different way the next time. That's why I ask parents never to destroy their own work in front of their children. It shakes everyone's self-confidence. One day a visiting grandmother, who was very accomplished with studio materials, sat next to a parent who had been struggling for weeks with her beginning paintings and was just becoming comfortable about her work. The novice painter was admiring the work of her experienced neighbor, hoping that she too would come to reach this high level of facility, when the grandmother ripped up her paper, threw it into the garbage, and started on a fresh sheet. What the grandmother had destroyed appeared so much better than her own work that the younger woman had trouble continuing to work with her own feelings of inadequacy. I always tell parents, if you don't like what you've done, put it aside and come back to it with a fresh eye another time.

TALKING WITH BEGINNERS ABOUT THEIR WORK

Most of us are sensitive about the way others react to us or our work. Sometimes a simple comment can send us soaring with confidence or make us feel very inadequate. We have all seen it work both ways. I constantly try to choose my words with care, so that they will be encouraging.

Being supportive doesn't mean extravagantly praising a beginner's work. Since many children's paintings (like a lot of professional abstract design work) seem to look very much alike to the inexperienced viewer, you may at first tend to overpraise in order to feel that you're encouraging their efforts. However, when they discover that you'll applaud anything, they may begin to wonder if you are really looking at their work and your words may become meaningless. Moreover, if anyone feels inadequate, no matter how you compliment him, he won't believe you. If you overpraise a work in progress, he may stop working on it. Since you have already expressed your pleasure, he may not want to risk spoiling it. Exaggerated superlatives such as, "It's gorgeous! Great!" aren't helpful either, since no one can constantly live up to those high ideals. After calling the first painting a masterpiece, will you then feel you have to call them all masterpieces?

Sometimes a self-conscious adult will say to a child, "Yours is better than mine." I believe it would be more helpful to say, "Yours is different from mine." Putting yourself down doesn't make a person feel better about himself. Try to get accustomed to talking without making value judgments. Point out what you see, the events and ideas that are going on within the image, in terms of colors, shapes,

lines, and so forth. If you say, "I see you made your colors change," or "Look how you put all those tiny lines inside that big shape," or "You've made a pattern like the one on your shirt," you encourage the children to see things they may have overlooked and you will be sharing and enjoying the experience of their work.

If you keep them from resting on their past laurels by praising them for *doing*, not for the end products, they will become self-confident and move forward.

CLEANUP

Because cleaning up is part of the process of working with studio materials, we allot time at the end of the workshop for doing just that. I warn everyone five or ten minutes before I have decided the session must end, so that they won't continue to work into the cleanup time. When there is no need to stop the session at any given time, there will still be that moment when they are really finished. It is important to establish at the first session enough time for cleaning up.

We wash hands only at the very end of class. Children, as I have mentioned, love water play, and if you allow washing at any other time during the session they might spend much of the hour doing only that. If they can't wipe their hands satisfactorily on their smocks, I wipe them with a special cleanup sponge I keep handy in case of accidents or spills.

Sometimes parents and teachers end up cleaning up everything themselves for the children, and become exhausted in the process. It takes time, patience, sensitivity, and above all, know-how to guide young people so that they learn the setting up and taking-down procedures—but it is well worth it. While it's faster and more efficient to manage everything yourself, it deprives youngsters of eventually learning how to work independently. Even handicapped people of all ages can always help with something and will certainly grow in self-confidence, given the responsibility.

How much young children can help out cleaning up also depends on how much time and patience you have. I have found that there are certain things that very young children are incapable of doing without a great deal of help and if you are going to include them, you will need more time and patience. Also, as a general rule it's better not to let someone help if you really don't want or need their help. You can tell them, "You did your part of the cleaning up. This is my job to do now." The extent of their participation also depends on your home facilities. If your sink is high, for example, small children will have trouble reaching it.

GOOD CRAFTSMANSHIP—WHAT YOU CAN EXPECT FROM BEGINNERS

Good craftsmanship doesn't mean making products that imitate standards of commercial perfection. It is both an attitude and a process of doing things as well as you can. It is taking care of tools so they function well, learning to paste and join pieces so they stay together, preparing the clay so it doesn't crack and fall apart—in short, it is working with the potentialities and limitations of each material and tool. (See the discussion of kits on pages 215 to 217.) In order for you to communicate this attitude, you not only have to demonstrate it yourself but also understand your child's capabilities so that you don't demand a level of perfection he or she is unable to attain.

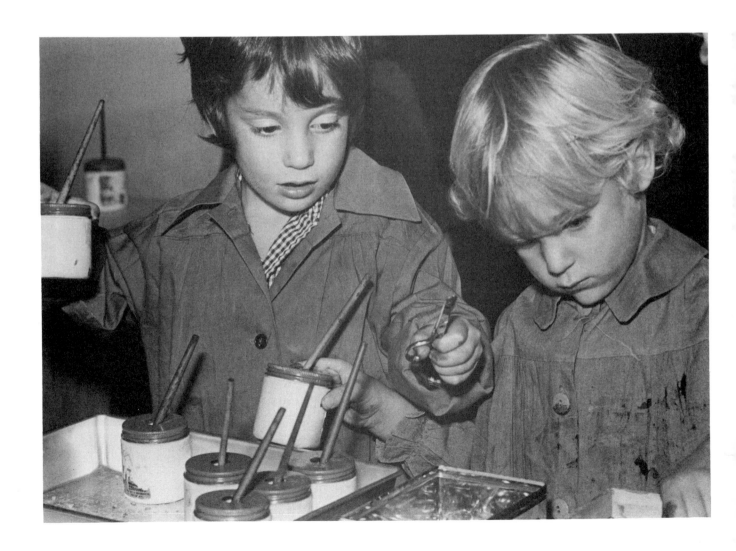

FOUR

Beginning Painting

Adopt the pace of nature, her secret is patience.
RALPH WALDO EMERSON
19th-century American philosopher

I RECALL THAT AS A CHILD it seemed unbelievable that the little seeds in a package could grow into flowers. It took so many days of watering and waiting and then it finally happened. After seeing the flowers I began to make connections between the process and the end product and to have an awareness that vegetables and fruits in the market had a source in seeds.

When the children start painting I often talk about letting their lines grow the way the stems of flowers and the branches of trees do. You will also start by putting your brush down and letting your marks grow. While young children do this naturally, an adult may have to consciously cultivate a sensuous movement and stroke. The growth of your freedom to do this may be slow until you limber up.

It is most important that you read the *whole* chapter before starting *each* studio project so that you understand exactly what you're aiming for. You have to realize that in the beginning you're not attempting to make "art," nor should you concern yourself with an end product. In every endeavor there is a warm-up period. In dance and music, exercises precede every session. If you haven't painted before, you should expect that you may be a little awkward at first. When I was seven years old and took piano lessons, my fingers were very agile. I invited an older lady to sit down at the piano with me to play some of the scales. I remember saying to her, "It's so easy. Look!" Never having played before, she put her hands on the keys and with great effort tried to make her stiff fingers strike the notes. Thinking back on that experience, I came to realize that nothing is easy unless you know how to do it and that success has little to do with intelligence; it has to do with experience. When you do this first project, try to think of it as a warm-up session rather than a command performance. The more concerned you are with an end product, the more inhibited you may become. For young children, the joy of painting comes from the sheer pleasure of moving the brush and paint

around. If you can see this in your child and allow yourself to let it happen to you, you can find the same pleasure.

WHAT ABOUT REPRESENTATIONAL WORK?

The important thing in these projects is to experiment with the range of possible effects you can achieve with tools and materials. You both start at the beginning, and the starting point of a two-and-a-half-year-old is simply to manipulate the materials and enjoy the feeling of moving the brush. Consequently, I encourage parents to work this way too, instead of trying to make representational subject matter, for several reasons. Free manipulation of paint leads to discovery as you observe what is happening on your paper. If you labor over making recognizable images instead of keeping your brush moving and allowing the paint to flow, you will miss the aim of the project. Also, if your children try to imitate you, the making of those images may become more important than discovering how to stretch their own abilities in creating colors, shapes, lines, and textures. It can diminish their courage to experiment and express their own imaginative ideas, and also discourage them because they don't have the technical skill to draw as well as you can.

If you evaluate or criticize their images on the basis of your preference for representational work, you may also misinterpret their work and keep yourself from finding out about their original and direct visions of the world. Younger children, like many professional artists of the past and present, often represent what their mind thinks instead of what their eyes literally see. The mark they make may present a poetic or symbolic image rather than a literal one.

My concern is with the rhythms of nature . . . the way the ocean moves. . . . The ocean is what the expanse of the west was for me. . . . I form from the inside out, like nature. . . .

Jackson Pollock, American painter*

If you ask young children what they are going to paint, they often have no idea and will make up something to please you. As they get involved, they may forget about their commitment to you, and when you say, "What is that?" or "What a wonderful boat!" they are uncomfortably caught and may feel they have to make up another story. By asking them this kind of question, you force them to fabricate a target, after they have already shot their arrows.

Unfortunately, sooner or later most children are exposed to a rigid, uniform method of representational drawing by well-meaning adults

* From Kynaston McShine, editor, *The Natural Paradise.*

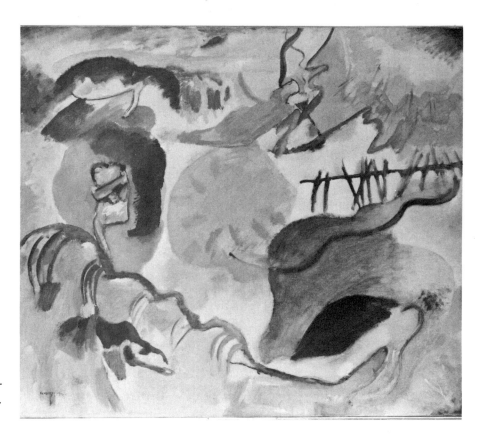

Wassily Kandinsky, Russian. *Improvisation No. 27,* 1912. Oil on canvas. 47⅜″ × 55¼″.

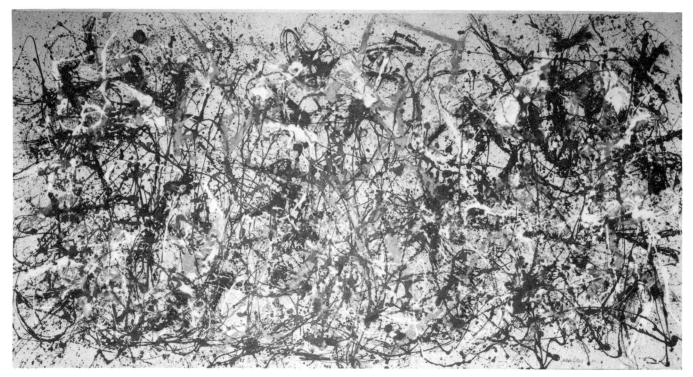

Jackson Pollock, American. *Autumn Rhythm,* 1950. Oil on canvas. 105″ × 207″.

or classmates. As four-and-a-half-year-old Jimmy pronounced after painting the standard yellow pie shape with spokes in the upper right-hand corner of his paper, "This is how the first-graders make the sun. My sister's in first grade and she knows!"

But if children ask you how to paint a specific object, you can help them to think about the visual elements of what they wish to draw. For example, just before Thanksgiving five-year-old Lisa came to me saying, "I want to paint a turkey but I don't know how." "I think you can paint a picture of a turkey," I replied. "Let's talk about it. What kind of a shape does a turkey have, a long skinny one or a round fat one?" She thought a bit. "A big fat one." As we were talking about shapes, Lisa gazed up at the wall where I had pinned a Chinese pleated decoration that makes a circular fan when you open it. It was dark blue at the edges and faded into light blue at the center. She looked down at her paper, dipped her brush into the caster cup of blue paint, and brushed in a large round shape. "I'm making a blue turkey." She looked up at me again, for she wasn't sure what to do next. "What else does a turkey have? Does it have a head? A tail? Something under its chin?" Once she was over the hump of deciding about these shapes, she painted with pleasure. Her last strokes were gently smoothed over with the brush as though she lovingly caressed her turkey. She was overjoyed at what she had accomplished herself.

. . . If someone says, "That looks like a bridge!" it doesn't bother me really. A lot of them do. . . . I like bridges. . . . Naturally, if you title them something associated with that, then when someone looks at it in the literary sense, he says, "He's a bridge painter, you know."

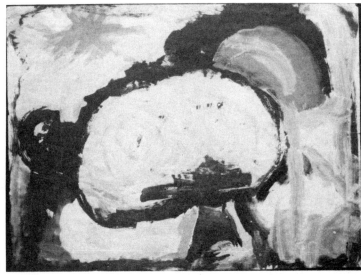

Lisa's turkey. (See Plate 3.)

There are forms that are figurative to me, and if they develop into a figurative image—it's all right if they do. I don't have the feeling that something has to be completely non-associative as far as the figure form is concerned. . . . I think that if you use long lines, they become—what could they be? The only thing they could be is either highways or architecture or bridges. . . .

Franz Kline, American painter*

You should try to have at least one experience with the paint (and with any other medium) yourself before introducing it to a younger person. If you are experienced with the medium, you can understand that if something is wrong with the consistency of the paint, or if the paper is too absorbent or wrinkles when wet, or if the bristles of the brush are too soft or defective, it may handicap and frustrate a beginner of any age. It would be preferable to do the first session when you feel comfortable with the paint setup yourself. Children can read ambivalence and timidity. In order to encourage them, you have to show some measure of enthusiasm and confidence from the start.

For adults, inexperienced or experienced painters, a piece of blank paper resting on the table in front of them can represent a tremendous challenge. Many fear messing it up or making a mistake. This is rarely a problem for young children unless someone inadvertently makes a comment that causes them to lose confidence in their own ability.

Since you will probably experience some anxiety when faced with that blank sheet of paper, try to give yourself a full hour alone after setting up your paint tray, without any other family members around to pass judgment. Give yourself a fair chance to become acquainted with the action of painting. Remember that your aim is to find out how to make the widest range of brush strokes and color combinations, learning from accidental happenings as well as intentional gestures. An attempt at making compositions or recognizable images may be inhibiting and lead you away from your original intentions.

Although in the workshops parents sit while painting to provide role models for the children, when you are alone you may choose to work standing up at the table. Standing encourages larger arm and wrist motions because you won't be tempted to rest your wrist on the table. For this reason, some educators feel that children should work standing, too. However, very young children usually move their arms freely even when sitting if they haven't been taught to use a pencil and rest their wrist on the table. If a child really prefers to stand at the table, I don't make an issue of it as long as he or she is not wandering around.

* Excerpt from an interview with David Sylvester, 1963, reprinted in Kynaston McShine, editor, *The Natural Paradise*. See illustration, page 65.

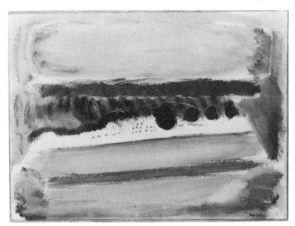

John Marin, American. *Popham Beach, Small Point, Maine Series No. 1,* 1928. Watercolor. 16¾" × 22⅜".

All three of these painters have chosen to use vigorous brush strokes to convey the turbulent rhythm of the sea. Notice how each has a different way of applying paint. Marin loosely brushed the watercolor so that the watery areas would bleed into surrounding colors while the dry-brushed strokes emphasized the texture of the paper. Frankenthaler puddled and spread her oil paint thinly in translucent washes so that it resembles a water-base medium. Hartigan worked thick impasto layers of paint into a densely-packed field of choppy and slashing gestural strokes.

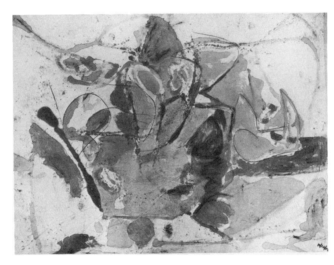

Helen Frankenthaler, American. *Mountains and Sea,* 1952. Oil on canvas. 86⅜" × 117¼".

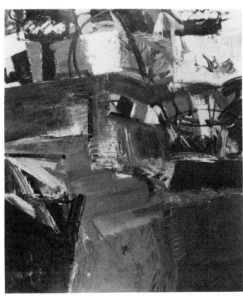

Grace Hartigan, American. *Shinnecock Canal,* 1957. Oil on canvas. 7'6½" × 6'4".

PREPARING YOURSELF FOR A PAINTING SESSION

I've outlined a few sets of exercises to get you started and set you free to experiment further. In all my workshops, I display reproductions of works of art such as those throughout this book in order to stimulate ideas. As you look at the examples, you will see the great range of possible brush strokes made by painters through the ages. I recommend that you look at some of these, including Chinese and Japanese paintings and works of such Western artists as Franz Hals, Cézanne, Van Gogh, Monet, Pissarro, de Kooning, Marin, Hartigan, and Frankenthaler.

Try to be as patient with yourself as you would be with your children. Adults often set standards for themselves that are unrealistic. You may have accomplished many challenging things in your life, yet not have developed the small-muscle coordination in your hands.

Your Project: Getting Acquainted with Paint

(You will find a buying guide and discussion of your tools and materials at the end of this chapter.)

Setting Up the Painting Tray

Painting tray setup.

1. Limit the colors to red, blue, yellow, black, and white. Fill the caster cups half full in the beginning to avoid spills.

2. Arrange the filled caster cups on the right side of the tray for right-handed people or on the left side for left-handers. Place white at the front, then yellow, red, blue, and black. (Omit black from the young beginner's tray for the first few sessions.) This order, light to dark, seems to work well, because younger children usually will start off with the color nearest to them. Starting with lighter colors makes it easier to mix colors because the dark ones will dominate the mixtures when used first.

3. Soak and wring out the sponge to be used for pressing excess water from the brush. If the sponge on the tray is hard and dry or too wet, it will not absorb properly. Set the sponge at the front of the tray as shown.

4. Fill the water bowl half full and place it above the sponge on the tray. (If you are going to ask a very young child to remove the bowl and empty it as we do in the workshop, fill it only one-third full.)

5. Place your large brush in the center of the tray alongside the paints. (Keep the smaller brush out of sight for later use.)

6. For young children, tape down the paper on the table so it

won't slide away as they work. Put one-inch strips of masking tape on the upper right and lower left corners so that the sheet is flush with the table edge.

7. Place the assembled paint tray to the right of the paper. (The tray should be on the left for left-handers and you slide the caster cups, in the same order, to the right side of the paint tray.) Ideally, each person should have his/her own tray set up in this way.

Painting Exercises

1. Dip your brush in any one color (you will try them all, so it doesn't matter which one you start with) and put it on the paper. Although your particular brush grip doesn't matter much now, try not to think of the brush as a pencil but use your whole arm as if you're painting a wall with house paint.

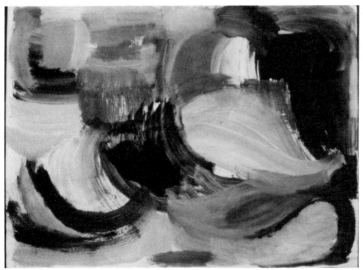

Adult's brush stroke painting, demonstrating blending paint and building shapes with strokes instead of outlining them. (See Plate 2.)

Adult's brush stroke painting, demonstrating a range of techniques from daubing with a loaded, and then almost dry, brush; to dropping paint onto still wet areas of the paper; to vigorous gestural brushing. (See Plate 4.)

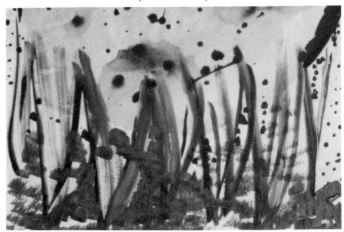

Adult's brush stroke painting, demonstrating overpainting. This adult started the background with red and added blue and black to make a grayed purple background. After it dried slightly he painted over it with dabs of yellow, blue, and then black. (See Plate 6.)

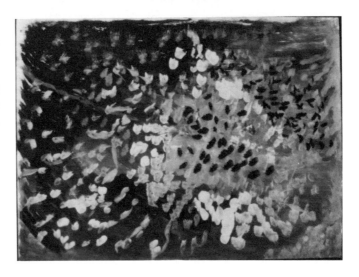

Adult woman painting. If there are very young children in your workshop, it is helpful to sit at a table while you paint in order to provide a role model for them. Restless beginners are more likely to wander around the room with loaded brushes if they are not seated at a table.

Moving your strokes across the paper, alternately lift and press down the bristles to vary the width and texture of the color path. If you continue to paint with the same brushload as long as you can before redipping it, you can get great variety of textures and color gradations as the paint in the bristles diminishes—going from soft, spreading, wet puddles through more crisp-edged swatches, to dry rough tracks and trails like the bark of an ancient pine.

I always tell the adults in my workshops if they have a problem getting started, "Dip your brush in any color, close your eyes, and move the brush around all over the paper. When you open your eyes you will find that you have started to paint."

2. Now observe what happens when you push the brush, drag it, twist or whip it into an arc like a boomerang flying across the field of the paper. What happens when you try the same stroke at different speeds? If painted slowly it may be shaky, when fast it becomes more regular, and your starts and rapid stops create jagged shapes of different widths. See what happens when you hold the brush perpendicularly and at different angles to the paper. Direct the stroke first through the fingertips, next with the wrist, then from the shoulder, and finally move all parts of your arm while brushing, flexing them at the joints. Dip your brush into the pigment and touch it down—vibrating, sliding, and rolling the bristles from edge to edge.

3. Add some water to the paint brush and try all of these again. You will find that the thinner paint creates softer wash tones, and translucent and transparent atmospheric effects when very diluted. Thicker and drier consistencies can be built up into raised *impasto*, or thickly laid on, textures. (See illustrations of Van Gogh's *Cypresses*, page 47, and Gorky's *Water of the Flowery Mill*, page 91.)

Paint never seems to behave the same. Even the same paint doesn't, you know. In other words, if you use the same white or black or red, through the use of it, it never seems to be the same. It doesn't dry the same. It

doesn't stay there and look at you the same way. Other things seem to affect it. There seems to be something that you can do so much with paint and after that you start murdering it. There are moments or periods when it would be wonderful to plan something and do it and have the thing only do what you planned to do, and then, there are other times when the destruction of those planned things becomes interesting to you. So then, it becomes a question of destroying the planned form; it's like an escape. It's something to do, something to begin the situation. You yourself, you don't decide, but if you paint you have to find out some way to start this thing off, whether it's painting it out or putting it in, and so on. . . .

Franz Kline, American painter*

CHANGING COLORS AND CONSISTENCIES OF PAINT

When you are ready to use another color, dip your brush into your water bowl and stir it around several times. Next, dry the brush by pressing it several times on your sponge. If you load your brush with a lot of paint, you may have to repeat the washing and drying several times.

* Excerpt from an interview with David Sylvester, 1963, reprinted in Kynaston McShine, editor, *The Natural Paradise*.

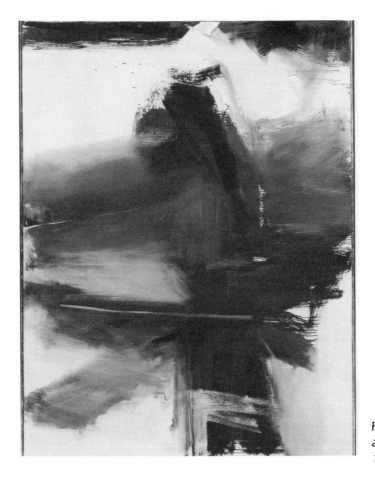

Franz Kline, American. *Black, White and Gray,* 1959. Oil on canvas. 105" × 78".

You dip your brush in water only when you change colors, unless you want to thin the color you are currently using. In that case, *before* reaching for more of the same color, dip it in water and thin the paint directly on your paper (*not* in your caster cup), because once you water down your paint supply, you can't rethicken it easily.

BLENDING AND MIXING COLORS

We blend and mix colors on the paper, *not* in the paint dishes. To *blend* colors, put down different colors side by side on your paper and sweep some of one color over into the nearest section of the other. The overlapped areas will produce the blended color. To make new color *mixtures*, apply a second color right on top of the first while it is still wet and mix them together with your brush. Next you might try changing the color from opaque to translucent or transparent by dipping your brush into water and brushing it over previously painted areas, so that the white of your paper shows through the paint in some places. (See blended tones in Franz Kline's *Black White and Gray*, on previous page.)

If you can mix colors directly on your paper, it will help you work more freely and see results more quickly, because you can see immediately how colors look together. (Identical colors appear to be different according to which other colors they are near.) By mixing on the paper, you will also be repeating the method young beginners use to mix their colors. This method allows great spontaneity and increases your receptivity to effects that you didn't expect. Remember that you are experimenting. You don't have to like the end result as a painting, although it's possible that you will at least like sections of it.

OVERPAINTING (OR PAINTING OVER)

"Why don't you try using your cover-up paint?" I heard Jane Bland say to a child who wanted to start over on a new paper because she thought she had made a mistake. "That's why I call this kind of paint 'cover-up paint,' because if you don't like what you have done, you can change it when you cover it up." I hear myself using those words from time to time—they usually work very well.

You can paint over everything once it dries. Often it's more helpful to just start adding, changing, and mixing over small areas. What at first may seem to be a dull, drab color field can vibrate dynamically with the addition of tiny strokes of bright colors on top of it. Don't give up easily.

When you paint over a section that has already dried with a different color, you may completely wipe it out by covering it (if the under color is light), or else you might deliberately allow some of the first

coat to show through the second one. If you want to totally obliterate the first color, let it dry. Then paint over it with a coat of white. Let this dry also. Finally, paint over the previous two layers with any other color of your choice. Of course, the coverage is going to be more complete with thicker paint right out of the caster cup than with pigment that has been diluted with water. (Too much water might bring up some of the undercoat.)

THINKING ABOUT WHAT YOU'VE DONE

Before you started this project, what did you think of when someone mentioned painting? If you're like most of us, you probably imagined an artist at an easel. This image is often one adults bestow on children by setting them up at an easel with paints they cannot control because they drip down the upright surface. Now that you've painted, you can see that you must work on a flat surface to control the poster colors, and can understand why I recommended that you offer your child a horizontal work table instead of an easel to paint on. (Notice that when artist Jon Carsman paints with a water-base medium he works flat on the table and uses the easel only for oil painting. See illustration, page 25.)

Although the West has not popularized water-base paints as a serious fine art medium until relatively recently, the artists of the Orient have done their finest painting with it for thousands of years. They have used the water-base colors to depict representational subjects, as well as to evoke the inexpressible poetic qualities of nature, such as a sound in the air, a ripple in a reflecting pool, or the moment of full bloom of a flowering tree.

Ancient Chinese poets, philosophers, and Buddhist priests, as well as painters, sought to master the brush, because similar ones were used for both writing and painting. Indeed, the two arts often shared the same piece of paper or silk. Strokes used for writing were originally developed from pictorial representations, and then later the painters borrowed back many calligraphic marks from writing to depict objects, such as the branch of a tree or tail plumage of a bird. In addition, writers and poets evolved and developed scripts with visual names like "cloud writing," "dripping dew," "snake writing," "goose head," "hanging needles," "tigers' and dragons' claws." Many worked with very broad brushes, wider than those you will be using here.

The Chinese had names for each sweep of the brush. The initial stroke might be started with a "nail head," a slight pressure of the bristles to the paper that was held momentarily to make the paint puddle expand before drawing out the path of color. Raising the brush without losing contact with the surface made a thin point called a "rat tail," while descending pressure splayed the bristles into

Hon-ami Koetsu, Japanese. *Poem Page Mounted as a Hanging Scroll: with underpainting of cherry blossoms,* 1606. Ink, gold and silver pigment on paper.

a broad "praying mantis body." One twisting stroke that crossed back on itself was called a "phoenix eye." A sensitive dab would evoke a dripping wet mass of blossoms, a ripe persimmon, or the body of a shaggy monkey. A dry stroke to accent clouds suggested imminent rain. After brushing in pale circular strokes for a cloud, before that liquid dried, a smaller, almost dry brush of darker pigment would be used to touch in textures, skimming the surface so that the bristles barely caressed the paper.

With practice and experience you may find that your own brush-work with color can be just as expressive of your individuality as your handwriting is now.

GETTING COMFORTABLE WITH THE PROCEDURES

Try out all your strokes with one color on top of another, blending, mixing, overpainting, and even painting out parts until you feel at ease. If you didn't get that feeling this time, try a second or third session alone before you do this demonstration for your young beginners. Above all, don't compare your own results with the finished paintings of others.

DEMONSTRATING PAINTING TO YOUNG BEGINNERS

After you've done the project yourself first and are ready to do it again with a young beginner, remember that until children develop a sustained attention span for their own work, you may not be able to concentrate on yours. However, it's important to set up your tray and paper so that you can present a role model and so that you won't be tempted to hover over anyone else.

I explain the procedures of painting in an area away from the children's paint trays, just as you should do at home. It is difficult for young children to be interested in listening or watching if their trays are visible. The paint looks so inviting that once they go to their places I like them to be able to start immediately.

No matter what colors or marks you make while doing any of these projects, try not to act like you've made any mistakes. There are no *mistakes* in aesthetic choices here; there are only *changes* to be made. With inexperienced people, lay out your own tray and paper and use your setup for demonstrations. You always demonstrate only on your own paper. Young children will also come to realize that you paint only on your paper and they can work only on theirs.

A young artist mother told me with amusement that when her very young daughter made marks on her canvas, she incorporated them into her paintings. I could not help imagining what was bound to

happen in the future when her child (wishing to be helpful) drew or painted on a finished work that was ready for exhibition.

Setting guidelines, even for the smallest child, probably will prevent unpleasant accidents. Self-respect, as well as respect for one another, can be fostered when each person works only on his/her own projects.

When I demonstrate painting procedures at the museum, I repeat the process at the start of each session where the adults are going to be painting as well as the children. I vary it to incorporate instructions for the new adult project while reviewing the painting process at least three times for the little ones. I always review the process at least once for beginners of any age, so they understand the system.

You may not get all the way through this whole sequence with very young beginners the first time. If you are too slow or draw it out through the entire nine suggested steps, they may get restless. Once they've seen the colors mixed (steps six and seven), if they're raring to go you might postpone the last ones until next time. If you see that they are most eager to paint after they see what happens when the colors touch each other, let them start painting then. The idea of demonstrating is mainly to show the process of washing and wiping the brush, not to make a painting in front of them. It also gives the young ones a chance to stay with their parents and look around before going off to their own places. Since I never make a finished painting during a demonstration I am not concerned that the children will try to copy what I've done. Once they pick up a brush, the materials take over and each child proceeds in his/her own fashion.

DEMONSTRATION:

1. I pick up the brush off my tray and ask, "Do you know what this is?" (Most two-and-a-half-year-olds look at it and are hesitant to say anything, even if they know.) Pause. "It's a brush. Is it a toothbrush?" (A big No.) "Is it a hair brush?" ("No." They smile and relax.) "It's a paint brush, and we're going to paint with it." This is not an absolute recipe—it is something that has worked well for me to help everyone relax in a first session.

2. "Where is the paint?" (They point to the paint tray.)

3. "What color shall I start out with?" Point with the brush to the caster cups and name each color separately in order. Pause slightly between each one so that if they know it they can call it out. "Shall I use some . . . white, . . . yellow, . . . red, or . . . blue paint?" If they don't know the names, I just point and name each color.

4. I dip the brush into the chosen color. "Now, I'll put the paint on my paper." I try to use up all the paint on the brush by spreading it in a few separate places across the page. "I think I'll use some more red," and I redip the brush and spread more of it on the sheet.

5. "I want to try another color, which one should I use?" (They will point to it or name it.) "What do you think I have to do before I put my brush into that yellow paint?" Pause briefly as the child looks puzzled. "I have to wash it. The water bowl is like a bathtub for the brush." I stir my brush in it saying, "Wash, wash, wash." I take the brush out and pause. "What do I do now?" Pause. "I have to dry it just as you dry yourself with a towel when you take a bath. After I wash, wash, wash, I press, press, press, so the colored water goes into the sponge." (Try not to call the colored water "dirty." See page 23 for explanation.) "Now I'm ready to put the yellow on the paper."

6. "I'm going to let the yellow sit next to the red." I spread the yellow closer and closer to the red. Then I let the brush drift over into the red and exclaim, "Look what is happening! When the colors bump into each other, they change." (Since I always feel the anticipation of what is about to happen when the children see colors change for the first time, they sense my attitude.) It is important that they realize that I think it is very special, and permissible, even exciting, to let the colors bump into each other and make them change.

7. I quickly go on to mix these two colors together some more. "Look what I did. I made the colors *change*. Do you know what color I made?" Pause. If there is no immediate or correct response, I name the color. It's important not to seem as if you're testing them, but rather to reinforce the process that is happening on the paper.

8. "Now, what color should I use?" Repeat the same process of "Wash, wash, wash," and "Press, press, press." I spread this third color near one of the other swatches but without mixing them. "I think I'll let my blue sit next to the yellow and talk to the yellow." I put a dab of blue in an empty section of the paper. "This blue has no color to talk to. It's all alone, talking to the white paper." (Older children may say, "Colors don't talk." I reply, "Colors tell a story in a different way than words do, without sounds. When you're painting, you are telling a color story or a story about the colors.")

9. As a final step (one that I do more for adults who may be less adventurous than the children), I quickly show some of the possibilities for using the brush. "Look at all the things I can make my brush do. I can make it slide up and down or walk around." I also make dots and dabs as well as longer strokes here. "I can take a trip around the paper. Now let's see some of the things you can do with your brush and colors."

Now you can set down their paint trays in front of them in the proper locations. Be sure to remember whether they are left-handed or right-handed. Stand back and let them paint.

TIPS FOR TEACHING

If you forget to wash your brush while changing colors when you are demonstrating in front of young children, do *not* place the loaded brush in the water but put that paint somewhere on the paper out of the way to dry. If the children see you putting brushfuls of paint into the water, they will do the same thing and become confused about when you wash the brush. Once you dip your brush in paint, try to follow through and put it on the paper even if you change your mind about the color. It's part of learning to be flexible. You can paint over that spot with white or another color of your choice when the paint dries and then see what happens.

Just as it would be difficult to force yourself to demonstrate brush-work to them if you are timid, you also shouldn't try to coerce your children into painting. In the workshops at the museum, I ask the adults to work continuously to show the children that they have nothing to fear. This may take time and you must have patience.

For example, three-year-old Susan sat in front of her paper and did not paint for more than six classes, which was quite unusual, before she finally gained the courage to pick up her brush. Although I tried to motivate her gently by talking about colors she liked, her only response was to nod her head yes or no. Because this session wasn't a parent-child class, she didn't see her father or mother work-ing as a role model. She sat watching the other children and as they finished their painting and emptied their water bowls, Susan got up and emptied hers also and joined them at the collage table. Making collages and clay pieces seemed to pose no threat to her, and she loved doing them. When other children asked "Why isn't Susan painting?" I told them, "When Susan is ready to paint, she will. Right now she just wants to watch. That's okay. We all can learn a lot of things by watching."

Susan looked forward to the class and her mother responded by giving her paints at home and waiting patiently. I suggested that her mother make no value judgments about Susan's work since I had the feeling that Susan was overly concerned about being able to make a "good" painting, and didn't want to risk failing. Around the seventh week, Susan picked up the brush in class and started to paint. We both acted as if there had never been a problem.

Because talking interferes with visual thinking and because I want to encourage each person to develop in his or her own way, I try not to be overdirective and am very careful about my choice of words and attitudes. They will see and do what interests them, and even though I may call attention to something, they may not respond,

because they are too involved with their own work. That's fine with me. They may hear me another time.

Everyone has his/her own way of painting. Some work in a more thoughtful precise way, while others love pushing thick paint around with their brush and will paint and paint. Sometimes they become fascinated by the changing color of the water as they wash their brushes, and may even put paint into the water or paint the sponge and bowl. Such experimentation is fine up to a point. However, it is important not to let them go too far from their real purpose and to remind them that the paint is to use on the paper.

Allowing a child to paint on surfaces other than the paper or to smear paint with his/her hands after being given a brush is unspoken encouragement and sanction for that activity. I try to speak simply, directly, and gently, without nagging. Once in a while, if I see a child is confused about washing the brush, I may hold my hand over his/her's on the brush and guide the bristles into the water bowl and onto the sponge saying, "Wash, wash, wash. Press, press, press." Sometimes they chant "Wash, wash. Press, press" for the delight in the sounds of the words, even though they may not understand the connection with their actions. Even though I may have explained frequently that you use one color at a time and mix colors on the paper, at first they may try plunging the brush from one caster cup to the next as they paint. If you are inclined to remind your child continually to wash his/her brush, you will find it helpful to concentrate on your own work so that your child won't feel that you are impatient and critical. Sometimes too much guidance can turn off enthusiasm and make them dependent on your constant approval.

One day, two-and-a-half-year-old Sam had his brush full of paint ready to lay it on his paper when he heard me say to someone, "Wash, wash. Press, press." All of a sudden he remembered that he hadn't washed his brush and into the water went his brushful of paint. Then he put the wet brush onto the paper. He thought it was fun, so he did it again, and forgot why he was washing his brush in the first place. It takes time to learn procedures and children do need to be reminded. However, try to time your suggestions carefully. Occasionally every beginner, young or old, forgets to wash and press the brush before changing colors.

When younger children realize that they can change the colors by painting over them, they will probably keep doing it because it gives them a sense of power. While the end result may be a brown or gray mass that may not be attractive to you, they believe the colors are there because they put them there. It's like playing peek-a-boo, covering favorite belongings with a blanket, or turning out the lights and making things disappear. It's such fun because they have learned the

First paintings of three-year-olds. The child who drew the circle was more experienced since she had been given materials to work with at home. She was interested in mixing colors and using her brush in different ways.

secret that things don't go away even if you can't see them. It's like magic. Try to allow them to learn this way, even though the end result may not look so appealing.

Four-year-old Bonnie painted and painted so that there were at least three paintings on her paper, one on top of another. She started with red, added white, and changed it to pink. Adding blue changed it to light purple. Yellow and red became orange next to the purple, and where the yellow bumped into blue it changed to green. The painting continued to flourish and in the end there were great masses of dark grayed colors from the constant mixing of colors on top of each other. As the children were finishing I asked, "Did anyone make green today?" With great excitement Bonnie called out, "I did!" "Where?" I asked. "Right under here," she said proudly, pointing to a dark area on her paper.

Sometimes a child may have a specific idea or process that only they can explain. For example, one teacher told me how she watched five-year-old Harold first cover his whole paper with brown, then paint over it completely with green, next fill the entire sheet with black, and finally spread white over all that. The final painting was an all-gray field. She wondered if he was fooling around, but didn't

stop him because he was so seriously absorbed in his task. When he finished he smiled up at her and triumphantly announced, "Do you know what I just made? I made a road." He had diagramed the process of building a road. He painted the dirt, covered it with grass, then tar, and finally paved it with macadam. Harold had thought through the whole sequence and from his point of view had represented it very accurately.

Please remember not to get so involved with teaching techniques that the joy of using the paint brush is no longer interesting and becomes distasteful. Techniques are like facts. They are only useful if you need them to do something. Washing a brush, mixing colors, or whatever will be learned as someone finds the *need* to learn these things. It is never worth making a contest or battle of your respective wills. If the children don't want to try something you suggest, don't force the issue. Change the subject to redirect the focus. Go back to your own work, and if you have been painting you might announce, "Look what I found—a new color!" Or, glance at their work and

Children's story paintings. Children often make narrative paintings which in their outward appearance seem very abstract. They diagram things as they know them to be. Sometimes they enjoy telling about them, but often they don't. "Would you like to tell me about your painting?" might bring forth the story, but since they have already told it in a nonverbal language, they shouldn't have to explain.

exclaim, "Look at what a lot of shapes you made over there!" In my classes I only stop the children if I see them doing something that will harm them, damaging their surroundings, meddling in someone else's work, or using tools for the wrong purpose.

If your child holds the brush in a different way from the one you have demonstrated, don't interfere. If they have grabbed the handle very high up near the top so that they have no control over it or too far down next to the bristles, you might gently slide their hand toward the middle area without saying anything. If they tense up at all, let go. Don't make an issue of it as long as they can work reasonably well. After they are more secure and relaxed with painting, you can suggest a change this way: "When I paint I find it's easier if I hold my brush this way. Do you think this might make it easier for you too?" When I tried to change the brush grip of a child at the first session, he put down his brush and announced that he was finished. I think that he interpreted my desire to help him as disapproval. Usually I wait until they have completed several paintings before trying to suggest anything.

Dripping and spattering are not techniques I encourage when trying to teach use of the paint brush. A young child is not experienced enough to be able to make choices between techniques of applying paint, nor to have the degree of control to be able to use them purposefully. They may forget about the original intent in making a painting and just spatter for its own sake. If your children discover dripping or splattering, don't discourage them if they are able to control the paint. Show them how to do it by holding the brush filled with paint perpendicular to the paper (as you would do when dripping paint) and shake it up and down. When they are a little older and more experienced, you can show them how to splatter with a short, snappy wrist action while holding the brush horizontally. In any case, if it gets out of hand, you will have to stop it by redirecting their attention to something else.

Two-and-a-half- to four-year-olds often need a little remotivation to help them focus in on what they're doing and continue painting, because they have short attention spans and haven't learned to see many possibilities. If someone has stopped painting, I frequently ask, "Would you like me to turn your paper around so you can reach the places on your paper where there aren't any colors?" If they say no, I leave it alone. This often works; however, if the paint on the paper near them is wet, they may not want to reach over it. When I do this, I explain to the adults in the room that they too might reposition and turn their work around so that they can look at the paper with a fresh eye, or different point of view. Older children and adults often find the idea of turning a painting upside down too difficult to accept.

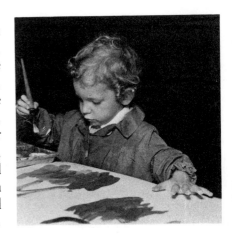

You also might ask a child who has gotten involved in a corner of the page, "You have so many colors over here and the other part of your paper looks very empty. Would you like to put some colors over there?" (Before you use a word, be sure they know what it means. Most two-and-a-half-year-olds know the word *empty* because of its constant use with food. The plate, bottle, and glass all become empty every day.)

If they announce that they are finished after just a few minutes, I try to interest them in continuing by offering small pieces of colored construction paper (which will stick to wet painted surfaces) or a smaller brush. If they've only put a few dabs or spots on the page, I might say, "I see you have put some blue (or whatever color) over here, what color do you think would like to sit next to it?" Either they will become involved again, or else they will put one more dab on the paper saying, "Now I'm done!" That last dab is like the token bite of food when you say, "One more bite for Mommy." It's not really for them, it's for you. Although I would like children to feel that they are painting to please themselves, showing interest may motivate them into continuing. If all the other children are still working and it is too soon to allow them to move on to collage, I may say, "It is still painting time. It's all right if you don't feel like painting anymore, you can sit and watch, and maybe you will change your mind and decide to paint some more." If not, don't press them further. In a group situation, I am not so quick to offer another paper, because everyone else might want one too. At home you might offer another piece, but use careful judgment.

HOW TO TALK ABOUT THE WORK

If a child is really involved, I don't feel that I am being neglectful if I refrain from talking with him until he is finished or asks for my attention. Even if someone is not actively painting, he may be thinking about what he is doing and should be allowed that privacy. Therefore, I avoid interrupting silences as well as concentrated effort. However, if the children are excited, and occasionally want to share something they're doing, I might look and listen or help them to identify the color they just mixed. Later on when they become more interested in mixing colors and ask how to make a particular one, I ask them which paint in the caster cups looks most like it. Sometimes I show them a nearby piece of colored construction paper. I say, as we look and compare each color. "Which color looks most like the one you want to make?" If they don't succeed in mixing the original color they wanted, don't do it for them, but add, "Look at what you did, you made a different color! Do you know its name?"

Even older children will occasionally be ignorant of how the colors are made.

For example, Wing, a fourteen-year-old recent immigrant from China, was enrolled in a summer remedial reading and art program with much younger children to help him catch up with his language and reading skills. He was working with colors for the first time despite his advanced age, and reacted angrily when his younger classmates frequently teased him. One day while he was painting, a passing child jostled his arm. Wing turned and grabbed the boy and the teacher had to intervene. As Wing turned back to his paper he cried out in bewilderment, "Who did that? How did that color get on my painting?" A green streak sat where his jostled hand had swept his loaded brushful of blue across a still moist yellow area. The teacher recognized her opportunity to make Wing special in the eyes of the other students and exclaimed, "You made green, Wing!" Since none of the other children had discovered how to make green, they all gathered around him to see what he had done that was so wonderful. She had him repeat the process of putting blue on yellow to demonstrate for the others how he had done it. Not only had he learned to make green, but his ability to do something special had made him less defensive. Wing's self-confidence grew as well as his interest in studio work, and carried over to all of his studies.

It is not useful to ask very young people to identify colors because they may learn to give rote answers without knowing what the words really mean. They probably won't really know many colors until they mix them on their own papers. It's very important to realize that children are not necessarily color-blind if they can't tell you the names of colors. If you make an exam out of it, they're very apt to tell you nothing for fear of being wrong. One approach is to involve them in talking about the colors of their foods or the clothing they are wearing. When they're excited about something personal and want to share it, they are more likely to talk about it.

Often young children won't even think about how they've made a particular color in the past until they have a reason to want to make it again. Five-year-old Willy arrived at a workshop and announced that he was going to do a painting of the pink rabbit he carried under his arm. However, I began class by showing a great variety of shapes that can be found underwater—coral forms, shells, and scuba divers observing fish and sea life. As we examined the pictures we imagined what colors and shapes we might see if we were those scuba divers. After we finished our discussion, Willy made a very pink octopus painting and then declared, "Now I'm going to paint my bunny rabbit! What color is it?" I couldn't believe my ears. "Willy," I said, "you just painted that color."

He looked at the rabbit and then the painted octopus. "Oh, it's pink!" he said. "How do you make it?"

"The same way you made the octopus," I explained.

Someone else at the table called out, "Red and white."

"Oh!" With a flash of recognition on his face, Willy suddenly became aware of the fact that the pink he had made came from those two colors. He had not planned to paint a pink octopus, but had just mixed the color spontaneously without being intellectually aware of what he was doing.

In short, children frequently need you to talk about what they've done to draw their attention to the process. You might say, "That's a new color. Do you know the name of it?"

What I hear I forget
What I see I remember
What I do I know.
　　　　　Chinese Proverb

CLEANUP

When the children are really finished and lay down their brushes, they get off their stools or chairs, take their water bowls over to the waste bucket or sink, and empty them. I encourage them to do only one thing at a time. In the beginning, I show them how to place both hands (with their thumbs locked over the inside edge) around the bowl while carrying it to avoid spilling the water on the floor. I caution them to watch what they're doing because they are often distracted by other things and don't pay constant attention to the job at hand. Although a little bit of water may spill at the start, even the youngest will be able to accomplish this task perfectly by the end of the semester. If youngsters have always had everything done for them (from picking up their toys to putting on their clothes), they haven't had the opportunity to develop hand skills. Here is one opportunity for them to start. At the museum, I can't let any young child wipe up the floor with a sponge because everyone would want to help, and energy would be directed away from the art experience. At home, however, the child who spilled the water could help to clean it up.

When your child says "I'm tired" or "I don't feel well" to get out of cleanup, if you give in rather than risk a scene you will only sabotage your own studio program. Even if they are unable to do very much, and you are tempted because of lack of patience or time to allow them to shirk this duty, they should do something. If you would

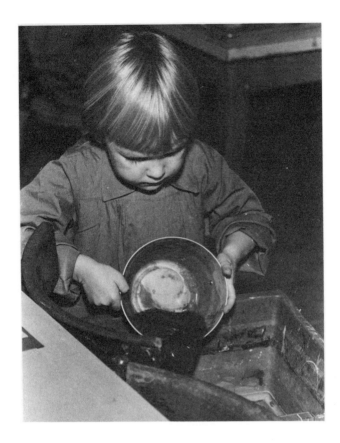

rather not have them carry the water bowl, then give them another task such as carrying the brush and sponge to the sink.

If you would like children to participate more extensively, try out one task at a time and supervise it. Some two-and-a-half- to three-year-olds are able to wash out their water bowl, paint sponge, and brush, and clean the caster cups (if they are empty and already in the sink). You can help them develop a sense of placement of things by explaining that, "We do this so that we know where everything is and don't have to waste time looking for things for the next workshop." If you have a reason for the order it will appear less arbitrary to the children.

You might check to see that the brushes are thoroughly washed and stored upright (bristles on top) in a can or other tall container. Leaving the bristles standing in water, even for a short time, will spoil their shape.

If you've bought large quart jars of paint, you might turn them over occasionally to keep the pigment from settling on the bottom of the jar. Decanting the paint from large jars into smaller syrup dispensers makes for easier pouring and fewer drips to clean up. How-

ever, these small containers must have airtight tops. Remember to remove any paint from the jar or container edges while it is damp; otherwise it will harden and prevent the lid from functioning properly. If that happens you can remove dried paint with hot water.

If you left your paint caster cups uncovered and they have dried out, you can put a little water into each caster cup and it will resoften the paint in a while. (If you discover this with your caster cups just before you're ready to paint, put these aside—don't throw out the paint—and refill another set.)

MATERIALS AND TOOLS: BUYING GUIDE

PAINT

Like the ancient Chinese, we use only the three primary colors— red, yellow, and blue—plus white and black. Other colors can be made from these.

A nursery school teacher once told me that during a parent-and-child interview the mother proudly told her that Johnny could count. She asked him to demonstrate this and he quickly recited the numbers "12345678910," running them together in one gulp and counting off all the digits on the fingers of only one hand. It was obvious that he knew how to say the numbers but didn't really know what they meant. In my workshops I want everyone to know what they are talking about when they name a color, and how to find out for themselves how they are mixed.

I never buy green, purple, and orange because these are colors you can make by mixing the primaries, and the ability to do it is invaluable. Starting out with a number of ready-mixed colors deprives beginners of having the basic mixing experience. They end up making new colors without knowing how those first colors were made. Moreover, a wide palette presents too many choices at once to a young beginner. When you and your child are both more experienced, you may want to add more colors.

I use only poster paint (also called show card paint), because it is water soluble, has a good consistency that flows freely, and has brilliant color. Because it is opaque (unless you thin it with lots of water), the colors are not as affected by the color of your paper as transparent watercolors are. Poster paint is especially good for strong colors, contrasts, and spontaneous effects. You can rework your painting when the underlayer dries without muddying your colors.

Good quality watercolors and gouache (opaque watercolor) in tubes are very expensive and more difficult to use when starting out. In addition, the little cakes of hard watercolors in variety stores are adequate for working only on small papers.

My own feeling is that oil paint is most unsuitable for beginners, because it lacks the free-flowing quality of the water-base poster medium, dries very slowly, can stain clothing, and certain colors are toxic if eaten. Oil paints and canvas are also expensive, and you might feel inhibited when working for fear of wasting costly materials.

EXTRA INFORMATION FOR SOMEONE WHO WANTS TO KNOW
 MORE ABOUT PAINT

All paints are distinguished from each other by their binders, the substances that hold the colored pigments in suspension. Pigments, the coloring matter, were originally made from minerals, plants, sea animals, or insects, although now most are made chemically. The same pigments may be used in oil paint or water-based mediums. It is their binders that create the different visual reflective and absorptive qualities and their textural consistencies.

The binders for tempera, poster colors, and watercolor (also gouache) have different formulas that influence their painting qualities. The traditional translucent tempera medium was an emulsion of pigment in a liquid oil or fat (like egg yolk), wax, or a resinous gum arabic base. (Today some paint companies sell a "tempera" with a plastic polymer base that is opaque.) Poster colors were mixed in a simpler glue-water solution of gum arabic or acacia (from various trees native to Asia, Africa, and Australia) or glue size (a gelatinous substance from animals). (Again, some companies may now use chemical substitutes.) Poster colors have a thicker consistency and are more brittle than traditional tempera, but their colors are no less brilliant. Watercolor and gouache also have binders of gum arabic or gum Senegal (a better quality gum), but the pigments are more finely ground and their formulas have additional ingredients to improve solubility, flexibility of the dry paint (so it doesn't crack), adherence to the paper, and flowing capabilities (which also makes it difficult for beginners to control).

POSTER PAINT

Sometimes poster colors in jars are called tempera when they are not. Some manufacturers use the word *tempera* to distinguish the finer grades of poster colors from cheaper ones. In my classes, I use a brand called "Rich Art: Moist Watercolor." It is not a watercolor but a water-base paint. Its label also says, "For tempera, poster, and Airbrush." Crayola puts out another good poster paint and other companies produce acceptable colors as well. There are new paints being developed all the time, so you might want to consult with a local art supply store. Recently a company came out with a squeeze bottle for poster paints. I tried it and found that it invited squirting accidents for adults as well as for children. So far I prefer twist-off tops on jars.

While poster colors come in powder form, I prefer the ready-mixed liquid in jars. It usually has a good consistency and is convenient to

use. However, I know teachers who do use powdered colors successfully. One teacher has young children mix their own powdered pigments as a way of learning to mix colors. Nevertheless, as a beginner, you give yourself the best chance of initial success by buying the liquid paint in jars, because you don't know what the proper consistency of the mixed powder should be like for painting. In addition, if you get the liquid paint in jars you can be reasonably sure you have poster colors even if the label says tempera or moist watercolor.

BRUSHES

I supply two bristle oil-paint brushes to each person, one large (1 inch wide) and the other smaller (½ inch wide). You can also use ¾ inch and ¼ inch sizes. Although they are flat in appearance, they are called "brights." True "flat" brushes (or "flats") have longer bristles and hold too much paint for this poster medium. The bright, supposedly named for a Mr. Bright, has a shape that is a bit sharper at the corners and has a shorter and thicker bristle than a flat. The shorter bristle is especially good for manipulating the thicker consistency of the pigment as it is drying on the paper.

I used to give the adults two brushes at the very first session until I realized that the smaller brush for some adults became an invitation to draw rather than think about painting, and one child didn't want to use the large one at all because she saw her parent using only the small brush. Although you do not use the smaller brush in your first session, I introduce it into each subsequent class after the young ones have painted for a while with the large brush and seem to have exhausted their possibilities. At that point I suggest that they might like to add some tiny shapes or skinny lines with the small brush.

Good watercolor brushes are very expensive and do not work well with the poster colors because they are too soft and small, with a shorter handle, and have shapes that are less versatile for our purposes here.

When you show the bristle brushes to your youngster, you might explain the various parts and what they're made from. The standard oil-painting brushes I use are made from grades of bleached hog's hair. Pig's hair has a split or forked end that branches like a miniature twig and is called a flag. The watercolor-brush hair, by contrast, comes to sharper tips.

A test of the excellence of your oil brushes is their ability to keep their shape under controlled pressure instead of becoming too soft when wet and spreading or splaying out at the sides like a straw broom. This may be difficult to assess in the store because manufacturers spray their bristles with starch or gum to protect the bristles from damage in shipping and store wear, so that cheap ones may

look and feel as sturdy as the better grades. However, if you get a standard brand-name brush, you will probably get one of reasonably good quality whose bristles won't fall out or lose their shape while you're painting.

PAPER

I recommend using an 18-by-24-inch white (or neutral tan color if no white is available) paper of about a 60-pound weight. Since this is one of the standard drawing pad sizes, you should have no trouble finding it in art supply stores. Buying the paper as loose sheets may be less expensive. You can also use white construction paper of about the same size. If the paper is too big, not only will youngsters be unable to reach all its parts, but they will also be unable to see the sheet as a shaped field within which to compose their images.

PAINT CONTAINERS

I prefer to use furniture caster cups, either the glass or plastic ones, because they're so practical. They supply just the amount of paint needed for a session, don't tip over, stack easily, and you can set them up ahead of time or store them from day to day with plastic wrap over them. I order mine from the Travco Company, 4718 Farragut Road, Brooklyn, New York 11203.

If you can't find caster cups, jar tops are fine, or you might cut down small yogurt cartons or Styrofoam or waxed paper cups to about ¾ inch high. The latter are less satisfactory because they lack the stabilizing weight and are only a temporary device.

STUDIO SUPPLIES

Paint trays can be improvised from baking pans or tins or small serving trays. The water bowl can be any medium-sized unbreakable dish. Remember that if you have no sink in your workspace, a bucket or plastic dishpan can serve as a waste container for the used paint water. Keep an extra sponge at hand for cleanup in addition to the sponges for each individual to use for pressing water from brushes. Assemble protective coverings for nonwashable work surfaces and for rugs.

FIVE

Suggesting Mood or Place with Color

WHEN I WAS IN HIGH SCHOOL, a group of friends came over to my house to visit. We got hungry and decided to cook spaghetti and eggs. While pulling out the supplies from the cabinet we saw a package of food colors and decided to use them on the food. We made the scrambled eggs blue and the spaghetti pink. When we set the table and sat down to the meal, it looked very pretty, but no one really wanted to eat it. The colors looked all wrong. Everyone tried it, and it tasted the same as usual, but the inappropriate colors took our appetites away. It was the first time we realized the power of color could have a physical as well as an emotional effect.

Color is so complicated in its effects that, despite many books about color systems and theory, it still remains one of the most personal and mysterious visual elements. Although most of us agree to use dictionary definitions of words when we speak, we perceive colors through many other experiences we don't even have words for.

Once one has had the experience of the interaction of color, one finds it necessary to reintegrate one's whole idea of color and seeing in order to preserve the sense of unity . . . when you really understand that each color is changed by a changed environment, you eventually find that you have learned about life as well as about color.

Josef Albers, American artist (born in Germany)*

Imagine describing color to a blind person who has never experienced the blaze of a sunset, the splendor of a field of flowers, the prism of the rainbow, or any of the kaleidoscope of colors we encounter daily with every glance around us. Words would be inadequate. Moreover, expressions such as "green with envy," "white with fear," or "red with anger" have no objective actuality. Indeed, who ever turned green when jealous or blue when depressed? These expressions merely point to the fact that colors do provoke strong

* Excerpt from exhibition catalogue *Josef Albers: White Line Squares*, Los Angeles: Gemini G.E.L., 1966. See illustration, page 208.

84

emotional responses. Yet these reactions have different meanings within each situation, and only in relation to other colors and shapes. For example, red can be seen as a sign of danger at a stoplight, or as a token of love in a rose. Green can be thought of as a color of hope and joy in the budding plants of spring, or as a cold, depressing color of decay on a moldy piece of food. Response to color is so complex because we react to it in three ways that are all merged together: visually, emotionally, and symbolically.

One of the common misconceptions about children's color choices is that "If they're happy and normal, they like bright colors." Actually, most children enjoy and use all colors at different times. For example, after a workshop led by a friend who teaches in a Head Start school, a very distressed mother demanded to know why her son's painting was mostly black. "What are you doing to my son that makes him so depressed he paints black pictures?" she asked angrily. Before my friend could ask her how she was so sure black was depressing for George, he piped up, "Mommy, don't you know what I painted? I painted you in your beautiful black nightgown. I love the way you look in it."

Many artists and thinkers have called color the music of the visual arts because it resonates in the mind like sound, has unlimited vari-

Claude Monet, French. *Morning on the Seine near Giverny,* 1897. Oil on canvas. 32⅛" × 36⅝". (See Plate 11.)

Pierre Bonnard, French. *The Terrace at Vernon,* c. 1930–38. Oil on canvas. 57¹¹⁄₁₆″ × 76½″. (See Plate 12.)

ations when combined like notes into visual symphonies, and excites strong emotional reactions with a power equal to that of music. I know of one classical singer who refuses to perform opera because she feels that the competition from the visual parts of the performance is too tough to compete with. André Gide's novel *The Pastoral Symphony* recounts the tale of a successful attempt to teach a blind child about color through music.

The Effect of Color

If you let your eye stray over a palette of colors, you experience two things. In the first place you receive a purely physical effect, namely the eye itself is enchanted by the beauty and other qualities of color. You experience satisfaction and delight, like a gourmet savoring a delicacy. Or the eye is stimulated as the tongue is titillated by a spicy dish. But then it grows calm and cool, like a finger after touching ice. These are physical sensations, limited in duration. They are superficial, too, and leave no lasting impression behind if the soul remains closed. Just as we feel at the touch of ice a sensation of cold, forgotten as soon as the finger becomes warm again, so the physical action of color is forgotten as soon as the eye turns away. On the other hand, as the physical coldness of ice penetrating more deeply, arouses more complex feelings, and indeed a whole chain of psychological experiences, so may also the superficial impression of color develop into an experience.

Wassily Kandinsky, Russian painter*

* Excerpt from Wassily Kandinsky and Franz Marc, editors, *Blaue Reiter Almanac,* New York: Viking, 1974. See illustration, page 58.

I don't make hard and fast rules about using any *single* color because its effects come from so many variables. But I do point out how similar colors are perceived differently according to the influence of background color. When I give the children dark paper to paint on, they notice that the light colors seem to pop out in a way that they did not on their white paper. It is this magical quality of color relationships that gives artists the power to evoke subtle, mysterious, and marvelous sensations of mood and idea.

FEELING AND COLOR

Feelings of attraction and repulsion to certain color combinations may be both practical and cultural. Because white and light colors reflect light and heat, some people in hot climates favor very loud bright colors in their daily surroundings, while others from different cultures are annoyed and irritated by brightly colored walls. Cool colors are relaxing to some and chilling and depressing to others. Legend has it that the Notre Dame football coach Knute Rockne ordered his own team's locker rooms painted red and the ones for the visiting teams painted blue. He theorized that the visitors would relax in their soothing blue rooms, while his own team would become keyed up and ready to win in their red quarters. Whether this was a significant factor in the outcome of the games is questionable. Another study attempted to prove that highway drivers tend to pass red, maroon, cream, and yellow cars more often than they do black, blue, or green ones. Whatever you may conclude about the validity of such studies, they are based on the psychological truth that we respond differently to different colors.

You might not, for example, be conscious of the moods and feelings evoked by colored light, yet it does have strong emotional effects. If you go into a room with a red, blue, or green light bulb instead of a regular one, you may find that the colored bulbs produce a depressed or restless feeling. Conversely, some people install light pink bulbs in their living rooms to create an impression of warmth.

The old cliché "Beauty is in the eye of the beholder" has some bearing here, although we do share many experiences in common and reach mutual agreements about lots of color phenomena. Designers and psychologists have long tried to engineer color schemes to influence our emotional reactions. However, they sometimes provoke responses other than the ones they seek, because of a variation in cultural backgrounds and emotional personalities.

Freedom to choose color is often associated with roles and status. In Western societies, those at the top of a business organization and those at the bottom have the freedom to wear what they like, while

the climbers in between have to dress conservatively in subdued colors. For years, we held a prejudice against pastels in the clothing of adults, perhaps because baby clothes were made in those colors. Pink and baby blue were signs telling the sex of the baby so that one could treat them differently according to their gender. I once made the error of assuming that one of my young students was painting a girl because the figure was pink. Indignantly, she informed me that she was painting a boy. Now I think twice before I comment about the color of anything. Although society has traditionally dressed infants in pastels, children develop early responses to colors and seem to enjoy bright ones.

All of us bring memories and associations to our perceptions of colors, such as a fond recollection of the color of our room when we were very young or the color of the sky during a pleasurable outing. When I see loden green, I am reminded of the colors I saw when I went to a family wedding in Germany. As we drove through the forest around Bremen and Hamburg, the trees and thatched roofs were covered with moss. The people of the region wore clothing of similar green colors.

Sometimes these associations have little to do with the actual colors of a place. For example, one parent in my class decided to suggest her memory of the island of Jamaica in her painting. She tried to capture the warm glowing feeling she had when she was in the plane flying home. She started her painting by trying to represent what she saw from the air. As she worked she began to realize that the green foliage and blue and white of the sea and sand had little to do with what she had felt inside. She wondered why she couldn't get the same feeling from her painting. I suggested to her that perhaps there were other colors that might evoke more clearly the impression she was seeking. Finally, she made a bright, multicolored mixture of shapes and textures that began to represent the excitement she felt about the place by creating a dynamic visual rhythm. The overlapping layers created mixed colors and textures that suggested an environment of rare flowers, brightly colored clothing, and carnival music. There was no one scene that could have captured all of these aspects at the same time. The personal subjective dimension of the piece would have been diminished if she had used color only naturalistically.

Your Project: Suggesting a Word, Mood, or Place Through Color

When you were discovering ways of using your brush and colors in the last project, you probably got certain kinds of feelings from your

results in paint. For example, you might have felt confusion, exhilaration, harmony, or discord. Now we want to think of creating those effects in a purposeful way. Last time we were interested in the techniques of getting the paint on paper without self-consciousness. Now we're seeking awareness of how mood is created by combinations of colors and brush strokes. Here you might also examine reproductions of paintings to see how the use of specific colors and strokes contributed to the mood of the work.

This time, think of a word, place, or feeling that you associate with a particular color or color combination or start laying down the colors and see what they suggest. If you look through your last project and find a section of it that suggests a strong sensation, you might want to enlarge upon it as a beginning for this one. There are several approaches you can take to start this exercise. Each person can find a way most suited to his or her personality. Remember that much invention comes from a willingness to suspend preconceptions; respond to the medium, and let ideas come to you.

No matter how you start, remember that the initial decision-making process is not a final one. Once you put down a color and it doesn't do what you wanted it to, or calls up a different feeling, you might consider changing direction. You have choices and some control. It's important to leave yourself open to new ideas and feelings. Keep the paper and carry it through as far as you can, or else let it dry and put it aside to look at later. If you are dissatisfied at the beginning, you have to realize that it's within your power to make it change, and that this is a learning experience. You can always change the colors and never need to destroy a painting. If you can't get it to please you, you can recycle it into a collage painting (see Chapter 13).

These color experiments are like sketches because they can be both a means or an end in themselves. As a means of learning the color language they become tools. However, they may very well become complete statements. When experienced painters make experimental sketches to keep refreshing themselves and renewing their vision, these pieces become more than textbook exercises or disciplines and are generators of new ideas. You can think of these as warmups to stretch your imagination as well as to gain further control over your tools and materials.

Your Studio Experiment

1. Start by covering the entire paper with a single or even two or three colors that recall a place or experience. You can either start with the paint first and then try to respond to it, or start with the idea first. Make this first coat of paint rather thin.

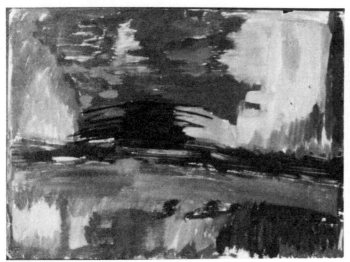
Adult's mood painting. (See Plate 7.)

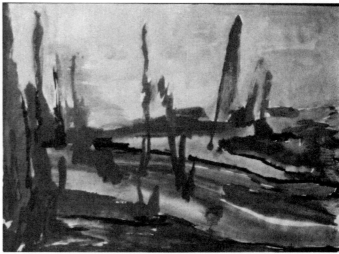
Adult's place painting. (See Plate 8.)

Try to see your color as a field instead of a shape, or as an atmosphere instead of an object. For example, if you see a green field you may have associations such as a ground for flowers growing, woods or mountains, the sky before a storm, a lake or ocean. Ask yourself, what time of year is it? What time of day?

2. Brush in gestural strokes on top of the background coat that activate your field with the attitude or energy of the place. Try not to see these masses of color as shapes but as directional marks. You can discover as you work that the brush strokes as well as the color create different kinds of movements, fast or slow, relaxed or excited. They set a sense of what is happening there and become actors on the stage of the first background coat. For example, one parent laid in a first coat of green, a second coat of multicolored dabs and dots to suggest a field of flowers, and finally brushed a black and red slash 'across the paper to record where someone fell, got hurt, and interrupted the picnic.

If you find any other elements that you want to add, feel free to do it. The first two steps can be ends in themselves, or stepping stones to representing more complex ideas.

THINKING ABOUT WHAT YOU'VE DONE

How paint texture affects color
Perhaps you've already noticed that your paint changes color when it dries. When it is wet and shiny, or has *gloss*, the light reflections give it a sparkle and white highlights. When it dries it becomes *matte*, or a flat, less reflective paint surface. Some painters find that gloss paint lessens the intensity of their color because of these reflections,

while others prefer it. You might notice how paint texture influences color the next time you go into a room painted with a gloss paint and then into another one painted with a flat wall paint. While you are in these rooms also be aware of how the light appears to change the color on each wall according to its angle in relation to the light source.

You may also have observed that a thin *wash* of color gives a feeling of transparency like a veil or atmosphere while a thickly textured *impasto* creates a sensation of solidity and weight. When you use your poster colors thinly, the white of your paper shows through the paint and gives a luminosity to the color. You can see this most obviously when you put the two textures together side by side, the wash next to the impasto. The color of your paper influences what your painted colors will look like. If you have started painting on the backs of tan paper bags or have used any other off-white color, your results will be different than if you had used white paper. In order to avoid letting the color of your paper dictate your results, you may want to paint in white areas. As you practice, you can find out how to make textures with paint or create illusions of texture.

Arshile Gorky, American. *Water of the Flowery Mill,* 1944. Oil on canvas. 42½″ × 48¾″. (See Plate 13.)

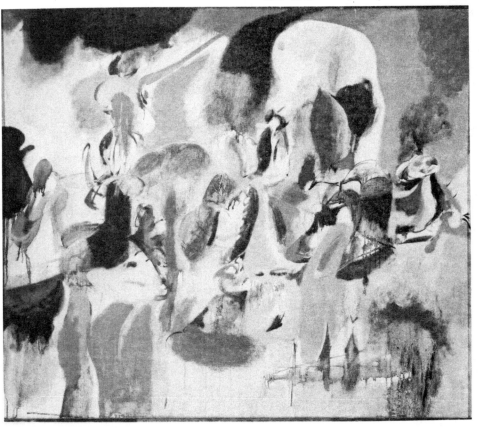

MAKING COLORS WORK TOGETHER

If you feel a sense of pleasure or even distaste for your painting, you may be experiencing the joint effect of two or more colors in relation to each other. Popular color tests may state that if you like red, for example, your personality is dynamic or temperamental; ignore this critical element of color relationships. Moreover, as we mentioned before, no single color has the same universal emotional, visual, and symbolic meanings for everyone, and colors are tied to the shapes they are part of. When I have shown a reproduction of El Greco's *View of Toledo* in my workshops (see illustration), many find the sky ominous. Yet one four-year-old boy remarked with glee that he liked that painting. He thought it looked like thunder and lightning in the sky! Similar colors can be used to evoke different qualities of mood and place.

We can think of color composition as something like a melody in music, an arrangement or succession of notes or colors. Popular opinion often considers harmonious colors to be combinations of ones that are closely similar so that the colors meet without sharp contrasts between them (for example, the warm colors of red, orange, and yellow together or combinations of blues and greens). However, if you think of the green holly bush with red berries, you realize that harmony can be created with contrasting colors as well, by varying their proportions in a composition. Harmony can be made with balances of color arranged by area and position to make an agreeable result. This feeling of harmony tends to give us a wide range of agreeable, positive feelings that are rarely upsetting or shocking.

A very large part of our reaction to color may also be culturally learned, for we see that our children, who haven't yet learned these negative associations, use all colors and combinations with enthusiasm. A friend's child brought home a painting that the mother greatly admired for its attractive color combinations. When Mom exclaimed, "Oh, it's so pretty," her daughter burst into tears—"It's not pretty. I wanted it to be ugly."

Contrast: Contrast makes colors stand apart from each other so that we clearly see differences between them. For example, when one person in a group is wearing red and everyone else is in gray flannel, that one in red stands out sharply. If you plan a meal using contrasting colors of foods, such as red meat, a green vegetable, and white potatoes, each food seems more distinctive, and you may feel less inclined to decorate the dishes with garnishes. This practice of aesthetic meal arrangement using contrasts of color, texture, and shapes is often carried to levels of extreme precision in some countries, for instance, Japan.

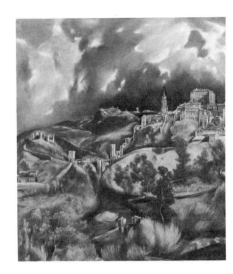

El Greco (Domenicos Theotocopou-los), Spanish. *View of Toledo*, c. 1604–14. Oil on canvas. 47¾" × 42¾". (See Plate 10.)

Color contrasts give a painting a feeling of change and visual movement. It's exciting because the contrasts create visual vibrations. The basic color contrasts are those between light and dark and warm and cool. Although young children understand the first concept of light and dark as day and night, I don't try to conceptualize these ideas of contrasting colors to them.

Warm colors are those that approach red-orange, and cool ones are those that approach blue and green. Yellow can be either, depending on whether it tends toward a greenish direction or an orange one. By juxtaposing or contrasting warm and cool combinations, you can evoke personal subjective sensations as well as ones that others can agree are naturalistic. The next time you look outdoors at a landscape, you might notice how cool and warm colors appear in nature and also how they constantly change.

You can make a third kind of contrast by using *complementary colors*, or those that are most unlike each other (or opposite each other on the color wheel* or scale). Examples of these are red and green, yellow and purple, and orange and blue. This kind of contrast is more difficult for beginners to control for specific effects, but gives visually exciting results. Years ago, I can remember sitting on a green sofa in my red bathrobe when all of a sudden out of the corner of my eye I realized that the red and green looked as if they were jumping back and forth. It was a disturbing feeling, because I was trying to read and couldn't concentrate on the printed page in front of me.

* A color wheel is a circular diagram of the relationships of colors to each other and is sometimes referred to by artists when they are mixing pigments and designing color compositions. You cannot merely choose colors from the wheel and expect to get harmonious results because elements such as size, shape, position, lightness and darkness, and others all determine the specific total effect of the work.

The contrasting colors seemed to vibrate. I had to move to another chair of a different color in order to continue reading.

Further Experiments with Color Relationships
1. As you continue to paint trying different color relationships, you might try varying the area of each color in size, to change their relationship to each other. Again you might think of the holly bush with tiny spots of red against the mass of green foliage and compare it to the full-blooming poinsettia plant with lots of large red petals and fewer green leaves than the bush.

2. If you paint the background coat and make marks on top of it with all warm colors (or all cool ones) and then duplicate the arrangement using combinations of warm and cool colors, you can compare for yourself the different qualities of mood and sensation that are possible. Some combinations will appear to jump off and move toward you while others will appear to remain static and calm, holding their positions or sinking into the background. Next try reversing the color you first used for the background with the one you used for the second coat of gestural brush marks, and compare the difference.

YOUNG BEGINNERS' PAINTING

Very young beginners are continuing to paint as they did in the first session, very involved in moving the paint around and making colors change. I remind them of the process of washing and wiping brushes, and at a moment when I will not be interrupting their concentration, I help them to see what is happening on their papers.

However, most inexperienced older children will enjoy using brush and paint as you have been doing, and making similar discoveries. Encourage them to mix color and try different brush strokes in their early paintings. Children who are a little older may need to focus their ideas and thoughts on special themes while working. They like to paint their personal environment and experiences. If they are more involved with drawing objects when you want them to think about color, I would not intrude or break their concentration or attempt to push adult concepts onto their work. They will probably become more interested in the uses of color at a later time.

TIPS FOR GUIDING YOUNG BEGINNERS

WHEN IS ENOUGH ENOUGH?
If they make a decision to stop painting out of a sense of completion (even though there are still great areas of unpainted spaces on the

paper), I don't try to extend the painting if they have made a serious commitment to the work. However, if anyone has stopped out of restlessness or because he or she has merely run out of ideas, I try to present new possibilities. Often giving the children a second, smaller brush to make different marks will be enough incentive for them to continue painting.

Deciding whether to remotivate or let them stop can be difficult for you at the beginning. You can make the mistake of dwelling on or trying to push the activity so long that it becomes unpleasant. If that happens, your child may want to stop painting altogether.

One day when the three-year-olds were talking about painting buildings, Stacy announced that she was painting the museum. She made a large black line that went around her whole paper. Then she made a few lines inside it with other colors. Finally, she took a brush-

Children's paintings. Although skill may increase from week to week, it is not always evident in people's work. Much depends on what is happening in the rest of their lives. The picture top right reflects the exuberant energy Julie felt when she painted on her fourth birthday. The following week (lower right), she had a cold and was tired and listless. Three-year-old Cindy (top left) loved painting and occasionally got a little paint on her hands and face. After someone scolded her for being messy, her determination to be neat made her unable to work freely (lower left).

ful of black paint saying, "It's nighttime in the museum," and proceeded to paint the area inside of the line all black. I asked, "Are you going to put some colors outside your black shape?" "No, I want it white." She was feeling very good and strong about herself for painting a whole museum as she announced she was finished. She had created an entire world within her space.

If she had been older, I might have tried to help her develop the painting further. However, to urge her to work longer on a painting that she was so obviously proud of finishing would have been unkind and pointless. If I had asked her to explain or justify why she painted anything the way she did, she might not have been able to express her reason in words (nor should she have to). There's no reason to have a logical explanation for every paint stroke. To start to reason with a three-year-old about dark and light colors or night and day would be confusing for them, frustrating for you, and would detract from the learning process.

THE IMPORTANCE OF PRIVACY IN THE STUDIO

If anyone becomes very involved with using only one color, I leave him or her alone and allow him or her to explore without interruption. When Janie was making an all-red painting with white shapes in between her brush strokes, Ann looked over and announced to me, "She's only using red." I replied, "That's fine. That's the way she wants it to be." Then Janie, feeling an implied criticism from Ann, noticed she had only used red and decided to use yellow to make some orange. However, her concentration had been broken and she stopped painting soon afterward.

Perhaps when you were a child you kept a diary with a lock and key. You could write anything you wanted because you hid it away from the judgment of others. No one could criticize your grammar or lack of ideas, or compare you to other writers. You didn't think about whether or not you were a writer, so you wrote every day because it was a secret pleasure and freedom. Years later, even though you may never have become a professional writer, you had a splendid chronicle of past experiences and impressions. You could see how you changed as you grew up.

For most people, that freedom was sadly lacking with studio work. We couldn't sculpt and paint in private easily. I remember drawing hunched over my work with my arms around it so no one would see what I had done until I was ready to show it. How our lives might have been changed if we'd been given blank drawing books with locks and keys, and a little supportive guidance! Painting and drawing might have become as much a part of our daily communication as words are now.

Plate 1—Child's nighttime painting.

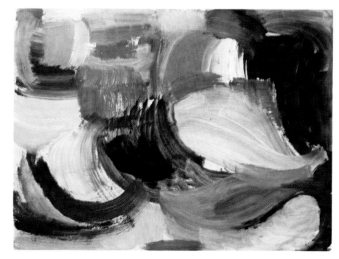

Plate 2—Adult's brush stroke painting.

Plate 3—Lisa's turkey.

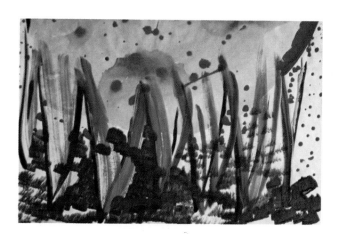

Plate 4—Adult's brush stroke painting.

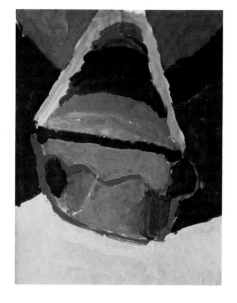

Plate 5—Joy's shape painting.

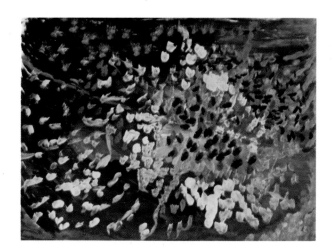

Plate 6—Adult's brush stroke painting.

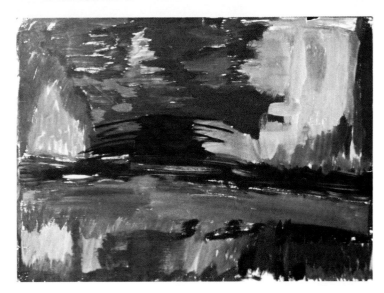

Plate 7—Adult's mood painting.

Plate 8—Adult's place painting.

Plate 9—Joanna's painting.

Plate 10—El Greco, *View of Toledo.*

Plate 11—Claude Monet, *Morning on the Seine near Giverny.*

Plate 12—Pierre Bonnard, *The Terrace at Vernon.*

Plate 13—Arshile Gorky, *Water of the Flowery Mill.*

Plate 14—John Trumbull, *The Sortie Made by the Garrison of Gibraltar.*

Plate 15—Thomas Cole, *A View Near Tivoli (Morning).*

Plate 16—John H. Twachtman, *Arques-La-Bataille.*

Plate 17—Child's painting.

Plate 18—Child's painting.

Plate 19—Children's "Purple Day" paintings.

Plate 20—Mablen Jones, *In the Clouds.*

Plate 21—Georges-Pierre Seurat, *A Sunday Afternoon at the Grande Jatte.*

Plate 22—Adult's Experiment #1.

Plate 23—Adult's Experiment #2.

Plate 24—Adult's Experiment #3.

Plate 25—Betty Blayton, *Concentrated Energies.*

Plate 26—Claude Monet, *Path in the Ile Saint-Martin, Vertheuil.*

Plate 27—Adult's tissue-paper collage.

Plate 28—Adult's tissue-paper collage.

Plate 29—Maurice Prendergast,
Piazza di San Marco.

Plate 30—Paul Gauguin,
A Farm in Brittany.

Plate 31—Hans Hofmann, *Rhapsody.*

Plate 32—Marc Chagall, *I and the Village.*

Plate 33—Child's painting.

Plate 34—Adult's shape painting.

Plate 35—Adult's shape painting.

Plate 36—Ferdowsi, *Ardashir and the Slave Girl Gulnar* from *Shah-nameh*.

Plate 37—Adult's patterned-paper collage.

Plate 38—Adult's patterned-paper collage.

Plate 39—Yoshu Chikanobu, *Enjoying Cherry Blossom Viewing at Ueno.*

Plate 40—Claude Monet, *Terrace at Sainte Adresse.*

Plate 41

Plate 42

Plate 43

Plate 44—Adult's collage painting.

Plate 45—Adult's collage painting.

Plate 46—Romare Bearden, *The Woodshed.*

Plate 47—Japanese Suit of Armor, c. 1550.

Plate 48—Headdress (Temes Mbalmbal).

Plate 49—Ferdowsi, *Tahmuras Defeats the Divs* (detail).

TALKING ABOUT THEIR WORK

After hearing my ideas, a deeply concerned parent told me that she realized that she had done the wrong thing with her young child, who loved to draw. In an effort to be helpful she became too critical, and her child had stopped drawing altogether. I responded by saying "She is only three years old. How wonderful that you understand and now can help her to start drawing again."

Everybody is intimidated about making marks on paper or marks on canvas. . . . Freedom should be first before judgment and self-criticism.

David Smith, American sculptor*

Although children soon learn that winter is cold and summer is hot, if you ask three- or four-year-olds what colors look warm and cool, they probably won't understand you. However, some might guess or parrot something they've heard, without really making a connection between the word and the color. Later you can start to point out how things stand out from each other in their daily experience because of contrast. Always make visual relationships concrete by pointing out colors in daily life rather than talking about abstract ideas like "contrast." Encourage them to examine specific details of what they are looking at and only talk about what they can see.

* Excerpt from talk presented at the National Committee on Art Education, The Museum of Modern Art, New York, May 1960.

David Smith, American. *Untitled,* 1957. Ink on paper. 17" × 22".

Every week I read aloud *Little Blue and Little Yellow*, a children's story by Leo Lionni about colors and shapes. Many of the children don't really understand the ideas until they have painted for a while. The book helps illustrate a number of concepts about simple shapes, changes of color, and visual movement in a way that's understandable to two-and-a-half-year-olds. It relates ideas of color families to daily routines common to the life of a young child. However, they have to create color changes on their own papers to appreciate how they happen.

As you go along, I hope you realize they are making their own color stories. When they cover one color with another and one peeks out, it looks as if they are playing hide-and-seek, a game they are familiar with at a very young age.

I accept everyone's work as a painting and not as a test of their sense of reality or ability to talk about it. Remember yourselves that a painting is not a mere illustration of experience, it is an invention of experience. Stacy created a color story of her own about painting the museum. These works are not (nor should you require them to be) literal descriptions of how things are in the physical and intellectual world. I don't analyze or interpret these as measuring sticks of their intellectual or emotional states, but approach them from an aesthetic point of view. That is, I try to get the children to appreciate the sensory qualities of their marks on the paper and to connect them to other events in their worlds.

TASTE: DECIDING WHAT YOU LIKE

THREE-YEAR-OLD JOEY: This part is ugly!
ME: You think this is an ugly color?
JOEY: Yes.
ME: Is that the way you want it to be?
JOEY: Yes, I like it that way!

When someone asked me, "When do you start to teach which colors are ugly together?" I asked in reply, "Ugly according to whose taste?" Most of you have heard that something is in good or poor taste. Those familiar with history know that taste is culturally determined or relative to your own time and place. It is subject to change.

Taste is simply the tasting of colors and forms and making choices, much as you do with food and drink. You can learn a personal sense of taste, a feeling of what is fitting and pleasing to you, through direct tasting, so that no experts or rules can convince you to buy what you have found you dislike.

You can also learn to enjoy new tastes by trying out wider ranges of possibilities. Although you may read that certain tastes are con-

sidered to be of the highest or "classic" quality, when you try them out for yourself you may still be repulsed by them. In short, everyone can only learn to make personal discriminations between the sensory qualities of things by tasting them themselves. You can't go just by the rules. The greatest artists have the courage to break the rules of taste in order to make personal aesthetic statements. I try to expand everyone's tasting experiences, and not restrict them by making aesthetic rules. I always try to be careful how I say things to children so that they don't feel I am making rules.

Some adults don't realize how literally youngsters interpret their words. For example, four-year-old Joanna loved to paint masses of color and always covered her whole paper completely. One day the peculiar way she suddenly stopped her painting (leaving one tiny spot in the corner) aroused my curiosity. It was as if, when she had almost finished the last corner, she remembered something else she had to do and put down her brush. I asked her, "Are you really finished with your painting?" She answered, "I am finished. My father says that to do a good painting you always have to leave some white." "Well," I replied, "some people think that a painting is good when it has colors all over it. But if you're finished and that's the way you want it to be, that's your choice. You don't have to cover the whole page. You can leave white spaces if you want, for they are shapes also."

Meanwhile, her father across the room was putting down colors on his paper, one here and another there, spread widely apart. I went over to him and asked "Have you ever tried to do a painting by covering your whole paper with colors?" "I liked to do that when I was a kid," he responded.

I told him, "I guess I'm a big kid, because sometimes I like to cover the whole surface when I'm painting." He took my cue and that day he covered his whole paper. He realized that he had inhibited Joanna's free choice in her painting and that she had left that white spot in the corner to please him. After Joanna saw her daddy change his mind and cover his whole paper, she left white spaces in her work when and where she wanted to leave them.

There are many young children who love to cover every inch of their painting as they become deeply involved. It's most unusual for them to think about leaving parts of the white paper free of color to make special shapes. However, if you observe them working you will notice that they do some very unusual things once they become more visually aware.

As Ben worked on a nighttime painting, he covered part of his paper with black. When he finished, he noticed that there were tiny white shapes where the white of the paper showed through. He liked them and decided to add more white paint on top of the white spaces,

Four-year-old Joanna purposefully left white places in this painting. (See Plate 9.)

and also put white on top of the black paint to make more of them. I was surprised and pleased to see him make this deliberate choice. It was unusual for any beginner, let alone a four-and-a-half-year-old, to be so conscious of the spaces he hadn't covered with paint.

It isn't necessary to cover your entire paper with color, although I encourage older beginners to do it when they start a painting so that they will paint white purposefully as a color and shape, rather than having it as a leftover byproduct of areas they forgot or didn't know what to do with. You might examine the differences between the look of paint texture and paper texture as you work. An experienced painter has a basis for choosing when to use the paper as a white shape and when to paint white on. I certainly don't mean that leaving your paper with unpainted areas is bad, but it's important to be aware of what these do to your design.

When children are around six or seven years old, they usually paint outdoor scenes leaving a large white area between the sky at the very top of their paper and the ground at the very bottom. Even though you could go to a window and point out how the sky appears to bump the ground on the horizon, it would probably not affect their way of painting (unless you insisted). Children of these ages paint things as they know them to be and not according to adult concepts. Although you could mention that a painting is never the real thing and that you can make it any way you want it to be, it would seem most important to allow each person to express his/her own level of development. If the same child were given a special subject to paint, such as "an inside place I like to visit," or a collage painting of a fantastic creature in a strange land, or how the world looks from a spaceship—the patterns seen from high up in the air— they might be more likely to cover the whole paper.

There are no set rules of design in these workshops. I think that you can learn to make choices in these projects that represent your own ideas and feelings.

All the rules discovered in earlier art and those to be discovered later—which art historians value too highly—are not general rules: they do not lead to art. If I know the craft of carpentry, I will always be able to make a table. But one who knows the supposed rules of painting will never be sure of creating a work of art.

These supposed rules, which will soon lead to a "thorough base" in painting, are merely the recognition of the inner effect of various methods and their combination. But there is no rule by which one can arrive at their application of effective form and the combination of particular methods precisely necessary in a specific case. . . .

<div align="right">Wassily Kandinsky, Russian painter*</div>

STAGES OF STUDIO DEVELOPMENT

What distinguishes the studio work of young beginners from that of older and more experienced students is that the youngsters' pieces are records of physical activity, exploratory learning, and expressions of feeling instead of controlled statements. The work changes as new experiences are encountered and as beginners gain skills with the medium. Although certain aspects of personality continue in the work, one's painting or sculpture may not necessarily be better aesthetically from year to year. Development of skills rarely follows a steady course for people of any age. Chronological and developmental age are not simultaneous.

Even though I recognize that there are stages that everyone inevitably goes through as they use studio materials, experience and the quality of guidance are key factors. Age is an element which also cannot be ignored. However, being older doesn't mean doing better.

My friend Annie, who is now in her mid-seventies, began painting recently when someone gave her a paint set. I was explaining to her the stages children go through when they start to mix colors. They mix one color on top of another so that all mix together. "Oh I did the same thing when I was starting to paint. My colors were so muddy I just didn't know what to do," she interjected. However, because she was very experienced in sewing, crewel, and embroidery, Annie could carry over some visual and manual experiences with craft materials to the studio. Consequently she went through all the stages the children do, only more quickly.

Sometimes people are fascinated by a new tool or material and get

* Excerpt from Wassily Kandinsky and Franz Marc, editors, *Blaue Reiter Almanac*. See illustration, page 58.

caught up experimenting and testing it for its special qualities. Four-and-a-half-year-old Jeff sat down to paint and heard another child ask if she could add some collage material to her painting. He liked that idea and went to fetch something for his painting also. He took a small piece of sponge rubber from the collage tray and put it on top of some wet paint on his paper so that it would stick there. At that point, he lost interest in the paper as a whole as he became intrigued by the absorbent qualities of the sponge. Jeff now painted over and over on the sponge. He always enjoyed the way wet paint spread over his papers, and now the process of the paint disappearing into the sponge was quite miraculous. At the end of the class Jeff was still excited by his experiment and eager to return to the workshop next week. Fortunately, his mother was more interested in a contented, stimulated son than a picture of a recognizable image.

Experimenting with intriguing discoveries is hardly limited to children. I know adults who have become obsessed with using a new food processor to the extent that for a while, their dinners become grand spreads of all-chopped foods.

Most very young children's work is full of experiments and beautiful accidents that they don't know how to repeat. They make marvelous movements with startling effects they are not aware of nor find necessary to repeat. This doesn't mean they don't value their work. They like it purely because they've *done* it, not because of how it looks. Despite its apparent similarity with some contemporary abstract painting, beginners' work still lacks a purposeful use of skills, aesthetic dynamics, and a focus necessary for mature visual statements.

Six-year-old Joy's painting at the beginning of the semester.

Joy's Halloween painting, after five weeks of class.

Joy's shape painting. This work came late in the semester after she no longer felt the need to explain her works to adults. (See Plate 5.)

All art demonstrates
constant change
in seeing and feeling.

To design is
to plan and to organize, to order, to relate and to control.

In short it embraces
all means opposing disorder and accident.
Therefore it signifies
a human need
and qualifies man's
thinking and doing.

Josef Albers, American artist (born in Germany)*

* From Josef Albers and Francois Bucher, *Despite Straight Lines*, Cambridge, Mass.: MIT Press, 1977. See illustration, page 208.

SIX

Experiments in Mixing Colors

YOU MAY HAVE DISCOVERED in the last project that your end results had little or no relationship to your desired effects. Perhaps you used a lot of intense colors to create a mood of excitement yet the impression was drab, even though you did not mix or modify your colors. As I pointed out in the last chapter, it is possible that the variables of size and placement of colors caused this effect. It can be gratifying, exciting, intriguing, and sometimes frustrating, to find out through painting how colors affect one another and how they affect you. Doing paintings that are based on the following experiments with mixing colors will help you achieve some control with the paint.

If you painted colors you remembered about a place but found that they didn't seem to capture it, it might have been because you were unaware of the quality of light which transformed the colors. Qualities of light in the atmosphere sometimes more easily escape notice than the colors of objects themselves. Yet, when we try to use color to describe a place and time, the illumination is a most important consideration. The more you modulate your colors to accommodate the wide range of different kinds of light and climatic conditions, the greater the number of situations you may be able to represent.

Responding to color means becoming more aware of nuances of what at first glance may appear obvious. For example, when you glance at a field of grass you may automatically think of an expanse of green. However, when you look closely you may see that it is a field of yellow, yellow-green, blue, blue-green, gray-green, purple, and so on. Expanses of single colors rarely exist in nature, for each surface and texture is colored by light and shadow in different ways.

These modulated colors are often muted into colored grays (or grayed colors) that we experience as subtle feelings without recognizing them. This often happens when you step outside on a cold, gray day and automatically withdraw under your umbrella or back into the collar of your overcoat. Once you become aware of the subtle

Georges-Pierre Seurat, French. *A Sunday Afternoon at the Grande Jatte,* 1885. Oil on canvas. 27¾″ × 41″. (See Plate 21.)

John H. Twachtman, American. *Arques-La-Bataille,* 1885. Oil on canvas. 60″ × 78⅞″. (See Plate 16.)

colored grays in the atmosphere, however, you will see a greater range of colors than you ever noticed before. You are most likely to attend to these colors under pleasant conditions, especially at dawn before the sun appears on the horizon, when exquisitely grayed colors of orange and pink glow in the sky. Walking in warm mist can be particularly enjoyable when you look for the fine shades and tints of blues and purples or whatever color predominates at that time of day.

One mother came back to class the next week after doing these following exercises and reported, "You'll never know what an effect making these colors had on me. When I left the museum it was raining. Instead of ducking my head down as usual, I looked up, and was amazed to see the colors of things reflected through the misty wet air. I never noticed them before."

When the Impressionist painters first represented colored shadows of things, visitors at their exhibitions became upset because popular opinion held that shadows were gray-black and many academic painters depicted them as such.

Most beginners struggle with unwanted colored grays while they are trying to mix other colors, and don't know how they got them. As a result, colored grays sometimes come to be associated with frustration, instead of being seen as colors in their own right that can be controlled and developed further. Learning to use colored grays

John Trumbull, American. *The Sortie Made by the Garrison of Gibraltar,* 1789. Oil on canvas. 70½" × 106". (See Plate 14.)

opens the way to making such interesting effects as iridescence, striking contrasts, and a range of atmospheric conditions.

The first experiment in this project shows you how to deliberately make grayed colors, not only so that you can use them to communicate moods and ideas, but also so that you know how to avoid them when mixing other colors so they don't appear accidentally.

. . . then sometimes, when the artist is working along and free, once in a while there will come this great sense of alarm. As if you have shocked yourself. You combined certain elements in such a way as to work something new and puzzling. *It* ran ahead of you and did this to you.

Helen Frankenthaler, American painter*

MIXING ON THE PAPER

If you put various pools of paint all over your paper as you work, you can use these puddles as a palette. You might also leave samples of colored grays in case you want to compare various mixtures to construct a mood image as a painting in itself.

You also use the paper for mixing colors while you paint in front of young children so they will copy you. If very young people were to mix colors on a palette, they might become so intrigued with the process there that the paint might not get to their papers.

* Excerpt from Eleanor Munro, *Originals: American Women Artists.* See illustration, page 61.

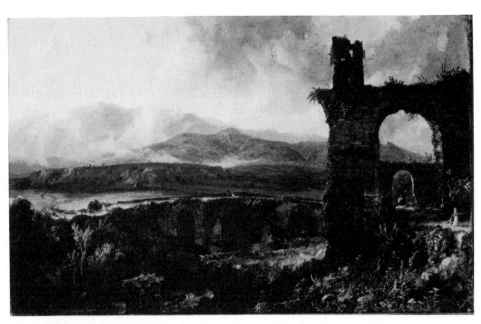

Thomas Cole, American. *A View near Tivoli (Morning)*, 1832. Oil on canvas. 14¾" × 23⅛". (See Plate 15.)

When you feel more daring and confident, and you want to mix a larger quantity of a single color, spoon the paint out of one caster cup into a small dish with your brush, a tongue depressor, or a small plastic spoon. I avoid pouring it from either the dispenser jar or caster cup, because it's hard to control the exact amount poured, and if I want to duplicate that mixture again, it will be difficult to judge the quantity of each color. Young children may also copy your pouring process, and this invites accidents.

HOW TO MIX PAINT

Although you can darken your mixtures by brushing darker colors from your caster cups onto paint already on your paper, you make lighter ones through a different process. To get light-colored mixtures, first start with a larger quantity of the light color and then add very small quantities of the darker ones until you get the mixture you want. If you start with a dark color and add a light one to it you will have to add so much more paint to get a light color that you may make more than you need for a single painting. If you tried to mix a light color but started with a dark one first, let the paint dry and begin again or work in another area of your paper.

It can be very frustrating to learn through trial and error. For instance, a friend of mine entered her first course in painting along with much more experienced painters. Her teacher assumed that most of them already knew principles of color mixing. His only in-

structions were, "Take out the paint and just start. It will be fun." She decided to mix a very light pink but began with a large quantity of red and a tiny bit of white. As she kept adding more and more white to the mixing dish, it just seemed that the red kept eating it up without changing. So she continued to add vast portions of the white. By the time she got the pink she originally wanted, she had used up a great amount of white and had more pink than she could possibly use. She felt mortified and discouraged and never went back to the class.

Your Project: Mixing Colors

The same subject themes you used in the last project, that is, suggesting a mood or place or interpreting the feeling conveyed by a particular word (like *misty, somber, strange,* or any other that comes into your head) can be used as a motivation for doing these paintings. In the first one you will be mixing colored grays.

I suggest that you work with patches of color instead of lines enclosing shapes, so that you can blend mixtures in a field, and use brush strokes on top of the first layer the way you did last time. When you try these different color combinations, remember how you saw in your last two projects that the brush stroke, texture, density, and blending of paint affect the qualities the colors suggest.

All of these experiments can be done in one session when adults in my classes are working alone. However, if you are also supervising young beginners, plan to spend several sessions on them. Try number one the first time and then in following workshops do the other three. If you want to try these out quickly, you might work on half-sized papers for numbers two, three, and four. However, the subtleties of the different effects will be more noticeable on the larger size sheets (18 by 24 inches). All the color experiments are for adults and experienced older children, not young beginners. Even older children just may not be interested in this project unless it is presented by someone who is excited about these issues themselves, and can also draw analogies back to the everyday lives of their students.

If you are doing an experiment with color and begin to feel the painting take over because you have an idea or feeling—let it flow into the painting and continue more precise experimentation another time.

Adults' Experiment #1: Mixing Colored Grays. (See Plate 22.)

Experiment #1: Mixing Colored Grays
(for adults or experienced children in junior high school and older)

Use only the four colors (yellow, red, blue, and white) without black in this first exercise. Black and white also make gray, but on a misty day you rarely see pure black. The point of this exercise is to discover the possible varieties of colored grays.

1. Brush blue on your paper. Then add red and brush the two together to make purple.

2. Add yellow to the purple and mix it.

3. Finally, add white and mix again. You've made a colored gray.

The particular colored grays you make will be determined by the quantitites of each pigment you use. See what happens if you add just a little yellow to the purple, and then more of it. Set the second mixture to the side of the first so that you can see the difference between them. Continue to experiment by adding the other colors to each other. Again, set them down in separate areas for comparisons.

THINKING ABOUT WHAT YOU'VE DONE

You will discover that you must have some parts of yellow, red, and blue to gray your colors, even if they are in the form of orange (red and yellow), purple (red and blue), and green (blue and yellow). In other words you are making colored grays by using *complementary colors* (see page 93). Depending on the colors you start with, you may also find that you have arrived at brown before adding the white.

Most adults are surprised at their results when they try this first experiment, because they didn't think of them as colored grays before but as different shades of the colors.

Continue to think of as many varieties of these colors in nature as you can, such as those you see during a rainstorm, on a snowy day or a foggy morning, and make them up. At the same time, continue to use your brush stroke to suggest the attitude or energy of that moment and the textures of the place.

You may have accidentally arrived at some colored grays by putting lots of colored water on your previously mixed colors, because the water is filled with various mixtures from cleaning your brush. However, because there is no way of knowing the amounts of any given color in the water, it will be impossible to control or to duplicate your results.

Experiment #2: Mixing Black and White and One Other Color

1. Choose a color and mix quantities of black and white into it. Add small quantities each time to see the changes step by step. Set out separate color samples on your paper before adding the next addition each time.

Adults' Experiment #2: Mixing Black and White and One Other Color. (A) Adding red to the other colors. (B) Adding blue to the other colors. (C) Adding yellow to the other colors. (See Plate 23.)

2. Take another paper and repeat the procedure with a different color. If you have time, try it with a third color on another sheet.

THINKING ABOUT WHAT YOU'VE DONE

You may have seen that adding black will inevitably gray the color, although adding only white will not. If you want to darken a color without graying it, you will have to add a different dark color instead of black, which we will do in the next experiment. Inexperienced painters often repeat this graying process with black accidentally in an effort to darken their colors, instead of mixing deeper colors into their original ones. They often can't figure out why their colors become grayed instead of darker versions of the original ones.

The first time I did this last experiment myself, I chose yellow to mix with white and black. I'll never forget my excitement when I discovered I could make olive green from these colors. Your own results may vary according to the kind of yellow and black that you use because of different manufacturers' formulas. Some blacks have a bluish tinge, and others have a warmer brown color, and the yellow may be slightly green or orange.

When you were mixing your grays in both of these experiments, you may have noticed that the mixture had either a warm or a cool feeling. If you used a lot of red or orange, it became warm; if you

used blue and green, it became cool; and if you used yellow, it could have gone either way depending on the type of yellow. In addition, you may also have found that adding white to tint a warm color might have cooled it even though you may have added no cool colors.

In the next experiment we're going to see what happens when you want to make a mixture that is very cool or very warm. If in your project in the last chapter you chose to project a cool feeling but also used bright colors, the painting may not have looked the way you wanted it. One solution would have been to use only cool colors. Another would have been to mix cool ones into the warm colors to get a cool result with a wider range of overall color.

Experiment #3: Mixing Warm and Cool Colors

1. Choose a color. Mix it into every other color you mix on your paper. If you have chosen red, what kind of a feeling do you get? Is it warm, cool, or does it vary in different parts of your painting?

2. Do two more paintings, each time mixing a different color into every other color on the papers.

THINKING ABOUT WHAT YOU'VE DONE

You may have discovered that some yellows and reds are warm and others are cool, depending on the manufacturer's formula of the original color.

Do some of your color mixtures appear to advance when they are placed on an area where you have previously set down a color? Recede? If so, were they ones with warm or cool colors predominating?

Experiment #4: Contrasting Unmixed and Grayed Colors

Have you ever noticed how brightly some colors stand out in the muted colors of twilight or on a foggy day, like the bright red or yellow flowers in a garden or traffic and car lights? Master painters, such as El Greco in the "View of Toledo" (see page 93), have often contrasted areas of somber and grayed colors with touches of vivid ones to get effects of visual excitement. Notice how brilliant the yellow-green becomes in contrast to the grayed sky. The Mablen Jones painting illustrated on page 112 contrasts the bright sky with grayed clouds.

Through this next experiment you may be able to get greater control of your color effects by contrasting unmixed colors with areas of colored grays, and shaded and tinted ones, without having complementary colors canceling each other in the eye (called *optical mixing*) and seeming drab.

Adults' Experiment #3: Mixing Warm and Cool Colors. (See Plate 24.)

Mablen Jones, American. *In the Clouds,* 1980. Oil on paper. 41" × 26½". Notice how the relatively small areas of unmixed color become more luminous when contrasted against the large ones of grayed color. (See Plate 20.)

1. Paint a layer of grayed colors on your paper, leaving a few patches of white paper blank.

2. Let it dry for a few minutes.

3. Paint colors straight from the caster cups both on top of the grayed surfaces and also on the white areas (covering the white completely).

4. Now you might try also increasing and decreasing the size of the colored areas in relation to each other on a separate piece of paper to compare the two sets of paintings. What happens when you do this? Does the effect of depth stay the same or do the colors of the two layers of paint appear to move?

5. Put up your paper on a vertical surface in order to examine more thoroughly how the colors function together. What kind of feeling do you find in your response to the colors you have used in your painting?

THINKING ABOUT WHAT YOU'VE DONE

If as you work you have also been observing young children, you will notice how some find consistent enjoyment in energetically moving large amounts of paint around the paper in a carefree manner. Others work in a more thoughtful, careful, decisive way. By now, you have realized your own inclinations in the use of paint—and it's fine to be yourself. But, just as in guiding young children, you allow them to be "themselves" by encouraging them to be flexible and to try things different ways, so you should do the same for yourself in your own work.

The effects you obtain from these experiments of mixing and blending as well as shading and tinting can enable you to express moods, places, and sensations with more control, subtlety, and precision. Another advantage of being able to use mixed colors is that you are more easily able to control the effects of contrasting areas so that they don't play optical tricks on you such as happened in the following story.

Early in this century the manager of a textile mill called on Johannes Itten, a famed color theorist and teacher, to solve a costly color problem. The manager couldn't sell hundreds of yards of tie silk because the black stripe on the red background looked green instead of black. Customers insisted the black stripe was green and refused the material. Itten stopped the black from vibrating with the background color by recommending that a warm, brownish-black yarn replace the previous cool black one to neutralize the green effect.

In the same way, you also can subdue unwanted color effects by adding small amounts of other colors to your mixtures, as well as by tinting them with white and shading them with black.

After you've done these experiments, you might go into a clothing store to look at a rack of gray garments and compare the tremendous variations in colors.

The visual awareness you now have can be applied to other areas of your life. When you take a family color snapshot with your camera, you might try to make your portraits more dynamic by considering how to effectively pose your subjects against a background. For example, if your subject is wearing something bright, you might pick a muted-colored wall as a background. You might even arrange a group according to the colors of their garments.

YOUNGEST BEGINNERS' PAINTINGS

Younger children—aged two to four—will continue to do the same kind of free-flowing expressive painting.

In parent-child classes, I demonstrate these color experiments in front of both the children and adults, although they are meant for the parents. Because the children are there, as I do these, I emphasize a review of the process of putting paint on paper, making colors change, and washing and wiping the brush. At home, you can also review the painting process for them if you have noticed that they still need reminding about washing their brushes. Try to avoid these reminders while they are painting, however. While you are doing these experiments yourself, don't try to explain a lot of ideas about color. If you tell young children, "Paint what you feel," they probably won't know what you mean, because that's what they've been doing all the time.

Youngsters don't understand these color concepts because they see things in broad categories while adults draw finer and finer perceptual discriminations. For example, young beginners struggle to merely sort out the five primary colors but do not immediately see the difference between, say, an orange-red and a blue-red. They may identify pink but not understand its relationship to red and white (see Willy's story, page 77). Inexperienced adults may also perceive colors in general ways. One mother in a beginning workshop felt frustrated when she found that there was no green paint in her caster cup selection. She wanted to depict a scene with a lot of green in it, but she did not immediately remember that the color was made from yellow and blue. She probably would have painted with one green color if it had been there. However, by mixing her own greens she came to an active and operational awareness of dozens of variations of the color even though she had a passive awareness of these before doing the project. She reported excitedly, "I used some of every color on my tray. I never realized that there are so many different greens."

There is no particular age level that will insure any interest or understanding of color concepts if a person has had no contact with these elements. A need to use the information for some personal pleasure or goal can spark interest to some extent. However, people of any age may not be interested in the reasons for, or the aesthetic aims of, these projects unless they have come in contact with people who have inspired their curiosity, and they can experiment in a psychological "safety zone" where they know no one is going to compare or criticize them for their choices or slowness in manual dexterity.

MORE EXPERIENCED BEGINNERS

Children aged five to seven, who have painted for many months, still do not do the color experiments, but they may need the additional challenge of a theme to stimulate their painting. The whole point of a theme or project is to get them into a painting experience, not to choose a subject for them. One theme that I use when children become more experienced and are aware of their colors is "Color Day."

Color Days increase their awareness of how to mix particular colors, and let them discover the range of different variations mixing can present. Before we begin the workshop, I show a reproduction of a painting where the chosen color for that day predominates. On "Purple Day," I collect a variety of purple collage materials, arrange them on a piece of purple or white construction paper on a bulletin board, and set out an arrangement of live flowers in that color (if I'm fortunate enough to get them). Eggplant, purple cabbage, or other

objects will do just as well. I ask them what they have seen that is purple, and they mention lollipops, grapes and grape juice, dresses, shirts, and plums. At home you might even give them some grape juice to drink before class, observing how the color changes if you add water to it, just as when you paint on paper.

I mention how lovely the light purple flowers look sitting next to the dark purple ones, or that the purples look as if they are playing hide-and-seek between the green leaves.

Rearrange the paint caster cups for this project so that the order from the bottom up is: red, blue, white, yellow, and black. See if they notice what you have done and guess why.

Some of the children will inevitably make purple just because the blue and red are now closest to them. Some will not, and I don't push them to do it as long as they are involved in painting. However, when purple first appears on someone's paper I may call attention to it by saying, "Julie, you made purple. It's like some of the flowers. Do you know how you made it?" Someone else joins in, "I made some too. It's purple." Occasionally during the painting session I point out

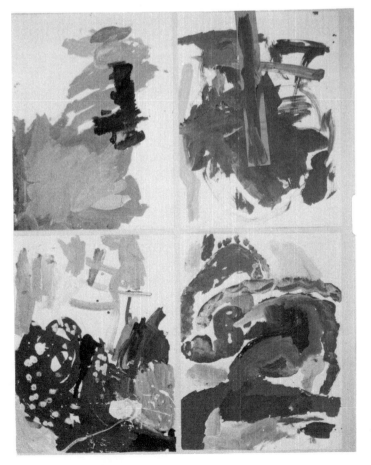

"Purple Day" paintings by children three, four, and five years old. (See Plate 19.)

the different kinds of purples as they appear on the paintings (pinkish, bluish, reddish, dark, and light ones) and help them think about how they made them.

BEGINNING OLDER CHILDREN

School-age children (aged seven through high school) may need more reassurance and encouragement than preschoolers because they are often afraid to be different from their peers and are worried about criticism. Preadolescents become frustrated when they begin to compare their work to realistic representation. The younger the children are, the less they compare themselves to other people, while older ones are looking for the "right" standards to conform to. You may find it more demanding to work with the older age group because of these issues. Whereas the youngest children are delighted and enticed by the sheer pleasure of manipulating the materials, older ones may have to overcome social fears and inhibitions to be able to enjoy the workshop. They may feel as if they are unable to do anything and may be quick to resort to stereotyped imagery. By that age it is possible that they have been judged by adults and peers, and their art work graded on their ability to please others. The first thing for you to do if you want to work with them is to earn their trust by letting them understand that you won't make critical judgments but will help them to learn skills and explore possibilities.

If you and other parents set up a space to do these projects and begin them yourselves, the children are more likely to become curious and interested in joining than if they are asked to participate initially. If adults work at separate tables from the youngsters it helps prevent parents from inadvertently imposing their tastes and keeps youngsters from feeling that they are being supervised. Making a clear understanding that no one has to talk about or show their work unless they want to can make everyone feel more comfortable in experimenting with the mediums.

Please use examples of visual phenomena only from outside sources, such as reproductions of art work or elements of nature, to avoid singling out anyone in the group as superior to the rest. Consciously or unconsciously drawing comparisons between people's work can only inspire rivalry and defensiveness. I have found that Dr. Haim G. Ginott's books *Between Parent and Child* (New York: Macmillan, 1965) and *Between Parent and Teenager* (New York: Macmillan, 1969) are extremely helpful for becoming aware of behavioral issues with elementary school and older children.

It might be best for an inexperienced workshop leader to have beginners of this age start with collage constructions, collages, and collage painting before they attempt painting itself. These mediums will help develop their skills in organizing a visual field and begin to exercise fine hand muscles.

One great issue with this group is that they generally want to draw realistically in their paintings and are often incapable of doing it. Since drawing involves fine hand-eye coordination, it can be frustrating for anyone who has done little fine manual work. The advantage of doing collage projects is that no one can fail at representation because the free-form images can't be judged against any objects or scenes in life. Even if children are working representationally it is preferable that adults do not work this way, so that youngsters will not compare themselves to more experienced beginners and feel inadequate.

If a child gets stuck and says, "I don't like it" or "I can't," "Show me how" or "Do it for me," talk with him or her about how something appears by asking questions and looking at things together.

TIPS FOR GUIDING BEGINNERS

If you are talking about color or any other artistic process, do not persist with any line of questioning designed to elicit the "correct" answer. It should be a conversation, not a test.

Try out the mixtures of any chosen color in advance, so that you know if it is possible to mix that color with the paints you are using before you start collecting any visual aids. Depending on what brand of poster colors you have purchased, you may be unable to mix certain colors if the original ones are already mixed. For example, if you have a greenish-yellow and a bluish-red, you may not be able to make a bright orange.

When a child announces he or she is finished without having done very much, I attempt to keep him or her involved by offering a different-sized brush. Later, to encourage more involvement, I may bring out construction paper strips and small shapes. I ask if the child would like to add some colored shapes to his painting, and suggest tearing shapes to put down on top of the wet paint. I explain that the paint will act like glue or paste and make the shape stick onto the painting surface. I may at some time present the possibility of painting smaller shapes on top of the added ones, or putting paint around the paper shapes to make the same color with paint as is on the construction paper. It becomes another way of changing colors and shapes, and an additional motivation for continuing to work.

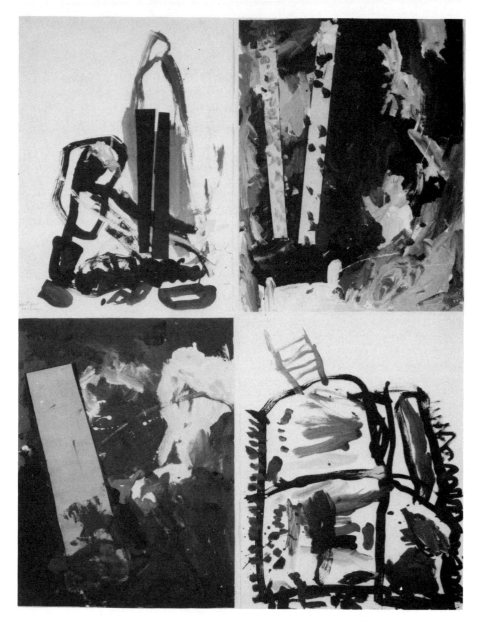

Children's paintings with cut paper. Offering young beginners paper strips for their paintings calls attention to lines as well as providing additional motivation to continue working. Some may not use the paper strips, preferring to paint in their own.

People may have very strong aesthetic tastes at any age. One day I decided to have a "Green Day" and set up their trays without red paint so that they would find a variety of ways to mix greens without the temptation to use red. Three-year-old Suzy just sat and became more and more upset. I bent down beside her quietly trying to find out what the problem was and attempting to get her into her painting. She became nonverbal and started to shake. "Did you sleep well?" "Yes." "Did you have a good breakfast?" "Yes." She looked ill and did very little painting. Later she went on to make two collages and worked in clay. By the time she left the clay table she was her

cheery self. As she walked out the door I noticed that she had made two red collages. When I looked in her painting folder I found that she always used a lot of red and orange and that when there was a choice of colored paper to paint on—her choice was red.

I called up her mother to discuss the incident and she mentioned that the day before class she and Suzy had been at Rockefeller Center where they saw the tulip plants before they had bloomed. As they looked at the masses of green foliage Suzy told her that she hated the color green.

That experience convinced me of several things: first, that I might rearrange the order of paint on a tray to make children aware of possibilities, but that I should not remove any color from a young child's tray. I now place red farthest away at the back of the tray. Second, I found that often a very verbal child may become nonverbal when confronted with a problem he/she never expected. If Suzy had told me she wanted red paint, I would have given it to her immediately, but she didn't know she could have it and was afraid to ask.

Light Green *
Light green is ugly I hate it I
hate it. All the colors do;
regular green, pink, orange,
purple, red, blue, black.
If you see light green step on it.
 Anthony Bonina, 5th grade

Everyone may have preferences and dislikes that change with experience. If you as a leader impose your color tastes and associations on students, they may not explore a wide range of colors for themselves. Sometimes youngsters don't have exposure to many colors, because we adults naturally choose our favorite combinations at home in decorating and clothing combinations and they have limited experience with the world outside. They will sometimes accept your colors as their own preferences.

For example, young Johnny usually came to the studio wearing his purple shirt. He liked me to notice it and to mention its color, after which he would say, "Purple is my favorite color." On a special occasion, his seven-year-old sister, Elizabeth, who had formerly been in my class, joined the workshop and did a purple painting. I was intrigued by the fact that both brother and sister seemed to be partial

* "Light Green" by Anthony Bonina from *The Poetry Connection: An Anthology of Contemporary Poems with Ideas to Stimulate Children's Writing* (New York: Teachers & Writers, 1978). Copyright © 1978 by Kinereth Gensler & Nina Nyhart. Reprinted by permission of the authors.

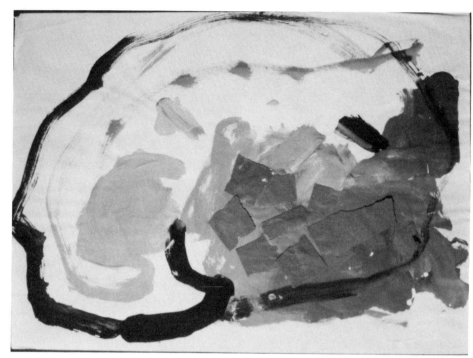

Four-year-old's painting with torn paper. (See Plate 17.)

Two-and-a-half-year-old's painting with cut paper. This is a very precocious work for such a young child. Not only did she live with a large collection of contemporary fine art at home, but also both parents came to class and encouraged her painting. (See Plate 18.)

to the color purple. "Do you like purple? You have used the same color as Johnny's shirt in both your painting and collage." "That's not why I did it," replied Elizabeth, her eyes beaming with delight. "Purple is our daddy's favorite color, and we love our daddy."

Although children between four and seven can understand how colors tell stories, don't insist they stick to any set of colors or ask them to rationalize their color choices. If you've suggested "Green Day" and they've ended up with red paintings, you needn't feel un-successful with all your preparations. Merely put away your props and save them for another time when they are ready for such an idea, or when they spontaneously paint that color.

They may equate color with physical objects more than with mood, especially if they have a favorite toy or piece of clothing in that color. Another possibility is that they may associate color with sound. Seven-year-old Janet described her friend's squeaky voice as "yellowy-green."

TALKING WITH YOUNG BEGINNERS ABOUT THEIR WORK

During the session when the parents are doing their experiments with color, we all become very color conscious. We talk about gray misty moisty days and sometimes I ask, "Do you ever go out when it's raining or look out the window—what do you see? Did you ever find a gray animal in the zoo? Pigeons in the park? See what I found . . ." (as I show feathers of various colored grays). If they don't want to talk, I never press them. I also try not to interrupt them when they are working in order to get them to do something different. If I want to make a suggestion, I wait for a time when they seem to need further information.

I help them to see how the colors they have painted relate to the things they know. "Look how the red is touching the yellow over here and the blue is there all by itself." "I see you made two kinds of blue, dark blue and light blue." Sometimes a brief comment will trigger information about their painting. I listen if they want to talk about their work.

Torn-Paper Collage

THE UNIVERSALITY OF COLLAGE

RECENTLY, I saw a copy of an ancient torn-and-cut-paper collage that stirred my feelings. It was one more reason for believing that if only everyone had access to art of the past, they would find that people have universally found similar ways to invent and express their ideas and fantasies.

A friend invited me to see her extraordinary copies of pages from a twelfth-century Japanese poetry anthology called *Sanjurokunin-Kashu*. In addition, I saw one original piece taken from the *Ishiyama-Gire*, the only two books out of more than thirty original volumes that were taken apart and the individual pages sold to private collectors and museums. The originals are highly prized as works of art. I was amazed when I learned that many of the pages of the book were executed in a collagelike "joined-paper technique" of overlapping layers of very thin papers.

The collage pages were made up of both torn and cut pieces of paper, in softened, muted colors—deep rose, grayed lime-green, tans, browns, and grays. Some were flecked with little geometric shapes of gold in a patterned way that made me think of the European painter Gustav Klimt. Some of the papers were printed and others painted. Some pages suggested landscape, and others were purely abstract. The torn and cut papers were placed in layers and arranged in many directions. They had perforated torn edges that looked to me like the tips of marshland grass, and where they overlapped in several layers, they suggested waves or rippling waters.

What particularly fascinated me was the preciseness of the torn, undulating curves. I wondered how an artist could possibly tear contours with such immaculate precision or if some super virtuoso with a knife or tiny scissors had cut those tiny serrated edges. Then my host explained that the Japanese had put tiny holes in the paper before tearing the edges. Some of the paper was probably torn while wet and other sheets were cut while dry. Like so many things, it seemed obvious once I knew, and all kinds of intriguing ideas for my own work began to pop into my head. A pastry wheel, ordinarily used

Gino Severini, Italian. *Still Life; Bottle and Vase and Newspaper and Table,* undated (early 20th century).

for making holes in pie crusts, or a sewing tool called a ponce wheel used for transferring pattern markings to fabric, might possibly be used in a similar way. I could hardly wait to try them.

I was delighted to see not only such an old source of collage but also one that overwhelmed me by its inventiveness and beauty. I had been introduced many years ago to torn-paper collage as a means of learning the possibilities of two-dimensional pictorial space, and I had used it in my formal art work and informal greeting cards and had presented it to my classes each year since. Because I've been looking at art in museums for most of my life I thought I'd seen every possible variation of collage. Like most of us, at one time I had thought of fine-art collage primarily as a style of pasted paper created in the early twentieth century by the Cubists and Futurists who did *papiers collés*. The discovery that collage existed so long ago brought a connection with history, unifying my own experience with that of ancient artists in a far-off land. We both were using a way of *drawing* with paper edges that you too will be able to share.

One parent came back to class a few weeks after making a torn-paper collage. She had gone to visit the Clyfford Still exhibition upstairs in the museum, and enthusiastically she explained how arranging the torn shapes in her collage had helped her to understand Still's abstract oil paintings. Part of her excitement seemed to flow from her sudden understanding of the use of intervals between shapes, as well as how to create a feeling of depth. She realized that, having had her own collage experiences, she would never look at paintings in quite the same way again. Now she had become aware of how overlap, edges, and directions of the sizes and shapes can affect the illusion of space.

COLLAGE AND SPATIAL PERCEPTION

By 1941, space and the figure in my canvas had been resolved into a total psychic entity, freeing me from the limitations of each, yet fusing into an instrument bounded only by the limits of my energy and intuition. My feeling of freedom was now absolute and infinitely exhilarating.

Clyfford Still, American painter*

Making flattened images has been one of the first and most basic ways of representing things. Our idea of linear perspective wasn't developed until the Renaissance in the mid-fifteenth century, because until that time artists had presented shapes arranged on a ground plane that symbolically portrayed space.

* Excerpt from Kynaston McShine, editor, *The Natural Paradise.*

Pablo Picasso, Spanish. *Student with a Pipe,* 1913–14. Oil, charcoal, pasted paper, and sand on canvas. 28¾" × 23⅛".

Tosa Mitsuyoshi, Japanese. *A Meeting at the Frontier* (chapters of Miyuji, Sekiya, and Ukifune illustrated of the Genji story), 16th century. Screen; colors and gold leaf on paper. 65½" × 124". Suggesting depth with overlapping shapes.

Traditional linear perspective is based on the idea that we see the entire field of vision from one static viewpoint. The only way that you can come close to seeing a fixed vanishing point and horizon line is if you look out with only one eye through a peephole. This peephole approach was the basis of drawing machines (such as the camera obscura) used by Western artists that allowed them to draw statically precise contours when that idea was both a scientific and artistic goal. Many people today still unquestioningly accept this concept as the "only" method to represent spatial reality in spite of having seen Oriental art which depicts it in another way, and the works of Manet, Courbet, Cézanne, and others who used modulated color and directional cues to create an illusion of space in the mind of the beholder.

While you were painting you may have noticed that other visual cues besides perspective suggest space and depth, even without the use of diagonal direction lines receding from us. For example, in a landscape the bright contrasts of color and clarity of texture characteristic of nearby objects differ from the grayed color, and softer, less distinct textures farther away. Up to this point we've been filling the entire space with painted color without emphasizing the qualities of shapes that define spaces. Now we're using collage because it is perhaps one of the easiest mediums in which to begin thinking about these elements on a flat surface. You can arrange and rearrange both the qualities of shapes and their positions so easily. It's like a kind of two-dimensional carpentry where you have the freedom to break up appearances into parts, and then, through imagination, to reassemble them in a new way.

Clyfford Still, American. *Untitled,* 1946. Oil on canvas. 61¾" × 44½".

124

DRAWING WITH COLLAGE

On a very simple level, collage is about making connections between ideas and feelings and arrangements of things in daily living. If you think of it in a visual way, everything around you is an arrangement: the furniture in your rooms, the food on your plate, the combination of your clothing and the accessories you are wearing, and so forth. Collage-making gives everyone freedom to think about and invent imaginary connections between visual ideas, because they are not going to be criticized for not making an illustrational scene.

If you are like most adults, you can accept collage as a design arrangement because you've seen it most of your life in advertising. However, some people may judge art according to its ability to portray recognizable things. Others may see it as a measuring stick of the artist's sense of reality and technical skill. Since you don't have to justify not making a recognizable image in collage, you don't think of it as a kind of drawing. Drawing is a bending and shaping of lines that define edges or the boundaries of things. It is the boundaries of objects that create space, whether it be the edges of a piece of paper or the walls of a room.

The challenge of these collage projects lies in drawing shapes (through tearing and cutting) and in becoming sensitive to arranging the spaces between them and to seeing their visual relationships to each other.

You may wonder if this collage process allows as much freedom for changing forms as, say, pencil or charcoal that you can erase. In

Artist unknown, Italian. *The Annunciation,* first half of the 15th century. Tempera on wood. 18″ × 15″.

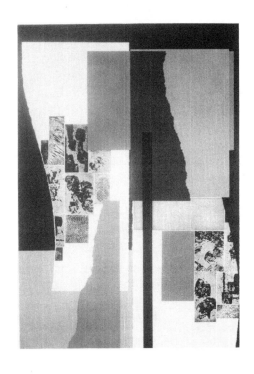

Louise Nevelson, American. *Celebration Series, #520-88-4,* 1979. Torn-paper collage and aquatint etching. 44" × 31½".

fact it does, because you can move things around before gluing, or change them by pasting one outline over another until you get the one you want. When shapes or arrangements don't come out the way you want, just tear or cut and glue on another piece right over it. Using rubber glue permits you to peel off and move shapes around without making any permanent marks (it's actually very difficult to

Christo, American (born Bulgaria). *Running Fence, Sonoma and Marin Counties, California,* 1972–76. 18' × 24 miles. The Running Fence cuts out a winding ribbon of shapes in space.

completely erase a pencil or charcoal mark on paper). You can then alter or reshape edges you wish to change.

Many experienced painters, such as Willem de Kooning, Robert Motherwell, and Henri Matisse (see illustrations on pages 20, 133, 147 and 171), used collage as a sketching tool to get ideas for future work and to try out arrangements in their compositions. In addition, Matisse and Motherwell used collage as an end in itself. The environmental artist Christo makes dozens of collages and drawings in preparation for his large-scale projects. In collage, we're really paying specific attention to learning to see things abstractly, and to translating our three-dimensional experience onto a two-dimensional surface. We are learning how to chart shapes on the space of our papers much like diagraming or making a map.

I like a large spatial clarity, and by overlapping the paper forms I am able to work out the ordering of my space.

Robert Motherwell, American painter*

Arthur Dove, American. *Reaching Waves,* 1929. Oil and silver paint on canvas. 9⅞″ × 23⅞″. This oil painting has edges that resemble torn paper and uses overlapping of shapes to suggest depth.

WHY MAKE TORN-PAPER COLLAGES?

Tearing allows your fingers to explore the qualities of paper—its physical and visual textures, its flexibility and responsiveness to touch that give you an intimate knowledge of the material. Often, we are afraid to spoil the geometric perfection and smoothness of a perfect surface by marking it up. It's like walking in freshly fallen snow where we hesitate to disturb the virgin beauty of the surface. You will have less to fear from the blank sheet of paper when you go to paint after making these torn collages, because you feel the defenseless fragility of the page. Water dissolves it, flames consume it, fingers transform it, light darkens or fades its color, and wind blows it away.

Using torn shapes instead of cut ones helps you to recognize and purposefully use ragged edges to suggest qualities in nature such as the surfaces of tree bark, rocks, rough water, and leaves. Such painters as Arthur Dove, Clyfford Still, and Augustus Tack have painted shapes with edges that look torn and suggest these associations.

When you tear paper shapes without the aid of any mechanical devices you tend to make many which have both concave and convex curves (even if these are very slight) with edges of similar ragged textures. Your torn shapes may also have fewer complex turns than would be common (because easier and faster) with scissors cutting. Because your design is restricted to two colors with identical paper surfaces and your pieces have general similarities in their edge textures and degree of complexity, there is a certain degree of homo-

* Excerpt from Kynaston McShine, editor, *The Natural Paradise.*

Adult's torn-paper collage.

geneity to your visual field on the paper. Your eye is not invited to focus on any single dominant shape in the arrangement so that it tends to scan the overall organization of the page. This makes it easier to see the shapes as spaces and the spaces as shapes. Rudolph Arnheim notes in his book *Toward a Psychology of Art* (Berkeley and Los Angeles: University of California Press, 1972) that this level of similarities in parts of an arrangement can evoke a feeling of "an unspecified mood, . . . a drifting rather than an oriented aiming. Its boundlessness affords the elation of a primitive sense of freedom, the sense of 'open spaces.' "

Your Project: Discovering How to Create Space with Shapes

This experiment of arranging torn paper shapes on a background shows how the direction and placement of shapes in a composition can produce the sensation of depth and projection to make a flat picture seem spatial, suggest movement, and create mood.

If you want to use a theme from nature, try to work freely in a semiabstract way so that you think about the directions of shapes in a visual field instead of illustrating particular objects or scenes. Because this project deals with optical rather than physical spatial qualities, it's best to work flatly in a two-dimensional graphic way rather than making parts stand up on the paper for three-dimensional effects.

Avoid using a mechanical edge to get geometric lines or shapes because it will make your design more static and keep you from exploring the great range of organic shapes available in hand-tearing. By the same token, don't fold your paper in half to make symmetrical pieces. Not only will the resulting creases in the paper interfere with the spatial effects but your symmetrical shapes will reduce the illusion of movement in any one specific direction.

Torn-Paper Collage in Two Colors
MATERIALS:
Selection of 18-by-24-inch sheets of colored construction paper (or 9 by 12)
Rubber cement

DEMONSTRATING TEARING TECHNIQUES:
Often beginners of any age do not realize that there are several ways to tear paper shapes. When I demonstrate these before they begin their projects, I hold the paper with two hands and try pulling

Adult's torn-paper collage. This person used the whole paper as a field. Notice how she tore a long narrow shape off the large upper right one and repasted it about a half inch away to make an "in-between shape."

on it. That doesn't work very well—so I hold a sheet at one edge with my hands close together and twist the paper while pulling.

a. *Tearing shapes flat on the table*: I tear a straight edge without a hard-edged tool by placing my hand down flat on the paper, using my forefinger and the side of my palm as a ruler, and pulling up on the paper.

b. *Tearing shapes in the air*: I hold paper in front of me and show how I have to turn the paper while tearing it to get a shape.

c. *Making holes*: I also show how you can poke a hole with your finger and tear an inside shape—making a "see-through" space. I hold up both the hole shape and the remaining paper from around it, and point out that I've made two shapes. When I put the outside shape down on the background, I get another round shape in the underneath color. We look at all the possibilities for new shapes from the ones I've torn, as well as the ones left behind in the tearing process.

d. *Moving the shapes*: I move the shapes around, rearranging them several times, and point out what happens to the spaces in between the torn shapes. I show how it looks when shapes go to the edges of the paper as compared to when they are well inside the margins, how the background shapes change when I move the torn pieces around and how the contours change when shapes touch.

Tearing shapes flat on the table.

PROCEDURE:

1. Pick up any two 18-by-24-inch (or 9 by 12) pieces of construction paper and see how the colors look together by holding them

alongside of and overlapping each other. Pair off another combination or another color next to the first one, until you feel you have a pair that you want to use. Overlap one piece over the other and then reverse the two to decide which one you will use for the background. Cut or tear the other sheet in half for easier handling if you want to.

2. Tear out a few large shapes first from the half-sized sheets, and then take some pieces out of these. Look at the spaces or holes left in your torn paper and consider using them as shapes in your arrangement as well as the inner piece you removed (see illustration).

Instruction #2.

3. Tear out a few different kinds of shapes so that you can see a variety of possibilities for arrangement. Put them down onto the background and move them around without pasting them until you find an arrangement that pleases you. It does not have to express a special idea or mood, although as you work one will probably develop. Examine what happens when you change the outer silhouettes by overlapping, or use overlapped pieces to indicate a direction. What happens when you make two shapes connect end to end, or change their initial direction by adding another piece on top of the first so that you cover only part of it? When do your shapes look like they're moving out toward the edges of the paper, and when do they seem to oppose or block each other? As you keep moving the shapes you can get a feeling of a canyon or a valley, of clouds passing across the sun, figures dancing, or strange-shaped animals herding together in a field.

Keep watching what happens to the background spaces in between the torn pieces as you continue to fill up the whole page so that you can see how the intervals between the shapes change as you move the ones on top around your paper. Slowly the importance of in-between shapes will become more meaningful to you. Often you can't tell which is foreground and which is background. Turn your

background paper around a few times to see if there might be another arrangement you might like better.

4. If you want to add an inner shape that gives the illusion of a hole through the paper, you can put some of the ground-plane color on top of the other torn pieces.

5. Finally, when you have a composition that you like, begin to glue the pieces. Keep the paper flat on the table. Instead of picking up each piece, gluing the background, and replacing it, just lift the outside edge of each shape, slide a bit of glue underneath, and press the shape down. (If you use a small amount of glue, you are less likely to have any excess squish out at the edges.)

Instruction #5.

6. Now you can hold it up vertically and look at it again. Since you are using rubber glue, you can still rearrange it again by peeling off any pieces and repositioning them. If you're satisfied now, let it dry. If you have any bits of glue sticking out, you can rub them off with your finger or an eraser when they are dry.

7. Save all your scraps for other collage projects.

THINKING ABOUT WHAT YOU'VE DONE

You may have found that tearing shapes freed you from the concern of trying to make preconceived representational images so that you were not so worried about getting a shape "right." This allowed you to be more responsive to unexpected results. Yet tearing actually did allow you to draw by shaping the edges.

There are a variety of ways to continue experimenting with tearing. Earlier in the chapter I mentioned the method of perforating or scoring your shapes with tiny holes the way the Japanese did. The

French collagists used *brûlage* (burning the edges), *fumage* (smoking the edges with a candle), and *décollage* (peeling back layers of the paper—even to the extent of tearing away part of the background paper as well). For example, I have seen people cut up corrugated boxes and peel off areas of the top layer of paper exposing the bumpy surface to use as a background for collage or painting.

While you have been tearing, you may have seen that there was a distinct color change in the paper between the smooth top surface and the rough edge. You may have missed this if you used light-colored papers, but if you had been placing pieces of torn black on top of each other you would have seen quite a spectacular effect. You might try an all-black collage to see this color phenomenon if you did not use black this time. Sometimes the construction paper has faded and has a different shade of color on each side. So, if you used both sides, it will look as if you've used three colors instead of only two.

I realize, when I look over the many torn-paper collages done in my classes at the museum, that it is common for people to feel a sense of outdoor space or field of pattern in nature in their work. This is not only because the qualities of the torn shapes suggest rough natural textures (straight-edged geometric ones carry more associations with man-made objects), but also because of their relationship to the background. Moreover, the softness of the torn edges and their reduction of detail to a texture can evoke the feeling of being at a distance too far away to see things sharply.

Whenever you put a shape on a page, you set up a visual spatial relationship between it and the field of the background sheet, and when you add other pieces they also interact with both the page and themselves. If you have overlapped shapes, you can also see how overlapping suggests space in depth. If you have used both large and small pieces so that they are grouped by size, the small ones may read as far away and larger ones seem closer. If you have torn off your shapes at the edges of the background paper so that they look incomplete, this can suggest an extended space beyond the edges of the paper where, if the page was longer, the scene would continue. All of these techniques of spatial representation are used frequently in many different kinds of paintings, although we see them perhaps most obviously in the work of painters in the Orient.

The ancient Chinese and Japanese found that pictorial space was the most important element in unifying and harmonizing all the elements of a painting, and had a symbolic significance as well. Space was seen as the equivalent of *tao*, the active power and principle of change in the universe, and it was filled with energy and vitality.

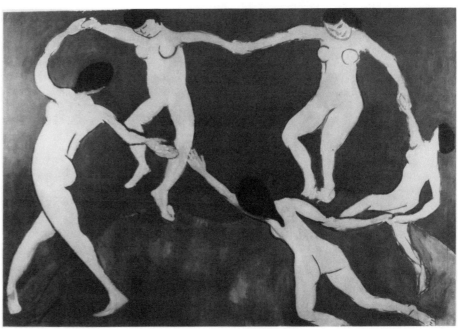

Henri Matisse, French. *Dance (First Version)*, 1909. Oil on canvas. 8'6½" × 12'9½". The spaces between the figures are shapes that are as carefully composed as are the bodies of the dancers themselves. Notice how the cut-off shapes suggest an extended space beyond the edges of the painting.

They painted (or left blank) great oceans of space that contrasted with rhythmic brushwork and geometrically precise shapes.

If you see a spatial reversal of your pieces with their background, it comes from seeing a unified field of only two colors where the visual impact of the parts is so equal that there is an ambiguity about where to look first. Because we can't perceive two different organizations of a pattern at the same time, we alternate by seeing it one way and then the other. Figure-ground reversal works best with arrangements of shapes that have convex and concave curves, because these are felt as visual forces instead of static areas. The ancient Chinese used this effect in the convex-concave design of the yin-yang sign representing the universe because it visually demonstrates the idea that each element suggests change into its opposite and complement.

Because your torn-paper collage tends to make a picture where foreground and background tend to coexist more or less as equals it makes it easier for you to see this spatial principle of organizing a composition. Beginning painters, who look only at the shapes or objects on the ground plane instead of seeing the entire container of space on the page, often put in objects, surround them with color, and then can't think of what to do with the leftover spaces in between.

Although this spatial issue in design is often spoken of as dealing with positive and negative space, I do not use this language in class with young children because "negative" implies something not so

good. Both kinds of space are equally important in reality because you can't have one without the other. It is hard for me to think of brilliantly colored blue shapes of the sky seen through tree branches as "negative."

YOUNG BEGINNERS' COLLAGE-MAKING

Although young ones may enjoy tearing for its own sake, I don't give them a special project but rather help them to think about tearing as another way to make shapes change. I encourage them to cut with the scissors so that they acquire both skills, begin to see the differences, and learn to make choices as they work. The concepts behind your collage will only have meaning for them as they grow older, more experienced, and more visually aware.

Before beginning collage for the first time with anyone, prepare in advance, and to avoid misunderstanding, be precise and definite about what materials are for cutting, tearing, and pasting.

PREPARING THE CHOOSING-DISH SHAPES

(Also see Chapter 2, page 39.)

Cut up all pieces for the choosing tray or dish into simple shapes such as strips, squares, and rectangles that are between 2 and 4 inches long. These shapes need not be perfect because their function is merely to divide up the paper pieces into manageable sizes. Avoid cutting round shapes so that when the children want them, they try to do it themselves. If someone asks for a round shape, I demonstrate how to move the paper around while cutting it in order to make rounded shapes and guide their hands if necessary.

First I emphasize learning new skills and then much later set problems with materials and themes that we will cover in the following chapters. I give two-and-a-half-year-olds simple precut shapes to learn the skill of pasting. Inexperienced young beginners think of pasting and cutting as two separate activities. Consequently I prefer to teach only one of them at a time. When I guide older children or adults who already know one skill or the other, they can combine both at once.

As in painting, very young beginners enjoy the physical activity of what they're doing; they will be fascinated by the processes and not particularly care about their visual results. Two-and-a-half-year-olds may apply a lot of paste and then not put any shapes on the background paper. Sometimes they may spend a long time cutting and then stop without pasting anything down. Others may squabble over a particular piece of paper in the choosing tray, get it, put it on their

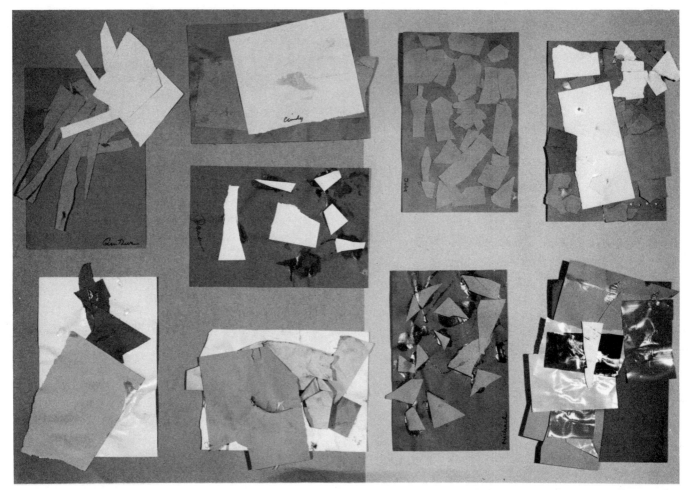

Children's beginning collages. An abundance of paste is evident in many of these beginning collages by three-to-five-year-olds. Their level of skill is not determined by age but by past experience with these materials.

collage, and then not recognize the collage as their own after they are finished.

DEMONSTRATING PASTING TO YOUNG BEGINNERS

1. I put a small precut shape on my 6-by-9-inch background paper, then pick it up and tilt the sheet so that the piece slides off.

2. "What do you think I have to do to make the shape stick to the paper?" (Short pause—they may or may not know.) "Let's try using some paste and see what happens."

3. I spread some paste on the background sheet, put the shape on top of the pasted area, press it down, pick up the paper, and shake it a bit. "Now it doesn't fall off. It sticks to the paper. I put the paste on the background paper and then put the shape on top of the paste and pat it down."

If you pick up a shape and spread paste on it while it is in your hand, they will copy you and get paste all over their fingers. Then they will find the papers sticking to themselves instead of to the

135

background sheet. Moreover, if they put down a shape on the table surface and then put paste on it, they will paste the table and find pieces sticking there.

4. Repeat the process again, letting the children choose the shape to be pasted. "What do I have to do to make it stick?" and so on.

I do not show the method of slipping paste under the edges of previously arranged collage shapes to very young, inexperienced children because they will find the process too difficult to handle. Later, after they have learned this first method and start to preplan their designs, you can introduce this more advanced process of pasting.

If the children don't understand, they may put paste down and then place the shape somewhere else. They need a personal reference for the idea of covering over the paste. Every child knows about being covered with their blanket so you can use the following analogy. "When you go to sleep, does Mommy or Daddy put a blanket on you?" ("Yes.") "Covering over the paste with shapes is like putting a blanket on the paste."

Sometimes they will place a shape on the pasted area, then put a second one on top of the first without adding more paste to it. They may continue to pile on pieces without realizing that they will fall off until at the very end when they pick the paper up to show you what they've done. A few of these incidents will tell them more about the pasting process than if you constantly remind them what to do. When their pieces fall off you might ask: "Why do you think that happened?"

Some young ones love the shiny look of the wet paste and they put more paste on than they need or spread it all over the paper. Don't try to wipe off the excess but suggest instead that they might want to add more shapes to the remaining pasted areas. If they don't want to do that, don't insist on it. Later, after they have gotten over the excitement of brushing on paste, they will be more interested in assembling something.

Often they don't realize that pasting makes an arrangement permanent. Three-year-old Danny announced to me that he was going to make a birthday collage for his father. "I'm going to take it home to him as a surprise." He grinned as he carefully chose a variety of materials and pasted them down. "I think he will be surprised when he sees all those colors and shapes you pasted," I replied. As I moved away to help another child I saw Danny take a fresh tissue from his pocket, meticulously put paste all over his collage, and pat the open tissue over the whole paper. "There! Now he can't see it right away and it'll be a surprise when he opens it," he exclaimed triumphantly as he went off to work at the clay table.

Danny forgot to take his surprise collage with him when he left

class. However, he had the joy of making something without any possibility of disappointment if his father reacted with confusion to the tissue-covered present.

PASTING AND ARRANGING FOR MORE EXPERIENCED BEGINNERS

I explain to more experienced six- and seven-year-olds that they can arrange part of their design without pasting it and then slip paste underneath the edges of the pieces. I show them that it is easier to move things about in different arrangements before making a final commitment to the design. Occasionally I find an advanced four- or five-year-old who can handle this concept.

For example, during her first day in my class four-year-old Julia was really judging and examining where she wanted the pieces to be and how she was going to position them. She began to prepare the pieces with paste beforehand. Then she held each piece with glue on it over the paper and moved it around in the air just above the surface until she made each decision about where to set it down. As she worked, she got paste on her hands and the papers began sticking to her fingers instead of to the paper. Although she was experienced in cutting and pasting, no one had shown her the possibility of planning her arrangements. To look at the paper and preplan abstractly was too complicated for her. After I showed her how to arrange and slide paste under the edges, she worked more freely.

Children plan a design because they like it that way, not because they're following any kind of design rules. Planning is moving shapes around the way you move your furniture until you find a comfortable arrangement.

Although they work on a 6-by-9-inch background paper, if their collage is growing out and expanding beyond the edges, you can show them how to paste on additional 6-by-9 extensions. If this becomes too awkward, then offer them a larger piece of paper upon which to put the whole collage.

Sometimes children build on to their collages naturally. As their ideas expand, they expand their collages by adding more paper. Using letters and numbers as shapes may turn a child's thoughts in a new direction, or the child may just use them to make other shapes.

TORN-PAPER COLLAGE FOR OLDER CHILDREN

Older children might enjoy making a torn-paper collage like yours as an introduction. It looks like a magic illusion because of the optical reversibility of the background and the shapes on top of it.

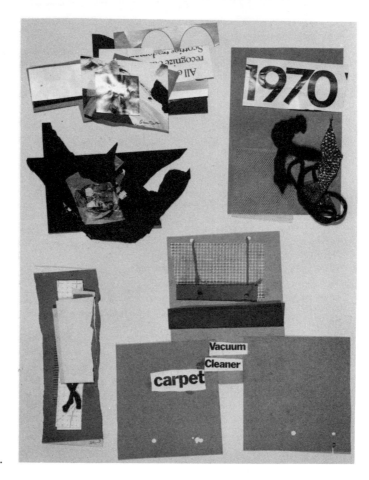

Children's extended collages.

However, it may take more skill to interest older children in tearing paper. You may need a greater variety of photographic illustrations to start with in order to find ways of relating this project to their own experiences. By third or fourth grade they may need themes and reproductions of artists' collages showing them that this is an adult thing to do. Try to collect some aerial photographs or continental maps showing land masses or photos of the earth taken from outer space showing cloud formations. These suggest making imaginary maps as if seen from a plane. The photographic volume *Worlds Within Worlds*, by Michael Marten and others, is a good source of this type of photograph (see Recommended Additional Reading list, page 283).

TALKING TO CHILDREN ABOUT COLLAGE

When working with two-and-a-half-year-olds, I begin by calling this activity a pasting-and-cutting picture (or a pasting picture if they're only pasting) instead of a collage in order to call attention to the

process. After they've been doing it for a while I introduce its real name. With older children who already know the process, I describe it in terms of the end product—collage—and tell them how it got its name (from the French *coller*, meaning to paste or stick on).

You will find it easiest to explain shape and color if the children have experiences with the three different mediums I use in my workshops. Visual ideas, especially the idea of changing form and color, are reinforced in a different way by each. If you omit painting, they won't know how colors change. If you exclude clay, you will have to explain more about shape. For example, if they do both collage and clay they learn that "round" is not just one thing but can take many forms. These are ideas you just can't explain in the abstract and will have to supply with additional field trips and concrete examples.

I talk about things I see on the paper as they happen. If you expound ideas before they have made their own visual example, the children probably won't understand what you're talking about. If they are tearing for the sheer joy of the tearing process, I try to direct their attention to shape-making. ("Look at the shapes you are making! Some are little and others are big.") Most of these won't be any shape you can name precisely except for saying that they are long or fat or skinny. I also keep a little box for collecting these torn pieces so that they can be reused in another collage. If they have piled one collage shape on top of another so that parts stick out, you might point out that they have changed the underneath shape by covering it up. I don't tell them how to do it. Although they are overlapping their shapes, I don't use the word *overlap* until it comes into their own vocabulary.

Try to find examples that are most like the kind of situation they have in their work. If they have a flat round shape, I look for another flat round shape that is fastened to a background like a button on a shirt or clock face on the wall to explain "round" and "flat." When I talk about color, I don't confuse it with shape. If you want them to understand the qualities of a certain color such as orange, show them many examples of different shapes with the same color (such as a round orange, a pointed carrot, a rectangular box) so they can see that the same color can be in different shapes.

As you all progress you can start to make finer distinctions between colors such as "That's a yellowy-red or an orangey-red," so they don't think of any color as a static, unchanging category.

When I point out spaces or shapes, I don't refer to them by their geometric names such as circle, triangle, rectangle, and the like, but emphasize how they look instead (for example, round, pointy, or long shapes and in-between shapes or spaces). Younger children won't cut a wide range of shapes because they don't know how to

make complex ones. One may know about "bridge" shapes if there are bridges near his house; another may know about egg shapes if they've been coloring eggs at Easter time.

Try to be precise so that they don't confuse words for two- and three-dimensional shapes. For example, if they say their paper shape looks like a ball, I talk about other round shapes and note that a ball is round also. I don't use "ball shape" as a term because that restricts their associations of roundness only to balls. I speak of "in-between shapes or spaces" on the paper and "see-through shapes" instead of "negative space" and holes. With more experienced beginners I might mention an "inside shape" instead of a "see-through" shape.

There's a delicate line between helping them to see possibilities to expand their skills and just pushing ideas at them. With experience it's easier to recognize when someone is receptive. Wait until they know they need help or want to know something, and then try to find out what is bothering them before offering advice. I remember the story of a nine-year-old boy who told his teacher he was having trouble with his picture. He had made parallel railroad tracks, put in some other shapes on either side of them, and sat staring at what he had done. She assumed he wanted the railroad tracks to look as if they were going off into the distance and started explaining how to draw them in linear perspective. He waited patiently until she had finished her whole speech and then spoke up: "Oh I know about that. What I'm trying to decide is how to put in a danger signal by the side of the tracks." He wasn't the least bit interested in perspective and she hadn't bothered to find out what he really wanted help with.

MATERIALS: BUYING GUIDE AND PREPARATION

Supplies and materials for collage are the easiest to come by and the least expensive of the three mediums. The biggest expenses are scissors, jars, paste, and a pack of construction paper. All else can usually be found around the home or gotten free. (See Chapter 2, page 36, for a list of common sources.)

SCISSORS
Get two good pairs of 4-to-6-inch small scissors (*not* the type in ten-cent variety stores unless you have tried them and are certain that they cut easily) with blunt tips for children under five and with pointed tips for older ones. Buy larger shears for yourself. You need an extra pair of small scissors because if you are demonstrating how to cut to beginners you need to use the same size pair as they are using. Omit this extra pair if they already know how to cut or keep them if you want to be able to invite a small friend in.

If this is your child's first experience in learning how to cut, you will make it extremely difficult for both of you if you buy an inferior pair of scissors. Remember, paper will dull your fabric- or hair-cutting shears, so it's best to get scissors just for paper work.

HOLE PUNCHER

This is optional. They can make patterns of "see-through shapes" in rows and use the cut out holes to paste down. One of my own children was not particularly interested in cutting and pasting until he got the hole puncher in his hand and was fascinated by the patterns of holes he could make. This, in turn, led to his greater involvement with collage. I also use it as an additional tool like the small paint brush to motivate activity when attention begins to flag. When they get to be three-and-a-half or four they are more physically active and need to use their bigger muscles. It takes a certain strength to use it, but many find the punch an intriguing instrument.

PASTE

I use Carter's CICO liquid paste in my workshops for children because it has a smooth creamy consistency and is nontoxic. Although there are other equally good pastes, regular library paste is too thick to use without thinning it by mixing it with some water and a few teaspoons of Elmer's School Glue or Elmer's Glue-All.

Elmer's Glue-All, Sobo, and other similar formula "white glues" that are classified as nontoxic are nevertheless made from a plastic resin with a polyvinyl alcohol base. These are water-resistant when dry and more difficult to remove from clothing when hardened than the nonresin types. Elmer's School Glue is completely nontoxic and washable from clothing even after it dries.

Rubber cement (used for the adult projects) is all right for older children who can be trusted to immediately recap the jar after each use and who won't sniff or eat it (it can be fatal if swallowed). Most brands give off vapors and are extremely flammable. However, one nonflammable type is made by the Columbia Cement Company. You also will need a container of thinner along with the glue if you get a large amount because the glue will thicken before you reach the bottom of the jar. When it is liquid (its proper consistency), it will drip off the glue brush unless you are sure to wipe the brush against the top edge of the jar before lifting it out. Also remember to replace the top on the jar immediately after each use or the glue will solidify quickly.

The advantage of rubber glue is that any excess can be rubbed off with your fingers or picked up with a special eraser designed for just that purpose. If you put your collage pieces together while the rubber glue is wet, you can separate them again when dry if you haven't

used a lot of glue. If you let both glued surfaces dry separately before putting them together, the bond is more permanent. While it is extremely versatile and convenient for sketching and rearranging, the glue itself does deteriorate paper although it may be a few years before you notice it. If you want to preserve any collages, use a vegetable-base glue for assembling and mounting the finished piece. Different varieties of this type of glue are available in art supply stores.

PASTE JARS

The best way to buy glue is to get a large jar and then decant it into smaller screw-top jars with attached paste brushes. Plastic squeeze bottles for white glue and also containers such as those used for mustard and ketchup are not functional because they get clogged easily and when you squeeze hard to get the glue out much more will come out than you intended. They also may invite squirting accidents.

It may be difficult to find paste jars with the brush attached to the top, depending on where you live. You may have to buy a small jar of library paste or other glue just to get the proper jar. Throw out the glue if it is toxic or its consistency is so fluid that it drips from the brush. (However, you can recondition library paste to the right consistency as I mentioned before.)

Remember to fill all beginner's glue containers only one-third full so the glue doesn't go up so high on the handle of the brush that they get their fingers in it. The paste jar is also less likely to tip over when the weight is centered in the bottom half. If you can't find an attached glue brush on a top, or a special small brush for pasting, you can cut down an old one-quarter-inch paint brush to about 5 or 6 inches long. It is easier to knock over the glue container if it has a long-handled brush in it. Little plastic spatulas are not as satisfactory because they are not flexible.

PAPER

I start beginners with only construction paper because it is the easiest to learn to cut, and the dye completely saturates the material instead of being printed on the surface (as with "Color-Aid" papers). Children use 6-by-9-inch background sheets for their collages because that size is easy for small hands to handle. Adults and teenagers use 18-by-24-inch papers for their ground planes (9 by 12 if they wish to work smaller).

Each semester I start all over again with just construction paper. I do this mostly for the newcomers to the class. However, I find that even for children who come back for four semesters, it becomes a

challenge to use the same kind of paper. They may ask for one or two other textures but once they have developed their powers of imagination they don't feel limited. Learning to transform the materials is important. Although I add new materials to remotivate them, such as the second paint brush or hole punch, I try not to give them a lot of extremely seductive materials at first (such as metallic patterned papers) because they won't transform them as readily by cutting and building new images. They may be satisfied with merely pasting. If you put out a lot of different papers at first, they will run through them quickly and learn very little about any of them.

EIGHT

Cut-Paper Collage

ONCE WHEN I WAS SICK as a child, a visiting relative who wanted to entertain me and keep me busy folded a handy newspaper and, cutting into it, produced a chain of paper dolls. How delighted I was when she unfolded the row of figures with geometric links in between. It was a great trick and I soon mastered it. However, nobody suggested that I could vary the design or rearrange the parts differently and glue them on another sheet of paper to make a collage. The emphasis was on the trick of cutting paper and making multiple figures rather than on using this skill to invent my own designs. Naturally, it got boring after a while.

Although you may be a beginner at cut-paper collage, you may have learned some form of decoupage (or cutting out complete images) to paste into scenes or use as decorative items in grade school. I loved the image of the two little children that was used to advertise Campbell's Soup and cut them out of every old magazine I found. We all did the various types of paper-folding and cutting on the folds to make snowflakes, valentines, and other items. Often if an adult gave you a tulip or pumpkin pattern to color, copy, or cut out, you were expected to follow suit. If you departed from their design, they may have seen this as a rejection of their idea and made you feel inadequate, disobedient, or untalented. The result could well have been to discourage you from using art materials, because you were not encouraged to learn a skill or invent anything of your own.

There was a discouraging element to the fold-and-cut process as well, because it was subtractive. Once you cut away the shape, the paper was gone and you couldn't glue it back. So you had to be very cautious about cutting in the correct place lest you destroyed your work. The fear of making a mistake was very inhibiting.

Cut-paper collage, by contrast, is additive. You create images by layering and building them up from bits and pieces, like two-dimensional carpentry. It's much easier to make variations and change ideas. If you don't get the shape you want right off, you just keep adding more pieces on top of the first one until you do.

You have seen reproductions of assembled cut and pasted images all around you in advertisements although you probably never

thought of them as collage. In addition, some modern painters use collage-like imagery in their works. This process originated in folk art so long ago and in so many different countries that we can't accurately pinpoint its source. It has been used for greeting cards, decorations, valentines, Victorian screens, homemade children's picture books, and decorative covering for boxes and lamps.

In the last chapter I mentioned that many painters use collage as an aid to arranging compositions. Henri Matisse started using cut-outs as a sketch medium and then later adopted collage as finished work. He has been my inspiration for this project. He drew images by cutting paper with scissors and assembling layers of precolored papers, in the same way we will do ours in this chapter. Matisse praised this method as superior to painting alone for unifying the elements of line with color and outline shape with its inside surface.

It is a simplification. Instead of drawing an outline and filling it in with color—in which case one modified the other—I am drawing directly in color, which will be the more measured as it will not be transposed. This simplification ensures an accuracy in the union of the two means.

Henri Matisse, French painter*

Cut- and torn-paper collages combine some of the best qualities of each of the other two mediums: the drawing and color of painting plus the tactile joys of making sculptured bas-relief. Although you handle your pieces by cutting out shapes in real space (as opposed to pictorial illusory space in a painting), you have the possibility of creating the illusion of a whole environment like a picture, in a way that the single-object sculpture cannot. A single sculpture may have little effect on its surrounding environment while a drawing or painting can frame an entire area. This kind of collage also has much in common with the graphic arts because of its emphasis on line.

Most people think of a pair of scissors as a separating, dividing, or removing instrument; they don't see it as a drawing tool. However, when you cut into a material you are making a line in it. This cut makes a mark that defines a contour line, a perceptual boundary that stands for the physical edges of a shape as separate from other things, and defines the spaces between the shapes.

The reason why drawing with scissors works so well for making pure contour lines is that it incorporates the senses of sight *and* touch: You pick up and handle the shapes while you look and cut. This focuses your attention on the subtle topography of edges and helps establish eye-hand coordination. Contour drawing emphasizes a meticulous processing of sensory information that stimulates visual

* Excerpt from Jack D. Flam, *Matisse on Art*, New York: E. P. Dutton, 1978.

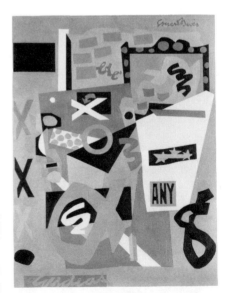

Stuart Davis, American. *Seme*, undated (first half of the 20th century). Oil on canvas. 52″ × 40″.

thinking. For further reading on the subject, I recommend Betty Edwards' *Drawing on the Right Side of the Brain*.

Although you can make many different qualities of lines (such as jagged, smooth, curved, straight, and the like) by various methods of cutting paper, *modeling*,—the process of rendering the illusion of three-dimensionality—is often thought of as being produced by shading. However, an accomplished artist such as Matisse can make contour lines in paper that do suggest the volume of three-dimensional forms as well as two-dimensional shapes (see illustration of Matisse cutout, next page). Matisse felt that for him the "scissors can acquire more feeling for line than pencil or charcoal." However, from the fifteenth until the twentieth century most drawing has been joined in the popular mind to a style of representation associated with the pen, pencil, chalk, charcoal, and brush, and not with the scissors.

That paper cut-out, the kind of volute acanthus that you see on the wall up there, is a stylized snail. First of all I drew the snail from nature, holding it between two fingers; drew and drew. I became aware of an unfolding. I formed in my mind a purified sign for a shell. Then I took the scissors . . . at times, merely drawing in air was enough.

<div align="right">Henri Matisse, French painter*</div>

Your Project: Cut-Paper Collage

What is new in this project is your investigation of the linear motions of edges and the arrangements of shapes, while at the same time incorporating all the other visual elements you learned in the previous projects.

When we speak of the flowing lines of a robe or dress, the sleek lines of a sports car, the undulating lines of a hilly landscape, or the majestic lines of a sailing ship we call attention to one of the special

* Excerpt from John Elderfield, *The Cut-Outs of Henri Matisse*, New York: Braziller, 1978.

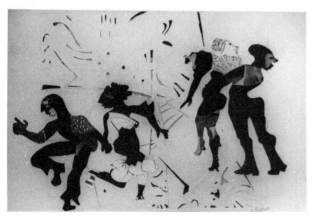

Camille Billops, American. *Dancer Series #4*, 1980. Cut paper, colored pencil, and ink. 22" × 15".

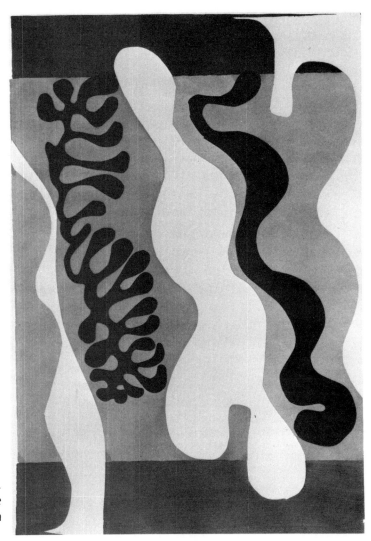

Henri Matisse, French. *Jazz*, 1947.
From the album of 20 plates for the
book *Jazz* by the artist. Paint on
paper. 16⅛" × 24⅛".

qualities of line—that is its ability to represent movement and change. You may have found that you could suggest this quality of gesture in your painting through loose and calligraphic brush strokes, for our experiments with brush and color with the water-base poster paints allowed us to create linear motion with much spontaneity. Now we're going to experiment with another way of creating motion with line, by cutting paper shapes.

I began using cut paper—a lovely thing to do. You're drawing with scissors. You're inside out and upside down. You don't know where you are and you get lost. You have to go by trust.

Mary Frank, American sculptor*

* Excerpt from an interview with Hayden Herrera in Eleanor Munro's *Originals: American Women Artists*. See illustration, page 244.

MATERIALS:

I suggest that you start with only three colors at first: one for the 18-by-24-inch background sheet and two other colors in half-sized (9 by 12) pages. The scraps you've saved from your torn-paper collage may suggest new shapes you might want to cut from the half sheet, or else you can trim and reshape the scraps to use as fourth and fifth colors in this new arrangement.

Since you will be using these large papers, you may find it easier to cut with a 7-or-8-inch-long scissors instead of the small 4-or-5-inch blades used by your children for their smaller 6-by-9-inch pieces. However, if you have bought a spare small pair, you might try using both. The smaller pair is particularly effective for cutting intricate shapes.

PROCEDURE:

1. Choose your background color for the largest sheet and two other colors for the foreground shapes.

2. Cut up the sheets for shapes into half (9 by 12) or smaller sizes for easier handling when cutting out pieces.

3. Cut out all types of shapes with your scissors: jagged, smooth, pointed, round, ones with holes; cut out the remaining outlines left from the larger pieces—every possible variation you can think of. As with your previous projects, you might begin like a child and just

Judy Pfaff, American (born London). *Untitled,* 1979. Con-Tact paper and Mylar on drafting paper. 42½" × 97". Ms. Pfaff's collage uses overlapping, patterning, and transparency in the layering of shapes.

enjoy cutting different kinds of shapes. Weave your scissors in and out for a variety of edges and shapes.

If you cut by holding the paper up in the air in front of you, you will be able to watch the progress of the shape more easily than if you keep it flat.

If you want to cut a round shape, don't fold your paper in half and then cut a half circle. Your circle will look static and be less expressive than if you have cut a continuously drawn contour all the way around. The geometrically perfect circle does not express movement and change. If we want to get a kind of symmetry into our projects, we do it by balancing the colors and placement of our shapes rather than by making identical shapes. I was surprised when I first saw an original Matisse cut-paper collage to discover he did a great deal of pasting of small pieces of paper of the same color over the original shapes in order to form the contour lines he wanted. Remember when you do your own work that you can change the outer edge of a shape by pasting-over until it pleases you, the way you painted-over your earlier projects.

4. Put the pieces down randomly on the large background sheet as you cut them out so that they may suggest possible arrangements and future shapes. Overlap them and pull them apart much in the same way you arranged the torn-paper project. Be sure to examine the possibilities of using outlines made by the shapes of the holes (as with your torn-paper collage). When you set· your pieces down on your background, note the shapes created by the spaces in between the shapes you have already cut out. Keep cutting and moving your pieces until you come to an arrangement you like. At this point you might feel you want to add small amounts of an additional color by adding scraps from the torn-paper collage to highlight or emphasize some quality in your design.

5. Lift the outer edges of each piece and glue it down by inserting glue under the piece. Pat each shape down.

Further Possibilities
As with your torn-paper collage, you can use this cut version as a starting point for a painting or add paint to it as another element. You might also try combining both torn and cut paper for a wider range of contrasting shapes and edges. Ask yourself how you can create the most striking kinds of contrasts here by thinking of size, quality of the lines, shapes, edges, colors, textures (by peeling back layers), and different spaces within the arrangement.

THINKING ABOUT WHAT YOU'VE DONE
When you assemble your shapes into a layered collage arrangement, your finished organization has a similarity to a basic seeing experi-

Adult's cut-paper collage. This person used overlapping to create lines within the outer contours of the shapes.

Adult's cut-paper collage.

ence you have all the time. That is, no one ever sees closed black outlines running all around objects. What we do see is a collagelike vision of colored planes to which painted or sculptured surfaces may correspond. Cutting or drawing contour lines can depict the essence of shapes rather than describing everything about them.

Your collage-making process, selecting shapes and arrangements, may be somewhat similar to that of children's drawings because the truth of your image is a truth of feeling and knowing, and may or may not be a picture of visual reality that other people agree to. What matters is that the shapes and their arrangements are both the tools and vehicles for you to communicate your personal visions in your own way. However, your visual message may tell someone else a very different message than the one you intended.

You might have noticed when you finished your torn-paper collage that you got a feeling of immense space, even though you might not have been able to tell which part of your collage was the foreground and which was the background, especially around the very thin ragged edges of the papers. When you cut your shapes this time and overlapped them, you could more clearly see the contrasts of several colored layers coming forward or receding so that you felt a clearer definition of near and far space.

The reason for defining this space in your collage is to make your shapes relate to each other in order to express some idea or feeling. While anyone who can cut can draw contour lines to make shapes, the artistry comes in relating them to each other. One way of doing this is by not only arranging the group of pieces within the shape of the surrounding page but by also designing the individual spaces between the cut pieces. If you have time to make another collage, you might take the same basic arrangement and move the cut pieces just slightly closer together, further apart, up, or down to see what happens. What happens if you put the whole arrangement on a larger sheet of the same color paper? Then try a different color one. Think of what happens when a lot of people are crowded together in an elevator and you all step out into a large lobby.

The arrangement of colored shapes can lead you on a visual journey. Imagine if all the highway signs along the road were grouped in one place. They wouldn't point you to anywhere in particular. However, if the signs were placed at intervals, you could progress from one to the next. In the same way, you might make visual connections between shapes across the space of your page by using similar shapes at various intervals. You might also find that repetition of the same or similar colors in dissimilar shapes does the same thing.

If you try reversing the colors of the foreground pieces and background page, what happens? Do the shapes look closer or farther

William Harnett, American. *The Artist's Letter Rack,* 1879. Oil on canvas. 30″ × 25″. Several 19th-century painters composed naturalistic still lifes that look like collages. This painting is an example of an American's approach to this genre. How do the lines of the rectangles in this painting create a different sense of depth or flatness? Motion or stasis?

apart? If you paint a room light yellow, will it feel bigger and less crowded than if you paint it a dark wine color, even though you keep the same amount of furniture?

Last time you might have noticed that the jagged agitation of a torn edge evoked a sense of vigorous spontaneity or turbulence, while this time your sharply cut shapes suggested a different range of ideas, such as a sense of stable precision, static geometric perfection, or other varieties of motion. These sensations are also influenced by the relations of your lines to the paper when they set up tensions through oppositions, or stability by a harmonious relation with the shape and orientation of the page and with each other. For example, when you look at the lines and shapes of the parents' collages on page 149, you can see how these qualities create the vibrant emotional tone of the scene. What happens when the shapes in these paintings by Jacob Lawrence and William Harnett appear to point to others or oppose them? Do any lines continue and emphasize

Jacob Lawrence, American. *Pool Parlor,* undated (20th century). Gouache on paper. 31" × 22¾". The motion of the lines going back and forth across the picture planes promotes the feeling of the balls zig-zagging across the tables.

the movement of others by paralleling them or imitating their movements?

As with color, no one line has any absolute meaning and all qualities are relative according to the way they are used. However, most people agree on certain general characteristics suggested by shapes and lines. For example, vertical ones can bring to mind feelings of uplifting aspiration while horizontal ones can give a kind of calm repose. What happens if lines are placed at oblique diagonals and acute angles or in opposing directions? When do they suggest tensions or excitement or the opposite quality, locked-in immobility? I often show reproductions of contrasting moods in class to demonstrate how the compositions make different use of linear devices to come up with totally unlike effects.

YOUNG BEGINNERS' PROJECT: CUTTING SHAPES WITH SCISSORS

I encourage the youngest beginners to concentrate on learning the skills of cutting and pasting without burdening them with specific themes. Although cutting with scissors is an automatic reflex action for many of us, it's actually a complex skill because it involves coordinating three separate motions: opening and closing the blades, moving the paper at the same time, and moving your fingers that are holding the paper so you don't cut them. In addition, you have to keep the blades perpendicular to the paper. Of course, you can't explain all this to a two-year-old. The most candid thing for you to do with children is to acknowledge that cutting with scissors is hard until you know how to do it.

Most children can't tell exactly how you do it even by watching you cut. Two-year-old Diane, who saw older children cutting with scissors, took a pair, put her fingers into the handle holes, pressed the tips against the paper, then sat staring—waiting for the blades to move. She thought that the scissors did it by themselves.

DEMONSTRATING HOW TO CUT WITH SCISSORS
If children are having problems with scissors after I demonstrate cutting, I position their hands and put my hands over theirs, helping them get the feeling of opening and closing the scissors. As we use them, I say, "Open and close, open and close." I also help them move the paper with their other hand toward the blades until they get the feel of it. If they become irritated when I put my hands over theirs, I explain that I don't want to cut for them but want them to learn how to do it themselves. Once they get the feel of the physical

action of cutting, it becomes an automatic reflex and they don't have to think about it each time.

Start with a strip of paper that is narrow enough to be cut in two with only one snip so that the children can concentrate only on opening and closing the blades without maneuvering the paper. Then they can graduate to cutting off corners and finally making larger pieces.

After they realize that they must keep the blades perpendicular to the paper ("You can't make scissors move around if they're lying on their side"), I don't hold their hands anymore but demonstrate cutting with my own small scissors if they need further help.

TIPS FOR TEACHING
Your desire for your children's success can make you so impatient that you may not allow enough time for them to explore without making finished products. Sometimes they won't learn how to cut for months because their muscle coordination is slow in developing. If you want them to continue, don't make an issue of it or make them feel as if they've failed.

When they discover new ways of using the paper on their own, I call attention to their discoveries. For example, many fringe their papers because they can't cut out a large piece to make a shape. I

Children's collages. Three- and four-year-olds sometimes find shapes left over from another class and consequently their collages may appear to be more complicated than their real ability would normally allow. Sometimes children may be so pleased with one shape they have cut that they will not want to add anything more.

may point out what they've done so they realize that it is both a way to treat the edge of a paper and also a way of making a pattern.

It would be very confusing to show beginners how to make many forms when they are very young. When teaching how to paste and cut, I focus only on those two activities. Later, when we do constructions and texture or bas-relief collages, I concentrate on other skills. Remember to introduce ideas slowly.

Cutting with scissors is always difficult for anyone who's never learned how. Sometimes it takes weeks for a child to become comfortable with scissors. If you say, "It's so easy, anyone can cut!" they may stop cutting altogether when they find it difficult. I rarely see any two-and-a-half- or three-year-olds upset by their problems with cutting unless their parents start making comparisons of their progress with that of anyone else. I have found that most children love to use the scissors after they learn how. The only ones who don't are those who have had unhappy experiences while learning the process.

INTRODUCING NEW MATERIALS

After their introduction to pasting and cutting (which may take two or three sessions), I begin to introduce new materials.

The first requirement is to choose a variety of papers that are easy to cut and handle. If you stay with different kinds of medium-weight papers such as corrugated and shiny (not metallic) or very simple patterned papers (such as gift wrapping, shelf papers, corrugated liners from inside cookie boxes) until they've mastered the scissors, they feel confident enough to tackle new materials.

Tissue paper and cellophane are hard for young beginners to handle at first because they are flimsy and floppy (like chiffon and silk) and stick to their damp fingers.

If you are doing all these collage projects, you can add materials slowly each time one by one after they have had at least one session with only construction paper. Refer to the chapters discussing each specific type of material and back to Chapter 2, when organizing these supplies.

Outside field trips to find new pasteables can also be ideal sources for both you and the children. They provide an opportunity to talk about the materials and how each one looks and feels. You have to use words consistently and precisely when you introduce terms describing texture. For example, when you tell them that corrugated paper is bumpy, they don't realize what that means until you point it out in the paper in their hand and have them run their fingers over it. Then they will recognize that quality again when they see it and when you connect it with other materials as well. "Bumpy" can refer to a line, pattern, or texture. Later they will come to recognize gra-

dations and different kinds of bumpiness, "rough bumpy" in sidewalks and "smooth bumpy" in their corrugated paper.

If they start collecting materials on their own and choose more difficult-to-paste textured and patterned ones, refer to those respective chapters to obtain the proper glue and background supports for their pieces so the collages will hold together.

Lucas Samaras, American (born Greece). *BOOK*, 1968. Five-process print: silk screen, lithography, embossing, thermography, and die cutting. Each leaf 10" × 10" × 3/16". Samaras' accordion-folded book has cut-out "see-through" shapes as well as ones that are pasted and printed on the pages.

EXPERIENCED BEGINNERS' PROJECTS

If you have an older child (five- to seven-years old) who finds both pasting and cutting easy, you can reemphasize the idea of changing shapes by both cutting and tearing them. You may also begin to point out how they made shapes change by overlapping them and encourage them to try shapes in several different places before starting to paste so they may think about an arrangement. It may take time before they start to consciously shape and arrange the pieces with care. Finally they may begin to see the scissors as a drawing tool to make lines that define shapes. If they see you cutting and arrang-

ing interesting and complex lines and shapes, they may begin to consider their own cutting a means to a further goal rather than an end in itself. Later, after they begin to cut preplanned pieces to assemble into story images, they may try to create recognizable objects.

You may also introduce the hole puncher as a new tool here for those who can paste and cut.

SCHOOL-AGE BEGINNERS' PROJECTS (SEVEN YEARS OLD THROUGH HIGH SCHOOL)

I start the session by showing reproductions of collages, paintings, and various photographs of natural and man-made objects (depending on the theme). We talk about using the scissors as a drawing tool, about different kinds of shapes and their edges, and the spaces in between them. I ask what happens when you overlap them to change the character of their outlines, and their directions within the arrangement.

You can use collage for many projects such as greeting cards, masks on Halloween, a study of flags, and, later on, hats. Older children who need more challenges may work on making books. You might give them a blank notebook or make little accordion-style or fold-over-and-stapled booklets they can fill with their own collage and color stories.

Although you can get lots of educational books and magazines containing many paper projects, it's my hope that you will use them only for ideas and processes while encouraging individuality and departure from predetermined patterns and images.

NINE

Tissue-Paper Collage

W HEN I SEE THE SUN coming through mist or light shining
through the overlapping leaves of my window plants I think of
this tissue-paper collage project. The translucency and transparency,
plus the delicacy of this tissue medium suggest a warm lyric quality
because they create the glow of colored sunlight. Many artists
through the centuries have used the ethereal splendor of colored
light to evoke a sense of joy or feeling of the spiritual.

If you ever had an old set of those filmy, translucent nylon cur-
tains, you might remember how the overlapping folds of the material
muted the forms in the outdoor scene beyond the window. We see
this same translucent quality in man-of-war jellyfish and some kinds
of seaweeds, especially if viewed underwater.

When you overlap your tissue paper in this project some of the
underneath shapes and lines seem to hold back from asserting any
strong individual character, then later emerge from beneath a gos-
samer-spun film to move freely against a softly colored background
as if across a screen. Whether the shadows of the lines are fine or
heavy, swift or wavering, deliberate or capricious, they dance about
in an illusive field. Shapes appear through the layers as if in a mirage
or a dream with constantly changing figures.

These visual qualities are not peculiar only to translucent tissue or
transparent cellophane but are also common to stained glass, water-
colors, and transparent glazes in oil and acrylic paints. Opaque me-
diums can represent this luminous effect as well if they are
manipulated skillfully to create an illusion of transparency. (See
Blayton and Feininger illustrations, pages 158 and 159.) However,
since this quality is easy to see and achieve quickly with tissue paper,
we can learn about its visual effects without having previous experi-
ence mixing paint.

Plan to spend several sessions on this tissue-paper collage because
you are starting with a new medium that takes time to get used to.
Not only will you need more time to master pasting the filmy tissue,
but you also will be dealing with a new way of mixing color and
textures as well as using translucency and transparency.

Betty Blayton, American. *Concentrated Energies,* 1970. Oil paint and rice paper on canvas. 59" diameter. Ms. Blayton has used translucent rice paper instead of tissue paper for greater durability. The visual effects of this collage medium are similar to ones possible to achieve with tissue. (See Plate 25.)

I suggest that you tear your first collage shapes so that you will have one less tool to think about and be able to work more directly with your hands. After completing a torn collage with light colors on a white background paper, you might try a cut collage (or a combination of cut and torn shapes) and also vary the color or texture of the background. If you try a rough-textured paper or burlap for the ground, you can get a different set of spatial effects.

You can mix colors in two ways for this project. First, you can get one type of mixture by overlapping dry layers of tissue. Second, you can make an entirely different set of colors by spreading the glue both on the background and over the shape as you place the pieces on top of each other. By combining both techniques you can achieve an even wider range of shades, tints, and contrasts in texture as well as color.

You may observe other visual elements as you work with tissue paper. The strong effects of physical (or tactile) and purely visual textures may sometimes reverse the spatial illusion you planned through your color choices. The degree of density or opacity, transparency, matte flatness, glossy shine, roughness, or smoothness influence mood as well. In short, you may be in for some surprises, so don't try to stick rigidly to a preplanned effect.

Because the attractive colors of the tissue papers are very seductive in themselves, it's easy to rely on their intrinsic decorative qualities and let the paper dictate the results instead of really stretching the possibilities of the project. You might also be inhibited by becoming wary of messing up your pretty papers.

By tearing and working freely with the glue you can get a greater range of colors and textures than if you get overly precious about cutting and pasting. If you can paint with the glue as well as using it as an adhesive, you have the opportunity of working with a wider range of effects. Glue under the tissue causes a texture and color change in the paper that makes shapes where the glue is. If you paint down a layer of glue on the white background, lay down the colored tissue, and then lift it up after a few moments, you will get a pastel dye-transfer shape where the color bled onto the paper. Next, if you take the glue-covered piece and set it down in another place, the previous dye mark carries a trace of where it's been and suggests the quality of changing movements. If the arrangement doesn't work out just the way you wanted it, just keep pasting layer over layer, or do the reverse by peeling and tearing back the already pasted pieces. You have a while before the glue dries, so you don't have to rush.

WHAT KIND OF TISSUE WORKS BEST?

You may not have a choice of many papers if you live in a small town with few stores. However, if you can find a variety to choose from, it's better to get tissue that is as translucent as possible. The thinner papers are stronger and less porous than thicker, coarse types. Cheaper tissue has a kind of matted texture or grain that you can see when you hold it up to the light and will produce different effects than the finer kind. You can sometimes find a mixed pack of colors, but if you have to buy them separately you can always use the surplus

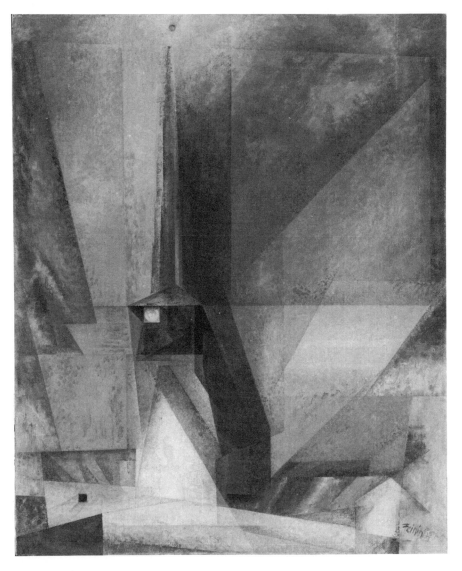

Lyonel Feininger, American. *The Church at Gelmeroda,* undated (early 20th century). Oil on canvas. 39½″ × 31⅝″. A good example of overlapping planes and transparency of color.

for gift wrapping. I purchase twelve different colors but restrict the initial collage arrangements to only three so it's easier to see how many different variations are possible by overlapping. If you use three light colors for your first collage, you will be able to see the color-mixing effects more easily.

Your Project: Mixing Colors and Creating Spaces by Overlapping
(For adults or advanced beginners)

MATERIALS:

18-by-24-inch sheet of white construction paper for the background

three different colors of 18-by-24 sheets of tissue paper. Cut these into half sizes (9 by 12) for easier handling.

a mixture of half white glue (such as Elmer's) and half water. If you add more water, the collage will be more matte and dryer looking, and if you add more glue you get a higher gloss with less texture. A 4-ounce jar of the mixture may last for several collages.

a ½-inch or smaller brush and an applicator stick (a coffee stirrer or toothpick will work here). If you are using a small glue container, make sure the handle of the brush is cut down to about 7 inches long so that the weight of the handle won't tip the container over.

large size (8-inch blade) scissors for your second collage

PROCEDURE:

1. Choose three different colors of tissue for your first collage on white construction paper. For your first collage, choose at least two fairly light ones out of the three because dark colors such as deep blue or black tend to obscure and block out the colors of the light ones underneath. (For your second collage, at another session, try

Adult's tissue-paper collage (below right). This work was done with pink, blue, and yellow tissue. The overlapping of shapes produced a variety of different colors. Note the clarity of color where there is no evidence of glue. (See Plate 27.)

Adult's tissue-paper collage (below left). The fascination with textural qualities that result when you use glue under and over tissue paper, giving a feeling of mood and place, took precedence over thoughts about shapes and space. (See Plate 28.)

mixing warm and cool colors using different degrees of light over dark and dark over light.)

2. Tear out shapes from the tissue sheets and move them around on the background so they partially overlap one another (the way you did with your previous collages). Try reversing the order of layering colors, putting one on top of and then underneath the others. Try two or three layers of the same color and then add different colors on top. Watch what happens to the intensity of all-the-same-colored layers over white. See how many new colors you can make with the combinations of papers.

3. Fill your entire background sheet, letting the shapes and colors suggest a theme if you wish. You may find it difficult to preplan a design because the gluing and overlapping dramatically change the visual elements as you work. You will probably make many changes when you see what the glue does to colors and textures. After you have torn a number of large and small shapes and have moved them into a basic arrangement, begin pasting before you finalize the details of any one solution.

4. *Pasting techniques*: Paste down your shapes using both of the following methods. However, you may want to use only one method at first so that you can discover the difference.

a. Lift the edges of the tissue and lightly dot the tissue paper at intervals under the outer edge of your shape, using the stick for applying the glue and keeping the center areas free of glue. You do not need to glue the entire border unless you want to. Notice that you have a mark where you place your glue—that is why it is a good idea to follow the contour of your shape.

b. Using your brush, paint down a layer of glue onto the background paper and press the piece down with your brush into the glue. This will change the texture and color considerably as the glue soaks through the paper so that you can see the underlayers with greater clarity. If you paint a layer of glue on the top surface of the piece as well, it will give you a glossy glaze.

If you find your colors beginning to bleed into your glue brush, you may have to wipe off the brush on another piece of paper. If you are working alone or with a child who is old enough to understand what you are doing, you might keep a small dish of water nearby to wash your glue brush in. However, it would be very confusing for a small child to see you washing your brush while pasting.

You may have to wipe your fingers on your smock frequently if they get damp or covered with glue, or you will have trouble handling and tearing new shapes from the tissue.

5. Because the pasting process takes more time with tissue than with construction paper, you may need more than an hour to com-

plete the entire piece. If you have to stop in the middle of gluing, place a piece of wax paper or plastic wrap over your whole arrangement. Next, slide a sheet of cardboard or other stiff paper under your collage so that you can carry it (keeping it horizontal) to a shelf or drawer for storage without disturbing the arrangement.

6. Save the rest of your tissue-paper scraps for later projects, putting the small scraps in a flat box and the larger ones in a manila folder or larger box. Even the very smallest scraps can be used for making greeting cards or bookmarks.

THINKING ABOUT WHAT YOU'VE DONE

To really see what you've done you've got to put your collage away, let it dry, and tack it up later on a vertical surface to examine it closely. It won't look the same dry as it did when it was wet.

The important issue in thinking about it is making connections with what you've learned in your previous projects. One reason we're doing these different experiments is to find out how to see things in a new way. If you merely arrange new materials without relating them to your last studio experiences, you may end up with a pretty result that relies only on the attractive qualities of the tissue rather than on your ability to manipulate the medium as a means of self-expression. Like some pretty pictures, this type of collage may become boring if it only displays a very limited range of expression.

A way of getting very striking qualities of design here is to really push the materials in as many different ways as you can think of, all the while remembering how to get contrasts between the elements of shape, size, texture, line, color, and spatial arrangements.

CREATING A SPACE WITH COLOR

When gazing at an outdoor landscape we often become conscious of a haze that seems to envelop all distant objects, especially when we see hills or mountains in the distance. The shapes become less distinct and colors become muted, cooler, and grayed. If you sit in a field on a summer day, there is no mistaking the yellow-green of the nearby foliage. But as you look at bushes that are farther away you can see a bluish tinge to the green leaves. If the field is also filled with red poppies, the farther away you look, the more the red also turns bluish-gray until finally all colors lighten and vanish in the atmospheric haze. When you soften and mute the shapes as well as cooling and graying the colors it suggests objects at a distance, while sharper shapes with strong bright colors suggest things nearby. This pictorial use of color and shape is called atmospheric (or aerial) perspective. Look at your tissue-paper collage to see where it occurs.

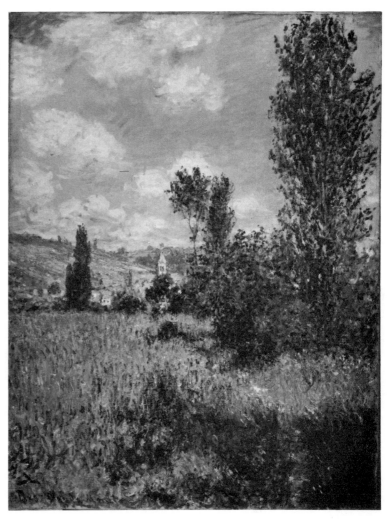

Claude Monet, French. *Path in the Ile Saint-Martin, Vertheuil,* 1880. Oil on canvas. 31½" × 23¾". (See Plate 26.)

CREATING SPACE WITH TEXTURE

On the other hand, you may see another set of effects that contradict these color expectations because of the textures and their relative degree of transparency. Although you may have found that in your earlier collages, certain colors tended to recede behind other ones, now you may see that the effects become reversed. Moreover, if you have left white spaces on your background that are uncovered by any tissue at all, these shapes may appear solid and project out sharply in front of the tissued areas to dominate your arrangement instead of creating a spatial field. This is why I suggest you cover your entire paper.

However, there are no set rules for using these individual visual elements for specific effects, because, like painted color, each one is governed by all the qualities of the shapes next to it—position, texture, translucency, and size. Watch how the size of your colored shapes also affects their depth illusion. For example, a large red area underneath a small yellow one may remain as background. But if the

yellow is bigger and overlaps the red, the yellow becomes background and may push the smaller red forward. The color of the paper they are on will also influence the illusion.

YOUNG BEGINNERS' WORK WITH TISSUE PAPER

I do not suggest giving tissue paper to any beginners before they learn how to paste because they will find it very difficult to handle. However, I usually have introduced it to the children by the time the adults have an experience with tissue paper. While I plan no specific project for the young beginners, I do call attention to the material by

Collages with transparent materials by young beginners.

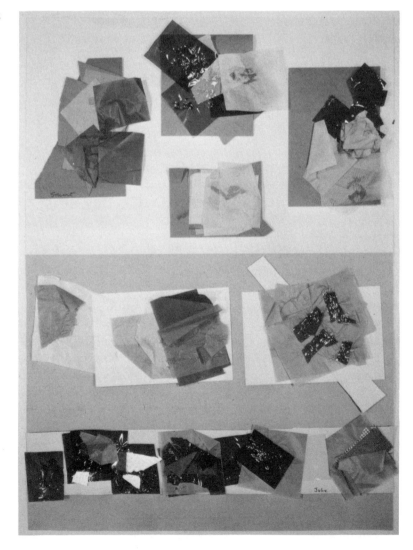

showing and talking about it first and then by adding pieces of cellophane to their choosing tray around the fifth or sixth session. Cellophane may be easier for some children to handle than tissue and its transparency (or "see-through" quality) is more immediately recognizable and intriguing. (Discarded theatrical lighting gels are even better because they have an even wider range of colors and stick to the CICO paste more effectively. However, they are too expensive to buy for this purpose.)

When I prepare cellophane, I cut it up in squares and show it to the children after they have been working for a while during the session and have already pasted some other kinds of shapes on their papers. I present it by holding it up in front of my eyes and saying something about how it makes colors change. Then I give each person two pieces of it so they can also hold it up and see this phenomenon for themselves. I may pick up a shape from the choosing dish, lay the cellophane on top of it, and note that the cellophane appears to have changed the underneath color. Young beginners may or may not see this immediately because they notice the shininess and "see-through" qualities first before they see the color changes. If youngsters have painted before, they will understand the concept of color change more easily. If you keep adding one color at a time, they will be able to explore the possibilities of each in more depth than if you set out a lot of them in the tray all at once.

Children may come to cellophane first when collecting collage materials because so many foods are wrapped in it. Sadly, now cellophane is being replaced by thin plastic that doesn't have the same clarity, but can also be used for collage.

MORE EXPERIENCED BEGINNERS' WORK WITH TISSUE PAPER

By the sixth session, when they know how to paste, you can add tissue to the collage materials. They find it in the tray and as they use it I help them to examine some of the ways in which it differs from the other papers they have been using. We learn that tissue makes a rustling sound when we touch it (in contrast to the bumpy sound of corrugated paper), and it's floppy and soft instead of stiff and hard. We discover how overlapping changes the appearance of underneath shapes, but I don't show how to paste it in any new way. They continue to put paste on the background paper and then put the tissue on top of the paste.

Another material I often add to the collage tray (about five or six weeks after we start) is a few cotton balls. You get these in medicine

jars and can purchase them in drugstores. As they use them we talk about how they feel. What happens to their shape if you pull them apart? Do they look like clouds blowing around in the sky? ("Sometimes we can even see through clouds when they are close to the sun.")

ADVANCED BEGINNERS' WORK WITH TISSUE PAPER

I show many examples of tissue collages and reproductions of paintings as well as photographs of nature. Underwater scenes with lots of sea creatures suggest a likely theme for tissue. Sometimes we combine patterned paper with the tissue, or add paint. You can combine all these mediums and techniques as you go along. However, first you need to examine each one separately in order to build awareness of their unique qualities.

We may tape layers of cellophane on the windowpane and change the colors to see how different they look. We think about stained glass windows in churches, temples, and in the museum. Do colored bottles make the food inside look different?

TALKING ABOUT THEIR WORK

If you ask beginners leading questions, you might be able to get them to talk and think about what they see happening on their papers so that they can relate ideas to themselves. We often forget that awareness is not an outright gift. No one automatically sees something. People will walk the same route day after day and never notice many things on it because our social orientation has always emphasized learning practical and competitive skills instead of sensory pleasures.

Yet connecting words with visual experience is useful as well as enjoyable. Our sense of the significance of things comes from making comparisons, evaluating, and saving experience in memory. This is less likely to happen, or may progress very slowly, if anyone is working on these projects alone. It's the shared looking, doing, and talking together that leads to greater awareness. You point out what you see and feel and the other person does the same. Artists have long worked in association with each other in order to nurture new ideas.

When the children and I talk about collage materials together, it's a discovery for them and a rediscovery for me to touch and explore what each material can do. Some parents tell me they've never enjoyed going to museums as much as when they've brought their children. One time when I took a group of young children who were

starting dance lessons to see the Lumia exhibit—light and sound on a large screen—at The Museum of Modern Art, they saw it as a ballet of color and began moving in rhythm to the changing light patterns. Later when we went into the sculpture garden, I was acutely aware of the pink-orange light of the setting sun and was delighted when the children noticed how the sunlight danced on the metal sculptures.

In short, I have found that sharing awareness is a pleasurable two-way street. If you only try to fill your children's minds with your own ideas, you lose the opportunity to come to new perceptions yourself.

. . . it is not my design to teach the method that everyone must follow in order to use his reason properly, but only to show the way in which I have tried to use my own.

<div align="right">Descartes, French philosopher*</div>

* From *Discourse on Method*.

TEN

Painting Shapes

W HEN CHILDREN OCCASIONALLY ASK ME "Why are you always talking about shapes? Nobody at home talks about them!" I reply, "Because everything is made up of shapes. Your head and hands and the table are all shapes." Then they want to know, "How can you say all those things are one word?" and I explain that *shape* is a word that tells you how to recognize many things. You know an orange is round. If you have a pointy orange shape, it might be a carrot. Shapes are one way of showing how things are different from each other. A house or tree is not one kind of shape but many of them.

I don't paint things; I paint the differences between things.

Henri Matisse, French painter*

More experienced beginners also come to discover that shape not only defines the boundaries and differences between things but also expresses ideas. For example, an organic shape can relay qualities of growth and sensuousness or feelings of vitality in nature. Geometric shapes not only reflect qualities in both nature and man-made objects but can also suggest ideas of stability, perfection, and balance.

People often think the word *abstract* means something that cannot be touched, like "sensitivity" or "excitement"—something without physical reality. Yet abstract shapes most certainly can be touched; they are physically real, yet may not literally illustrate something in nature. Their selection and arrangement in an image can express the structure or the essentially important qualities of an object, situation, feeling, or idea. An abstract image is not merely a distillation and simplification of traits taken from our visual surroundings but seeks to represent a deeper underlying quality of life beyond surface appearances. Using abstract shapes in the visual arts can be compared to employing metaphorical images in poetry where a word or phrase does not literally stand for an object or idea. For example, in William Blake's poem "Tyger, Tyger, Burning Bright" from *Songs of Innocence*, the poet used the word *tyger* but was really talking about the fire of the generative spirit of creativity, not the animal itself.

* From Jack D. Flam, *Matisse on Art.* See illustrations, pages 133 and 147.

Marsden Hartley, American. *Portrait of a German Officer,* undated (early 20th century). Oil on canvas. 68¼" × 41⅜".
These paintings by Hartley and Miró illustrate the idea that portraits can be composed of shapes without being photographically representational.

168

When we paint shapes we are making a kind of abstraction, no matter how allusionistically we represent them, because we do not actually see objects in terms of lines and brush strokes. When we make images in any medium, we first choose what qualities are important to present, and then we express an equivalent for them in paint or other medium. Everyone, adults as well as children, sees much more than they are capable of expressing with the materials. As experienced adults we are aware of different ways of representing images, even if we haven't painted before and don't know how to reproduce them, because we've seen pictures our whole lives. When children make marks and arrangements that superficially resemble abstract fine art, remember that not only do they have a more limited basis for making their aesthetic decisions and that they make shapes expressing momentary impulses, but also that they know fewer ways to paint these. Although many of their marks are deliberate, a great many others are delightful, nonrepeatable accidents. If an adult chooses to paint a few abstract shapes that are simply arranged, it represents a deliberate choice to structure their image in a way that focuses most clearly on the expressive aspects they want to emphasize.

Shapes that appear to be derived from no single representational object or place and seek to evoke universal symbols are termed "nonobjective" or "nonreferential," yet they may call to mind very concrete sensations of celebration, mourning, energy, or playfulness.

Joan Miró, Spanish. *Portrait of Mrs. Mills in 1750*, 1929. Oil on canvas. 42½″ × 35″. When I show this to the children, I point out the variety of different shapes—round, wavy, and spiky. Older people might notice the way Miró laid out a background field and arranged the shapes on top of it.

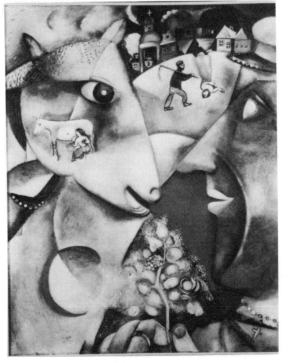

Marc Chagall, French (born Russia). *I and the Village*, 1911. Oil on canvas. 75⅝″ × 59⅝″. I put a reproduction of this painting up in class because the directions of the shapes point to the dialogue between the forces of life (those of nature and the works of mankind) that sustain the life of the village. I point out to the children how the various colors sit next to each other and on top of each other. This painting also illustrates the dynamic effects of overlapping shapes. (See Plate 32.)

Abstract shapes can evoke emotional responses, so when you choose your painted shapes, try to think of what they feel like apart from their associations with recognizable objects.

There is an infinite variety of shapes and no one single way to shape anything. Your perception of what a shape represents depends on your viewpoint in space, culture, and time. You know that when you look at a building from a distance the size and features are very different from when you are next to it and the roof towers above you.

Aesthetic judgment varies with the times and personal interpretation. When one five-year-old in my class said he was painting a cat, a second child looked over and said, "That doesn't look like a cat." At this point a third boy got off his stool, came over and studied the painting carefully, and announced with great authority and assurance, "Yes, it *is* a cat!" Some shapes, however, do have widespread traditional associations, such as the circles, stars, crosses, trees, and animals that artists have used in paintings for centuries. (See Marc Chagall's *I and the Village*, previous page.)

How you paint a shape also depends on how you want to use it within your composition and what you want it to say. For example, do you want it to be seen close up, at an oblique angle, or at a great distance? It takes several elements to define a visual situation or tell a story with shapes. Shapes can look big, heavy, or monumental, no matter what their actual size when they are placed next to much smaller ones. A round shape can look light and buoyant like a balloon or heavy like a rock, depending on its precise shape, texture, and color.

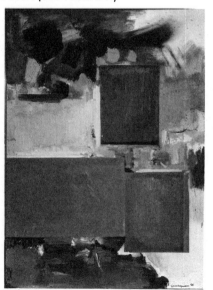

Hans Hofmann, American. *Rhapsody*, 1965. Oil on canvas. 84¼" × 60½". (See Plate 31.)

COMPOSING A SPACE WITH SHAPES

What is common to both your past collage and current painting projects is a similar method of constructing a pictorial space with shapes. Each successive type of collage added more visual information in order to focus on how to represent specific ideas about the images you were making. In your torn-paper collage with two colors, you placed pieces on a background to see how shapes were formed by the spaces in between them. What you may have gotten was a generalized space which evoked no precise place. Your cut-paper collage in three or more colors used overlapping of different colored shapes in arrangements that made things seem to project and recede more precisely than in the torn collage. Next, your tissue collage project gave you the opportunity to mix colors and define space by virtue of the translucency and texture of shapes.

Often when you look at a painting you might be able to analyze how elements of color, line, and arrangement express certain ideas

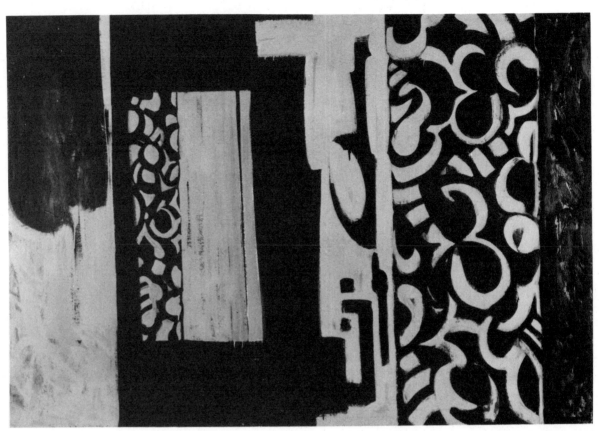

Lee Krasner, American. *Blue and Black*, 1951–53. Oil on canvas. 58" × 82½".

Robert Motherwell, American. *Elegy to the Spanish Republic, 70,* 1961. Oil on canvas. 69" × 114".

Maurice Prendergast, American. *Pi-azza di San Marco,* c. 1898. Water-color and pencil. 16⅛″ × 15″. (See Plate 29.)

David's cat. This cat looked like a praying mantis to me until months later when I saw a photograph of a cat reaching up ready to climb. There was the "cat" painting. David owned a cat and obviously had watched it closely (whereas I had not noticed this feline gesture).

and feelings, but you don't know how the painter actually made the work, the order of procedure for putting the parts together. Often when beginners draw and paint, they place shapes horizontally and vertically around the page as separate objects, alter the outlines to give the illusion of depth with lines of perspective, and then fill in each area with color like doing a jigsaw puzzle or paint-by-numbers set. By contrast, experienced artists more often work in a series of layers, painting one shape over the next instead of stopping at the boundaries of each and moving their brush a few inches left or right to start a new one. It's somewhat like designing a stage set: putting in the backdrop, adding the props, and finally moving the actors across the stage from back to front and side to side. This kind of process is building a structure from the ground (or paper) up. If you merely progress from one small area to another across your paper, filling in shapes and spaces instead of layering in depth, you may have a more difficult time making your painting hold together as a composition. It's also more difficult to begin a work this way because you may feel the need for a preconceived image in order to start painting at all. If you don't have any specific idea of what you want to do, how and where do you start? At the top, the bottom, the middle?

That's why I suggest you use this layering method of first making a

general background and then adding shapes to build your picture. If you first paint two or three washes of color to cover and divide your entire paper, these areas will already begin to suggest a pictorial situation. Horizontal divisions, for example, almost automatically suggest a landscape or seascape.

When you use your large paint brush to make shapes by enlarging puddles of paint, you won't be tempted to merely draw outlines and fill them in. When you generate a shape from its inside, your edges will be a result of your internal organization of strokes. It is possible to see this clearly if you look at the Clyfford Still and Van Gogh paintings reproduced on pages 124 and 47. Other good examples are Impressionist landscapes where the dab, the stroke, or splash of pigment is the blade of grass or the diamond-shaped glint of sunlight reflected atop water instead of being the interior of a black outline. Remember when you were doing your collages that the cut or torn outlines didn't stand out as separate from their shapes. Matisse felt this was very important to his work.

Color must not simply 'clothe' the form; it must constitute it. . . . when I use paint, I have the feeling of quantity—a surface of color which is necessary to me, and I modify its contour in order to determine my feeling clearly in a definitive way.

Henri Matisse, French painter*

* From an interview with Maria Luz, 1951, in Jack D. Flam, *Matisse on Art.*

Dona Nelson, American. *Untitled*, 1978. Oil on canvas. 32" × 41".

Paul Gauguin, French. *A Farm in Brittany*, undated (last half of the 19th century). Oil on canvas. 28½" × 35⅝". (See Plate 30.)

Adult's shape painting.

Adult's shape painting.

Many artists do outline shapes in contrasting colors for specific effects, as for example to give the feeling of a stained-glass window. You might try making shapes with both methods to see the results for yourself by using light outlines. However, if you make a dark outline on a shape first, you may be less likely to want to change it and the line may be difficult to cover with a lighter color. You may have to erase the previous outline by painting it over with white, letting it dry, and then continuing.

I suggest that you do not spend a lot of time trying to get any individual shape "right," but instead brush in areas of color freely and directly. Painters and illustrators may work over a shape dozens of times, even using tracing paper to transfer the final result onto a fresh sheet of paper. When you see the end product in museums and books, you have no idea how many sketches and preliminary drawings preceded it. To set yourself up to compete with the finished drawings or paintings of professionals during your one-hour project is to put yourself in a no-win situation. That's not the aim of these projects.

Your Project: Making a Painting About Shapes

PROCEDURE:

1. *Choosing a theme:* You might think of a shape that is familiar to you and imagine painting it in many large and small variations. If you use the letters of your name, you might turn them on many sides and put them on top of each other. Another source of themes might be music or movie titles such as *The Grand Canyon Suite* or *Modern Times.* On the other hand, you might not choose any theme at all now and just work intuitively by letting your first colors and shapes suggest an idea.

2. Use your large brush to color your paper into one, two, or three sections of thin washes or thicker opaque layers of different colors, making sure you cover the entire white surface. These sections might be roughly horizontal, vertical, or diagonal. Remember, if you paint over a wet area at once you will get a different effect than if you paint over a dry one.

3. Dip your brush into another color and set it down in one of the sections. Spread your paint with the brush until it becomes a shape.

4. Make other shapes in the same and different colors, and continue to fill your page. Vary the textures and the kinds of brush strokes on different shapes.

You might make two or three groups of shapes communicate across the page by letting them express different gestures or direc-

tions in space according to their arrangements. One of these groups could be the most important visually by virtue of its size, color, and depth of overlapping. You might even think of it as a circus of shapes. One action group might surround another, penetrate it, or almost completely overlap it. You could use translucent or transparent washes of shapes on top of opaque ones underneath to show overlapping of parts as you did with tissue-paper collage.

5. Let some of the shapes dry enough to paint other colors on top of them. Then you can overlap new shapes in layers without blending the colors. You may find that you get spatial effects that you had not anticipated. If you are displeased with any results, merely paint over that section with white, let it dry, and begin again.

6. Examine the spaces in between your shapes as you work. If you find the intervals between them too regular or irregular for your taste, alter the shapes surrounding them with your smaller brush. You might also consider painting the in-between shapes with another color.

7. Let your painting dry on a horizontal surface. Later, tack it on a vertical one to examine your results. Feel free to change any of the parts by reworking them with either your large or small brush.

Adult's shape painting. This person made a stained-glass effect by isolating the shapes within yellow and black lines. (See Plate 35.)

Further Possibilities
When you do a second shape painting another time, you might use one of your previous collages as a starting point so that you can compare the same composition in two different mediums. Construct the painting the way you did with the collage by first painting a wash of the same color as the background, and then progressing to the uppermost layers by overlaying more painted shapes. You might also do a painting of your tissue-paper collage, attempting to mix the same colors. Feel free to deviate from the original collage and investigate new directions.

THINKING ABOUT WHAT YOU'VE DONE
In this project you've been putting together ideas from all your previous painting and collage projects. You've mixed and blended the paint to evoke a theme or mood and have used the graphic or drawing qualities of collage to make shapes and spaces.

One element of shape that makes it so compelling is a concrete and graphic quality that is a result of its use of edge. It is this element of edge, or boundary between things, that defines a shape.

At this point you might compare all the different kinds of edges you've worked with. When you explored shape in torn and cut collage, you saw the absolute clarity and hardness of the edges because

Adult's shape painting. This person used overlapping of shapes to achieve a quality of spatial complexity. (See Plate 34.)

Domenico Ghirlandaio, Italian. *Francesco Sassetti and His Son Teodoro,* undated (last half of the 15th century). Tempera on wood. 29½″ × 20½″.

of the physical thickness and layering of the paper. You became familiar with the uniqueness of the torn ragged edge, the smooth-edged cut contour line, and also the blended edge with overlapped tissue paper. Here, when you painted edges, you could get all of these effects together in the same work: ragged (see Clyfford Still illustration, page 124), smooth (see Stuart Davis illustration, page 145), and combined effects (see Gorky illustration, page 91). Your edges become expressive in relation to the colored shapes beneath them and around them.

Many paintings use combinations of several types of edges to define shapes, although individual painters may emphasize one kind of edge or another in their own personal style. When the effect of edges and the impact of individual shapes is subordinated to a general flow of colored brushwork, the style of painting is called *painterly*. Another style, where the edges of shapes emphasize lines that lead the eye from shape to shape, is called *linear*. Neither style is superior. Each can be used as a means of expressing different ideas and feelings.

You explored the painterly approach in your earliest paintings where you created mood in a field of color without shapes. If you defined areas of color, they were blended or dissolved in translucent washes or merged with other soft atmospheric shapes. You may have found this method useful for representing atmospheric images such as clouds, water, smoke, fire, and rain. This kind of paint handling can also be used to imply distance. For example, when you look at someone close up, you can see the lines of his face and clothing. When he is across the street, you may only see a suggestion of small features. Painters such as Titian, Hals, or Rembrandt might paint an embroidered collar as a white shimmer to establish a general view of a whole scene at a certain distance.

If your present painting has the lines of edges dominating your composition, you might also have felt an appeal to your sense of touch. That's because when you can clearly read the edges of the

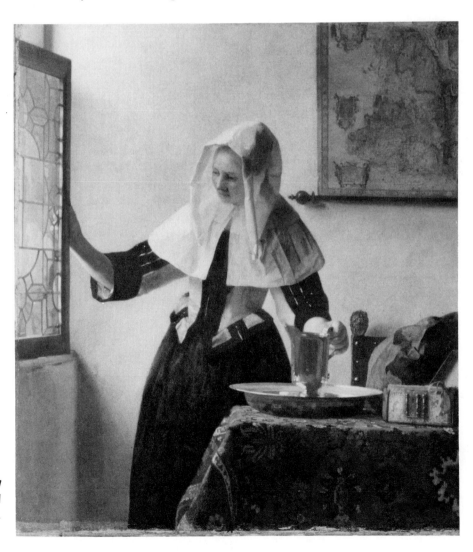

Johannes Vermeer, Dutch. *Young Woman with a Water Jug,* undated (mid 17th century). Oil on canvas. 16″ × 18″.

shapes, it seems as if you can reach out and move your fingers along their boundaries. Many painters use this emphasis to suggest a definite physical concreteness and a sense of permanence rather than a feeling of continuously changing appearances (see Domenico Ghirlandaio illustration, page 176).

I have found that many adults seem to need to identify each object in a representational way, yet by doing this project I hope you will come to see that scenes and objects can be perceived in terms of pure shapes as well. You can see Vermeer's *Young Woman with a Water Jug* as a harmony of rectangles (walls, window, map, chair back, box, table, and so forth) with variations in the angles and overlapping shapes. Yet within this quiet, orderly structure of abstract geometric shapes you can get a precise feeling of the cool hardness of the metal, crisp edges of the linen headdress, and nubby woven tablecover. Jean-Baptiste Siméon Chardin's *Blowing Bubbles* can also be viewed as an arrangement of overlapping shapes. From the background forward comes a half-circle of the younger boy's head, a triangle of the figure blowing the bubble, the glass rectangular ledge, bubble out front.

YOUNG BEGINNERS' PAINTINGS

I would like to remind you not to suggest topics for young beginners. The paint and brush are motivation enough. Children may announce what they're painting while they're working and then change the subject several times during the process. They become involved watching colors flow into shapes and lines, and when these look like something special, they name it. But it may change with the next brush stroke, and at the end, they may forget entirely what they said before.

Sometimes I've heard adults ask children as they come into the art room, "What are you going to paint today?" or, "Don't forget, you said you were going to paint a cow." Adults often have the mistaken idea that, like putting on a smock, you need a subject to work on to be able to start. Actually, young children rarely preplan their paintings. As they begin to develop control of their brushes, they often make shapes that take on meaning for them. When they want to paint what they are thinking about, they usually do not announce it in advance but go directly to the paint and do it.

It was unusual when Naomi, almost three, came in, sat down, and immediately drew a large red shape with blue ones on either side, and then more blue ones. She did it with such authority. Her mother was amazed as she watched the painting develop. Naomi had told her before class, "Today I'm going to paint a house with blue trees

Four-and-a-half-year-old's painting. (See Plate 33.)

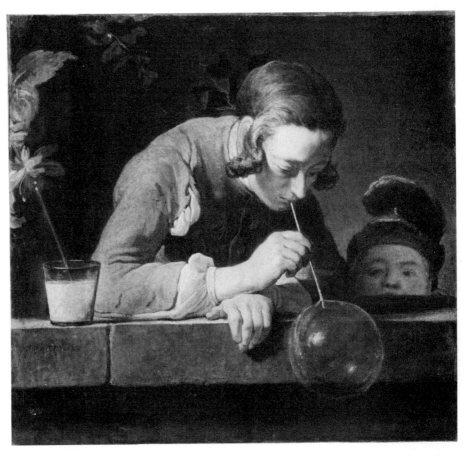

Jean-Baptiste Siméon Chardin, French. *Blowing Bubbles (Les Bouteilles de Savon),* undated (18th century). Oil on canvas. 24″ × 24⅞″.

around it," and had done it. As far as I could tell it was her only preplanned painting that semester, or at least it was the only one she talked about.

Older children may preplan, although I never push them into doing it. The mother of four-and-a-half-year-old Shawn told me that every night before class he planned out what he was going to paint the next morning, and then did it. He made very formal symmetrical designs. I was afraid that he would lock himself into trying to paint things that he couldn't represent and feel he had failed—just as a lot of adults do. So I told him, "It's wonderful to think about what you paint, but the paint also has a way of telling you about other things that may be more interesting to you than your first idea." Then he embellished his design a bit more and preached to his mother, "When you're doing your paintings you might want to change things!"

Children who paint after they've had a vivid impression may diagram it in a very simple way, explaining it as they go along. Some may do a whole series of such paintings on one subject.

Three-year-old Guy was obsessed with trains. He came to class each week clutching one in his hand and painted trains week after week. He adored the reproduction of Picken's *Manchester Valley* because of the train in it. He really knew what each car looked like, whether it was a tank car or a caboose. In order to get him to expand his paintings so that he would also think of colors and other kinds of shapes, I would ask him where the trains were, "Is it a place where there are trees? Houses? Bridges?"

Steven, also aged three, loved tigers and also painted them for weeks—tigers in the woods, in caves, in houses, even floating in the clouds. He may have had a favorite book at home on tigers or have seen them at the zoo. Steven's images didn't really look like tigers. Sometimes they were even behind things so you couldn't see them.

These children illustrated two different approaches to storytelling in their paintings. Guy was interested in an analytic way of illustrating trains and used a linear style of drawing. He could have been using any other medium to make them—crayons, pencils, or felt-tip markers. Steven was interested also in the qualities of paint as well as his subject so that his tigers had tremendous variety. At times I wondered if the tiger (as in the previously mentioned Blake poem, "Tyger, Tyger . . .") was an intuitive metaphor for his creativity or a subject title to satisfy his parents when they asked him what he painted that day. Despite the tigers, Steven had learned how to enjoy the process of invention in painting and didn't measure himself against a representational ideal.

Guy's trains. (There are two trains here, one above the other.)

Charles Demuth, American. *I Saw the Figure 5 in Gold,* 1928. Oil paint on composition board. 36″ × 29¾″. This painting was inspired by the poem of the same name written by Demuth's good friend William Carlos Williams. The gold figure five was on a fire truck and you can see how the design incorporates the headlights and poet's name. This work is a good example of how overlapping shapes can create an intense visual rhythm, here evoking the feeling of this racing vehicle with a clanging gong.

Sometimes adults have the mistaken idea that painting is more of a learning experience if the children can tell a story about it. My four-year-old nephew used to come home from nursery school day after day with the same painting, but a different story recorded for him at the bottom of the page. He became very skilled at telling stories but learned very little about painting. When I talk with children about their paintings, we discuss what they've done on the paper. If what they have actually done seems important, then making up fantasy stories becomes less absorbing than the process of making a painting. If you allow children to make shapes that don't necessarily have to represent something or tell a story, they may feel freer to paint more spontaneously without fear of criticism.

Four-year-olds are more conscious of shape than three-year-olds even though things may be put down on paper where their brush

lands while they are looking across the table at someone else. They organize visual experiences into general traits (such as·a vague blob for a person, later roundness for a head) and add more particulars as they progress. People may be upside down or sideways, not because they see them this way but because they do not care about how to represent perpendicularity by horizontal and vertical gestures on

Four-and-a-half-year-old's beginning story painting with figures.

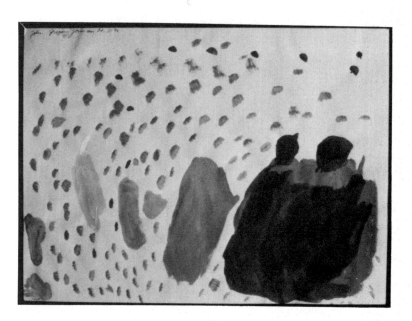

Painting by a four-and-a-half-year-old who is learning letters.

their paper. They will only become interested in doing that when it becomes important to them. Often in their early paintings of people there won't be any arms or maybe only a head and a lot of hair, especially if they or their mother have a lot of beautiful hair. The details chosen may be personally significant to them but not to you because they are painting what is important to them *at the moment*.

By contrast, mature artists choose arrangements and details that embrace a whole range of experience from the initial inspiration through the long task of fitting that experience to the particular demands of the medium. They look for elements that can communicate to other people a depth of expressive meaning, a form that can convey universal values within their specific image.

ADVANCED BEGINNERS' PAINTINGS

As they gain in experience, I continue to point out what I see happening in their paintings, especially the way they let their brush "walk around the paper" or make lines. I show reproductions of paintings that have a variety of shapes and lines, abstract images as well as representations of bridges, smokestacks, roads, and tree trunks. Although I might suggest a general theme—"Letters," "Where do animals live?" or "A place I like to go with my family"—if the children are making other discoveries on their own I don't impose my project on them. My topics are broad enough so there is room for the children to carry them in any possible direction according to their own interests. One might like cars, another might want to paint a place as seen from an airplane.

I may show them the insides of old clocks, unusual stones and leaves, the branches of pussy willows in the spring, or a collection of different-shaped items—always talking about their visual qualities and the place where you would see them. I have a collection of hats that I have displayed on top of bottles—a pith helmet, beret, sun hat, and golf or baseball hat. One session the group had a great time talking about what you might be doing if you were wearing one of those hats. The result was a wide variety of paintings that never would have happened without seeing the hats. There were hunters in Africa, ice skaters, Hawaiian hula dancers, as well as a circus clown. Some children made color paintings about a place; others invented fantastic hats of their own.

TIPS FOR TEACHING

If you demonstrate how to make images by having them copy your examples, you are really telling them that what they can do by them-

selves isn't good enough. This can inhibit their trying to invent anything for themselves. While you might like to encourage your child to make pleasing pictures that you can proudly display in the living room, I have found that being overdirective will hinder beginners.

I tell painters never to imitate other painters' manners because by so doing, they will be called grandsons, and not sons of nature, as far as art is concerned. For, as natural things are so plentiful, one must rather have recourse to nature herself than to the masters who have learned from nature.
Leonardo da Vinci, Italian Renaissance painter*

Naturally, there will be teachers who have other ideas about learning how to paint. For example, Jennie, aged four, enjoyed mixing colors and experimenting with her brush and paint. One day she came to class excited with holiday spirit. She said nothing but began to paint a large figure, something she hadn't done before. Her painting told of wonderful things that were happening outside—a great big Santa Claus was standing tall and ringing his bell. The following week she made a collage-painting and again, exuberantly mixed many of her own colors.

After the holidays, Jennie did not return until the last two sessions of the semester. As she worked on her new paintings she was strained, painstaking, and very quiet. She drew the outline of a house in black and door in yellow, and then stopped. In an attempt to get her to develop her painting further I commented, "You've made a house. Is it in any special place?" She said it was a ski house and dabbed in some white snow around the house. When I asked if she was going to use any other colors she looked up and said, "My teacher in my other school says you must never mix up your colors if you want to do a good painting, and you must be very neat."

I explained, "There are many different ways of painting and some teachers believe different things. But when you are here you may paint the way you like to paint." My attempts to encourage her to paint in her own way again were futile. She had started in a five-day-a-week nursery school and came to art class one afternoon a week. I asked if she had art often in her new school. She answered, "Every day, but you don't have to go if you don't want to." I said, "Do you go?" She shook her head sadly, "No."

WHAT ABOUT COPYING TO STUDY SHAPES?

This issue depends on the aim of your workshop and the experience of your participants. These workshops for *beginners* seek to encourage personal involvement that will build a general awareness of many

* Excerpt from his notebooks.

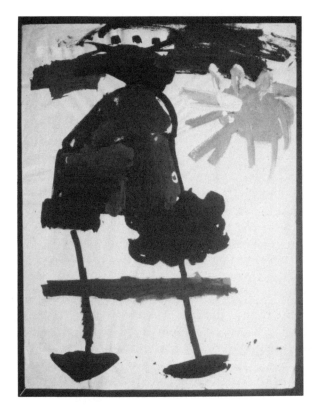

Jenny's Santa.

issues in art and also begin to develop one's visual and inventive abilities. Professional art school exercises using copying are designed for people who are already intensely involved with art and who study to achieve a very high degree of visual discrimination. Copying is frustrating for young beginners who are neither interested in nor capable of this level of specialization. Because young people are often afraid of being wrong, they can easily be seduced into copying. However, if praise for this activity stops, they may rebel and refuse to do any studio projects altogether. Even with older beginners one has to understand what can happen if copying is used as a studio exercise. I've known people who've resented their unhappy experiences of finding out that after enjoying early years of prestige in school for skill in making copies of pictures, it was very difficult for them to invent anything of their own.

. . . Don't be mistaken. I didn't copy the tree. The tree has a mass of effects upon me. It is not a question of drawing a tree which I am looking at. I have before me an object which exerts an action upon my spirit, not only as a tree, but also in rapport with many other sentiments. I don't rid myself of my emotions by copying the tree exactly or by drawing the leaves one by

one in the current popular style, I identify with the tree. I must find my own symbol for the tree, not the symbol for a tree as seen by another artist, but one which grows out of my own spirit.

Henri Matisse, French painter*

As adults, we're able to make choices about the aims of our studies and also whether or not we want to expose our own ideas and feelings. If we haven't had experience in using particular materials and don't know where to start, we may feel the need to rely on the technical expertise of a professional pattern or recipe and follow it exactly. However, if we are familiar with the practice of inventing in other areas and have confidence in our own judgment, then, even if we do use a pattern we will feel free to depart from it and make changes that are closer to our own taste.

I feel I owe it to the children and any beginner to give them the opportunity to develop respect for their own ways of seeing and representing their feelings and ideas, because they are not aware of all the choices that are open to them. When your child is first writing a story, if you want him to feel free to write, you don't criticize his penmanship or his narrative technique.

I find that another problem with copying for young beginners is putting the emphasis in the wrong place. If you stress that paintings are models of achievement to copy, they have no possibility of competing with professionals who've devoted their entire lives to their art. The value of personal invention becomes subservient to competition with art history. Beginners won't be able to develop a way of working that is generative of their own ideas and will need to continually look to the teachers or masters for advice and approval.

If you use paintings for ideas, let them be jumping-off points for individual expression. If you say, "Look at the kinds of shapes, or colors, or brush strokes," the children will learn to represent their own subjects in their own ways.

. . . It is only the sign-painter who should copy the work of others. If you reproduce what another has done you are nothing but a maker of patchwork; you blunt your sensibility and immobilize your coloring.

Paul Gauguin, French painter†

After having withered for days and nights before immobile and inanimate nature, we are presented with living nature, and suddenly all the preceding

* Excerpt from Henri Matisse, *Ecrits et Propos sur l'Art*, Paris: Collection Savoir-Hermann, 1972, translated by Sharon Adler.

† Excerpt from his notebooks, quoted in Robert Goldwater and Marco Treves, *Artists on Art: From the 14th to the 20th Century*, New York: Pantheon, 1945. See illustration, page 173.

years seem wasted: we were no more at a loss the first time we held a pencil. The eye must be taught to look at nature; and how many have never seen and will never see it! It is the agony of our lives. We have been kept thus for five or six years before the model when we are delivered over to our genius, if we have any. Talent does not declare itself in an instant. . . .

Jean-Baptiste Siméon Chardin, French painter*

EXHIBITING CHILDREN'S WORK

Just as copying reproductions puts too much emphasis on the final product, so does exhibiting everything your child makes all over the house. If you do so, you distort the value of the work as an exploratory experience. You can teach children something about decision-making by letting them make choices about the one or two they want to exhibit.

You can make a gallery in any one of many places in your home with a cork or Homasote bulletin board or by holding paintings and drawings onto the refrigerator door with magnets. If you have already purchased a child's easel and are no longer using it for working (see page 30), you can use it to display their finished work. This way you needn't put up tacks or tape on the wall and paintings can be held by clips that fasten the painted paper to the easel board.

Some parents have one or two works nicely mounted and framed to put up in their offices or living rooms. This is fine if you put the emphasis in the right place—that is, by acknowledging your pleasure at having something given to you by someone you love rather than exaggerating its artistic value by claiming that it is a masterpiece or that your child is an "artist." It may be a visually beautiful piece. However, at this age the work does not represent the depth of experience characteristic of mature artistic statements.

The danger in exhibiting children's work is that by framing a lot of pieces you put a value judgment on their work as precious objects instead of recognizing that the process from which the work evolved was experimental and an important stage of growth. You may inhibit their progress if you overpraise certain works, because the need for approval may make beginners feel that they have to repeat past designs in order to please you and they may become less inclined to try more things in new ways. If you show interest and approval for their involvement and way of working, they can feel free to be more inventive and grow in confidence.

* Excerpt from a speech to the exhibition jury of the French academy, 1765. See illustration, page 179.

Patterned-Paper Collage

(Left) Claude Monet, French. *A Bridge over a Pool of Water Lilies,* 1899. Oil on canvas. 36½" × 29".

(Right) Eliot Porter, American. *Pond with Marsh Grass and Lily Pads, Madison, New Hampshire,* 1952. Dye-transfer photograph.

Claude Monet's painting and Eliot Porter's photograph show how the same subject of pattern in nature can be seen and interpreted in different ways.

W HEN THE POET PAUL VALÉRY SAID, "To see is to forget the name of the thing one sees," he was referring to the fact that you can make the familiar seem extraordinary by perceiving things in terms of their pure sensory qualities rather than thinking of their practical use and recognizable identity. We are so accustomed to judgment, reason, and logic that we may find it difficult to allow our senses free play, in order to see pattern and form in the shapes around us, instead of only their functions and identities. If we can develop the observer side of ourselves and learn to suspend the evaluative, we will enrich our entire visual experience.

Our daily visual fare is a pattern collage of color and graphics in advertisements, interior decoration, and commercial products if only

we could see it that way. Television and other news media show us international tastes in patterns in the clothing and decorations of peoples in many countries. Designs in Persian and American Indian rugs, jewelry, woven hangings and tapestries, and patchwork quilts have become common sources of pattern in our homes.

A few years ago it was considered unfashionable or in poor taste to wear a variety of patterns together. If you wore a striped shirt you were supposed to wear solid-colored pants and jacket. Now many have cast aside these conservative ascetic notions and assembled sumptuous multipatterned outfits inspired by centuries-old Oriental examples where pattern next to pattern gave a feeling of warmth and opulence.

I explain pattern to beginners as a lot of identical or similar small shapes and lines that are repeated many times.

While many people immediately associate pattern with designs that are applied or painted onto a surface, you can see pattern within natural materials as part of their structure, as in the grain of wood or the veining of marble. Pattern can be a growth configuration in nature—leaves sprouting out from a stem at regular intervals—or an effect of light—sun and shadow cast to the ground underneath trees. When you look at the facade of a brick building, you can see patterns in the brickwork, in the windows set at regular intervals, in the arrangement of windowpanes, and even in the shingles on the roof.

You may have experienced this quality of structural patterning when working on your paintings if your brush strokes made a series of repeated marks of the same shape and width. Many painters use this type of patterning to suggest mood and abstract ideas. For example, the repetition of dense, raised, flamelike marks such as in Van Gogh's *Cypresses* illustrated on page 47 bring to mind a kind of

Artist unknown, British. *Portrait of a Lady (Queen Elizabeth I?)*, 16th century. Wood panel. 44½" × 34¾".

Yoshu Chikanobu, Japanese. *Enjoying Cherry Blossom Viewing at Ueno*, 1887. Triptych, woodcut print. (See Plate 39.)

radiant energy, while the pattern of the tiny oval petals of the blossoms of the cherry trees in Yoshu Chikanobu's print *Enjoying Cherry Blossom Viewing at Ueno* illustrated on the previous page suggest the delicate buoyancy of floating bubbles.

Pattern can delight the eye in an illusion of movement and vibration, unifying an arrangement of many diverse shapes and colors, as for example in Charles Burchfield's *Dandelion Seed Balls and Trees* illustrated on this page. Moreover, it establishes a visual rhythm and emphasis according to the arrangement of its lines, shapes, and the spatial intervals between them in the same way that a drumbeat in music accents a melody. The animated rhythm in the Burchfield landscape suggests an exuberance; the repetition of curved, serpentine lines moving in interlocking arcs without symmetry plays against the staccato dots of the seed balls, the jagged marks for tree bark, and steady rows of lines for grass in zigzag rows. What other rhythm contrasts can you see here?

When pattern is used as decoration or ornament it often makes things appear more luxurious, yet it can also interpret or explain the nature of a place or designate the importance of a person or object. Pattern is most often applied to a three-dimensional design in such a way that it doesn't disturb the clarity of the sculptural form it decorates. This is why most patterns are designed to be two-dimensional or flat. Pattern can be pleasing and attractive or unpleasant according to how it's used and its intrinsic qualities of line, shape, color, and

Charles Burchfield, American. *Dandelion Seed Balls and Trees,* 1917. Watercolor on paper. 12" × 18".

arrangement. While you might like a patterned fabric on your sofa, you might not want patterns on furnishings and surfaces in a small room where they might make the space feel cluttered, overcrowded, and confusing. However, lots of pattern might humanize the vastness of a large space. You may appreciate a pattern on your dinner plates but not on your mirror. When organic patterning taken from nature is used in man-made environments it contrasts with and warms the cool, geometric precision of the architecture. We can also enjoy the reverse situation when patterned geometric sculpture is set outdoors within the lush patterning of natural foliage.

Pattern is commonly used in utilitarian ways as well. If you've ever had to spend the night in a small motel room with jarring patterns on the upholstery, competing patterns on the wallpaper, and equally flamboyant ones on the floor, you may have wondered if the owner was blind. Probably not. Owners of public places have long known that pattern can be used to hide dirt and scuff marks on surfaces. Perhaps you chose a pattern for your kitchen floor for the same reason.

Religious imagery has often expressed itself in pattern instead of representational images. The architectural sculpture of cathedrals and illuminated manuscripts of medieval times used pattern to convey the order to religious life in harmony with natural forces. Geometrically styled patterning has a quality of timelessness that transcends feelings of mortality that a naturalistic image of organic

Richard Haas, American. *The Potter Building*, 1974. Oil on canvas. 15⅞″ × 20″. Notice how the shapes inside of other shapes keep getting smaller inside each enclosure. Architectural patterning has long been a means of humanizing the scale of large buildings by breaking up large expanses of walls into units that relate to the size of people.

Ferdowsi, Iranian. *Ardashir and the Slave Girl Gulnar,* from *Shah-nameh (Book of the Kings),* Verso 516, c. 1527/8. Detail from manuscript. Water-base paints with glues, size, gum on egg yolk binding mediums, approximately 12" × 18". (See Plate 36.)

flesh implies. Because people believed in the occult powers of numbers, pattern was also used as a symbolic code in which natural objects were simplified and transformed into mathematical systems.

Islamic religious art opposed naturalistic images of living beings because it was felt that an artist would usurp the power of God by breathing life into inanimate creatures. However, in the court art made for Moslem royalty, a stylized or decorative image of animals and humans was considered harmless if it cast no shadow, was executed on a miniature scale, or was used to decorate utilitarian objects such as rugs, fabrics, or pottery.

Early in this century, Picasso, Braque, and Gris used patterned print from newspapers in their Cubist still-life collages for visual and symbolic reasons. Not only did the type function as a static pattern when cut into geometric shapes, but it also called attention to the contrast between the real world of news and the painted illusions of art. A few years later, the Italian Futurist painters used printed type for its associations with the avalanche of words we face from printed materials, but they also cut and arranged their patterned shapes to suggest motion, energy, and the machine images of their industrial world (see Severini illustration, page 122).

Both groups of modern artists realized that whether or not a pattern or print can be traced to a specific source, it always suggests a multiplicity of meanings and associations. Found, man-made patterns can elicit nostalgia, bring spiritual comfort, or suggest modernity or industrial process. They bring with them a specific organization of visual elements designed for a previous use (such as any of the ones discussed in the last few pages).

THE RELATIONSHIP OF PATTERNED-PAPER COLLAGE TO PREVIOUS PROJECTS

We often don't recognize pattern all around us because we read it as shape instead of pattern. For example, we may see a wall instead of recognizing that it's made up of bricks. If you look at the wall from far away you can't see the pattern at all. When you look at a tiger lily from a distance it looks as if it is all one color, but when you get up close you can see the patterned specks on its petals.

Awareness of pattern is noticing a kind of detail. In your torn-paper collages, you made simplified forms that gave a feeling of distance—as if you were seeing a grand panorama in nature. With the cut paper, you may have felt a medium distance when you saw sharp edges that suggested coming closer to more clearly defined objects. When you do patterned collage, the ability to distinguish small detail

Pablo Picasso, Spanish. *Girl Before a Mirror,* 1932. Oil on canvas. 64" × 51¼".

Mary Cassatt, American. *The Fitting (Jeune Femme Essayant Une Robe),* c. 1891. Dry-point and aquatint printed with color. 14¹³⁄₁₆" × 10⅛".

may give the feeling of being up close. When you combine the three types of collage you may be able to suggest different placements of things in space.

We do this project not only to learn to deal with the definition of shape in space but also to explore how to suggest attitude or mood with pattern. For example, putting pattern in unexpected places in your picture may elicit an unexpected feeling from ordinary shapes. By using pattern very freely you can experiment with new possibilities of interpreting ideas. Comparing Picasso's painting *Girl Before a Mirror* with Mary Cassatt's print *The Fitting* shows how the artists, using the same subject of a figure before a mirror, treated pattern in two strikingly different ways. Cassatt's depiction of the pattern of the dress reflected in the mirror conforms to our expectations of what it should look like, for it closely repeats that of the one on the standing figure. The vertical unbroken lines of each suggest a stationary pose. The few large shapes of wall and floor have subdued repetitive patterns which do not break up the surfaces into separate elements but function almost as texture in a mood of harmony and repose. By contrast, Picasso plays dramatic games in his painting. He sets up visual expectations by use of this subject and then breaks them for

us. We expect to see a mirror image in a mirror, a duplication of patterns and shapes. He doesn't give it to us, but instead depicts many views at the same time, switching and fracturing the patterns all over the scene. Even the background wallpaper switches colors and thereby changes pattern. When Picasso changes the direction of the repeated parallel lines under the girl's outstretched arm, we feel a sense of movement of both the arm and the mirror. Varying repeated patterns instead of repeating them identically creates elements of surprise, movement, and great complexity in the visual rhythm of the image.

Your Project: Patterned-Paper Collage

MATERIALS:

a selection of 18-by-24-inch sheets of white and colored construction papers or patterned wallpapers. (Vinyl-backed or front-coated wall coverings are not satisfactory because they warp and their edges curl when you cut them.)

a selection of differently patterned papers cut up into 9-by-12-inch sizes (such as wallpapers; gift wrapping; colored magazine photos with repeating patterns like those of woven fabrics, waves, leaves, and the like; and the stockmarket or classified sections of the newspaper with regular repetitive print patterns)

scissors

rubber cement or Elmer's Glue-All

crayons, Cray-Pas, or felt-tip markers for drawing additional patterns on the plain construction papers

Adult's patterned-paper collages. (See Plate 37.)

Suzuki Haronubo, Japanese. *Plucking a Branch from a Neighbor's Plum Tree*, 1766. Woodcut print. 10¾″ × 7⅞″.

PROCEDURE:

1. When you start to collect patterned papers for this project consider the difference between using large and small patterns. When the patterns are very large they may read as shapes in themselves instead of as pattern. If they are very tiny, they may not seem like pattern either but become surface texture. We will discuss the qualities of texture in the next chapter. Choose one piece for your background from the 18-by-24-inch sheets and judge various smaller patterned pages (9 by 12) against it by holding them together. You may wish to use some plain colored shapes to break up the background. The combinations may suggest a place or theme such as a piece of music or a view of the earth from an aerial photograph. Striped paper may suggest a cityscape. Other patterns may suggest a garden, florist's shop, or supermarket.

2. Cut your patterned collage shapes across the dominant direction of the design. For example, if you have stripes, you might cut diagonally or horizontally; if you have curved designs, you might cut geometric shapes. If you find yourself tempted to cut around the existing printed images, turn the printed paper over so you can't see the pattern and cut your shapes out this way.

3. Put your cut shapes down onto the background paper as you cut them out so that they will suggest the next shapes to cut.

Try to see the background paper as a field that has a shape of its own. Although you may not necessarily put shapes all over the paper, fill it visually so that the pieces interact with each other and with the

Berenice Abbott, American. *New York at Night,* 1933. Photograph. 13⅜" × 10⅝".

whole background space as well. One way of doing this is to equalize the importance of the shapes and the spaces between them with pattern.

4. Keep rearranging your shapes until you feel the composition is pleasing or most clearly expresses a theme or mood, and then glue the pieces by lifting their edges to slip rubber glue underneath them.

5. Cover every part of your paper with pattern. You can use Cray-Pas or paint to do additional patterns on your plain construction paper, or cut very small shapes to glue into patterns on top of the solid colors. Remember that you can also overlap shapes here.

THINKING ABOUT WHAT YOU'VE DONE

How did the sizes of your patterns influence your perception of the size and shape of the cut pieces? Think of what happens when you see a large person wearing a small or medium-sized print on his shirt and the effect when he wears a big pattern. More intervals can break up the volume of a surface (if they don't read as small texture), while larger or broader intervals may dramatize or accentuate the size. A big pattern on a tall person may look in proportion to his body, but the same pattern on a petite individual may dwarf the wearer. It's a

common rule of dressing that stripes accentuate direction. Length-wise ones can make a person look taller and thinner while horizontal ones can accentuate girth.

Have you ever noticed that when you look at a line of fence posts, traffic lights, or telephone poles that are nearby, the spaces between them look much farther apart than those seen at a distance? Not only do the distant ones appear smaller in size but they also look closer together. This visual indicator of distance is often so internalized that we aren't conscious of it. When you look at your collage, do you read the shapes with smaller patterns on them as nearer or farther away? The combination of pattern size, shape size, and the size of the spaces between them arranged into an organized pattern is a way of suggesting a close-up, medium, or far-away viewpoint. You might want to experiment with creating depth by these means on a second patterned collage.

You also may have made a second kind of pattern in this collage with your over-all placement of shapes, that is a pattern of rhythm. If you lined up similar shapes at regular intervals, you created one kind of rhythm. How does it differ from positioning them at irregular ones? You might think of the difference between the even rhythm of rock and roll compared to the more varied phrasing of symphonic music.

Artists have long used pattern to emphasize and unify a pictorial composition. You may have used pattern in this way in earlier projects where your brush strokes gave direction and movement to the field. Here, your patterns might have done the opposite by anchoring shapes in place. This painting of the Archangel Gabriel by Gerard David employs pattern in at least four different ways to establish a place and mood. The floor-tile pattern goes back diagonally to make the room appear three-dimensional; the vertical lines on the wood-work to the left side frame and set a boundary on the expanse of the two-dimensional area: the arabesque pattern on his cape communicates an energy to the gesture that suggests he is saying something important; and the upright parallels of the skirt of his robe emphasize a vertical monumentality in the figure.

Louise Nevelson's wall sculpture *Rain Garden Spikes* (see page 199) uses the strict rectangular framing patterns of the boxes to order and restrain the symphony of many different shapes and the directional movements that they project.

If you can read your collages and paintings in more than one way because of patterns that go forward and back as well as up and down and to the right and left, you are more likely to keep looking at them again and again. Monet's *Terrace at Sainte Adresse* on page 199 (one of the most popular paintings at the Metropolitan Museum) uses

Gerard David, Flemish. *The Arch-angel Gabriel*, undated (15th century). Oil on wood. 30″ × 24″.

Hilde Sigal, American. *Meditation*, 1980. Oil on canvas. 20″ × 24″. This painting combines pattern with transparency in the geometric emblem and also with representational imagery in the rows of the cultivated field and variegated cloud cover. Pattern also serves as a framing device for the whole composition as well as for individual sections of the image.

pattern to suggest a kind of visual happiness without resorting to the cliché of smiling faces. The three large horizontal stripes, the terrace, sea, and sky, set the mood of a calm, peaceful day and layer the space in depth. Yet the small, dense patterned marks for waves and repeated shapes of the billowing flags tell you of a pleasant breeze. The shapes of the boats measure rhythmic spaces across the horizon and suggest some kind of activity in the harbor. Repeating brilliant reds in the foliage and flags in the foreground enclose the area and suggest a festive occasion. Even with the repetition of a few basic elements the eye is never bored, never loses interest.

Other painters today continue to use pattern for visual impact in a variety of personal ways.

As you continue to do more printed-paper collages you might combine several mediums for more developed results. You can use tissue to mute the patterned lines and colors so that they don't overwhelm the importance of the shape. When you paint on your patterned collages you might also think of how manuscript illuminators used geometric boundaries to contain intricate and exuberant patterns (see the Islamic miniature illustrated on page 192).

Raoul Dufy, French. *View of Nice*, undated (first half of the 20th century). Oil on canvas. 14⅞″ × 18″.
Notice how in both of these paintings the arrangement of vertical lines and horizontal shapes influences your perception of space. Which of these two compositions takes your eye into the distance, and which one leads your eye in a circle?

Claude Monet, French. *Terrace at Sainte Adresse,* 1866. Oil on canvas. 38⅝" × 51⅛". (See Plate 40.)

Louise Nevelson, American. *Rain Garden Spikes,* 1977. Black-painted wood. 75" × 80" × 12".

YOUNG BEGINNERS' WORK WITH PATTERN

Although I suggest no special pattern projects for the youngest beginners, I begin to introduce the idea of pattern slowly and continue to talk about it in each studio session as well as before class. I point out the patterns in their clothing, on the walls, and in the corrugated paper they're already using. When they are painting, I ask if they would like to use a little brush to make patterns, and as I show how to use the hole puncher I call attention to the patterns the little holes make where there are a lot of them together.

While parents are doing their patterned-paper collages, I put a few kinds of all-over patterned shapes into the children's choosing tray. (See page 39 for instructions on preparing young beginners' collage materials.)

As you begin your own project, you might add some small pieces of your patterned paper to the children's trays and look around for objects that will illustrate what pattern is. You might dress both of you in patterned shirts that day so that you can talk about the idea that pattern is a lot of little shapes inside of bigger ones. If you keep calling their attention to patterns in many varied situations outside the workspace, they will be able to discover that similar patterns occur in many different contexts and materials. The markings on animals become familiar at an early age and make an excellent reference here.

One parent reported that the morning after three-year-old Joanna had worked with patterned papers she interrupted the family breakfast by excitedly announcing to her father, "Your tie looks like the card Grandma sent me!" She insisted that he come look at it and pulled him by the hand to the card collection taped to her closet door. Sure enough, there was a card, a reproduction of a Haitian folk art wall hanging, with an area of patterns shaped like the ones on his tie.

These two patterned-paper collages were made by a three-and-a-half-year-old who loved to paste. The one on the left is four collages all pasted on top of each other. Many children like to pile up the materials on the paper but forget about pasting so that pieces fall off. Others who are not as intrigued with pasting use fewer materials.

MORE EXPERIENCED BEGINNERS' PROJECTS

School-age children (five and up) who already know how to cut, paste, and plan arrangements might like to do a patterned-paper collage like yours or might want to use patterns to tell a story. I show lots of photographs of pattern in nature and point out some of the ways that patterns can tell about things. For example, we know the leopard by its spots and the zebra by its stripes. Patterns are a way of telling what a house is made of, whether it's wood, brick, or stone. We can also make a pretend story or dream when we pattern things

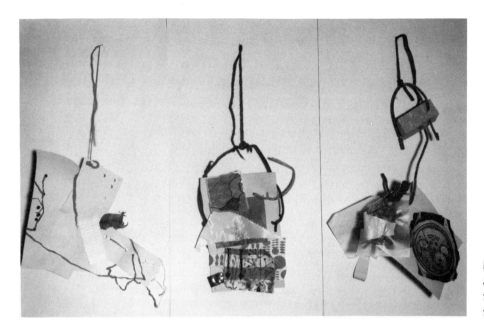

Hanging collages made by a three-and-a-half-year-old. She was thrilled that they could hang and move in the air like mobiles.

with colors we don't see in real life. Children may enjoy putting patterns into unusual contexts to produce a whimsical or comic effect (such as using a floral pattern for an architectural shape). When we want to give the feeling of a place where there are a lot of trees and flowers, we can make a color-and-shape pattern that makes us think of leaves and petals. More experienced beginners could combine tissue paper with patterned paper or do a collage painting.

DEMONSTRATING FOR EXPERIENCED AND ADVANCED BEGINNERS

1. Show many examples of patterns in your environment and in photographs and reproductions of art works that emphasize this element in their compositions.

2. Cut right through the patterned papers you have collected making all kinds of shapes, both organic and geometric.

3. Put the shapes down on a background paper to make different kinds of patterns, and discuss what you all see. (Avoid making representational shapes, and cut pieces out very freely so that they do not make precise images.) Stress how we can suggest the feeling of a particular place or story. Emphasize the shapes made by in-between spaces as you move the arrangements around and overlap the pieces.

4. Remind them how to glue by lifting the edges to slip the glue brush underneath (see illustration and instruction #5, page 131).

ADVANCED COLLAGE OR PATTERNED-PRINTING PROJECT

School-age children may enjoy making found-object prints (also called *collographs*) by using a printmaking process to make their own patterns for a collage.

Wooden blocks, spools, cross-sections of soup bones, or other small objects you can grasp firmly can be used for printing stampers. Additional textures can be made by wrapping these objects with fabrics or corrugated cardboard or by gluing additional homemade cardboard or Styrofoam shapes to them.

Next we make stamper pads by placing small pieces of cellulose sponges in the bottom of little plastic margarine containers (save old sponges to cut up for this purpose). Pour a little paint onto each sponge and then press the mounted objects onto the paint before stamping or printing the paper. (Don't put out the regular paint tray with caster cups here because the children may dip the stampers into the caster cups instead of pressing them onto the sponges. Not only will the printing blocks become covered with paint, but paint will be wasted.)

Finally, we may keep the printed paper or cut it up when it is dry into shapes for a collage and paste them down. This last step is very important because now the children are transforming the many easy visual effects obtained in the printing process into something more personal and inventive as they organize their compositions.

Adults might like to do this project also.

Lucas Samaras, American. *Reconstruction #53,* 1979. Sewn fabrics. 75" × 69".

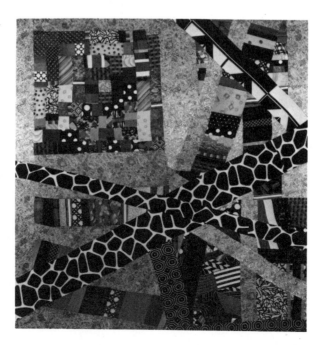

TWELVE

Texture Collage

ALWAYS IN THE BEGINNING of each semester there are children who come in carrying a blanket or teddy bear. They want to hold something close for warmth and comfort and its texture gives a sense of nearness. After they become involved with holding the paint brush, holding the scissors, and holding the clay, they forget about their blankets and teddy bears. They become more interested in reaching out and holding the textures of the outside world instead of being sheltered from it by the blanket.

Children who are forced to be overly clean and neat may have had very little tactile experience. Often they just want to get close, to touch and feel things to communicate with them. Touching is a way to find out about the world. I worked with a child who had never been allowed to take off her shoes to run in sand or grass, or get her hands soiled. After a few weeks, when she felt secure in class, she began to smear the paint and glue with her hands. Her new-found freedom gave way to a need to enjoy tactile pleasure and to be close to materials, and for a while it superseded any desire to do something constructive with them.

It's not just children who cling to their security blankets. Adults often grasp for recognizable identities of objects instead of searching for sensory qualities in forms that evoke a feeling of closeness. Very often the tactile qualities like the texture of the material encourage associations of intimacy, for they pull you close to something and verify what you see.

Touching often takes the place of thought. For example, we often react automatically to textures with our touch, muscle-sense, eyes, and ears without being aware of it. Often we can't remember whether we felt the chair when we sat down for dinner, whether we shut a door. Psychologists have said we depend on messages received through touch to stabilize our visual world. When kittens were carried through a test maze through which other kittens walked, the carried kittens never learned the maze by touch and didn't develop the same visual spatial abilities as the others. The kittens needed touch to verify their vision. Children, like kittens, are put at a great disadvantage if they are not allowed the physical experience of handling things. Usually children who have been allowed to touch and

move things around have superior eye-hand coordination and more self-confidence. They learn to do things much more quickly because they haven't been passive members of their families. It's not merely a sense of muscle coordination but a sense of well-being. When I see young ones who haven't been allowed to handle things, so that they can really feel and know them, I think of Thornton Wilder's play *Our Town*. In it, the spirit of a deceased girl returns to observe a day in her past life, her twelfth birthday. Now, too late, she recognizes the importance of her physical sensory environment, which, when alive, she always seemed too busy to notice.

We associate textures of natural materials with a closeness to nature. The vivid portrayal of natural textures is one of the strong appeals of Gerard David's painting *Adoration of the Shepherds* (see page 210). Variety of texture is becoming one of the properties of the unique handmade object and has a significance beyond its immediate sensation of smoothness or roughness. The quality of texture can give a sense of something unusual and alive instead of a dead object stamped out by a machine. A handmade pottery bowl that is smooth and pleasing to the touch also tells about the care an artisan took in making it. The rubbed wood finish produced by a fine cabinetmaker speaks of an extended period of time taken in the work and a dedication to a level of quality that is rare and expensive today.

Even though all distances in time and space are shrinking because of our instant global communication, jet-speed travel, and media images from every remote area of the globe, we are often intellectually aware of facts and ideas but have a sense of literally being out of touch with the world. Perhaps this need to grasp images and objects closer is evidenced in the deluge of close-up photography. However, the quality of these mass media images is more purely visual and graphic than tactile. You may find that working with textural materials has a depth of emotional and associative resonance that you may not have considered before.

Pattern and texture are closely related. Although we think of texture as something we can touch, we also get a feeling of texture from very even and regularly shaped flat patterns, from small similar shapes together, and from smooth surfaces that give the illusion of texture. (See illustrations of Claude Monet's *A Bridge Over a Pool of Water Lilies*, page 188, and Mary Cassatt's *The Fitting*, page 193.)

Pattern appears when a group of separate shapes has parts that are seen as distinct units in themselves. We see texture when the elements are seen as a whole single surface instead of being broken up into many separate parts. Pattern may have varied intervals or distances between the separate elements while texture suggests a greater

uniformity of marks on a surface. Part of this distinction is the result of our vantage point. When the lines or marks are so far away that they become so small that we can't distinguish their individual parts, we see a texture instead of a pattern.

HOW TEXTURE COLLAGE BEGAN

In fact I did not understand why one could not use in a picture, in the same way one uses colors made in a factory, materials such as: old tramway and "bus" tickets, washed-up pieces of wood from the seashore, cloak-room numbers, bits of string, segments of bicycle wheels, in a few words, the whole bric-a-brac to be found lying about the lumber room on top of a dust bin. From my standpoint, it involved a social attitude, and on the artistic level, a personal pleasure.

<div align="right">Kurt Schwitters, German sculptor and painter*</div>

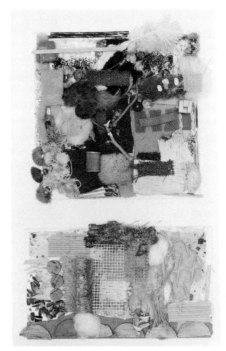

Adults' texture collages.

Texture collage-making began hundreds of years ago in the folk arts and crafts, long before twentieth-century artists appropriated textures into their paintings and sculptures. Ornamental designs containing seashells, driftwood, dried flowers, and leaves have decorated many homes over the years. Variety and souvenir shops still sell curios assembled from shells, bark, leather, and man-made materials in the form of little shelf ornaments, wall plaques, and decorated boxes.

While many representational painters through the centuries have depicted texture very allusionally, only a few in the nineteenth century arranged their picture plane in a collagelike way by overlapping flat shapes and juxtaposing disparate images while building a shallow layered space without the use of perspective devices. Examples of American artists who have made collagelike paintings are John Peto, John Haberle, Raphael Peale, and William Harnett, who not only portrayed textured objects convincingly but also arranged them in ways that appear like collage. (See illustration of William Harnett's *The Artist's Letter Rack*, page 150.)

The same artists (such as Picasso, Braque, Gris, and the Italian Futurists) who pioneered cut- and torn-paper collage in the first two decades of this century also used textures from life in order to contrast a poetry of abstract art forms with mundane recognizable objects from everyday experience. Others have used textures to make pure abstractions, and still others have emphasized the psychological and emotional associations of recognizable objects by juxtaposing them to each other. Even easily identifiable parts can become transformed by their literary and symbolic context.

* Excerpt from his magazine, *Merz*, 1927. See illustration, page 218.

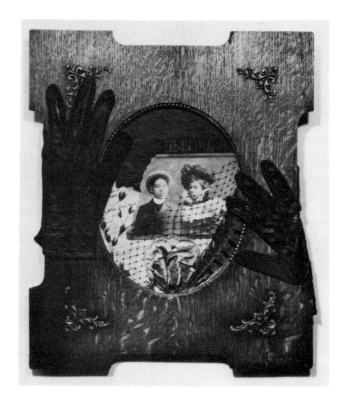

Betye Saar, American. *Ohne Hast, Ohne Rast,* 1976. Assemblage and mixed medium. 14" × 17" × ¾".

Your Project: Texture Collage

The possibilities are infinite when you use textured materials for collage. You may decide to use texture abstractly as pattern, for association. The following suggestions are merely to get you started. You can depart from them in any way you choose. You might even use an early painting as a starting point by thinking of the feelings evoked by the textural elements in it and how they can be translated into a collage. The following are some other ideas to try.

 a. *Tactile Scale:* Arrange side by side different types of texture on your background regardless of color relationships.

 b. *Story or Memory Collage:* Build up a portrait of a person; develop a place that an animal might live in; think of what the interior and contents of someone's pocketbook or briefcase might look like (the neatest, most businesslike persons might amaze you with what they carry in their cases). Or imagine the prized possessions in your special drawer or hiding place when you were a child.

 c. *Color Story:* Choose a color and find as many textures as you can of that one color.

 d. *Maze or Small Environment:* Arrange material so fingers glide around different places, inside and outside spaces, encountering various textures.

CHOOSING TEXTURED MATERIALS:

The first thing to do is to find materials in which the texture is more dominant than the color or shape, and that are easy to glue. I suggest that you collect textures that are relatively flat so that your fingers can slide easily over them. (We will be working in a more three-dimensional way in future projects.)

Finding visually interesting objects involves looking for the unexpected in the familiar or seeing the materials of daily life in an aesthetic way. You may choose a flat piece of shell not only for its texture, but also for its shape and subtlety of color and pattern; a smooth waferlike stone for its grain, luminous translucency, or smooth polished surface. A rusty piece of metal can have a miniature landscape etched into the terracotta-red texture of its encrusted surface.

As you may have noticed with your patterned-paper collage, the materials for this project have both visual and psychological associations as well as textures. This is one reason I prefer that young children not use edible foods like noodles or potatoes for texture materials or printmaking. However, dried fruit skins, pits, bleached and cleaned bones, cornhusks, and eggshells are different because the latter recycles used materials and the former destroys food and negates its primary purpose. It may be confusing for young children if you mix the studio materials with those for eating.

Materials often hold memories of their past history even when you cut them up to give them a new structure. Leonardo da Vinci noted that natural textures like weathered rock and rough wood are filled with images we project into them for they are themselves living chronicles of experience. They speak of the natural processes of growth, metamorphosis, and disintegration of the forests and mountains of the past. Man-made textures suggest another set of stories: fragments of childhood memories of lost and broken toys, the intimate associations of fabric that protects and caresses our bodies, parts of former furnishings and, in short, all the ideas associated with previous use.

MATERIALS:

heavy cardboard, mat board, or corrugated cardboard, either 9 by 12 or 12 by 18

Elmer's Glue-All or other white glue. About twenty minutes before you start working on your collage, pour some glue into a caster cup or small dish so that it thickens before you use it. If you are going to use plastic textures and objects in your collage, Slomon's Quick white glue attaches vinyl, Mylar, foil, styrene, and other plastics to paper, wood, and porous fabrics

Adults' texture collages.

Arthur Dove, American. *Portrait of Ralph Dusenberry,* 1924. Oil on canvas with applied ruler, wood, and paper. 22" × 18".

Ann Ryan, American. *Collage #340,* 1954. Pasted cut fabrics, cut and torn papers, gold foil, bast fiber on paper. 8″ × 7″.

(Above right) Josef Albers, American. *Rheinische Legende,* 1921. Glass shards mounted on copper sheet. 19½″ × 17½″.

a selection of textured materials. File your found materials in different boxes according to their textures and sizes.

cutting tools (any that are needed to work with your selection of textures). Remember to get the proper tools for the materials or you may ruin both your tool and your materials. For example, using your paper-cutting shears on very thick cardboard may dull the cutting edges. A mat knife or X-Acto blade would be more useful here. (With heavy materials it is better to pass the blade over the cut line lightly several times instead of struggling to cut the piece with one stroke.)

PROCEDURE:

1. Arrange your textured pieces as you did with your previous collages by moving them around on the background without gluing them down. Use some larger shapes to start to build your background spaces and then work forward in layers with smaller pieces.

2. Fill the in-between spaces with other textures, thinking of all the elements of shape, line, pattern, and arrangement that you used in other projects.

3. Glue down your materials. Sometimes you can merely lift an edge. However, for heavier materials you might have to lift up the whole piece and glue the entire undersurface. To glue down grainy materials such as wood shavings, pebbles, or sand, spread your glue

evenly and generously over the background where you want to place the texture and then sprinkle the materials on top of the glue. Tilt up your background to remove excess grains onto a piece of newspaper. Let the glue dry. If you find that you want to fill in spots where the texture failed to stick, repeat the process. To glue heavy or bumpy materials that do not touch your background at all parts of their surface, puddle the glue thickly under parts that do touch your board.

4. *Optional*: You may paint over some parts of your collage using the paint as a texture or as a color or as both. This is a way of unifying a great diversity of shapes, colors, and textures. For examples, see my *The Family*, this page, and Louise Nevelson's *Rain Garden Spikes*, page 199.

THINKING ABOUT WHAT YOU'VE DONE

How did you use the principle of contrast in your texture collage? When you make a salad you not only consider the flavors, colors, and variety of shapes of the food, but also its textures. The texture of cut-up fruits and vegetables, whether sliced, grated, chopped, diced, or julienned, influences your perception of their qualities. Most of us enjoy the pleasure of changing tactile sensations in the food we eat so we like variations in textures. The contrast between the textures of things heightens the sense of identity of each. In your collage, a smooth texture next to a rough one makes each of them visually prominent.

Texture, like pattern, can be used as decoration or ornament to make something look attractively opulent (as when you get a richly textured rug for the living room floor). Yet texture can also be used to represent nondecorative pictorial ideas as well. For example, you may have already noticed in your paintings that areas that were sharply textured with the brush appeared to be nearer and seemed to have more physical solidity than those painted with a thin wash. If you look out at a landscape in nature, there appears to be a gradual increase in the density of a surface (things seem closer together) in the distance and textures also become softer.

Texture in sculpture may communicate both optical and tactile sensations. It can give the impression of shimmering and vibrating in light or an object seen at a distance. A polished curving metal surface can catch reflections so it may appear weightless, or may give an illusion that there is an opening into its interior where there is none.

As with the other individual visual elements you have worked with, texture doesn't communicate any one idea by itself or in isolation but works as part of a composition to make the theme specific. It is the organization of all the features and parts of your collage that makes it communicate your ideas and feelings.

Muriel Silberstein-Storfer, American. *The Family*, undated (20th century). Mixed medium. 18″ × 11″ × 11″. Texture collage is an extremely flexible medium that can be adapted to a wide range of imagery from pure abstraction, as in *Genesis*, to lyricism and humor as shown here. I began this piece at the beach using Elmer's Glue-All to attach the parts. The man's head is a toy shovel with a horseshoe-crab-shell face; the woman's head is the top of a tin can covered with found cheesecloth for hair. The children's heads are small toy shovels; one is adorned with beach grass for hair and the other has mop locks. I made two headdresses from old plastic gloves which painters had discarded in the neighborhood and the boy's nose is a rusted key. At home I added a few more touches and painted the work.

If you made a texture collage in one color, you may have seen how textures changed the quality of the colors. The smoother the texture, the cooler it may have felt; and the rougher, the warmer. Sometimes winter clothing has a rougher or bulkier texture that makes it look warmer, even though it actually may not be so if a loose weave lets air flow through the fabric.

Although you may not have been able to see any difference between the colors of different textures, they may have felt different. Sometimes a reproduction of a painting may have very similar colors to the original work yet not look the same. One of the many reasons for this difference is that highly textured and painterly paintings lose much in the translation to the physically smooth photograph. When you go to a museum or art gallery also notice the ways in which a print differs from a painting in terms of texture.

YOUNG BEGINNERS' WORK WITH TEXTURE

Aside from the fun of exploring, collecting, and using materials children learn to connect words like *hard* and *soft* with their tactile, sensory meanings. Gradually such terms as *rough*, *smooth*, *prickly*, and so on, will also become part of their vocabulary.

Gerard David, Flemish. Triptych: *Adoration of the Shepherds* (center), *St. John the Baptist* (left), *St. Francis Receiving the Stigmata* (right), 15th century. Tempera and oil paint on wood. Center panel: 18¾″ × 13½″. Each side panel: 18″ × 6½″. I show this reproduction because of its great variety of depicted textures: grainy sand, fuzzy lamb, wood, coarse fabric of the monks' garments, and velvetlike dress of the women and wise men.

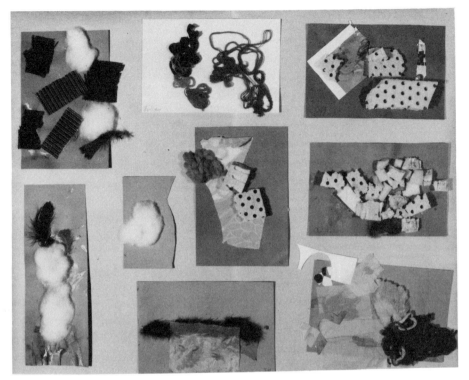

Children's texture collages. Over a period of weeks, new materials are added—cotton yarn, sponge rubber, bits of fur, and a few feathers. Some children are reminded of animals by the soft materials, while others enjoy the pure pleasure of touching and arranging them.

Although I do not present texture projects to the very youngest beginners, they watch and listen as I explain them to their parents and we discuss the visual and tactile qualities of many different objects. "How do you learn about things? If I gave you a flower, how would you find out about it? . . . You'd look at it and smell it. You might also touch it to see how it feels, and if it was prickly you probably would remember not to touch it again. There is a word for how something feels: It's called texture. I have lots of things for us to touch so we can find out about their texture."

I show them a collection of highly textured objects (primarily in neutral or earth colors so as not to confuse them with the distinction between color and texture at this point). There is a piece of rope, a bumpy dry gourd, a pine cone, tree bark, a prickly seedpod, a piece of rug, a corncob husk, shells, and corrugated paper. We talk about how each one feels: "Is this smooth or rough? Is it hard or soft?" I have seen younger children get upset when asked to put their hands inside a bag to identify objects by touch, so I always let them see what they are handling. Adults sometimes feel that children will appreciate a guessing game, but fear of the unknown may undermine their pleasure.

The textured materials that I add to their choosing tray are cut in small sizes and are not too heavy to press down or handle.

Muriel Silberstein-Storfer, American. *Bowery Harlequin,* undated (20th century). Mixed medium. 30" × 20".

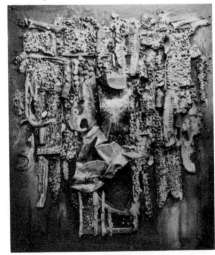

MORE EXPERIENCED BEGINNERS' PROJECT

Youngsters who have learned how to paste may enjoy making a "Please Touch and Feel Collage" on the inside of a gift-box lid with low sides. The idea is to see how many different kinds of textures you can paste in it. Together, you can both make a "Please Touch" board or tactile scale where children can come to touch and get ideas for paintings or collages. The size depends on your own facilities. You could make it in detachable sections for easy storage and future additions. Moreover, you might collect photographs of animals, mineral formations, and objects that have the kinds of textures featured on the board so that the children will make idea connections between the two. You might also collect reproductions of art works that have texture very prominently displayed.

A friend of mine who teaches in a Head Start school obtained a series of cardboard cartons used to hold small eight-ounce yogurt containers. Each child brought in a material that they glued onto a square and then they glued the squares over the holes in the carton. She then turned the cartons around so that the round sections with holes exposed the textures. Then she mounted the containers together into a cube that could be hung or set on a table to illustrate textures.

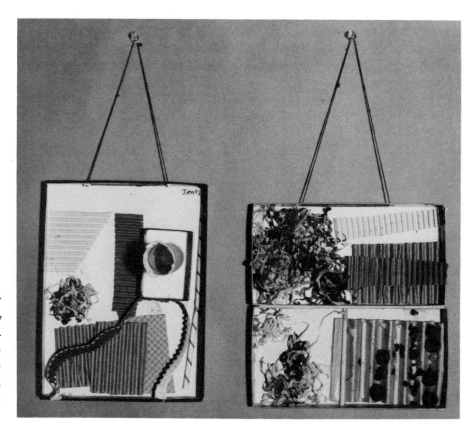

Four-and-a-half- and five-year-olds' hanging texture collages in shallow boxes. The child who made the collage on the right wanted to put the boxes together. I helped her hinge them with tape so that the halves would fold together and close like a single box.

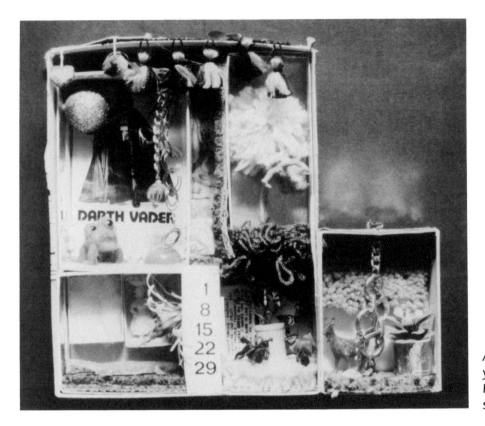

A "Memory Box" done by a seven-year-old in a studio workshop led by Hilde Sigal at The Metropolitan Museum of Art.

OLDER BEGINNERS' PROJECT

Older youngsters might make a "Treasure or Memory Box" with a scene telling a story using treasured objects they want to save. They can use pebbles, marbles, magazine photographs, miniature animals, people, or furniture, or anything that can be glued down.

Cut cardboard strips as dividers so that they can glue them into the bottom of a box lid for the background. They will need a caster cup or small jar filled with Elmer's Glue-All or a similar adhesive to hold things in place.

Photographs from magazines with visual textures are also good for texture collage if you guide youngsters into making this more than an exercise in cutting out complete images. I stress that we use these photographs for their colors, shapes, and visual textures, in order to express our own ideas and feelings.

Once I was assisting with a group of very restless six- to nine-year-old boys who couldn't get interested in the project at hand. I pulled out a book of fabric swatches of brocaded velvets and textured weaves and asked if they would help me tear them out of the book. Taking

something apart is usually intriguing for anyone and as they handled the materials the pleasure mounted. The boys enjoyed passing the samples around and organizing them for future projects. We talked about who might wear clothes made of those materials. "What would be good for a suit for a king or curtains for a castle?" and "What about some of the fabrics in the clothes rock stars wear?" Just the sorting out and organizing of the materials became a project in itself, and sparked their imagination. Now they would have loved to do a collage, but because of their involvement, the time had flown by and the workshop was over.

ADVANCED CHILDREN'S OR ADULTS' PROJECT

Although I don't usually talk about blindness with younger children, older ones might like to invent a touching-and-feeling picture for a person who can't see. We talk about how you find your way in the dark. Using your hands to feel the textures, forms, and spaces between things enables you to move around. Repeat this experience in texture collage.

I know of a church group where the teen-agers and adults made collages illustrating how they viewed each other. They used all kinds of materials: fabrics, paper, and textured objects. When they were finished, each explained what they were trying to communicate and some candid dialogue followed. Doing collages and then talking about them often brings a group together through a sharing of feelings and visual vocabulary.

You also might make a second texture collage where you begin to raise the textures off the base in order to work three-dimensionally. You could glue textures to pieces of shaped Styrofoam to make them stand up.

TALKING ABOUT THEIR WORK

Using words consistently and precisely is important when you introduce terms like *texture*. Although older children will recognize visual texture (as in photographs) as being both different from and similar to physical texture, young beginners will be confused by the distinction. When you tell very young beginners that corrugated paper is bumpy, they don't realize what that means until you have them feel it and hold the paper in their hands. Then they may recognize that quality when they see it again and connect "bumpy" to other materials. Much later you can explain that "bumpy" can be a line, pattern, or texture, but these concepts would be too confusing if

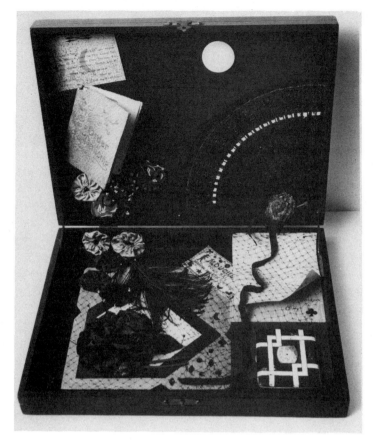

Betye Saar, American. *Last Dance*, 1975. Mixed medium. 12″ × 14¼″ × 12″ (opened). Mature artists have also used the box format, not only to frame and contain their compositions, but also to enhance the meaning of their pieces. This box makes objects seem more precious (as if encased in a time capsule that physically protects them) than if they were merely fastened to a flat surface.

presented all at once. Remember that children understand best the ideas that relate to their own experience. If they have relatively little tactile experience outside of the studio, it will take them longer to make the connections between words and sensations.

A pet, toy, or special interest might provide an opportunity to talk about texture in relation to studio work. For example, five-year-old Raymond was a student who had been praised for his drawings of dogs. When he came to class I talked about the process of painting and making collages as well as making recognizable images. When he found a piece of fur in the collage choosing tray, it became a treasured item. He put the fur down on his paper and repeated the texture of the fur with his paint brush. His work became a painting about his love of dogs even though he made no recognizable image.

TEACHING TIPS: WHAT ABOUT BUYING KITS FOR MY CHILDREN?

The value of kits depends on your attitude and guidance, the quality of the tools and materials in the kit, and the possibility for using it to develop personal inventiveness. Although you can buy kits for almost

any activity, they can never substitute for your leadership of beginners. Kits preorganize supplies but always lack the personal interaction that makes your workshop succeed. That is why the value of kits doesn't merely depend on the quality of tools and materials or even the type of projects they suggest. Beginners need your guidance and encouragement. Too often studio work with kits is seen only as manipulation of materials instead of use of materials to manipulate ideas. Kits can become boring and tedious if they do not offer an opportunity for decision-making, and adults may end up finishing the children's pieces.

Moreover, kits with predetermined results or patterns can be self-deceiving if you believe that you're being original when you've executed someone else's design. The patterns are the unique idea of the kit designer, not of the person following them. A friend of mine who is an art therapist in a hospital was brought a painting by one of her patients. It was done from a paint-by-number kit. The patient asked, "What do you think of my painting?" My friend looked at it carefully and said, "You know, it makes me think of when I come home and don't have time to cook a meal so I put a TV dinner in the oven. No matter how good it may taste, I still know I really didn't do it myself." The woman looked at her, thought a moment, and replied, "Yes, I know what you mean."

Unfortunately, too many adults praise the look of a commercially designed product instead of praising their children for learning a skill or process. Once you have fabricated a slick professional object that everyone praises, how do you get the courage to present one of your own projects that will certainly look much less polished because of your own inexperience? Kits give a kind of security to children when their parents buy them. The end product won't be rejected because they know the adults approve of it in advance. By contrast, when children invent something of their own, they risk disapproval. However, you can show that you do approve of their imaginative efforts when you give them a kit that encourages personal invention so they can feel free to make their own things.

Avoid kits that give you more packaging and box than studio materials and are more expensive than if you bought the same materials separately. If you can't get a good set of packaged materials at a reasonable price, then buy single items. You might give the children their own blank drawing book, another spiral-bound volume for collages, and individual drawing and collage materials. A small child's suitcase is large enough to hold both collage and drawing supplies and compact enough for you to take along when you are visiting so that the children can work in a corner by themselves without the need for attention.

If you do give children a kit, you can't expect that they're going to know what to do with it. Even if they have worked with similar materials during the studio session, they may not know where and when they can use the kit and that they must clean up their work area afterward. You will have to start them off again as if they're learning a workshop routine.

Consider carefully the reasons for buying any kits. One good reason for buying prepackaged materials is that supplies may not be easily obtained in small towns and rural areas. Another reason is that the projects in some kits do encourage the development of coordination skills and personal invention. However, kits with *rote patterns* do not do the latter. The only way you can really evaluate any of them, whether it is a one-time project or a collection of supplies, is to try it out first yourself before giving it to anyone.

THIRTEEN

Collage Painting

I BEGAN MAKING COLLAGE PAINTINGS as a sketching medium. It was a way of getting into a project when I didn't have the time to make painted shapes from scratch. When you're painting and not using any collage materials, it takes much more time and effort to build shapes and arrangements than when you can quickly cut and move them around. I had thought that when I had more time I would paint the textures of the materials myself instead of using the collage medium, but the collage paintings took on lives of their own and became complete statements themselves. I liked what I had done and also discovered that many other painters had used this same mixed medium. I found that I could not approach the sheer virtuosity of Rembrandt or Ingres in painting textures of objects. I thought about what it was that I wanted to say and why I was doing it. The collage paintings had expressed my own viewpoints about themes without trying to imitate masters of the past.

I remember how I was told by one of my art teachers that my light sources had to be uniform in a painting. But when I looked out in nature, especially at a sky filled with luminous wind-swept clouds toppling over into deep purple valleys to rise again like snowy mountain peaks, I saw a light here and a dark there—not at all like what it was supposed to be in a painting. So I stopped trying to follow rules and made what I saw and felt. I saw that the placement of colors on my collage paintings were justified because they unified the works on their own visual terms, along with overlap, line, shape, and arrangement.

Next I came to the idea of combining old paintings into a collage when I found a parent's unwanted painting in the trash can after class one day. I was surprised because I always make it a point to tell everyone not to destroy their work or throw it away in front of the children. The incomplete painting had a variety of colorful shapes that would have made a promising basis for another work. Recycling earlier or beginning works is a way of reorganizing and reexamining what you are doing in order to see freshly again. In this way the collage painting process can generate new ideas and images. (If you

Kurt Schwitters, German. *Picture with Light Center,* 1919. 33¼" × 25⅞". Collage of paper with oil on cardboard.

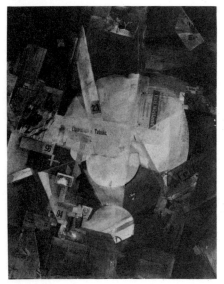

218

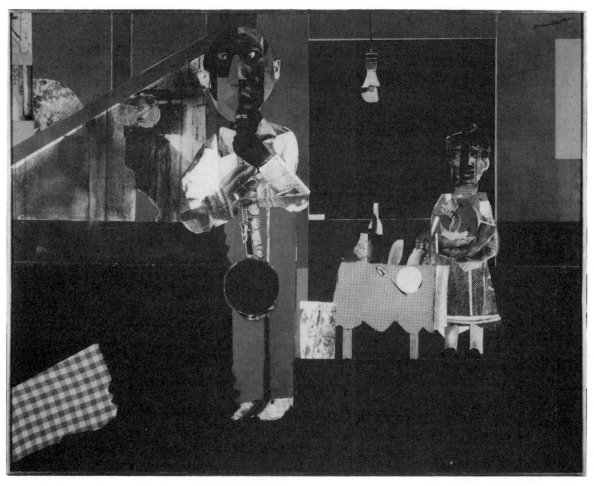

don't want to cut up any of your old paintings for this project, you can use a variety of construction paper shapes left over from collage projects or photographs from magazines.)

Romare Bearden, American. *The Woodshed,* 1969. Collage on board. 40½" × 50½". (See Plate 46.)

HOW DO YOU START A WORK?

One of the most exhilarating events to watch in class is the way very young children start a painting. Most of them plunge right in without worrying about what to paint because they can respond directly to the materials and experience without being intimidated by the need to represent things so other people can recognize them. They naturally emphasize what they think is important and leave everything else out. Sometimes, beginning adults have much more trouble representing what is significant to them, for when they try to portray a scene they either make the generalized symbols they learned in grade school—lollipop trees, square houses with triangle-top roofs, spoke-wheel sun, and three-petal tulips—or else try to depict everything they see and end up with a telephone directory instead of a message.

On the other hand, young children don't usually have that problem. Instead of ordering a sequence of visual ideas, they usually present only one. If they have a second thought, they simply paint it on top of the first one. In your own work you have the possibility of choosing to order your arrangement so that one mood or idea is most important and others are subordinate to and contrasted with it.

The first problem for the beginner is how to start a work you like; second, how to represent what you like or feel; and third, how to know what to change or keep. Many people feel they have no basis for making visual decisions and yet they make aesthetic choices all the time about dressing, home decoration, and other matters of appearance. Everyone has favorite colors, favorite materials or textures, and favorite shapes (for example, in flowers). We've all accumulated experience in visual discrimination that we're usually not aware of.

To start making a collage painting from your previous paintings you may begin by looking at past projects and making judgments about what you like and don't like as you go through your portfolio. As you examine the many visual ideas, situations, and moods presented, you may feel that some are more important to you than others. You react to them more keenly. Other pieces are perhaps only distant memories that have lost their impact. This sorting out of visual elements is similar to the way many people organize their closets and shelves. How you choose and arrange things in your work shows your point of view.

Hannah Höch, German. *Untitled Collage Painting*, 1922. 19¾″ × 13¾″.

I had an aunt who had a large collection of figurines. She didn't like the way they were arranged on her living room shelf and asked me for advice in arranging them. She was certain that because I was involved in the arts, I could tell her a better way to do it. She thought there were too many and didn't want the shelf to look like a department store even though she wanted to display all of them. I told her that I thought it was a very personal matter. If she felt there were too many, then there *were* too many for her because she looked at them every day. I mentioned that traditionally the Japanese exhibit a few items at one time and keep rotating their collection on display in their homes. They feel that to show everything at once is too ostentatious.

We rarely enjoy a haphazard collection of objects on a shelf and will organize it according to subjective preferences. Everyone arranges in different ways. Some people may group small plants or souvenirs close together so that the emphasis is on the drama of a large group instead of on each small individual item. If they place their collection in a group away from the center of the shelf, the arrangement creates a visual tension. If they move these objects

together in the center, it diminishes the tension by equalizing the spaces on either side. Other people might line up the objects at separate intervals to emphasize a steady visual rhythm that allows them to view each piece slowly, one at a time. Still others may put a few dissimilar things together and spread the others at irregular intervals to get the greatest contrasts of groupings, textures, colors, and shapes. The organizing process is the same when you emphasize and subordinate elements in your studio work to make your own personal statement.

When the photographer Brassai was taking pictures of Picasso's studio, he moved the artist's pair of slippers a few feet to one side on the floor to make what he thought would be a better photographic composition. When Picasso saw this he chided Brassai for imposing his own design taste rather than recording Picasso's arrangement of his own room. In this situation each person wanted to make his own personal statement about the placement of objects and the character of the spaces between them.

Sophie Taeuber Arp, Swiss. *Composition Project for a Tapestry*, mid 1920s. Paint and gold paper on paper. 5½" × 5."

Some people want to fill every inch of the space with shapes and motion. Others want to focus on a single image in one part of the paper and then do a second, third, or fourth work to represent other ideas.

Your Project: Collage Painting

Take out all your previous projects and look for works that may feel incomplete in themselves or that don't seem to add up to a satisfying statement. These may have attractive areas that you might want to save. The parts might almost be complete patterns or arrangements in themselves, have a pleasing passage of brushwork, or interesting texture, shape, or group of lines. Pull these out of the collection to use in your collage painting.

In each of these past experiments you explored the unique qualities of individual materials and techniques. This time you're going to put the elements together and add on to what you have done before. Instead of starting a new piece from scratch, you'll be making a new structure using parts of these past works.

Cut up these selected paintings and collages into manageable sizes before the workshop. Remember, though, it isn't a good idea to cut up your old paintings in front of very young children because they may think that you are destroying your work.

Even though you have cut your old paintings into smaller pieces before starting, when you begin cutting out shapes during the workshop your children may notice and be curious. If they ask why you're

Adult's collage painting. This person used the formal device of "passage" where he used paint to visually unite cut paper with painted areas. (See Plate 45.)

doing it you'll need to explain that you are saving the parts of your old paintings that you like best in order to put them together in a new way. If you stress the positive aspect rather than the negative idea of getting rid of the old, they will not be disturbed. If they show no interest at all, don't bother them with an explanation that may be confusing.

In this project you'll be using unthinned paint to paste your shapes down in order to experiment with another way of making an edge with paint. (If you wish to use glue to put some shapes down, you can; however, poster paint has glue arabic in it and using the paint is a more direct method and may produce interesting results. For further information on the paint base, see page 81.) Blending edges so that they disappear into the background is another method of unifying the pictorial surface. You can generate a raised edge around your glued shapes by brushing on a generous quantity of unthinned paint that will squeeze out from under the paper when you pat the piece down. *Make sure you press out all of the water in your brush before dipping it into the caster cups so that your paint remains the proper consistency for pasting.*

Last time you used ready-made textures in your collages. Now you'll be creating your own textures and also transforming others by using overlaps of paint and layers of translucent and opaque materials. When you made a texture collage you juxtaposed diverse materials as a method of construction. There was always the risk that the baggage of previous memory associations from the materials' former uses would take over the life of your image. This "scrapbook" effect happens when the pieces appear to have little visual relationship to each other outside of the memories they evoke. You can avoid this problem to some extent by transforming the materials: making physical and visual connections between the shapes by overlapping and extending the colors of the shapes with paint so that they blend with smooth transition areas into the background. You may have already noticed this if you painted your texture collage. This device has been called *passage*, and it was used extensively by such artists as Schwitters, Picasso, and Braque (see illustration of Kurt Schwitters' collage, *Picture with Light Center*, page 218).

You have seen from earlier collage projects that there are many ways you can unify all the varied materials and colors—for instance, making the background environment set the mood, overlapping pasted shapes, softening edges, and extending the gestures of the lines. You found that you could brush on colors to shape and change the spaces between the boundaries of each edge. You might have emphasized one or a whole group of colors or textures by repeating

them in different places or putting tissue paper overlaps on previously patterned or painted areas.

MATERIALS: (Remember that very shiny papers are not porous and will not take the paint as well as noncoated ones.)
one 18-by-24-inch sheet of white paper for painting on
selection of photographs from magazines, mostly cut up across the images. (Occasionally you may find one you wish to use whole for a special project.)
selection of earlier painting and collage projects cut into manageable pieces
leftover scraps from previous collages
paint and brushes, with your tray set up for painting (see page 62)

PROCEDURE:
1. Look through your cut-up paintings and collages to decide which of their areas you want to use. As you cut these out, remember that although you are using your scissors as a drawing tool, once you have your shapes cut and down on the background paper you can change them with the paint. Cut as spontaneously as you wish here.

2. On the white paper, brush in two or three large divisions of color that will relate to the kind of mood or place you have chosen to represent. Remember you can always change this if you wish.

3. Place your shapes on the background paper and move them around as you did in previous collages. After you come to an arrangement you like, glue down the shapes on the background by pressing them into wet paint.

4. *Gluing:* There are two possible ways of working here:
a. Use the paint as glue by painting it down on the background and then pressing the flat shape into it. Sometimes the paint squishes out around the piece to make a different edge. If you don't want a raised edge, smooth it into the background with your brush.
b. Slip paint underneath the edges of your pieces as you did with glue in previous collage projects.
To blend your shape into the background, make sure that you use the same color paint to glue with. To separate the shape from the background you might use a different color paint to glue with.

5. Overlap paint, tissue, or other papers onto the previously painted areas to mute patterns or to get soft- or hard-edged divisions.

6. For your next session you might use an old painting as the background paper and then cut and arrange shapes from other paintings and collages on top of it.

Adult's collage painting. Notice the painted patterns on top of the cutout wallpaper patterns. (See Plate 44.)

THINKING ABOUT WHAT YOU'VE DONE

Many people think of *composition* as a way of making something pleasing and attractive. However, I see it as a way of ordering many ideas or visual elements so that you can communicate what you find important. If you tell a story, no one will be able to understand its significance unless you put the details in some kind of order. This order gives an emphasis to certain ideas and subordinates others. If you think of people who tell jokes and take forever to get to the punch line because they add so many details, you know how irritating a poorly organized story can be. They haven't learned to emphasize the main points and leave out the others.

You face the same kinds of problems with your studio work. That's why I suggest doing all the collage projects so you can learn more about how to arrange the space on your paper.

The point of composition is saying exactly what you mean. You may change your focus as you work or express more than one idea in a piece. You can play contrasting visual elements against each other and present many visual elements together if you organize them so they're not competing with each other. You merely decide which aspect you want to be the most prominent, accentuate it, and then subordinate the other parts to it. You might think of composition as similar to putting together the elements of a recipe in cooking. If you throw in a lot of spices, none will be distinctive unless you order the amounts, emphasizing some and reducing others. If an orchestra is playing *Tubby the Tuba*, the tuba is the emphasized instrument, whereas ordinarily the tuba is subordinated to all the other ones.

How did you say what you meant in your collage painting? Did you arrange your lines, colors, and shapes to make one element more visually important than all the others? You may have begun this process when you painted your background into several divisions. Did you make one area as different as possible from everything around it with light and dark tones, warm or cool colors, large or small shapes, textures, direction or gestures of the shapes? What happened if you used converging diagonal lines? Did they lead your eye to a point on the paper that you wanted to emphasize?

Did the location of shapes on your page increase or decrease the visual prominence or weight of any of your shapes? If you think of a see-saw with its axis or balance point in the middle, the two ends seem equal. If that point is now placed closer to one side or the other of the board, which end looks heavier? Do bright surfaces make any of your shapes look more or less prominent?

If you wanted to emphasize motion or rhythm, you might have used lots of repetitious shapes or similar colors and textures to make your eye see them as a group instead of as single pieces dispersed

around a field. Did you use patterning of your paint marks to get thick impasto surfaces to emphasize a textural rhythm? You may have noticed how multiple lines and patterns could enhance a sense of tempo or rhythm. (See Charles Burchfield's *Dandelion Seed Balls and Trees*, page 190, and illustration from the *Shah-nameh*, page 192.)

YOUNG BEGINNERS

I do not offer young beginners any new projects while their parents are making collage paintings. Their growing skills in mixing colors and making shapes is motivation enough for them to continue their explorations with the paint. They enjoy the repetition of working with familiar materials in the same way that they delight in the repeated reading of their favorite stories over and over again. It's reassuring for them to have something they know how to do and feel close to.

I always have reproductions of paintings and photographs to show beginners of all ages. We talk about these things before they sit down to paint. We look at undersea scenes, sea and land animals, landscapes and cityscapes, castles and carnivals, and talk about places they would like to go. I show these to help the children to think in visual terms rather than to suggest specific themes. I was so pleased when a mother told me how her four-year-old was sharing her art experience with her two grandfathers, who both loved to paint. Lisa now says, "Let's talk about that color. . . ."

Inviting youngsters to cut up their own paintings might seem to be a rejection of their previous efforts so I don't ask them to do it. They may have already been making a type of collage painting by putting pieces of construction paper into their paintings, because I often offer them small construction paper shapes after they have painted for a while, explaining that the pieces will stick to their wet paint, in an attempt to remotivate someone who has done minimal work to begin painting again.

Gradually introduce new papers and textured materials into their choosing trays for each collage session. Don't be surprised or disappointed if they become more interested in handling and exploring the textures for a session or two instead of pasting them down into a collage. Julia, four-and-a-half years old, saw me show someone how to tie and knot yarn, and she became fascinated with making knots. She did little else on her collage. However, the next time, after her curiosity had been satisfied, she was able to use the yarn as a line in her collage.

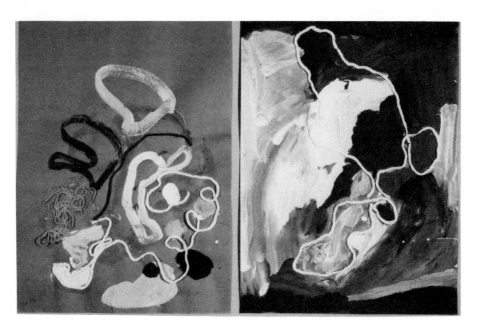

Children's collage paintings. These two five-year-olds painted their colored construction paper and added yarn to the wet paint.

When I add a material such as yarn for their painting, I make a distinction between making lines and shapes with the materials, and using these materials to paint with. Permitting a young child to dip yarn or paper into the paint would detract from learning to control the paint brush as a drawing tool. They may have problems knowing which objects are tools and which ones are to be pasted, painted on, or cut.

EXPERIENCED YOUNG PEOPLE'S PROJECTS

Ideas for collage paintings for older children (six through high school) might include: a place where a real or fantasy animal might live, a sculpture garden, a real or fantasy city or place where people live.

For each project I show reproductions of works of art and photographs from my picture file, and we talk about making a place where a person or animal might live. I suggest that they paint a background and then cut out shapes that portray the appropriate images. For example, when I was teaching six- and seven-year-olds at the Museum of Modern Art in New York I asked the children to go into the sculpture garden after I showed them photographs of which sculpture to look for. Then they cut collage sculpture shapes of their own sculpture that were reminiscent of spacemen, totem poles, medicine men, and witch doctors. After painting special places, some made collage shapes of figures holding up other figures. They painted all kinds of backgrounds. One made a city with lots of buildings and then superimposed a monster attacking the city. Another created a scene in space—then cut out a shape and put a spaceman inside it.

Experienced youngsters may also enjoy re-creating in paint the visual look of textures or materials they have been using in their work. I have seen some children paint cross-hatching on the paper to echo the pattern of Dixie Mesh (a stiffened plastic screening with large holes) or dry-brush the fuzzy quality of pipe cleaners with brush strokes next to the pasted-down textures. I don't suggest that they do this, but I do point it out when it happens ("Look how you made your brush strokes look like texture") so that they will make the conscious connection between the visual textures and the physical ones.

Experienced children who know how to cut and paste with ease may enjoy making a collage painting like yours. However, I suggest that they make painted papers to cut up specifically for this purpose rather than cut up any previous work.

For another project, you might start off by having them make a regular collage from cut- and torn-paper shapes. Next, put away the scissors and paste, and put out their usual paint trays. Now you might suggest they try to make the same colors in paint as those on some of their pasted-down shapes or change the shapes by painting over and around them. They may be surprised to find out that it becomes difficult to tell where the pasted shapes end and the painted ones begin.

Children might paint their own texture and patterns on pieces of 9-by-12 white and colored papers and then cut these up for collage.

Children's collage paintings. These children repeated the look of the textures and patterns with paint. Left: this three-and-a-half-year-old started painting, put on yellow tissue that he had crumpled, and then continued to imitate the crumpled texture of the tissue in yellow paint below it. Right: this four-year-old made the textured collage first and then painted the spotted pattern of the leopard fur (in the lower right corner) with white painted dots.

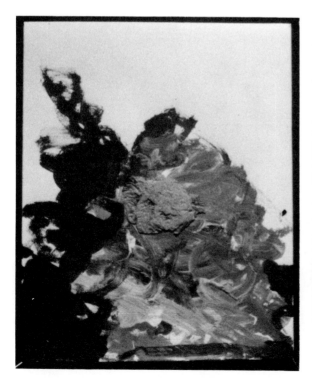

Four-and-a-half-year-old's collage painting with pattern. This child chose patterned-paper strips, then painted similar colors on her paper, and finally repeated the shaped patterns in rows of paint dabs.

If you have a group working together, they may be interested in sharing the pieces. Then they can put the new pieces into their own collages and later see how someone else used the patterns they traded.

Both children and adults may enjoy drawing on top of their whole collage painting with Cray-Pas. However, only give out these markers at the very end of the session. The oil-base Cray-Pas will resist the paint and glue will only adhere to the paper where there are no oil marks, thus giving a different kind of surface.

TIPS FOR TEACHING

Although I always plan a specific project, they may deviate from it as long as they are seriously involved. However, I never just say do anything you want, because most often people young and old need stimulation and motivation to find ideas.

When thinking of themes for any age group, the greater the number and novelty of the materials, the greater the danger that the project will become busywork. They may be seduced into handling the materials rather than using them to express feelings and ideas. The opposite extreme is making the themes and range of materials so narrow that it may restrict inventiveness. The idea here is to get everyone to find ways to invent their own subjects instead of depending on being told exactly what to do. Self-motivation and generating one's own ideas is the goal.

FOURTEEN

Paper-Sculpture Hats

T HE FIRST TIME I did this project at the parent-child classes at the
Museum of Modern Art was when my own daughter was three
years old. At the end of the hour, we were all so pleased with our
hats that we wanted to parade through the museum to show them
off. We had created an instant party and we wanted to share our
pleasure. We had worked with great seriousness making them, and
not only were the materials transformed in the process but the mak-
ers were changed also.

I've done this hat project with people from ages two and a half
through eighty, and it always works the same way. Under all circum-
stances it seems to make people happy. Even a few older men who
seemed very hesitant about the idea in the beginning because they
thought it childish, ended up in a high state, delighted with what
they had done. Sometimes the parents make hats for their children
and the children make hats for their parents. At the very least they
exchange hats for trying on.

A hat can tell where you're going or what you're doing. Its shape
and decorations can tell about the time, place, or climate, about the
personality of the wearer, about status, rank, or social role. When I
went to Buckingham Palace I remember vividly the great fur hats of
the guards. When I think of the hat of a pope or crown of a king I
think of its use in ritual and ceremony, while the helmet of a football
player or astronaut brings to mind a protective role.

Although today headcoverings sometimes may be dismissed as
springtime accessories or fashion postscripts, they have always been
both a vitally necessary protection against the weather and a vehicle
for flights of imagination. Before sunglasses were common the wide-
brimmed sun hat shielded the eyes from glare. Before heated trans-
portation, hats were essential when walking in the cold or riding in
freezing carriages. Before hair spray and permanents, fancy coiffures
would collapse or be destroyed by the weather without the protection
of headcoverings in wet weather. Hats were worn indoors and night-
caps in bed for warmth before central heating. These objects of ne-
cessity became transformed into extravagant symbols of glamour and
social status. Monumental or minuscule, hats became splendidly or-

Head from the statue of a king,
(Amenemhat III?), Egyptian, XII dy-
nasty. Wearing the double crown of
upper black granite. 42 cm. high.

Japanese Helmet. Iron, brass, lac-
quered neck guard laced with silk
cords. 12¼" high. You might try fold-
ing the top of your hat crown into
wedge-shaped points as in this tea-
bag-shaped helmet.

Albrecht Dürer, German. *Ulrich Varnbuler*, 1522. Woodcut. You can cut, roll, and overlap the edges of your own paper brim for a more three-dimensional effect.

Reuben Moulthrop, American. *Sally Sanford Perit*, 1790. Oil on canvas. 36¼″ × 29¾″. You might curl strips of paper into rolls to add different kinds of shapes to your hat.

nate gardens of jewels and flowers, feathers and fur. Hats for both genders adopted abstract sculptural forms. The shapes of men's tricornes and bicornes, bowlers and boaters rivaled in extravagance those women's bonnets of haute couture.

Although now many hats are often soft, floppy affairs made from knit materials, in other times hats were more architectural and geometrically formed. The crowns of kings, armored helmets, officers' hats, and popes' and nuns' headpieces were extremely architectural.

Like buildings, hats have aesthetic and spatial dimensions as well as utilitarian ones. Forms of architecture are organized to convey moods and ideas, for instance the monumentality of government capitol buildings or the spirituality of the great cathedrals. In the same way, hats can convey monumentality, dignity, and other attitudes.

Hats can be seen as pieces of sculpture. They go up in the air and you can see all around them. If you can see your hat project as sculpture instead of thinking of it as only a practical or recognizable object, you can invent more freely and make a visual statement. Hatmaking is a subject for organizing sculptural form in the same way you used themes for arranging your collages and paintings to convey a mood or idea. Many painters and sculptors have been commissioned to design sculptural and painterly costume pieces for theater and dance companies—Picasso and Chagall for theater and opera, Matisse for the Russian ballet. Such real-life outfits as ancient suits of armor are good examples of the sculptural and painterly aspects of costume.

At various times, hats have looked like pillboxes, pies, domes, flower gardens, or plumed birds. Can you conceive of a hat sculpture like a house, boat, or flower?

Your Project: A Paper-Sculpture Hat

HOW MANY VARIATIONS CAN YOU MAKE ON A THEME?

The aim of this project is to see how many ways you can find to transform and personalize the basic hat pattern given here instead of merely embellishing the surface of the structure. Many people can't wait to start decorating the hat and don't think of developing the three-dimensional shapes underneath the trimmings. Just as you set the stages for your paintings and painted collages by establishing your colored background, here you're doing the same thing by building up your forms first. You might think of yourself as an architect. First you build the house and then you develop the details to enhance your basic structure.

As you build your hat, try to think of all the things you can do to

the paper to make it more three-dimensional instead of using the pieces flatly. (See Dürer illustration, previous page.) You can roll the brim, cut out concentric spirals and pull them open to make them stand up and roll over, fringe parts and fold the tabs in various directions, or cut holes so that a part becomes a see-through shape.

The silk top hat (see Toulouse-Lautrec, *Divan Japonais*), invented in Florence about 1760 and perfected in the next century, was fabricated by a method similar to the one you are using to assemble this project. The cloth was stiffened with a varnish of shellac and cut into pieces for the crown, top, and brim. Next the sides of the crown were wound around a wooden hat block and the edges were joined by hot ironing. The top was similarly joined to the sides. Finally the brim consisting of three laminated pieces of calico was glued on. After assembly the whole form was painted with a coat of size so that it could be covered with a velour of silk. Linings were attached, the brim was curled, and it was ready for use.

Henri Gravedon, French. *Pourquoi Pas!* 1831. Lithograph.

In the same way, in this project you will be cutting out the pieces, assembling them into a basic form, and covering your hat with a finish of other textures and embellishing it with attached pieces.

I have specifically avoided the kinds of patterns and procedures you may find in some kits which result in predetermined forms that are difficult to change or transform once the initial cuts are made. It is preferable to work with processes that involve adding on pieces to make a finished form rather than taking away from a single paper pattern to make the finished form. Once you cut away from prefolded shapes, it's almost impossible to change the basic form or glue pieces back together. For example, it's difficult to do anything but embellish the traditional folded, origami-style hat and boat you may have learned in grade school.

Here you will be assembling separate shapes into a complete form just as you did with your collages. Each piece can be shaped both before and after it is joined to another part. Moreover, you may discover your own ways to put the parts together. You might assemble the crown and brim pieces so that they do not resemble the top hat indicated in the basic proportions of the sheets of paper. You can put on several brims going up the side of the crown or put the brim on top like a graduation mortarboard instead of at the bottom. You can cut the crown down or keep building it up by cutting tabs into the edges of each crown cylinder to glue onto another piece. You can cut your wrap-around brim into many shapes, take off all of it, put a visor on one side, turn the brim into ear flaps, paste it up onto the side of the crown, or fringe it. If you cut off too much in any place, you can merely paste on an addition to the part. Treat your hat as a three-dimensional collage.

Henri de Toulouse-Lautrec, French. *Divan Japonais*, 1892. Lithograph. 31⅞" × 24½".

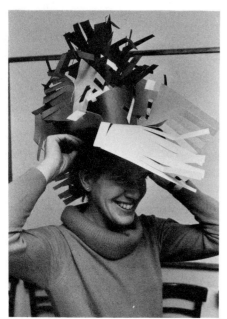

A mother trying on the hat she has made.

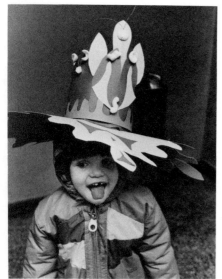

A child wearing the hat her mother made.

MATERIALS:

two 18-by-24-inch pieces of colored construction paper for the basic form. More may be needed if you greatly enlarge your hat.

scissors

rubber cement

decorative materials:

For the first experience, put out very little decorative material—just wire, small Styrofoam packing pieces, and a selection of leftover scraps from all your previous projects and newspaper pages with patterns of pictures or type. You can use any thin but structural wire such as florist's wire, trash bag or vegetable wrapping wire from a grocery store, or pipe cleaners from a variety store or smoke shop. Ask gift or appliance stores for their discarded packaging materials for the Styrofoam.

For a second hat, you might add a larger selection of textural or linear materials such as feathers, imitation fur, imitation flower petals, dried seedpods, copper or stainless steel scouring pads, cotton balls, ribbons, and sponge rubber.

painting materials (optional)

stapler and paper fasteners (optional)

PROCEDURE:

1. Cut your two large pieces of construction paper into the following pieces:

 a. A 9-by-24-inch strip for the crown

 b. An 18-by-18-inch square for the brim.

2. To make the brim, cut a round hole in the 18-inch square by pulling your scissors through the paper and cutting a round circumference (see illustration on next page). The diameter should be about 9 inches or smaller depending on the size of your head. Do not fold your square in half to do this, not only because you will put an unwanted crease through the center of your brim, but also because you are more likely to produce an oversized opening when you cut off both sides at once than if you enlarge the opening by smaller increments. Although the exact size doesn't matter, it's better to keep this smaller rather than making it too large. Sometimes it's better if the brim is small because you will be able to tie it onto any size head. If it's too large it may fall down over the nose unless you put a false crown inside by fastening inner strips across the diameter. Someone asked me once if she could make a square hat. We decided that she could try cutting out a square shape in the brim instead of a round one and folded her crown into a box form. It worked well.

3. On the 9-by-24 crown strip, fold over the long edge about an inch and a half (see illustration). Crease this and then open up the

Cutting the circumference of your brim hole. Instruction #2.

paper again. Cut tabs every inch all along that folded edge (see illustration). (If you have made the hole in the brim too small to fit on the head, you can fold down two unglued tabs to put tie strings on.)

Folding your crown strip. Instruction #3.

Cutting tabs in the folded edge of the crown. Instruction #3.

Inserting your rolled crown into the brim. Instruction #4.

4. Roll your crown strip into a cylinder (but don't glue it closed yet) and insert it into the hole in the brim (see illustration). You did not seal the crown edges in advance of assembly because you will have to overlap the edges more or less in order to make the crown fit the diameter of the hole in the brim.

5. Glue the bottom edges of the seam of the cylindrical crown shut (leave the rest open so you can mold the shape) and glue the tabs of the crown onto the brim to attach the two parts (see illustration). (Leave two tabs on opposite sides free if you want to make tie-on holes in them.)

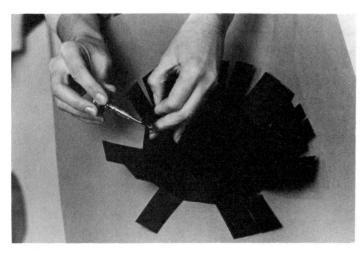

Putting glue on the tabs of the top of the crown in preparation for joining it to the sides of the crown cylinder. Instruction # 5.

6. Now you can start shaping your basic structure. There are several possibilities you might try. You can trim your square brim into any shape and attach the leftover circle that remained when you cut out your brim to the top of your crown by cutting tabs into the top of the crown and folding them down to glue them to the circle. Or you might change the shape of the top of the crown by pulling in and

overlapping the edges of the cylinder to make a narrow point on top. You might leave the crown open, cut into its sides to fringe it, and bend the fringes outward. You might cut the crown into strips that you curve across the top of the crown and glue together to make a domed top. If you simply pinch the edges of an open crown together and glue them you can get a totally different hat shape. You might cut see-through shapes in the crown and pull other materials through these holes or leave them open.

7. After you are satisfied with the basic paper structure, you can begin to embellish it by adding scraps of paper, textured materials, or wire (to attach protruding objects or tassels). Finally, add paint if you wish.

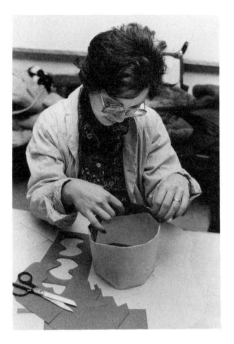

THINKING ABOUT WHAT YOU'VE DONE

When you made your collage paintings, you thought about many different ways to indicate what was important in your arrangements of shapes through the devices of contrast and repetition of colors, textures, lines, and sizes of parts. You can look at your hat in the same aesthetic way. You used the principle of contrast in the three basic hat parts: crown, brim, and embellishment. The brim was a planar surface, the crown was a volume, and your added strips, wires, fringing, or painted marks gave you lines. Each of these parts had a different quality of shape.

You may have emphasized one of these parts by its size and color. If you made a tall top hat, the volumetric crown was dominant. If you made a sun hat with a wide brim and cut down the height of the crown, the planar aspect was most prominent. If you cut down both brim and crown so that they were small and added long strips or parts that projected out from the hat, you might have emphasized a linear quality.

How you ordered your arrangement established a set of relations between the parts and determined your emphasis (or what you wanted the most important part to be) and the feeling that the whole form expressed. Each part made a kind of gesture or direction into space. If you had a tall crown rising from a narrow brim, the hat may have conveyed the visual idea of vertical monumentality. If the brim was the biggest part and it spread out sideways and curled upward, the main gesture may have been one of horizontal flight like that of a bird. If you had a large ballooning or expanding top like a chef's hat, it might have reminded you of the growth of a mushroom or expanding popover biscuit rising out of a baking pan. However, if you made all the parts of equal size or visual weight, no specific quality would have been noticeable.

You know that the proportions of ingredients in a recipe determine

Head of a Colossal Warrior, 20th-century copy of a 5th-century B.C. Etruscan work. Terracotta clay. 55" high.

the way the food looks and tastes. The proportions of your body determine whether you look sexy or not (36-24-36 gives a different impression than 36-36-36). The proportions of your hat sculpture, or the relationship of the parts to each other and to the whole piece, are the means by which you can emphasize what you think is most visually important, as you did with earlier two-dimensional projects.

Your collage painting used overlapping or painting to join shapes together. Here you may have either joined shapes by putting them up against each other with tabs at their edges or made the parts penetrate each other. If you had stacked several brims up the sides of the crown, the crown would have appeared to penetrate the brims. If you added paper strips, wires, or other materials that stood straight out from the hat, they may have looked like they were going into it. This quality of interpenetration of shapes is a kind of three-dimensional overlapping.

You can also use all the other visual devices you used in your collages and paintings to convey feelings and ideas in your hat. Your hat might have depicted a time and place in history or a character who would wear it. You might have experimented with a variety of different edges, have textured the surfaces with paint or other materials, or made see-through spaces by cutting away parts of the shapes. You could have extended, enlarged, or changed the shapes completely by pasting on more paper pieces and by painting colors and lines that ran from one part to the next. By using this additive process, you can even keep on building until you get a structure that feels right.

A child wearing the hat she has made.

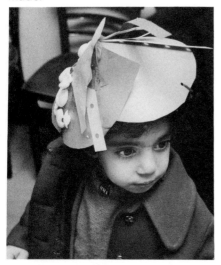

YOUNG BEGINNERS' HATS

Your hat with a brim and crown is too complicated for young beginners. When I do this workshop and demonstrate how to make the hat with a crown and brim, I talk about the parts and shapes with the children even though they are going to make simple tie-on bonnets that are pasted or stapled closed in back. I always want the children to know what their parents are doing so that they are less tempted to want to go over and look instead of working on their own hats. They also pick up a certain amount of information this way.

Before the workshop I put up reproductions of paintings and photographs with hats prominently visible in them. When we start to talk, I ask the youngsters what people wear on their heads and why (for example, when they go to a party). Then we talk about all the different kinds of shapes hats can be. I show a painting in which a man is wearing a crown and ask, "Do you know what this man is?

They all know he's a king because he's wearing a crown. I explain that sometimes a hat can tell you what the person in the hat is or what he is doing. I show pictures of a fireman, a clown, and people in funny party hats.

Then we talk about what kinds of shapes the hats are made up of. I explain that the part of the hat that goes up in the air is called the crown and the part that sits on the head is the brim. Some of the hats in the reproductions are highly decorated and almost look like texture collages. (See illustration of Reuben Moulthrop's *Sally Sanford Perit*, page 230.) I tell them that "When you make a hat, you can make a collage hat. There are all sorts of things you can do with your paper. You can curl it by looping it over and pasting it, you can fringe it, make see-through shapes, or stand-up shapes." I demonstrate each of these mainly for the parents but some of the youngsters may try them also.

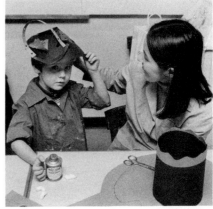

Tommy's mother takes a break from her own work to admire his "Robin Hood" hat.

Before the workshop I make a demonstration young beginner's bonnet for me to wear—decorated with a variety of pasted shapes so they can see the possibilities. I undo the staple so they can see the original shape.

For the young beginners, I give out 9-by-12, precut, rectangular shapes with rounded corners and holes punched at each end to accommodate tie strings of yarn. This shape makes a wrap-around bonnet that ties under their chins. (It can also be turned into a mask if you cut out eye holes.) You might include some tissue and patterned paper and some decorative materials that you are using on your own hat in their choosing dish, but make sure these are soft and flexible so they don't pop off when you curve the two sides of the back together.

I demonstrate how I cut a slit about one-third of the way up the center back, overlap the edges of the slit to form the bonnet shape, and staple the overlap closed (see illustration, next page). I don't expect the youngest ones to be able to slit and staple their own pieces. Finally I put the tie strings on.

The children make collages on the flat pattern before slitting and stapling. I show possibilities for adding different kinds of shapes as they work. If they have cut into their collages so that it would be difficult to make a hat, I offer to help them glue their pieces onto another precut hat pattern, slit it, and then staple the shape. Sometimes they want to keep their collage as it is and make a different one for a hat.

This project can be especially enjoyable at birthday parties or at Easter. At Halloween you can turn it into mask-making, substituting reproductions and photographs of masks for those of hats and talking about why and when people put on masks.

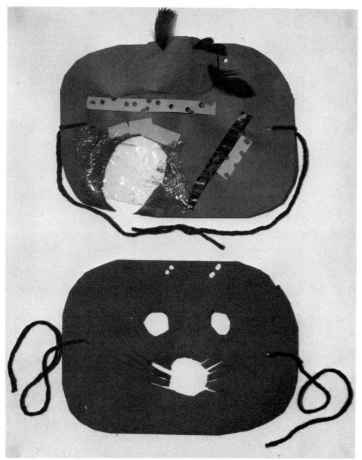

Stapling the back of a child's bonnet to form the curved hat shape.

Four- and five-year-olds' hats. One four-and-a-half-year-old child turned his hat into a cat-face mask by cutting out eye holes and a mouth framed by whiskers.

EXPERIENCED OLDER CHILDREN'S HATS

More experienced school-age children may enjoy making hats like yours. However, because the tabs of the crown are difficult to handle, they need a certain amount of dexterity and perseverance to accomplish this. Be careful you don't take over and assemble the pieces of the hat for them. If you find that the crown-and-brim hat is too difficult for them to enjoy making, switch over to the simpler collage bonnet or have them make a collage crown without tabs from a wide strip that can be wrapped around and fastened to sit on top of the head.

They can also make three-dimensional masks instead of hats. These can be structured for any degree of experience, from the simple precut flat shapes through elaborate paper sculptures. Again, I show illustrations of Oriental, Oceanic, African, and other ceremonial masks here.

Although you can use paper bags for hats or masks, I prefer to

have everyone have the experience of cutting out and assembling pieces themselves in order to encourage learning how to construct sculptural forms.

ADVANCED PROJECTS: OTHER THREE-DIMENSIONAL FORMS IN PAPER

Free-form mobiles, stabiles, and other paper sculptures are now within the capability of you and your older, more experienced children. However, you will have to do a bit of research and experimentation on your own to guide such advanced projects as making kites or full costumes in paper. Exploring these together and sharing your trials and errors may be more enjoyable than if you assume an authority role. Histories of art and costume books will provide good source material for getting ideas.

TIPS FOR TEACHING

In doing your hat project you undoubtedly discovered for yourself many ways of shaping paper by twisting, folding, curling, slotting,

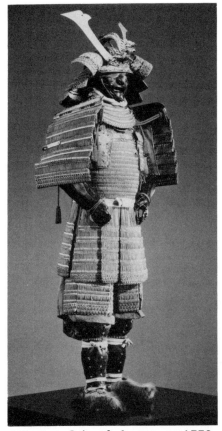

Japanese Suit of Armor, c. 1550. Steel, blackened and gold-lacquered; flame-colored silk braid, gilt bronze, stenciled deerskin, bear pelt, gilt wood. 66" high, 48 lbs. (See Plate 47.)

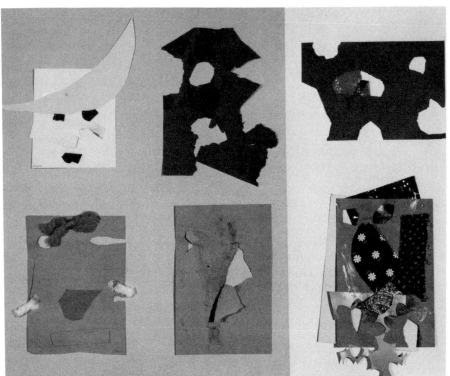

The week after the children had made masks some continued to make variations of the face in other forms.

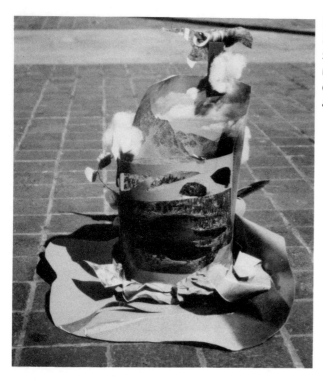

Landscape Hat by Nan Talese. This hat features a wrap-around land-scape diorama made with a magazine photograph, a three-dimensional bird, cotton clouds, and a sandy desert floor on the brim.

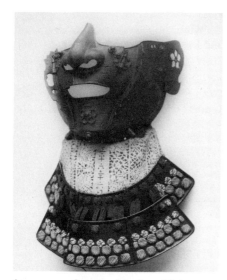

Japanese Armor Masks, 18th century. Leather, lacquer, and chain mail. (A) Full head covering, life size. (B) Armor for the lower face and neck, life size. You might attach other lightweight decorative materials, such as old scarves or jewelry, to your paper form.

and attaching pieces. Although you can read about many paper-sculpture techniques and dramatic effects listed in papercraft books, our first emphasis is getting people to fully investigate the properties of the medium themselves. Just as you give beginning painters only five colors so that they learn to mix the rest, here we start with the most basic paper-shaping processes. A similar situation occurs when you add decoration materials to your first hat. I suggested that you restrict your materials so that you could examine each element in depth.

When you are guiding beginners, try to remember to hold back both materials and information. Beginning teachers often are so insecure about their own abilities to interest the students in the projects that they may overcompensate for lack of knowing what to say by overloading the class with too much too soon. You may be very tempted to put yourself in this position with older, school-age children who may seem indifferent to cover up their own lack of self-confidence and experience.

FIFTEEN

Clay Sculpture I:
Getting Acquainted
with Clay

*Sculpture is like a journey. You have a different
view as you return. The three-dimensional world
is full of surprises in a way that a two-dimen-
sional world could never be.*

HENRY MOORE, British sculptor*

THE UNIQUENESS OF CLAY is its sensitive plasticity, that flexible
malleability that is exquisitely impressionable as it responds to
direct touch. Touch a soft piece and it instantly records your unique

* From exhibition catalogue *Henry Moore: Carvings, 1961–1970, Bronzes, 1961–
1970.*

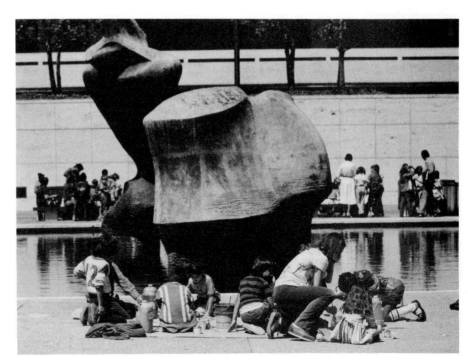

Students in Betty Blayton's "Chil-
dren's Art Carnival" from Harlem
visit this Henry Moore sculpture at
Lincoln Center in New York City.
They are making painted collages in-
spired by the forms of the sculpture.

fingerprint. Many people find that working with clay has a compelling emotional dimension because of the direct intimacy possible when working without tools and molding shapes with their hands. Kneading, stretching, squeezing, and rolling the clay can be compared to working bread dough, yet the potential for shaping precise forms is greater. Others say that working with clay gives a direct sensation of thinking with their hands. Its plastic mutability is a quality they seek in their own lives, the ability to change things and to move into new and deeper forms as well as to make connections between ideas and sensations. I had a woman in my class who did all the projects very happily but became ecstatic when she put her hands into the clay. She told me after class, "Now I know what I want to do. It's like coming home." She went on to take another course in sculpture.

Feeling the wet of clay
Is feeling a connection
With all the civilizations of humans
Forming the same material;
A connection of the soul,
Sensuous and plain;
A connection with time,
When there are moments
Like a rush through eternity.

Mimi Gross, American sculptor

Mimi Gross, American. *Portrait of Jody Elbaum,* 1980. Unglazed ceramic (before painting). 23" × 18" × 13". Viewing a sculpture from different angles can give you totally different impressions of the work.

Jean Arp, French. *Configuration in Serpentine Movements,* undated (first half of the 20th century). Marble. 9" × 14"

clay and really move it at her will. However, she too went on to take more classes for herself because she enjoyed it so much.

Sculpture emphasizes the physical and tactile qualities of things: hardness and softness, heaviness and lightness, tautness and slackness, smoothness and roughness, the penetration of forms into space and the concrete bounding or definition of space. Three-dimensional objects are compelling because they project out at you and assert their presence in space.

Many twentieth-century sculptors have used three-dimensional form to make tangible symbols of their inner sense of mystery by solidifying subtleties of feeling and sensation. Sculptures can physically and precisely materialize the dream or solidify the image beyond logical comprehension.

For some people who have never worked with clay, it may present more of a challenge initially than the other two mediums, and take more time to get used to. Once, in a workshop I led for teachers, a participant confided to me that it had taken her almost the whole hour before she gained courage enough to dig her fingers into the

Mary Frank, American. *Tree Landscape,* c. 1971. Ceramic. 15¾" × 16" × 17". Ms. Frank has contrasted softened geometric and organic shapes against ones that are cleanly and sharply cut with a knife. She pushed her fingers through the clay to make textures on the upright form.

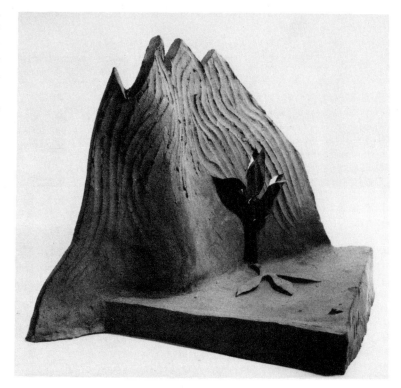

Sculpture has a kind of life of its own, a changing presence that presents a varied play of light and shadow for it reflects the color and light of the time of day in a way that the flat surface of a painting cannot. Shadows lengthen, deepen, and spread to dramatize some parts and obscure others. Forms become four-dimensional because our perception of shapes under varying light introduces the element of time in a direct way. It's like looking at a sundial without the hour numbers written on it. Some sculptors unite solid form with empty space by using polished metals with shiny, reflective surfaces that bring the sky into or form landscapes on their pieces. You might have noticed this phenomenon on the exteriors of large, glass-sheathed building facades that mirror the sky and landscape in a way that not only changes their color (depending on the light and atmospheric conditions at any time of day) but also alters their illusion of visual weight, size, and the apparent convexity and concavity of the flat surfaces.

If there is any means of possessing an absolute, objectively, instead of knowing it only subjectively, making three-dimensional forms comes closest to it. You get the reality of physical mass and not its illusion, an utter concreteness that you can reach out in time and space to touch and reaffirm. Painters have often made small sculptural models of tableaux with figures to get to know intimately the space and forms of what they want to paint. For example, Edgar Degas used sculpture to explore problems of form and movement that he had difficulty solving in his paintings. His dancers and horses

were made at the same time he was representing those subjects in his paintings. Henry Moore also prepared for his larger works by making small models, or maquettes, about the size of the shapes you will be working with in your project (see illustration, page 247).

Your Project: Getting Acquainted with Clay

MATERIALS:

approximately five pounds of gray, water-base potter's clay (enough for two people for this first project). See detailed Clay Buying Guide at the end of this chapter, page 261.

tongue depressors and applicator sticks

a covered plastic garbage pail (4-gallon size) and thin plastic sheeting such as the type from the dry cleaner for long-term storage inside the covered container

a rigid, nonmovable table for wedging. If you don't have a sturdy, washable table, you might use a kitchen counter.

a nonporous material for covering the work table, such as Con-Tact paper, oil cloth (some people prefer the rough side of oil cloth), or plastic sheeting

a movable sculpture base: a small, smooth 12-by-12-inch surface for setting your piece on and turning it as you work it, such as a sheet of oil cloth or heavy vinyl, or a piece of floor tile, tempered Masonite, finished wood, Formica, or linoleum.

a 12-inch-square piece of heavy mat board or other rigid cardboard to put your finished piece on while it is drying

tools for separating clay from the work surface: wire, heavy carpet or buttonhole thread, or a thin knife or spatula (clay will separate easily from the rough side of oil cloth)

a mixture of half Elmer's Glue-All and half water, about one ounce total for both your own and your child's shapes in this session. (You may already have a jar of this mixture because you may have used it in tissue-paper collages. Add a bit more glue to it for use on the sculpture.)

an inexpensive, soft paint brush (approximately one-quarter- to one-half-inch diameter) for applying the glue mixture

sponges or cloths for cleanup

Working the clay.

Wedging Clay: Preparing Fresh Clay for Use
The process of working fresh clay to make your material more structural by removing air bubbles, increasing its density, and making its consistency uniform, is called wedging. You wedge clay by squeezing, pounding, twisting, stretching, and folding the clay over on itself so that you press it uniformly all over. If you reuse clay, you will

need to wedge it again to remove the previously made forms and the air. You may have to add water if the used clay has hardened and then work it thoroughly again to be sure there are no hard lumps.

Check the consistency of your clay and wedge well in advance of your studio sessions so that if it needs work you do not have to waste studio time preparing it. This is especially important if you're having workshops with young children with limited attention spans or even with older beginners who have a short amount of time to spend on the studio project.

Wedging procedure: Take a melon-sized lump from your clay container and pound it down into a slab. Next, fold over one side and then another and pound it down again so that you squeeze and stretch the material as well. Continue folding and working the clay until you can feel that it has a uniform consistency.

Working with Clay

Before you start your project, take enough time to feel at home with the clay. Fold, roll, and press the clay into a rounded shape. Hold a small ball of it in your fist and squeeze it until the clay squishes out of your hand. Open your hand and look at it. Fold over or pull out even further any extruded areas that interest you. You will find that if you pinch the edges of shapes so that they are very thin they may crack off as the clay begins to dry. Keep twisting and turning the clay to look at it from all sides. If you work it by picking it up off the table, you will find this process much easier to do. Beginners usually end up working on one or two facets of the form without turning it when they model it flat on the table.

I'll produce several maquettes—sketches in plaster—not much bigger than one's hand, certainly small enough to hold in one's hand, so that you can turn them around as you shape them and work on them without having to get up and walk around them, and you have a complete grasp of their shape from all around the whole time.

Henry Moore, British sculptor*

Joining Shapes

Once when I was demonstrating the working of clay into shapes and showing how to add shapes onto a piece, one mother said she had been taught in school never to add on shapes, but rather only pull them out of a main mass.

Some instructors discourage all amateur beginners and especially young children from making complex forms by adding on. They prefer that people only pull out or extrude pieces from a main body

Joining clay parts.

* Excerpt from Robert Melville, editor, *Henry Moore: Carvings*, 1961–1970, *Bronzes*, 1961–1970, New York: M. Knoedler and Marlborough Gallery, 1970.

of clay, for it is much easier. In addition, although added-on pieces may physically stay on, they may not visually appear to grow out of the central form unless you learn to make flowing transitions of the surfaces between them (as you did when you made a collage painting). However, you can't really become aware of the differences between the two methods of attachment and their visual results unless you do both of them. Attached pieces certainly are capable of looking as if they're generated from inside the main form once you realize how to shape the joint to create that feeling.

I have found that almost everyone is quite capable of securely joining separate pieces once they know how. If the clay is extremely soft and plastic, you merely press one piece onto the other firmly and work the surfaces together with substantial pressure by taking your thumb and blending the surfaces on all sides of the joint. If the clay is a bit firmer, roughen up the two surfaces to be joined with your fingernail or a tongue depressor and then press them together and work them in the same way. The important thing to remember is to join the parts with enough pressure on the roughened surfaces so that you make an internal bond and not merely the surface joint made by smoothing down the clay.

Some people think that if you smooth down a surface crack with water it mends itself—it doesn't. You have to work both edges and press the crack closed. Otherwise, when the clay dries and shrinks the crack will reopen and the attached part will fall off. Using a coffee stirrer or a tongue depressor as an internal armature to stick on pieces will not work because when the clay dries it shrinks away from the support.

Remember that the thinner parts that you make, either by pulling out or by adding on, may dry more rapidly than the thicker parts and therefore may crack if you dry the piece quickly. Clay sculptors and ceramicists cover their wet pieces loosely with plastic to slow the drying. In clay studios there is often a "Damp Room" with controlled humidity to control the speed of water evaporation.

If you have to stop working for some reason and put the clay aside without covering it well with plastic, the clay will become hard. If this happens and you want to continue adding parts, you will not only need to roughen the surfaces to be joined, but you will also need to add water and work it into the clay pieces to soften them (some ceramic sculptors also use cider vinegar here) and then weld them together.

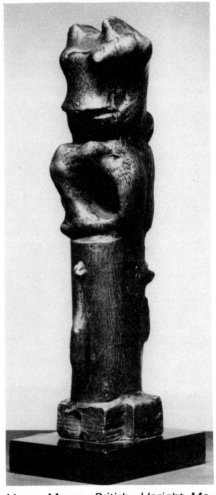

Henry Moore, British. *Upright Motive IX,* 1955. Bronze. 10" high.

Making a Shape that No One Ever Saw Before
The medium will suggest shapes as you work with it. Like the Eskimo ivory carver who replied he didn't know what he was making because

Adult's unfired clay: free form in space.

it was still in the tusk, I encourage everyone to allow a shape to emerge from within the clay, rather than impose a preconceived idea upon it. Once they begin to handle the clay, they ought to feel free enough to move with the clay, changing forms almost intuitively. As you press and feel the clay, certain shapes come more naturally than others—like the well-rounded ones of the body and other life forms, suggesting the fullness of organic beings. Bones, pebbles, and rocks have also given inspiration to many sculptors working in clay. You might examine your leftover dinner bones for shape ideas. Bones have structural strength, a variety of thicknesses, and tenseness of form, with subtle transitions of one shape into the next. Pebbles and rocks have rubbed hollows and bumps with a kind of asymmetry that suggests direction or gesture.

PROCEDURE:

1. Pick up the melon-sized lump of clay, and begin squeezing and pulling at the piece. If it is too heavy or unwieldy to work in your hands, you may have to pull off some material from the main mass to make it more manageable.

2. Continue working the shape in your hands instead of flat on the table. Not only will you be able to turn it more easily, but you will also feel how the surfaces turn and wrap around the sides.

3. After you have a general shape that interests you, set it down on your work surface and turn it in all directions so you can judge which surface you want for the bottom. You can continue developing the shape on the work base or pick it up again if you need to.

4. Exaggerate and build out bumps and deeply gouge hollows into the shape instead of working shallowly on the surface. What happens if you poke a hole all the way through it to make an inside shape where the light comes through? If you don't like it you can always close it up. Think "fat and heavy" for this project. Very thin, projecting parts will be fragile and may crack off easily if bumped or touched.

5. If you do not finish your shape to your satisfaction during this one-hour period and you want to continue to work on it, wrap it in plastic to keep it moist. If you will not be able to return to it for about a week or so, also spray or sprinkle it with water and wrap it in a damp cloth before wrapping it in plastic.

6. When you do finish your shape, detach it from the work base by slipping a wire, heavy thread, thin knife, or spatula under the clay.

7. If you wish to throw it back in the clay container, break it up to mix it with the other clay and then make sure the clay container is well covered with plastic or a watertight lid.

8. If you wish to save your shape, smooth any rough edges at the bottom where you detached it from the work base and set it on cardboard for drying. Paint any projecting joints with the glue-water mixture.

9. Place the shape on its cardboard in a cool place (not a sunny window ledge), because if you rush its drying it may crack. Even after the surface of the clay looks dry, moisture must evaporate from its center. If you put it on a hot radiator or in the oven while it is wet, high heat steam may form in the interior and break the shape open. As the piece dries it becomes lighter in weight and color (turning to a pale buff or gray) as well as becoming warmer or closer to room temperature. If the surface is still cool, it is probably damp inside.

10. After you are sure the shape is entirely dry (and you do not wish to paint it), you may apply a nonyellowing floor wax or spray a clear plastic finish such as Krylon to the top and sides (leaving the bottom uncoated so that any possible remaining moisture has a place from which to escape). This coating will make the piece easier to keep clean and prevent it from absorbing moisture from the air. If you would like to paint the clay with poster colors, do not apply a wax or plastic finish until after the paint dries.

11. *Cleanup:* Scrape up clay particles on your work surface with your wooden tongue depressor before you wipe it with your wet sponge, or you may acquire a layer of mud that is tedious to clean off. Rinse out your sponge after cleanup.

12. *For a second session,* you might start off with a larger piece of clay and build it up from the work surface into the air. Remember to turn the work base frequently as you work.

RECONDITIONING HARDENED CLAY

Even though you may be able to afford to buy new clay for each project instead of saving and reconditioning used material, the reconditioning process is in itself a learning experience that teaches children to see how clay can become soft and workable. They can see the process of change and how it works. Similarly, when you buy cakes from a bakery, children don't have the chance to learn how they are made if you never have made one in front of them at home.

If for any reason your clay has become a bit stiff but has not totally dried out, break up any hard lumps and stick your thumb into softer ones and pour water into the holes. You can carve out holes with your tongue depressor also. Don't totally submerge the clay in water. Cover the bucket with a plastic or a lid and let the clay sit for a few hours or overnight. Then see if it has absorbed all the water. If the clay is still too hard, add a bit more liquid. Avoid adding so much

water that you end up with a bucket of liquid mud that takes days to dry out again to the proper consistency.

If your clay has totally dried out and is hard or if you want to break up old dried shapes to reuse the material, use the following procedure:

1. Break up the lumps into small pieces approximately one inch square. You will need a hammer, mallet, or large rock to pulverize the clay.

2. Fill a small basin or bucket about half full of clay fragments and cover the clay with water. It will take a few hours to a few days for the clay to absorb the water. The speed depends on the amount and sizes of the dry clay fragments. Do not work the clay at this time but allow the dry pieces to absorb water until they disintegrate.

3. Mix the wet clay with your hands or with a stick and let the clay settle.

4. After the sediment has settled, pour off or siphon off any excess water left on top of the clay with a cup or a poultry baster. Let the clay stand until enough excess water evaporates (with the lid off the container) and it is the right consistency to wedge. If you have added a lot of water, this drying time may be a day or two. Again, this also depends on the amount of clay you are reconditioning. A bowlful dries faster than a bucketful.

5. Wedge the clay to a working consistency.

THINKING ABOUT WHAT YOU'VE DONE

When you made a texture collage, you may have noticed how the variety of textures could emphasize and contrast with different parts of the arrangement. The texture could make a shape look heavier or lighter and give different qualities of color according to how light hit each surface. Unfortunately, some people forget about this expressiveness of texture when they begin to work in clay. They often rub down their surfaces all over with their fingers or with a wooden stick to give the whole shape a slicked-down uniformity. On the other hand, you might have kept the textures you created in the shaping process. If you tore off a piece, you may have made a ragged edge; if you folded a shape over onto itself, you might have kept the line between the folded parts; or if you squeezed out shapes, they might have expanded and cracked at the edges giving a variety of lines. Your finger marks may have set forth a busy or measured visual rhythm.

Although the outer boundaries of your two-dimensional shapes may have been an important issue in your painting and collage compositions, in sculpture the volume or mass of your shapes is a central concern as well. The three-dimensional form communicates shape

through its surfaces and edges while its mass tells of physical weight and density.

Just as you opened up spaces in your collages to see through to surfaces underneath, here you may have opened your form to the light and color of the surrounding background. If you put holes into your mass, you were establishing both outer and inner sets of shapes. The British sculptor Barbara Hepworth mentioned that she made openings in her pieces to give an *inside* to her carvings. Sometimes she accentuated this interior with brilliant yellow and white paint to attract the eye into these spaces. Openings or holes multiply the number of your surfaces and the possibilities of varied textures and edges. While you deemphasize the quality of weight in your form when you allow light and air to circulate inside it, you intensify the dialogue between solid shapes and spatial ones.

Rodin once called sculpture "the art of the bump and the hollow." How do shapes on your piece connect with others? Do the lines of your shapes turn the corners and extend around to the back or sides? Composing this work is similar to getting dressed or styling your hair. It may look terrific in front but unflattering from the sides or back.

Many sculptors have found that the power and vitality of convex shapes comes from the feeling that they are pressing outward from inside the sculpture as if they are growing. Do your bumps feel as if they are attached to the surfaces like barnacles, or do they feel as if they are pushing out from inside the clay? This quality comes both

Barbara Hepworth, British. *Hollow Form (Penwith),* 1955. Lagoswood. 23" × 36".

from the character of the modeled contours and from the transitions of the shapes onto the forms around them.

YOUNG BEGINNERS' WORK WITH CLAY

It is very important that the clay be soft and malleable for young beginners because their hand muscles are undeveloped. If they have difficulty shaping the clay, they may become discouraged. Although very young people do not have the strength to wedge clay properly, you might give them a small already-softened piece to learn with. As they develop strength and skill, they can help prepare the clay for these workshops themselves.

Make sure you check the consistency of your clay the day before each clay experience. If it's too hard, you must take the time to work water into the clay and soften it. Small hands will look for another occupation if it's hard. If you add water immediately before the session without working it in, the clay won't absorb it quickly enough to make it inviting to touch. The surface will be slippery, muddy, and unappealing to handle. A child who might want to smear with paint may not want to touch clay if it is too wet. It will stick all over the hands and be difficult to make shapes with. If for some reason someone refuses to touch the clay, I may offer them a tongue depressor or other stick to use with it. However, I prefer the pure experience of working directly with the hands and offer tools only if I have to in order to get a child started.

If your children are reluctant to touch the clay, you can explain what clay is—that it comes from the ground and is often found near streams, lakes, and rivers. "You can make shapes change while it is soft, but when it dries it becomes hard like a rock."

I never force children to use any material. When they see me working with it as I talk to them, enjoying the feel of the clay, changing its shape by squeezing, rolling, and patting, they usually become interested in trying it for themselves.

We all work at the clay table together (directly on the waterproof, smooth surface without a work base) pounding, pushing, pulling, breaking, rolling, and sticking our fingers into the clay. Working on the table keeps everyone from being too precious about their early shapes. (If you are reluctant to touch the clay yourself, your child probably won't want to handle it either.)

As with any new material given to young beginners, they will be interested in the action of manipulating and feeling the clay to discover what they can do with it and how to control it. As their hands gain strength and skill, they begin to form simple shapes.

At the clay table, when there is conversation, I try to direct it

toward descriptions of what they have seen in terms of shapes. When some of the children saw the Thanksgiving Day Parade, we talked about the sizes and shapes of the inflated balloons and floats. We thought about what a parade is, and the possibilities for making our own parade of shapes on the table. Sometimes the children contribute pieces to a parade with enthusiasm. Other times, no one is interested and then, perhaps a week or two later, one of the children may decide to make a parade and the idea will take off with vigor; it has become their own.

If someone mentions eating a doughnut before class, I might ask as I work my fingers into the clay—"What kind of a shape was it? Did it have a see-through in it? Did you ever try making a see-through place in your clay? Sometimes I like to make one." I pick up my clay and look at the children through the hole I have made.

I often show photographs and reproductions of paintings with animals. Most children are familiar with animals through storybooks, pets, television, or visits to the zoo or circus. They can easily relate to the great variety of exaggerated sizes, from very tiny and round to huge and long. Elephants and giraffes make good examples of contrasts in shapes, the first with big stocky bodies and legs and long trunks and the latter with very long necks and thin legs.

One of the delightful qualities of clay is that you can make the shapes change so easily. I constantly point out how beginners can make their shapes change, how a round shape can become a long one or a "see-through" can close up. To illustrate gestures of shapes, I often make my clay bend over, sit up, and stand up. "You can make your shapes stand up or lie down. When you go to bed, do you lie down?" (They always answer yes.) Then I make my standing shape lie down. "And what happens when you are awake? Do you get up?" I make my clay stand up again. One day a child offered to make a blanket for the lying down shape and another made a pillow shape.

I never attempt to model exact images as I work with the clay. I slowly mold very crude shapes that relate to what I'm talking about, building them up and changing them. If everyone is busy working, expressing their own ideas, I say very little. It isn't necessary to have conversation if everyone is engrossed in what they are doing.

If I feel that there needs to be a new focus to reinvolve the children, I may take out a piece of rope or clothesline that I have joined together and lay it on the table to form an enclosed rounded area. "What do you think this special place might be? A circus ring? A swimming pool? A lake in the park? A corral for a rodeo? A cage in the zoo?" The children might respond with any of these thoughts or many others. The rope is flexible and can be changed to define a space in which to place different kinds of shapes. It even can be

raised in places to make a passageway. I sometimes give them a few wooden blocks to provide other possibilities for placing shapes and stretching their imaginations. The sculptures in the museum, park, or city streets are mostly placed on pedestals, and this is something to be noticed (they will also learn the meaning of a new word).

ADDING STICKS

Although most children love working with clay, there is a limit to how long they will continue at first. They may become restless after a few minutes unless some idea sparks their imaginations. With very young children, I may ask if someone would like a stick to use with the clay. When I first show this tool, I ask, "What do you think you can do with this?" I only give out one stick at first. Later I distribute several more. I find that if I present sticks early in the session they may decide that shaping gestures in the clay itself is less appealing than merely putting sticks into it. I encourage them to make constructions by adding small shapes onto the ends of the sticks and then sticking the free ends into other pieces to connect them. I don't tell them what to do—I help them to see possibilities as I work at my place.

A few sticks in a lump of clay almost invariably call up an association to the main social event in their lives—birthday parties—and they become distracted. When this happens, I try to redirect their attention back to the shapes they are making. "Cookies and cakes can be all kinds of shapes: round ones, long ones, and even shapes

Beginners' shapes. Three- and four-year-olds are able to draw from their own experience and shape clay into complex and animated scenes, such as a parade or people fishing from a dock.

Children's piled-up shapes. A three-year-old may not have the strength or coordination to make lasting clay pieces. The piece on the left fell apart when it dried. However, a child a year older with more experience may make a piece that holds together well, such as this one on the right by a four-and-a-half-year-old.

Children's joined shapes. Children who are given materials, tools, and encouragement often seem to be skilled beyond their chronological age.

like animals and people. What kind are you going to make?"

Sometimes they label an amorphous lump a house, car, or whatever and merely move the clay around without attempting to transform it into any shape at all. Pretending sometimes becomes more important than doing when they are very little because they haven't developed the skills and concentration to manipulate the material as yet. I try to encourage them to think a little about the visual appearance of the things that they are talking about, and avoid praising this imaginary labeling of unformed lumps, slick tricks, or decorative effects of sticking objects into the clay. I try to help them keep on exploring and inventing, and I praise them warmly for their effort when they do so.

CLEANUP
At the end of the workshop we all roll our shapes back into balls and put these into the clay bucket. Everyone helps to clean the table. A piece of soft clay pressed onto clay crumbs will help to pick them up. We scrape the work area free of clay with the tongue depressors so that later when the table surface is wiped with a damp sponge or cloth it will be easy to clean.

SAVING THEIR WORK
Sometimes in the beginning, a child makes a special piece and wants to save it. Most youngsters, however, are content to press their shape back into a lump and return it to the clay container. If they feel otherwise and want to save their shape, you can paint it with a mixture of half Elmer's Glue-All and half water and set it aside to dry.

In the beginning you may have to coat the areas where pieces are joined together with the glue-water mixture because your young beginners may lack the physical coordination or desire to join their pieces together securely. Although some instructors routinely have older beginners paint their whole forms with the glue-water mixture, I have found that it is really only necessary to coat the joints of the projecting parts. The glue also makes an extra surface bond. How-

ever, it will really not secure a part that has been poorly attached in the first place.

The problem with encouraging beginners to save their very first pieces is that they may get the impression they are making precious objects. Learning to mold clay is a slow process because it takes quite a while to develop hand-muscle coordination. Therefore, young children won't be able to control and join their shapes at first. The more they become product-oriented the less likely they may become to be able to experiment freely. If you throw back your shapes also, they will probably follow your example.

Four-year-old Peter made a form that was a recognizable image resembling a bird on a basket or nest. He took a lump of clay and shoved a stick through it to make a bird with wings. Then he took a ball and shoved his thumb down into the center of it to make a nest under the bird. When his mother saw something she could label she was visibly overjoyed and told him, "Why don't you ask your teacher if you can save it?" Naturally, I had to say no because everyone else would have wanted to do the same thing. It's unfortunate when this happens because each child will pick up any lump and ask, "Can I save this?" merely to join the crowd. How can I judge whose shape is appropriate to save and whose isn't? I explain that it takes practice to make things so they will hold together and that we will save a special piece at a later time.

For the next four weeks, because I hadn't allowed him to save his clay, Peter felt compelled to make the same form over and over again, waiting for the day when he would be allowed to keep it. Because his mother wanted to save it she gave the piece an importance it never had for him in the beginning. He had learned a trick of getting an easy effect with the stick in a lump of clay and found it simpler to repeat that than experiment anew.

MORE EXPERIENCED BEGINNERS

Beginners often model only one side of the clay piece and forget that the form is three-dimensional, so it is a good idea to give them a 9-to-12-inch turnable board like yours to work on. If their clay sticks to the table surface, they won't be able to turn it at all. You might call their attention to turning their pieces and suggest that they make the shapes connect with each other on all sides.

More experienced young people may become interested in placing shapes next to each other to make trains or cities. They may enjoy collaborative efforts where each person adds a shape. You might show and discuss photographs you've collected of complex sculpture and repeated similarly shaped objects in nature such as cactus plants,

Two Female Figures, Mycenaean, c. 1400-1100 B.C. Terracotta clay, 4½" high.

trees, people, and cityscapes. I might ask, "Did you ever ride on a train or subway? Were there people on it? What kinds of shapes are people?" I often show photographs from a book of clay sculptures entitled *Our Family*, by Shay Rieger. Most of the figures are monolithic, single solid masses that are freely worked with little detail.

The making of clay shapes and the process of making connections between them with clay or sticks are two separate activities just as pasting and cutting are. Connecting shapes often, but not always, comes later for beginners of all ages.

Older children may be interested in making fantastic creatures like the ones you will be working on in the next chapter. They may make animals in families or alone, or cars, trains, buses, knights and castles, depending on their experience and your guidance. They are quite capable of learning how to wedge the clay to prepare their material themselves.

Figure of an Acrobat, Chinese tomb figure, c. A.D. 206-220. Fired clay with traces of color. Sculptures of figures have been modeled into abstract shapes long before the 20th century.

TALKING ABOUT THEIR WORK

The great advantage of talking about shapes in clay is that beginners can actually feel the shapes. They can stick their fingers inside and around something that has weight and texture. As I have pointed out before, I use the term "see-through" shape instead of "hole" because this emphasizes the quality of the shape rather than labeling a recognizable object and points out what you are really seeing while relating it to a tactile experience. Although most young beginners know the words *inside* and *outside*, or *indoors* and *outdoors*, they won't connect these words with the process of making and seeing shapes unless you point out the concepts with something physically real. Again, I avoid the art term "negative space," because it's not a negative experience to look through a window or under a chair, but the positive act of seeing a space shape.

South American Indian Figurine, Caraja tribe, Brazil, 20th century. Gray sunfired clay, 7½″ × 5½″.

Beginners need the guidance of a supportive and knowledgeable person to help them *visualize* and create more specific shapes. It is important to keep them interested in manipulating the clay to gain skill in using it as a tool like a paint brush for learning precise expression of their ideas. I continue to focus attention on using these shapes in different ways so that like Steven, who used his favorite image, tigers, to construct new experiences for himself, the children can manipulate their own shapes to express new ideas.

Putting Shapes Together

It would be best if you work for many weeks with the clay before going on to the following chapter project on fantastic creatures. Beginners need more experience than just one session in making shapes

and discovering the properties of clay. Then begin thinking about putting many shapes together by working first with Styrofoam and toothpicks instead of clay so that they can learn the visual idea of connecting things without getting frustrated by the physical process of joining clay.

If you both have been working in all three mediums, putting shapes together will come more easily. Youngsters made shapes sit next to and hug each other in their paintings. They may have used yarn and corrugated paper shapes in collages and may have already started to put sticks into their clay. Now the idea is to physically connect the three-dimensional shapes and raise them off the table. I find that this exercise helps beginners become more inventive about assembling complex forms.

Styrofoam Constructions for Experienced Young Beginners
Since I do not like to change the routine for young children, I start with the clay first in this session before going to the Styrofoam. This project is not a substitute for working with clay but an addition to it. The fact that the foam is a hard, stiff material puts the emphasis on *connecting* rather than on changing shapes.

After everyone has finished working with clay for the day and has washed his/her hands, I offer them 1-to-1½-inch square pieces of Styrofoam and toothpicks. We work together at the same table and I demonstrate how to connect the shapes with toothpicks, pipe cleaners, and straws to build larger assemblages of forms. (If your children have been previously assembling plastic slotted shapes, building bricks, or other assembly toys or games, they will probably understand how to assemble parts more quickly.) Finally, I bring out colored feathers and let each person choose one or two to decorate his piece. If you put out the feathers and straws at the very beginning, the children may merely embellish single Styrofoam pieces without connecting them.

In following sessions as everyone becomes more skilled in handling materials, I introduce different-sized strips of corrugated paper and increase the variety of forms. You can also cut up used Styrofoam cup bottoms to make round see-through hoops, and egg or foam meat cartons to make other intriguing shapes. Variety and art supply stores sell sheets of Styrofoam in varying thicknesses. Appliance and gift stores often discard Styrofoam packing of all sizes and widths. Some packing grades of Styrofoam crumble when you break them and are not as easy to work with. Try out all materials yourself before offering them to beginners.

Of course, if you find that the children aren't interested in this project but have something of their own in mind, encourage their

Three- and four-year-olds' Styrofoam constructions. Age is *not* a factor in the complexity of children's work. An older child may be content to put a few sticks into a block while a younger one might make a more complicated construction.

initiative. Once I planned a special project for a group of four- and five-year-olds to help them think about connecting shapes. I gave them clay and sticks to make a construction and then I suggested that they make a painting based on the idea of contrasting and connecting shapes with lines as they had done with the clay. However, David wasn't interested in the sticks once he got the clay into his hands. He molded a dinosaur and then did two complex paintings of dinosaurs that amazed and delighted him, his mother, and me, demonstrating very well that he understood how to make connections of one shape to another. If I had been more concerned with his ability to follow my instructions about using sticks than about his learning to work with materials and understand a concept, he would have missed this exciting creative experience.

These flying machines done by four- and five-year-olds show a variety of ways of fastening and connecting the different parts.

(Above right) Edward Avedisian, American. *Yellow Steps,* 1975. Acrylic on Styrofoam. 18″ × 13½″ × 11″.

Dorothy Dehner, American. *Gateway,* 1979. Wood. 38″ × 17″ × 6⅞″ depth.

Styrofoam Constructions for Advanced Beginners and Adults

Advanced beginners and adults may enjoy using the same materials to make constructions of special environments as a separate project by itself. Many prefer working on a 9-by-12-inch cardboard or wooden base. You can glue pieces of Styrofoam to cardboard with Elmer's Glue-All to make a base and then construct a spatial environment by suspending and raising up forms with wire or wood sticks inserted into the base. (Allow your Elmer's Glue-All to thicken by setting it out in a shallow caster cup for about twenty minutes before you intend to use it. While rubber cement is most useful for gluing Styrofoam to itself, white glue is better for joining it to paper, wood, or other materials that absorb the moisture.) To make bigger shapes with the foam, you can glue layers of it together with rubber cement by coating each surface and letting it dry before you put the pieces together. I cut the one-inch sheets with a pair of large scissors or mat knife, but you can saw larger pieces with a hacksaw blade (without the saw frame).

Larger pieces of wire, applicator sticks, dowels, electrical wires, and any number of other materials you may have used on your texture collages are all useful here.

CLAY BUYING GUIDE

You need about five pounds of Jordan Ball or Buff firing water-base potters' clay for two people to start with. If you have no local art supply store, a nearby school may sell you some. Or else look in the Yellow Pages under "Ceramic Supplies" or "Pottery." Sometimes a hobby shop will carry this water-base clay. I prefer gray-colored clay for young children. (The terracotta color may have negative associations for young children who've recently been toilet trained. Jordan clay is medium gray when wet and dries to a cool light gray as it hardens.)

Always get premixed clay without grog that is ready to wedge and use. Mixing powdered clay with water can be extraordinarily messy and frustrating for anyone without a mixing machine. Grog—small particles of baked firebrick—makes the clay stiffer and harder for young beginners to shape easily. It is used in ceramics and for large clay sculpture to reduce shrinkage and increase the structural properties of the medium.

Make sure that you do not get oil-base plasteline, or self-hardening compounds that are meant to be cooked in the oven. Some of these are too difficult for small hands to manipulate and are more expensive than water-base clay. Plasteline also stains clothing.

NATURAL CLAY SOURCES

Sometimes you may have a vein of natural clay beside a neighborhood stream. This may be usable as it is or it may require much effort to remove twigs, stones, and other foreign matter. However, I suggest that you begin with prepared, purchased clay to decide if you enjoy the medium enough to put forth such efforts in preparation.

FIRING CLAY PIECES

Although most clay sculpture is baked or fired in a special high-temperature oven (called a *kiln*) to harden it into a permanent form, we do not fire these clay projects because we use the clay over and over again.

You can take your finished piece to a pottery studio to have it fired if you wish, but it won't be necessary if you keep your shapes thick and compact.

If you do think of having your work fired, remember that because your clay shrinks when it dries (and your smooth, wet surface will become sandpaper rough as well), your shape must be a bit larger than you intend the fired work to be. When fired it will again shrink

Robert Adzema, American. *Spring Street,* 1972. Wood, steel car springs, hook, and fired terracotta clay. 45" × 26" × 10". Constructions can be assembled from found materials from your home and street.

about 10 percent (more or less depending on the composition of the clay—the clay recommended for use here has no grog in it, so it will shrink a lot if fired) and you may be disappointed in the final result.

CONTINUING YOUR STUDIES IN CLAY

If you find that you want to learn advanced techniques and fire your pieces, there are many studios associated with shops that offer classes and sell materials. However, avoid those that merely offer courses in "China Painting." These classes sell unfired ceramic pieces that are already precast from molds that you merely decorate with glazes. This is no more inventive than doing your fingernails or polishing your shoes. On the other hand, these shops usually will sell clay and sculpture equipment and offer firing services for a fee.

There are many good books on ceramic materials and techniques that may be useful if you decide to continue studying clay work in depth. Paulus Berensohn's *Finding One's Way with Clay* (New York: Simon and Schuster, 1972) is an excellent one for beginners.

Adult's clay piece.

SIXTEEN

Clay Sculpture II: Mythical Creatures and Fantastic Shapes

WHEN YOU TRAVEL you often pick up folk art that lacks commercial slickness and gains a certain vigor and directness from its handcrafted origins. The mythical creatures or fantastic shapes you will create in this project may have a similar character. Their whimsical, brightly colored nature radiates lightness and joy. I still have and cherish the first animals I made in a parent-child class many years ago at The Museum of Modern Art. Although in the beginning some people feel self-conscious making fantasylike forms, after making them they are often so proud of what they have done they buy Plexiglas boxes or make little pedestals for them.

Ever since prehistory, people have been making images of fantastic animals. Yet the dragons of mythology are no less bizarre than real insects and animals found in nature now. If you look through a collection of natural history magazines with photographs, you can find creatures with colors and shapes beyond the bounds of anything you might dream up yourself—lizards, bugs, fish, and snakes.

Animals have distant associations with magic and nature worship. Small sculptures of animals were worn as talismans of power and good luck. Some people still carry a rabbit's foot, shark's tooth, or other similar charm. Ancient Chinese warriors considered the tiger to be the king of the beast world and its bones, blood, and flesh were supposed to have medicinal curative properties. Tiger ornaments were used to restore or increase courage in times of danger.

More recent cultures have substituted the image for an actual animal part. The Cora Indians modeled figures of animals they needed for food in wax, clay, and stone and deposited them in caves in mountains before the hunt. The Tadas of southern India offered silver images of buffalos to their temples when they desired more of these animals. An anthropologist traveling in Africa early in this

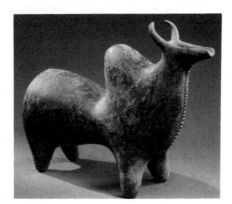

Earthenware Zebu vessel, southwest Caspian region, c. 900 B.C.

Eugenie Gershoy, American. *The Equestrienne*, undated (20th century). Painted plaster. 20″ high. The unicorn, a favorite mythological animal of medieval times, has been made into a contemporary circus performer in this piece.

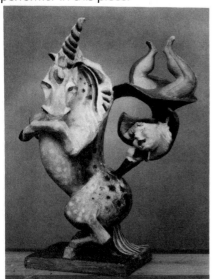

century told about Pygmy tribes who at sunrise on the day of the hunt outlined a circle on the ground and within it drew the image of the animal they hoped to find. As the sun peeked above the horizon, a woman in the tribe lifted her arms and cried out while one of the men shot an arrow into the drawing in the circle. If the arrow missed its target, they would not go hunting that day.

Painters and sculptors have traditionally used creatures as themes expressing union with nature or strong emotions. Some have combined vegetables and animals, or machines and animals, to give poetic resonance to their images. Hybrid creatures such as the minotaur, sphinx, flying horse, centaur, or other half-animal and half-human, half-demon and half-angel shapes embody the polarities of human nature.

As I looked, behold, a stormy wind came out of the north, and a great cloud, with brightness round about it, and fire flashing forth continually, and in the midst of the fire, as it were, gleaming bronze. And from the midst of it came the likeness of four living creatures. And this was their appearance: they had the form of men, but each had four faces, and each of them had four wings. Their legs were straight, and the soles of their feet were like the sole of a calf's foot; and they sparkled like burnished bronze. Under their wings on their four sides they had human hands. And the four had their faces and their wings thus: their wings touched one another; they went everyone straight forward, without turning as they went. As for the likenesses of their faces, each had the face of a man in front; the four had the face of a lion on the right side, the four had the face of an ox on the left side, and the four had the face of an eagle at the back.

Ezekiel 1:4–10

The animal remains a vital image for us today because we still have an insatiable need for icons, signs, symbols, and emblems. Many sports teams have mascots or are named after animals—for instance, the Detroit Lions, Chicago Cubs, and Miami Dolphins. The Mack truck uses the bulldog as its hood ornament. These names and emblems signify the strength, swiftness, agility, endurance, or tenacity of the original animals. The sculptured horse was the symbol of sovereign power, dynamism, and speed until the invention of the steam and gas engines, while heraldry and coats-of-arms have featured animals for many centuries.

Your Project (Part I)

When you make your mythical creature or fantastic shape, you are making a group of forms that lead your eye from one part to the next, just as you did in your collages and paintings. The main differ-

Martin Schongauer, German. *St. Anthony Tormented by Demons*, c. 1480-90. Engraving. 11⁷⁄₁₆″ × 8²¹⁄₃₂″.

ence between this and other projects is that it is three-dimensional instead of flat. A rounded head may lead to a thin cylindrical neck, to a massive trunk, to another kind of shape, and so on. The gesture or directional movement expressed by the parts will change at each joint, or at the place where you attach them. The feeling that your total image evokes will come from the sum of these visual directions and gestures when your shapes appear to connect, oppose, or move with each other.

Gesture binds shapes together by making them appear to move toward or away from each other. If you stand in front of a mirror and hold out your hands in front of you and move your palms and fingers in different directions, you may see how this works. If your fingers point outward, they appear to be extending to another person or object. If you curl your fingers back toward your own body, you feel as if you are referring to yourself. Think of body language and gesture in everyday life. If you had no words, how would you express stop, go, come here, or danger? How does a cat or dog show relaxation, fear, or well-being? Think of how it curls up in a ball to sleep,

stretches out on the floor, preens, prances on its toes when in high spirits, or sinks its head between its shoulder blades and crouches after doing something it shouldn't have. Think of the language of dance and courtship—how, for example, male pigeons puff out their chests and feathers to look larger in order to attract a female.

If you find your clay creature looking stiff, try twisting the trunk to give some motion to the body. This is often enough to propel the figure into activity. The appearance of springing from the ground or running converts heavy mass into an image of energy.

When shapes touch each other, the connections between them help determine another quality of feeling. If you join parts together at right angles, they look mechanically stuck on like stick figures. It is also more difficult to make right-angle shapes stay on if they are projecting outward and not supported by additional clay underneath. When you angle the attached limbs to more or less than 90 degrees, you can model their surfaces so there is a visual flow between the shapes suggesting extended or continued motion. When shapes meet each other perpendicularly at right angles, they block or stop each other's motion in space. This effect can be used to portray a static, motionless quality that gives a feeling of frustration, anguish, and stopped time. Some sculptors combine these different qualities of gesture effectively to create tension between movement and stasis in different parts of the same figure (see illustration of Tibetan figure, page 270).

This project will take at least two separate work sessions to complete. In the first, you will make the clay creature. Then let it dry for several days so that you can finally paint it in the second session.

Making Your Fantastic Creature
MATERIALS:
all the clay tools and materials listed in the last chapter (see page 245)
a selection of colored feathers, straws, toothpicks, pipe cleaners, wire, or other such linear decorative materials you can stick into the clay surface
a 50/50 Elmer's Glue-All and water mixture (approximately an ounce) and brush

PROCEDURE:
1. Take a lump of clay about the size of a grapefruit from the clay bin or container and wedge it (see page 245).
2. Pick the clay up off the work surface and squeeze and work it with your hands until you find it suggests a general shape that you like. Or, break the lump into several parts, squeeze these individually, and then attach the shapes together to make a form.

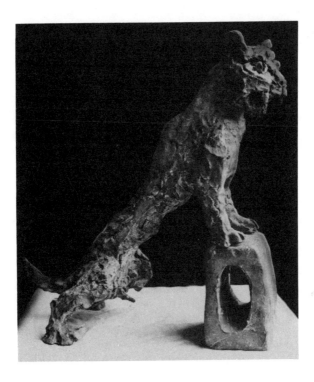

Alice Neel, American. *Wildcat,* 1978. Fired terracotta clay. 24″ × 12″ × 10″.

3. After you have made a general arrangement of the main shapes and have attached them together, set the form down on your work board to develop your piece further. Remember to keep turning it as you clarify your shapes so that you work on all sides equally.

4. You may want to use a tongue depressor or applicator sticks to carve out difficult-to-reach places or to make different textures on some of the parts.

5. When you are completely finished shaping the clay, add feathers, pipe cleaners, or other decorative materials to accent parts or to exaggerate the gestures.

6. Coat the joints of any thin attached parts with the glue-and-water mixture.

7. Transfer your piece to the corrugated cardboard square for drying (see page 249). Be sure that the bottom edges where you detach it are intact, and smooth any thin or rough edges that might break off.

8. Let the piece dry. The amount of drying time will vary from a few days to possibly a week depending on the size of your form and the heat and moisture conditions in your workspace.

9. In the next work session you will paint your creature.

THINKING ABOUT WHAT YOU'VE DONE

How did you communicate what specific kind of a creature you had in mind? Was it powerful, graceful, speedy, dangerous, or friendly? How did you show this? Just as you did in your paper hat sculpture,

267

Alice Neel at CLAYWORKS in New York City, beginning *Wildcat.* Age is no barrier to starting a new medium. Ms. Neel, famous for her paintings, began sculpture in clay when she was in her sixties. She stopped because of arthritis, but began again in her seventies.

Young child working with clay.

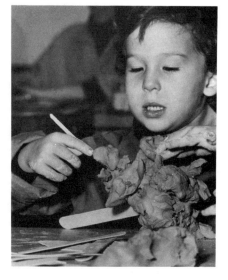

you might have used the shapes and their proportions to show ideas or what you wanted to emphasize. Here, short legs and neck with a large massive body might have suggested a powerful beast with great stability on the ground due to its low center of gravity. Its massive body size might have been the emphatic quality. A giraffelike creature with its bones jutting out as if about to puncture its skin seems vulnerable and top-heavy on its stiltlike, scrawny, knobby legs. The length of its neck and vertical height might be the dominant characteristic. It could embody grace or awkwardness depending on the gesture and the angles at which you attached its limbs.

When you began thinking about this theme of a mythic creature or fantastic shape, you were dealing both with the subject and also its suggestive meaning (dangerous, friendly, swift, and so forth).

Suppose a friend greets you on the street and waves his hand at you. You can look at the event from three points of view. What you see from an aesthetic viewpoint is the pattern of color, lines, and shapes in an arrangement that he makes up. Second, when you identify him as a friend and his gesture as waving at you, you think about the subject matter and meaning of his gesture. From the way he waves you may be able to see if he is in a good or bad mood, whether he is feeling happy, indifferent, or angry about something. These subtleties of gesture give the act a meaning that can be called *expression.* Reading expression differs from your initial identification of him because you needed a certain sensitivity or familiarity to know the significance of his gesture. Third, because you know the person, you have a viewpoint about how that gesture reflects his personality (that is, the sum total of his social, cultural, educational, and personal experience).

We can approach works of art in the same way as we interpret these visual events in daily life. First, we see the colors and shapes. Second, we identify the theme and interpret the mood. Third, we come to some feeling or conclusion about the attitude the artist had. The underlying attitudes or ideas in the work are called *content.* The content of a work of art can reveal a viewpoint of a country, a period in time, a social class, and a religious or philosophic belief, all as interpreted by the artist who has condensed them into the work.

Just as you can't hope to interpret the subtleties and meaning of a person's gesture without knowing something about him/her, you can't usually understand the full meaning of a painting or sculpture without knowing something about the work. Museums, art galleries, and books usually have some title or caption that tells you about the date and origin. Your children's paintings may not communicate anything to others, but they may seem clear to you as you watch them work, hear what they say, and see the progression of ideas.

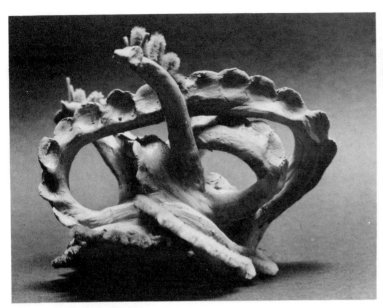

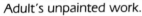
Adult's unpainted work.

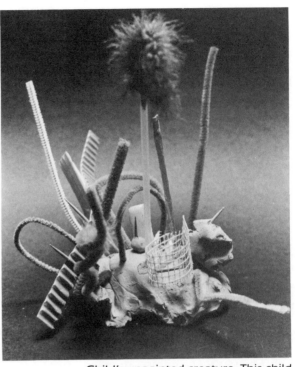

Child's unpainted creature. This child has become aware of the concept of joining many forms together.

One mother told me she set out paints and paper for her daughter Diane who was about five and a half. Diane painted all afternoon and did several paintings. At the end of the day she was exuberant and still wanted to do one more even though she had used up every color except black. She made one final graphic statement that said "MOM" in big black letters. When her father came home his daughter greeted him and took him over to see her paintings. He got upset when he saw the black MOM, interpreting it as an expression of hostility. He didn't realize that children don't have the same negative associations with the color black that many adults do.

Interpreting subjective expression in your child's studio work can be compared to judging that quality in painting and sculpture by people with very personal visual styles. When we approach those images, we need not only an acquaintance with the work itself but a familiarity with the themes or concepts the artists were dealing with. For example, a young child might like a painting of the Last Supper for its colors and people but be unable to recognize the subject. To him or her it might merely look like an excited dinner party where everyone wore costumes. We take for granted a great deal of literary, historical, and cultural information when we view representational works. Yet we often overlook this when we see more abstract imagery, even though similar issues may be presented.

Anonymous German artist. *The Last Supper*, late 15th or early 16th century. Limestone. 24¼″ × 15⅜″.

Tibetan Statuette. *Yamantaka with his Sakti*, 18th century. Cast bronze. 6⅞″ × 6″.

Interpreting and reading visual works is a learned skill, and full appreciation of their messages depends on knowing something about the cultural backgrounds of the artists in order to see the works on many different levels instead of only one. For example, see Gillian Bradshaw-Smith's *Elura*, and the Indian Ganesha, page 273. Both of these sculptures use the figure of the elephant to express widely different ideas. The Smith piece is a personal metaphor for emotion while the Indian Ganesha is a mythological figure in Hinduism, a very popular divinity who represents wordly wisdom which results in financial success. This book deals primarily with the beginning steps of learning to interpret visual works. Frequent field trips to local museums to look at many different kinds of paintings and sculptures are essential.

YOUNG BEGINNERS' CREATURES

If your young beginners are still continually assembling and taking apart their pieces for the sheer pleasure of the process, wait until they can enjoy making a finished form and leave it alone before you start this project with them. Ordinarily in a class of very young children I would not encourage saving pieces. The reason I do a project to save with the very young ones is because their parents will be bringing a clay piece home and they need to have one as well. At home it's quite different. If they make something they want to keep, and you have no room on a shelf, you can keep it in a shoe box.

Although young children are fascinated with looking at and thinking about animals, I talk about making a fantastic shape or special construction. Beginners of all ages can enjoy making fantastic shapes without worrying whether they resemble anything real. There is no age-limit to interest here. However, the very youngest ones will usually make very simple, amorphous, or very generalized shapes that they can embellish with a few decorative materials. More experienced people have the capability to shape forms precisely and may assemble complex ones that stand up and have see-through shapes.

I put up photographs and reproductions of a great variety of unusual plants and animals to show that all shapes exist somewhere in nature or myth no matter how fantastic they may seem. One day when I explained that "When you're making a creature it can have six arms, three tails, or ten legs, or any combination of different parts," one six-year-old looked disgusted and said contemptuously, "Very funny!" It seemed as though he thought I was being silly and trying to fool him because he was a child and he was not going to be taken in. When I pulled out photographs of sculptures of Oriental gods with many sets of arms and one of Ganesha, the Indian ele-

phant-headed God of Good Fortune, he became fascinated. I think he recognized that one could be serious about making something that might look silly. Just as the eighty-year-old thought I was treating him as a child by asking him to cut and paste a paper hat until I showed him a picture by Matisse, whose cutouts can sell for as much as one million dollars (see *Jazz*, page 147).

There is always a variety of opinions about what the shapes look like. When I showed a photo of a sea walrus, someone declared it had a nose like a pig and another thought the nose looked like a cauliflower. Often when adults look at children's forms, they criticize them or are disappointed if they don't find some realistic image they can name or recognize. Sometimes the youngsters' work is actually very representational but they've been looking at a shape from a different physical and emotional viewpoint than an adult.

A field trip to a botanical garden, natural history museum, zoo, or farm may inspire the birth and growth of a whole garden or zoo of creatures. A lot of young children also do look at and enjoy abstract sculpture. Nora, four and a half, carefully watched the installation of a Henry Moore sculpture on her street. When her mother showed her a photograph and story about it in the newspaper, she insisted that they clip it and send it to me. She felt she had a personal investment in the piece and reported to me how it looked in different weather, how it had shapes inside of other shapes, and how shiny it got when it was wet.

I review the clay processes the way I did with the painting in earlier sessions. I bring out some moist, ready-to-use clay and ask, "How does this feel? Is it soft?" Next I present a piece of dry clay, "Is this

Child's unpainted creature. As beginners become more experienced, they may shape the clay more thoughtfully before decorating it with objects.

Child's unpainted creature. Clearly it can be seen that the child was more interested in sticking objects into the clay than molding the clay itself.

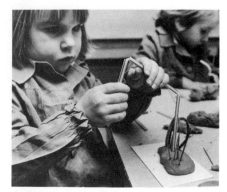

Child's construction. Young beginners (like many adults who seize colorful decorative materials first) usually become more interested in putting objects into the clay than shaping it. It is also easier for inexperienced children to bend pipe cleaners than to join forms.

clay soft? No, this clay dried and got hard." I show a broken piece of dry clay and explain that it came off of another shape because it wasn't attached properly. "Someone forgot to roughen up both sides before they pushed the pieces together."

Because young beginners may make a lot of shapes yet not get any idea about making connections or sticking them together, I may mention doing that, "just like when you paint you can make shapes come together or hug each other." I take my own clay shapes and point out what happens when they bump into each other and stick to each other. I hold out my hand and we look at the shapes of our fingers and how they connect to the hand, to the arm, and to the body. I point out that their head is connected to their neck. We look at reproductions of sculpture and connected shapes in nature like cactus plants. The basic ideas that things are made up of parts and that the parts are connected have not occurred to young children and you will have to point them out. I continue to demonstrate other possibilities, "There are different ways of putting shapes together. Sometimes I make them bump into each other and sometimes I like to use sticks, and other times I try to build up my shapes with other materials the way you did when you connected the Styrofoam shapes with toothpicks and pipe cleaners. You can do the same thing with clay, only this time you can make different kinds of shapes because you know how to work with the clay and make your shapes change."

I put an orange-sized lump of clay on a small piece of cardboard like the ones the parents are using, only smaller. As in every project, I attempt to take them step by step, and don't offer the extra decorative materials until they have made their clay forms. It is so easy to be seduced by the bright colors of the feathers and other materials that adults and children alike are apt to forget about making clay shapes and building up. I try to encourage them to work longer on the development of their clay forms and not to merely stick embellishments on top of a mound of clay.

As I introduce a new material to the children, I demonstrate possibilities for its use so that they will continue to explore ways to use it with the clay and find new ways to make connections. After they have finished their pieces, it's a good idea to paint over the places where materials are joined with the glue-water mixture yourself. More experienced children are capable of doing this, and at home even a young child might help to do it. However, with younger, less experienced ones I do it myself before storing the piece to dry. I want to be certain that it won't fall apart when they go to paint it next time.

Indian sculpture. *Ganesha,* Orissa, 16th century. Ivory. 7¼" × 4¾" × 3½" depth.

Your Project (Part II)

This time I show many photographs of patterned animals and painted sculpture from around the world to both parents and children in preparation for painting the creatures. As we look at the photos, we discuss the wide variety of colors that nature has given to tropical birds, fish, and insects. Once a mother told me how upset her daughter was when someone criticized her painting of blue and red frogs saying, "Frogs are green. They don't look like that!" Since then I've been collecting pictures of real frogs in multicolored patterns. I've discovered a red frog with blue legs, a green one with big red eyes, and another with orange spots.

Before you paint your fantastic shapes and creatures it might also be enjoyable to visit a collection of African or Oceanic art or a museum of folk art or of the American Indian. All of these collections will have many examples of polychromed sculptural objects, masks, dolls, animals, and figures.

Times have indeed changed since the sculptor Rodin allegedly raised his hand to his breast and declared, "I know it here that they did not color it." He was referring to the discovery that the ancient Greeks painted their sculpture. Until the middle of this century, there were some academicians who disapproved of polychromed sculpture because it was not in the tradition of classical pieces—or so they thought. When people had excavated and recovered the ancient pieces, the paint had worn off the marble, and the bronze statues were covered with a patina of oxidized metallic scale. Although the patinas on the bronze took on many varied colors, they

Gillian Bradshaw-Smith, American. *Elura,* 1974. Painted canvas stretched around to form a three-dimensional soft sculpture. 87" high. "My pieces are an attempt to express metaphorically those emotions and feelings within us that are beyond articulation for they predate language."

Ferdowsi, Persian. *Tahmuras Defeats the Divs,* from *Shah-nameh (Book of the Kings),* 16th century. Detail from manuscript. Colors, ink, silver, and gold on paper. 22½″ × 12⁹⁄₁₆″. (See Plate 49.)

were thought of as a natural coloring because these coatings were the result of the chemical reaction of the metal to the elements. Paint was seen as something that covered the natural surface and violated its integrity.

However, many sculptors of this century looked at African and Oceanic art and realized that polychromy added another expressive dimension to their forms. They saw that color could emphasize the structure in a work, divide or unite it. Color affects the apparent shape and size as well as the illusion of volume and massiveness. It can suggest a kind of naturalism or a fantastic dream quality. It can adapt a form to its environment like the camouflage of animals in nature, or isolate it. Some artists took their cues from coloring techniques already accepted on everyday commercial objects like cars, telephones, packaging, and the like. Coloring their own pieces wasn't merely copying an industrial process but a way of viewing contemporary life. (See illustrations of twentieth-century polychromed sculpture on pages 260 and 264.)

Painting can dramatize the creature by giving emphasis to shapes, feelings, or ideas. By using pattern, visual texture, line, and color, you can make the shape look heavier or lighter, thicker or thinner.

You might review your painting and collage projects using shapes and pattern for ideas. When you choose your colors, you might consider how you could emphasize a particular feeling, idea, or quality of shape. You might recall how pattern affected your collage shapes.

Painting Your Fantastic Creature

MATERIALS:

your regular painting setup (see page 62)

extra caster cups or small dishes for mixing paint. (You will not be able to mix colors on the clay itself and will have to do it in mixing dishes.)

a tiny, pointed watercolor brush. (Ask the art supply store salesperson to recommend a medium-priced brush.)

your dry clay piece from the last session

PROCEDURE:

1. Paint on a background coat over the whole piece the way you did with your paintings. (If you are going to leave part of your clay exposed, it has to look purposeful and not like forgotten patches without definite shapes.) The undercoat will dry quickly because the clay will absorb the moisture.

2. Use your smaller brush to paint on patterns, accent parts in different colors, or extend shapes with lines.

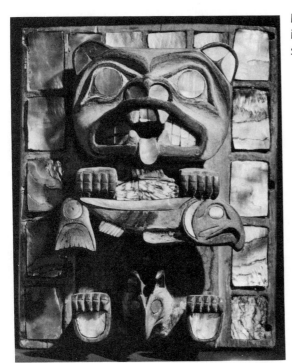

Headdress ornament. Canada, British Columbia. 20th century. Tsimshian? Wood, paint, shell. 7⅜" high.

Adults' painted creatures. (See Plates 41, 42, and 43.)

3. If you find that you would like to put your creature into an environment, you might paint the cardboard drying base as well and later glue the figure onto it. You may find that you also wish to alter the size or shape of your cardboard to complement the shape of the sculpture. Some people even make a wooden block base for their finished piece.

4. After the paint dries, spray your creature with a clear plastic finish such as Krylon to preserve the surface.

THINKING ABOUT WHAT YOU'VE DONE

You've just made a three-dimensional painting when you colored your creature. All the issues you dealt with in your previous painting and collage projects apply here as well.

Yet, you may have felt something different about these colors on sculpture. When you made a painting or collage you may have been able to see the colors more abstractly as part of a design or arrangement of shapes, but here the colors take on greater physical reality by becoming part of a mass or volume. Your creature may have seemed more emotionally neutral in the gray clay, but now that it is painted it has become more highly expressive of what you felt. The result is more than the sum of each element. Sometimes when you look at a piece of clothing in a store the salesperson will say, "That doesn't look good on the hanger. You have to try it on." They've seen the transformation of a design that may have little appeal when hanging or lying flat; there is a change when it takes on volume so that the colors and pattern of the fabric accentuate the cut of the style and flatter the shapes of the figure inside it.

All your color and design choices told what your attitude was in making this creature. It might have been a representation of something in real life or else a highly whimsical, decorative, or subjective symbol of your aesthetic experience in making the sculpture.

You might look at all painting and sculpture as a symptom or sign of what someone had in mind. If you do not know about the artist, your reaction will depend entirely on your response to the patterns, colors, shapes, and their arrangement. If you learn who the artist is and the subject or theme, you can relate to a work on two levels. And if you look for other information about the work, such as the date, country of origin, use, and expression of cultural ideas, you can get a third level of meaning as well. The more connections you can make with outside experiences and knowledge from all fields, the more fascinating you will find the work.

YOUNG BEGINNERS: PAINTING THEIR CREATURES

Although the very youngest children, who are still action-oriented, like the idea of painting their shapes, they may decide they're finished after they put on a few dabs of color. I have found that the more visually aware children become, the more they enjoy painting their pieces.

Young children may not have the patience to sit long enough to finish the job, especially if their shapes are tiny and it takes much fine coordination to complete them. It's very common for them not to paint the side they can't see. I may turn the piece around and ask them if they want to paint the other side, but I don't push them to color everything. At the museum, the children usually paint the clay after doing a painting. However at home, if it is the main activity, they will probably work at it for a longer time. If you want to complete painting your own piece, be certain to have other studio activities lined up for your child.

Youngsters may use the quarter-inch brush that they've been painting with on paper. However, if they ask for a smaller one like yours, have an extra one available to offer them for this session.

Holiday Project: Tree Ornaments

You can make a modeling dough from a mixture of salt, flour, and water to make ornaments that last for years. The salt acts as a preservative so that the pieces do not get moldy or decay after they are baked.

Recipe: To 2 cups of bleached white flour add 1 cup of salt. Mix thoroughly. Add ½ cup of water as you stir slowly. Add just a bit of liquid at a time until the mixture is smooth and thick. If you find it too dry, add a little more water. (You may find other variations of this recipe in other books. Also see Dona Meilach's *Creating Art with Bread Dough*, listed in the Recommended Additional Reading list on page 283.)

Knead after mixing until the batch is uniform. If you have not kneaded the dough sufficiently and have pockets of salt, these will break open on the surface and leave holes on your shape while baking. Now you can make your shapes the way you worked in clay. If you plan to hang them up, remember to poke a hole in the top so that you can pull a thread or wire through for hanging. Since the shapes are very soft, it's best to make them on a piece of aluminum

Vincent Leto, American. *Mask,* 1978. Salt dough and poster colors. 3¼" × 2¼". An adult's tree ornament.

Headdress (Temes Mbalmbal), Oceanic-Melanesia, New Hebrides Malekula Island, 19th-20th century. Wood (tree fern), straw, compost, paint, tusks, glass. 26″ × 19″ × 15½″. (See Plate 48.)

foil or cookie sheet so that you don't destroy them when you pick them up to put them in the oven. If the forms get quite thick, you may have to bake them at a very low temperature in order to cook the insides without burning the surface.

After the shapes are cool, you can paint them with poster colors, put nylon thread or fine wire through the holes, and hang them up. If by chance you forgot to put a hole in the piece for a thread, you can take a hand drill with a fine bit and drill one after the piece is baked.

After Starting Together, How Do You Continue?

SEEING IS A VERY COMPLICATED ACTIVITY and no great art work communicates its whole quality and value without some form of participation and preparation on your part. Your interest in looking at and making paintings, collages, and sculpture can be on as many different levels as you choose. You can have a relaxing hobby for the pure pleasure of manipulating studio materials or a thorough, in-depth pursuit in which you explore history and cultural ideas as well.

As with any new skill, sport, or field of knowledge, the depth of your understanding and expertise can transform it into a vehicle of the intellect and imagination. After you learn to write, you might compose grocery lists, love letters, or great literature. Likewise, after you've learned how to move your paint brush, scissors, and clay, what you express with your own visual language may be a pursuit you enjoy on many levels.

WHAT TO LOOK FOR IN OTHER STUDIO CLASSES

Now that you have been reading, thinking, talking, seeing, and doing studio work, I hope you have acquired a knowledge of how to set up workshops at home. However, if you decide that you would enjoy further guidance or the camaraderie of a larger group, or if you have found that it is difficult for you to guide your own child in the begin-ning, you may decide to seek additional professional expertise. Al-though you now have a basis for evaluating outside studio programs, here are some things to consider if and when you look for them.

In all cases it is important to understand the attitudes of the guid-ing teacher. Try to visit a class in action. You want to find someone who is sensitive to your feelings and those of your child, but who also challenges you to achieve a certain quality of work. I try to give people the courage to recognize that they all have innate capabilities

even though there is much to learn. If an instructor has a great deal of personal arrogance about expertise, it is not particularly helpful to any beginner, although advanced students may enjoy intellectual dueling to sharpen their own critical faculties. When you go to the classroom you need to see the kind of work being done there and also the studio facilities. I will always remember the look of pride and delight on Victor D'Amico's face as he examined the work of the students in his Teacher's Workshop and commented on how inventive and greatly varied their collages were, and if their work had looked alike, he would have felt that he had not done his job as a teacher. So as you look around, you might be suspicious about whether the instructor encourages personal experimentation and invention or whether they teach imitation of their own style of work. Sometimes institutions hire people to design exquisite art studios with lots of equipment but do not understand the importance of establishing a fundamental philosophy that might not require all that equipment but rather experienced instructors who can encourage growth of the individual. I once taught a little boy in the bleak and barren community room of a housing project. However, the respectful attitude, the sense of order, and the quality of the materials themselves so impressed him that after several sessions of intense but nonverbal involvement, he suddenly announced, "This is the most beautiful school in the world!"

When you visit several classes for your child or yourself, you might evaluate the instructors' teaching methods. Even if a school is popular, it may not suit your needs. It may be a lot of fun and everyone may be busy, but students may not be learning much, or perhaps not know what to do with what they've learned. This sometimes can happen when only techniques and copying are being taught. If instructors encourage comparisons between students, they may set up an unhealthy competitive atmosphere. Do they make students feel guilty or worthless when they make a mistake or don't know how to do something? Is the information taught as an isolated experience, or do the teachers help students to draw from their individual experiences and ideas? What is the value placed on personal expression, or do they stress learning only techniques of representation and making things?

After you observe a class, if any of these issues concern you, ask the teacher to explain the reasons for his/her procedures. You can't always assume the intentions. There may be a good reason for the structure of the class. If you disagree strongly, don't try to change the program—it may work very well for someone else. Move on and try to find something more to your liking. (It's like marriage: You can't marry someone to make them over and expect it to work.) If you feel that a class is mostly right for you, you need to evaluate both

the positive and negative points. Even if you don't approve whole-heartedly, if there are more points on the positive side than on the negative one, give it a chance.

Beyond these basic requirements, your personal needs may differ from those of your child. I would suggest allowing young people to explore different mediums and learn to make connections between the many possibilities in studio work. If you expose your children to only one specialized area, they won't be as able to see the relation-ships between a variety of visual ideas or be encouraged to examine the world visually from many viewpoints. On the other hand, be-cause you have experimented with a wider range of ideas in this book than did your young beginners, you have a basis for choosing an area that you liked best. Some people are fascinated with pure painting, others love mixed-medium collage-assemblage, while others feel most at home with clay.

WHERE TO FIND STUDIO CLASSES

Look in your telephone directory for the addresses and numbers of your nearest art schools, museums, YM-YW centers, community centers, or Arts Council. If you have none of these local facilities, you might write to your state Arts Council for further advice. Per-haps a local public school art teacher would consider doing an extra class if you can find enough other interested people to enroll.

You might even have a retired art teacher living in your town who would enjoy working with children and have more flexible hours than those still teaching a regular schedule. Your local board of education and school principal may be able to give you some names and addresses. There is an elderly woman who has been coming for many years to pick up leftover materials from our classes at the museum. When I inquired what she did with these, I found out that she was a retired art teacher who used the materials to provide col-lage, painting, and drawing experiences for her neighborhood young-sters. Every so often she tells me about a letter she received from someone, now grown, who writes to thank her for the inspiration she provided in their lives.

SHARING THE ART EXPERIENCE

Although you and your child may become interested in different mediums and ultimately enroll in separate classes, the shared expe-rience of doing art together that you have begun can continue throughout your lives, enriching relationships, revitalizing your spir-its, intensifying simple pleasures, and influencing your child's devel-opment in unexpected ways.

Edward Hopper, American. *Tables for Ladies,* 1930. Oil on canvas. 48¼" × 60¼".

Once, toward the end of a semester, after a class in the museum, I became so excited by the growth and development I saw in several student paintings that I gathered them up and climbed the stairs to a friend's office in order to share my enthusiasm. When I arrived, the door was opened and he was in conversation with the chief curator of paintings. I felt awkward and a little embarrassed as I started to explain that these were paintings from my parent-child workshops. The French-born curator interrupted me:

"I understand," he said. "Why do you think I am standing here today? It's because of my parents! My mother surrounded our lives with art. Every time we were to meet her to go anywhere after school, even to the dentist, we always gathered together in a different gallery in the Louvre Museum in Paris—one time in front of the Rembrandt, the next time the da Vinci or the Michelangelo, and so on. Mother always made certain that there would be time for sharing the experience of looking at paintings and sculpture together. It was always the most special time for us."

Although a museum visit is always a stimulating event, it is possible to view your everyday environment in an aesthetic way. I'll never forget the day I walked out of the museum after doing Color Day projects using all the different types of green. Green popped out at me everywhere—from the trees, from people's clothing, the cars in the street, traffic lights, and even the green patina of bronze trimmings on mansard roofs. I recognized how one could become sensitized to particular visual elements.

We are all surrounded by shapes, colors, lines, and textures. The American artist Edward Hopper is a good example of a painter who drew his themes from the commonplace in everyday life. No matter where you live, once you learn to see in this way, the possibilities are endless. Perhaps that's why so many artists live to such a ripe old age, revitalized by new visual experiences and their own creative acts.

For me, and I hope now for you, looking at art, living with art, and sharing it with those you love, will always be a special experience.

Recommended Additional Reading

I. • Educational Philosophy and Methods

ARTS, EDUCATION, AND AMERICANS PANEL. *Coming to Our Senses*. New York: McGraw-Hill Book Co., 1977.

A panel report on the significance of art programs in American education. The Arts, Education, and Americans, Inc., is an ongoing organization that has a nationwide speakers bureau and consultants for setting up art programs as well as a list of reports on all aspects of arts programs from assessments to fundraising. If you would like to help your school improve its art programs, write them at: Box 5297 Grand Central Station, New York, New York 10063.

ASHTON-WARNER, SYLVIA. *Teacher*. New York: Bantam Books, 1963.

One woman's personal experience in helping Maori children in New Zealand to develop the constructive side of their personalities. Ms. Ashton-Warner states: "I see the mind of a five-year-old as a volcano with two vents, destructiveness and creativeness. And I see that to the extent that we widen the creative channel, we atrophy the destructive one." Enjoyable reading.

BLAND, JANE. *Art of the Young Child*. New York: The Museum of Modern Art, 1968. Distributed by the New York Graphic Society, Greenwich, Conn.

A splendid resource for learning to understand and encourage a young child's art work. Although out of print, you may find it at your local library.

D'AMICO, VICTOR, AND ARLETTE BUCHMAN. *Assemblage, A New Dimension in Creative Teaching in Action*. New York: The Museum of Modern Art, 1972. Distributed by the New York Graphic Society, Greenwich, Conn.

This valuable book contains many projects using collage and construction techniques for children from 4 to 14, that can be used for adults as well. Although this book was written for teachers, you may find it helpful at home because the philosophy and instructions are so clearly stated.

D'AMICO, VICTOR. *Creative Teaching in Art*. Scranton, Pa.: International Textbook Co., 1953.

Mr. D'Amico, one of the great pioneers in creative art education, explains how he evolved his methods of teaching art from his personal experiences. Although this book is out of print, it is well worth searching for at your local library.

FRAIBERG, SELMA. *The Magic Years, Understanding and Handling the Problems of Early Childhood*. New York: Charles Scribner's Sons, 1959.

This helpful book offers an understanding of the fantasy lives of children and shows how to build their confidence and improve mutual communication. Enjoyable reading.

HOLT, JOHN. *How Children Fail, How Children Learn*. New York: Pitman Publications, 1967.

As interesting to parents as it is to educators.

JEFFERSON, BLANCHE. *Teaching Art to Children, Content and Viewpoint*. Boston: Allyn and Bacon, Inc., 1969.

An educator's evaluation of art curricula for children up to sixth grade. The discussions touch on many issues in Doing Art Together.

LORD, LOIS. *Collage and Construction in Elementary and Junior High Schools*. Worcester, Mass.: Davis Publications, 1970.

By a superb educator who has helped countless children, teachers, and programs to flourish. While there are more recent books on the subject, this one provides fine photographs of children working, examples of collages and constructions, and understanding of learning through art experiences.

MARSHALL, SYBIL. *An Experiment in Education*. Cambridge, England: The University Press, 1963.

This account of the author's personal experience teaching in a small village illustrates the importance of exposing children to a wide range of ex-

periences to encourage learning and self-expression and shows how you might use the arts as a way of introducing other subjects.

PILE, NAOMI. *Art Experiences for Young Children.* New York: Macmillan, 1963.

A fine text with many illustrations. It offers "Age-Appropriate Experiences" and mediums such as simple weaving, wood sculpture, print making, puppetry.

RICHARDS, MARY CAROLINE. *Centering in Pottery, Poetry, and the Person.* Middletown, Conn.: Wesleyan University Press, 1964.

This book sets forth a philosophy of learning and creativity and explores how one may find a personal center which will bring unity to disruptive urges within the self and society.

II. • Source Books for Studio Work (How-to-Do-It Manuals)

BERENSOHN, PAULUS. *Finding One's Way with Clay.* New York: Simon and Schuster, 1972.

A fine introduction to working with clay.

EDWARDS, BETTY. *Drawing on the Right Side of the Brain.* Los Angeles: J. P. Tarcher, 1979.

Enlightening for those who have had problems learning to draw and think visually.

MAYER, RALPH. *The Artist's Handbook of Materials and Techniques.* New York: Viking Press, 1970.
———. *The Painter's Craft.* New York: Viking Press, 1975.

These reference manuals may be useful if you wish to explore painting mediums other than poster paint.

MEILACH, DONA Z. *Creating Art with Bread Dough.* New York: Crown Publishers, 1976.

If you can't work with clay you might consider dough an alternative. However, the disadvantage of this medium is that it isn't as structural as clay and forms won't stand up in the air.

NICOLAIDES, KIMON. *The Natural Way to Draw.* Boston: Houghton Mifflin, 1975 (paperback).

An excellent book for learning how to draw.

WEHLTE, KURT. *The Materials and Techniques of Painting.* New York: Van Nostrand Reinhold, 1975.

This has anything you ever wanted to know about the medium of painting and its tools.

III. • Picture-File Photography Books

KLOTS, ALEXANDER AND ELSIE. *Living Insects of the World.* Garden City, N.Y.: Doubleday, 1967.

277 photographs, of which 152 are in color.

MARTEN, MICHAEL, JOHN CHESTERMAN, JOHN MAY, AND JOHN TRUX. *Worlds Within Worlds, A Journey Into the Unknown.* New York: Holt, Rinehart & Winston, 1977.

The microphotography, aerial photography, and other photographic styles represented here reveal a wealth of shapes and colors not visible to the unaided eye and are a wonderful source of visual inspiration.

RUDOFSKY, BERNARD. *Architecture Without Architects, An Introduction to Non-Pedigreed Architecture.* New York: The Museum of Modern Art, 1964. Distributed by Doubleday, Garden City, N.Y.

I highly recommend this as a source book for ideas. The excellent photographs show a wonderful range of inventive shapes of shelters around the world.

Pictorial magazines such as Audubon, Geo, National Geographic, Natural History, Smithsonian, *and* National Wildlife *are superb sources of inspiration. Also, many seed catalogues advertised in the gardening sections of newspapers are free. Park Seed and Burpee especially have lots of color photos of plants and flowers.*

IV. • Books That May Be Shared with Young People

(Many of these are particularly appropriate for high school and adult beginners.)

BEARDEN, ROMARE, AND HARRY HENDERSON. *Six Black Masters of American Art.* Garden City, N.Y.: Doubleday/Zenith, 1972.

A clearly written introduction to Black American artists for school-age children. Although junior high school and high school students may read it by themselves, you might read and show this to younger children also.

BLAND, JANE. *Childcraft—Art for Children, Volume 10.* Chicago: Field Enterprises, 1954.

A source book of reproductions of art for adults to share with preschool through grade school children. Ms. Bland discusses shapes, forms, and visual ideas in a way that relates to what you see every day. She presents a very personal understanding of how artists have made images of the things they love, know, and imagine. This book is out of print, but you may find it in libraries.

GLUBOCK, SHIRLEY. *The Art of Africa.* New York: Harper & Row, 1965.
———. *The Art of Ancient Peru.* New York: Harper & Row, 1966.
———. *The Art of China.* New York: Macmillan, 1973.

Ms. Glubock has also written many other children's books filled with photographs covering many aspects of art history that grade-schoolers through adult beginners may enjoy.

HOBAN, TANA. *Is it Red? Is it Yellow? Is it Blue? An Adventure in Color.* New York: William Morrow/Greenwillow Books, 1978.
———. *Circles, Triangles and Squares.* New York: Macmillan, 1974.
———. *Look Again.* New York: Macmillan, 1971.
———. *Over, Under and Through.* New York: Macmillan, 1973.

These four beautifully designed photographic books by Tana Hoban are very good for teaching concepts such as color, shape, and spatial ideas to preschool and early-elementary-school children.

KNOBLER, NATHAN. *Visual Dialogue.* New York: Holt, Rinehart & Winston, 1980.

This book, for older teen-agers and adult beginners, explains how to understand the formal elements of art and how to relate these concepts to your personal experiences.

LIONNI, LEO. *Little Blue and Little Yellow.* New York: Astor Honor, 1959.

A book I use regularly for sharing concepts and ideas with preschool children. It doesn't make value judgments about colors and leaves enough to the imagination to make them think.

MOORE, JANET GAYLORD. *The Many Ways of Seeing, An Introduction to the Pleasures of Art.* Cleveland, Ohio: World Publishing Co., 1968.

The text is interesting to older teen-agers and adult beginners, is historically informative about mediums and vocabulary, and is well illustrated.

PAINE, ROBERTA. *Looking at Architecture.* New York: Lothrop, Lee and Shepard, 1974.
———. *Looking at Sculpture.* New York: Lothrop, Lee and Shepard, 1974.

Handsome books that are very good for introducing sculpture and architecture to beginners of any age.

PRICE, CHRISTINE. *Made in Ancient Greece.* New York: E. P. Dutton, 1967.

Good for beginning students, from grade school through adult.

RIEGER, SHAY. *Our Family.* New York: Lothrop, Lee and Shepard, 1972.

This book contains photographs of very simple shapes that represent people in forms that are easily understood by preschool children. However, the vocabulary of forms presented is useful for beginners of any age starting clay work—adults included.

V. • Art History

Broad surveys for general reference, with many reproductions. Some of these may be difficult for the casual reader.

BOAS, FRANZ. *Primitive Art*. New York: Dover Publications, 1955.

GOMBRICH, ERNEST H. *The Story of Art*. New York: E. P. Dutton/Phaidon Press, 1966.

JANSON, H. W. *History of Art*. New York: Harry N. Abrams, 1962.

Larousse Encyclopedia of Mythology. London: Batchworth Press, 1959.

LEE, SHERMAN E. *A History of Far Eastern Art*. New York: Harry N. Abrams, 1964.

NEWHALL, BEAUMONT. *History of Photography from 1839 to the Present Day*. New York: The Museum of Modern Art, 1964. Distributed by the New York Graphic Society, Greenwich, Conn.

NEWTON, DOUGLAS, TAMARA NORTHERN, ROBERT GOLDWATER, AND JULIE JONES. *Art of Oceania, Africa and the Americas from The Museum of Primitive Art*. New York: The Metropolitan Museum of Art, 1969.

VI. • Individual Subjects and Artists

BEVLIN, MARJORIE ELLIOTT. *Design Through Discovery*. New York: Holt, Rinehart & Winston, 1977.

Contains visual analyses of objects in industrial design, fine arts, and photography and is useful for junior high school or older students and adults.

CLARK, KENNETH. *Looking at Pictures*. Boston: Beacon Press, 1960.

Mr. Clark's anecdotes and enthusiasm in discussing many very fine paintings make this a very readable introduction to art.

ELDERFIELD, JOHN. *The Cut-Outs of Henri Matisse*. New York: George Braziller, 1978.

The excellent color illustrations show the development of his collage technique.

FLAM, JACK D. *Matisse on Art*. New York: E. P. Dutton, 1978.

Words from the master himself describe what he learned about art during his long career.

HEMPHILL, HERBERT W., ed. *Folk Sculpture USA*. New York: The Brooklyn Museum, 1976.

This exhibition catalogue is profusely illustrated with color and black-and-white photographs and includes several interesting essays.

HENRI, ROBERT. *The Art Spirit*. Philadelphia: J. P. Lippincott Co., 1960.

A collection of notes, articles, fragments of letters, and talks to students on the concept of picture-making, the study of art, and art appreciation by the painter-teacher.

ITTEN, JOHANNES. *The Elements of Color*. New York: Van Nostrand Reinhold, 1970.

An academic color-theory manual available in two versions. One is the larger, expensive The Art of Color. The Elements of Color *is a simplified condensation of that volume. It is also for a fairly serious student and is not for children. The information is most interesting when applied to personal projects.*

JANIS, HARRIET, AND RUDI BLESH. *Collage—Personalities, Concepts, Techniques.* Philadelphia: Chilton Book Co., 1967.

This book has 500 photographs and an extensive text.

LIBERMAN, ALEXANDER. *The Artist in His Studio.* New York: Viking/Compass, 1974.

Notable photographs and enjoyable text give insights into how artists have integrated their lifestyles and work.

LORD, JAMES. *A Giacometti Portrait.* New York: Farrar, Straus & Giroux, 1980.

A personal account of Giacometti's development of a portrait painting by a man who posed for the sculptor-painter, giving a view of the creative methods and attitude of the artist.

MCSHINE, KYNASTON, ed. *The Natural Paradise: Painting in America 1800–1950.* New York: The Museum of Modern Art, 1976. Distributed by the New York Graphic Society, Greenwich, Conn.

A study of landscape painting, showing many different interpretations and styles with quotations from the artists about their paintings.

MUNRO, ELEANOR. *Originals: American Women Artists.* New York: Simon and Schuster, 1979.

Interviews with some of the leading women artists of this century.

NEVELSON, LOUISE. *Dawns & Dusks, Conversations with Diana MacKown.* New York: Charles Scribner's Sons, 1976.

This is an inspiring autobiography of one of America's most famous artists.

PANOFSKY, ERWIN. *Meaning in the Visual Arts.* Garden City, N.Y.: Doubleday/Anchor Books, 1955.

A series of difficult essays by one of the world's great art historians. Two of the most useful ones for beginning students are "The History of Art as a Humanistic Discipline" and "Iconography and Iconology: An Introduction to the Study of Renaissance Art."

PAZ, OCTAVIO. *In Praise of Hands, Contemporary Crafts of the World.* Greenwich, Conn.: The New York Graphic Society, 1974, in association with the World Crafts Council.

This shows a wide range of crafts in superb photographs.

SCHAPIRO, MEYER. *Modern Art, the 19th and 20th Centuries, Selected Papers.* New York: George Braziller, 1978.

These essays by one of the finest art historians of our times (especially "The Nature of Abstract Art," "Recent Abstract Painting," and others on individual artists) can be of great help in understanding contemporary art work.

SEITZ, WILLIAM. *The Art of Assemblage.* New York: The Museum of Modern Art, 1961.

A history of this medium in the twentieth century.

WOLFFLIN, HEINRICH. *Principles of Art History.* New York: Dover Publications, no date. Seventh edition.

An excellent discussion of the concept of style in painting, sculpture, and architecture and how it develops in different periods of time and different cultures.

Although there are many very beautiful and expensive coffee-table volumes on art, several of the lower-priced series by Time-Life Books (New York) and Scale Books (Florence, Italy; distributed by the Two Continents Publishing Group) on various periods of art, great museums of the world, and photography have excellent reproductions. The Abrams Library great painters portfolio editions offer folders of loose individual pages of art reproductions at lower prices than those of bound books.

Credits

The authors and publisher wish to thank the following individuals and institutions for permission to reproduce the works in this book:

Robert Adzema, pp. 25 top left, top right, bottom right; 261

Bill Anderson, p. 241

Helene Berg, p. 211 bottom

Camille Billops, p. 146

Bevan Davies, Courtesy of the Brooke Alexander Gallery, New York, p. 191; Courtesy of the Pace Gallery, New York, p. 202

D. James Dee, Courtesy of the Holly Solomon Gallery, New York, p. 148

eeva—inkeri, Courtesy of Cordier and Ekstrom, Inc., New York, p. 273 bottom

Ronald Erickson, Courtesy of CLAYWORKS, New York, p. 268 top

J. Ferrari, Courtesy of Zabriskie Gallery, New York, Collection of the artist, p. 244

Helen Frankenthaler, work on loan to the National Gallery of Art, Washington, D.C., p. 61 middle

Roy Godley, p. 158

The Estate of Hans Hofmann, p. 170

Arthur A. Houghton, Jr., work on loan to The Metropolitan Museum of Art, New York, p. 192

Jeanne-Claude, p. 126 bottom

Seth Joel, pp. 14, 15, 17, 19, 27, 29, 35, 55, 59, 62, 63, 64, 75, 79, 90, 100, 102, 103, 108, 110, 111, 115, 120, 128, 129, 130, 131, 149, 152, 160, 164, 172 bottom, 174, 175, 178, 180, 182, 183, 185, 194, 205, 207 top, 209, 213, 222, 223, 227, 228, 232, 233, 234, 236 bottom, 237, 238 right, 240 top, 245, 246, 248, 260 right, 268 bottom, 269, 271, 272, 276

Mablen Jones, pp. 25 bottom left, 112, 242, 267, 277

Just Above Midtown Gallery, New York, p. 215

Madeleine Chalette Lejwa, Collection of Arthur and Madeleine Lejwa, pp. 220, 221

Maggie Luycks and Elaine de Kooning, p. 45

James Mathews, pp. 73, 74, 95, 118, 135, 138, 153, 200, 201, 211 top, 212, 226, 238 left, 239 bottom, 254, 255, 259

Collection, The Metropolitan Museum of Art, New York
Gift of Joseph Albers, 1972, p. 208 right
Anonymous Gift, 1956, p. 208 left; 1965, p. 171 bottom; 1978, p. 97
Avery Fund, 1919, p. 230 top
The Jules S. Bache Collection, 1949, p. 176
Gift of George Biddle, 1971, p. 257 bottom
Gift of Mr. and Mrs. Ralph F. Colin, 1976, p. 243
Gift of Bashford Dean, 1914, p. 240 bottom
Bequest of Miss Adelaide Milton de Groot (1867–1967), 1967, p. 198 bottom
Harris Brisbane Dick Fund, 1932, p. 232 bottom; 1940, p. 231 top
Bequest of Julia W. Emmons, 1956, pp. 85, 163
Fletcher Fund, 1935, pp. 256, 257 top; 1955, p. 124 top
Gift of Mr. and Mrs. Thomas H. Foulds, 1924, p. 229 top
Bequest of Michael Friedsam, The Michael Friedsam Collection, 1931, pp. 125, 210, 270 top
Purchase, Pauline V. Fullerton Bequest, Mr. and Mrs. James Walter Carter Gift, Mr. and Mrs. Raymond J. Horowitz Gift, Erving Wolf Foundation Gift, Vain and Harry Fish Foundation, Inc., Gift, Gift of Hanson K. Corning, by exchange, and Marcia DeWitt Jesup and Morris K. Jesup Funds, 1976, p. 106
Gift of Edgar William and Bernice Chrysler Garbisch, 1965, p. 230 bottom
Gift of Mrs. Frank Jay Gould, p. 86
Bequest of Mary Stillman Harkness, 1950, p. 197
The Havemeyer Collection, Bequest of Mrs. H. O. Havemeyer, 1929, pp. 93, 188 left
Joseph H. Hazen Foundation, Inc., Gift, 1976, p. 260 right

Arthur H. Hearn Fund, 1940, p. 190; 1942, p. 151; 1959, p. 65
Arthur H. and George A. Hearn Funds, 1977, p. 124 bottom
George A. Hearn Fund, 1931, p. 282; 1942, p. 159; 1953, p. 145; 1956, p. 91; 1957, p. 58 bottom; 1970, p. 219
Hewitt Fund, 1911, and Anonymous Gift, 1951, p. 263
Gift of Arthur A. Houghton, Jr., 1970, p. 274
Morris K. Jesup Fund, 1966, p. 150; 1968, p. 105 right
Gift of Lincoln Kirstein, 1959, p. 189 bottom
Gift of Mr. and Mrs. J. J. Kleman, 1964, p. 273 top
Bequest of Margaret S. Lewisohn, 1954, p. 173 bottom
Bequest of Samuel A. Lewisohn, 1951, p. 105 left
The Howard Mansfield Collection, Rogers Fund, 1936, p. 195
Gift of Henry G. Marquand, 1889, p. 177
Courtesy of The Metropolitan Museum of Art, 1916, p. 236 bottom
Gift of J. Pierpont Morgan, 1911, p. 189 top
Roy R. and Marie S. Neuberger Foundation, Inc., Gift, 1961, p. 264 top
The Harry G. C. Packard Collection of Asian Art, Gift of Harry G. C. Packard and Purchase, Fletcher, Rogers, Harris Brisbane Dick, and Louis V. Bell Funds, Joseph Pulitzer Bequest, and The Annenberg Fund, Inc., Gift, 1975
Photography and the Fine Arts Gift, 1970, p. 197
Gift of Eliot Porter in honor of David Hunter McAlpin, 1979, p. 188 right
Gift of the Estate of Mrs. Edward Robinson, p. 172 top
The Michael C. Rockefeller Memorial Collection of Primitive Art, Bequest of Nelson A. Rockefeller, 1979, pp. 275, 278
Rogers Fund, 1903, p. 107; 1904, p. 239 top; 1920, p. 265; 1942, p. 264 bottom; 1949, p. 47; 1956, p. 20
Gift of Paul J. Sachs, 1916, p. 193 right
Jo Anne and Norman M. Schneider Gift, 1979, p. 262
Purchased with special contributions and purchase funds given or bequeathed by friends of the Museum, 1967, p. 199 top
Gift of Alfred Steiglitz, 1933, p. 40
The Alfred Steiglitz Collection, 1949, pp. 58 top, 61 top, 122, 127, 168, 181, 207 bottom
Bequest of George C. Stone, 1936, p. 229 bottom
Catherine D. Wentworth Fund, 1949, p. 179
The Elisha Whittelsey Fund, 1971, p. 41

Al Mozell, Courtesy of the Pace Gallery, New York, pp. 171 top, 199 bottom

Collection, The Museum of Modern Art, New York
Gift of the artist, p. 147
Gift of Mrs. Simon Guggenheim, p. 193 left
Mrs. Simon Guggenheim Fund, p. 169 bottom
Photograph courtesy of Madeleine Chalette Lejwa, p. 251
Gift of Nelson A. Rockefeller in honor of Alfred H. Barr, Jr., p. 133
Nelson A. Rockefeller Bequest, p. 123
Gift of James Thrall Soby, p. 61 bottom
James Thrall Soby Bequest, p. 169 top
Ken Sage Tanguy Fund, p. 37

Dona Nelson, p. 173 top

Otto E. Nelson, Courtesy of Marlborough Gallery, Inc., New York, p. 247

Pace Gallery, Pace Editions, New York, p. 155; 1979, pp. 12, 126 bottom

Lesley Saar, Courtesy of Just Above Midtown Gallery, p. 206

Hilde Sigal, Photograph by Dr. Leo Sigal, p. 198 top